IN THEIR COMPANY

Portraits of American Playwrights

IN THEIR COMPANY

Portraits of American Playwrights

Photographs by Ken Collins
Interviews by Victor Wishna

umbrage editions

To Vivian Raby
for her unwavering encouragement and support

To Jeanette and Sheldon Wishna
for everything

TABLE OF CONTENTS

8. NOTES BY KEN COLLINS & VICTOR WISHNA
10. EDWARD ALBEE
16. ROBERT ANDERSON
20. JON ROBIN BAITZ
24. ERIC BENTLEY
30. ERIC BOGOSIAN
34. CONSTANCE CONGDON
38. KIA CORTHRON
42. CHRISTOPHER DURANG
46. HORTON FOOTE
50. RICHARD FOREMAN
54. MARIA IRENE FORNES
58. JACK GELBER
62. RICHARD GREENBERG
68. JOHN GUARE
72. A.R. GURNEY
76. JEFFREY HATCHER
80. BETH HENLEY
84. ISRAEL HOROVITZ
90. TINA HOWE
94. DAVID HENRY HWANG

98. DAVID IVES
102. CORINNE JACKER
106. ADRIENNE KENNEDY
110. ARTHUR KOPIT
114. HOWARD KORDER
118. LARRY KRAMER
122. TONY KUSHNER
126. NEIL LaBUTE
130. WARREN LEIGHT
134. ROMULUS LINNEY
138. KENNETH LONERGAN
142. CRAIG LUCAS
146. EDUARDO MACHADO
150. WENDY MacLEOD
154. EMILY MANN
160. DONALD MARGULIES
164. TIM MASON
168. TERRENCE McNALLY
172. MARSHA NORMAN
176. LYNN NOTTAGE
180. DAEL ORLANDERSMITH
186. SUZAN-LORI PARKS

190. PETER PARNELL
194. DAVID RABE
198. PAUL RUDNICK
204. CARL HANCOCK RUX
208. JOHN PATRICK SHANLEY
212. WALLACE SHAWN
216. NICKY SILVER
222. NEIL SIMON
226. ANNA DEAVERE SMITH
232. ALFRED UHRY
236. PAULA VOGEL
240. NAOMI WALLACE
244. WENDY WASSERSTEIN
250. MAC WELLMAN
254. AUGUST WILSON
260. LANFORD WILSON
264. GEORGE C. WOLFE
268. DOUG WRIGHT
272. SUSAN YANKOWITZ
277. ACKNOWLEDGMENTS
278. BIBLIOGRAPHY

INTRODUCTION

Plays tell stories, and photographs tell stories. The words of a play begin on the page and come alive in real time with real people. The relationship created between the people onstage and those in the audience is an intimate one. Photography works the same way, though in the opposite direction—capturing real people in real time, the image on the page creates an intimate experience for the viewer.

I am completely enchanted by the passion, intellect, and grace of the playwrights who welcomed me into their homes. As a photographer, I could not have asked for better subjects. They wear their lives and their choices on their faces. To become a playwright is a leap of faith, and while these artists have achieved so much, they maintain enormous humanity and humility. That's what I wanted to capture, and why I chose to photograph them as people, not as "personalities." I wanted to invite the viewer in, to recreate the sensation of close contact found in the theatre, and, as best I could, to tell each person's story.

—Ken Collins

When we began this project a number of years ago, our goal was to create a book that would be, essentially, a portrait of the last sixty years of American theater. However, our work turned out to be much more personal than that. We both love the theater and were already fans of these playwrights. While some of them have literally seen their names in lights, most will never be as famous as the plays and the characters they create—or the actors who inhabit their roles. On the most basic level, we wanted to reveal them, to show their faces, and provoke readers to respond: "Ah, *that's* who wrote that play."

Since everyone featured in this book is a gifted writer, it would have been easy enough to ask each of them to submit an essay on why they do what they do. However, we decided early on that this project was about intimacy, immediacy, and spoken language, like theater itself. The central goal of *In Their Company* is to enable readers to feel as if they are listening in on conversations. The passages contained here are honest responses given in an interview setting—ruminations by playwrights on what it means to have chosen this life and this livelihood.

Combining their own words with photographs and presenting them as a collection, we hope to illuminate a close-knit community of people who, most of the time, work alone. As August Wilson explained, "You sit down in the chair, and it's the same chair that Eugene O'Neill sat in, that Tennessee Williams sat in, that Chekhov, Arthur Miller—whoever you want to name—all sat in. It's the same chair. It's the playwright's chair."

For me, it was fascinating to sit with these writers in their living rooms, their writing studios, their favorite cafés—to be alone with them, just as they are alone with their plays before any audience has heard the voices they hear or felt the truth of what those voices say. I met people who were polite, occasionally profound, frequently vulnerable, sometimes funny, and always friendly. My hope is that you will experience the same pleasure I did in their company.

—Victor Wishna

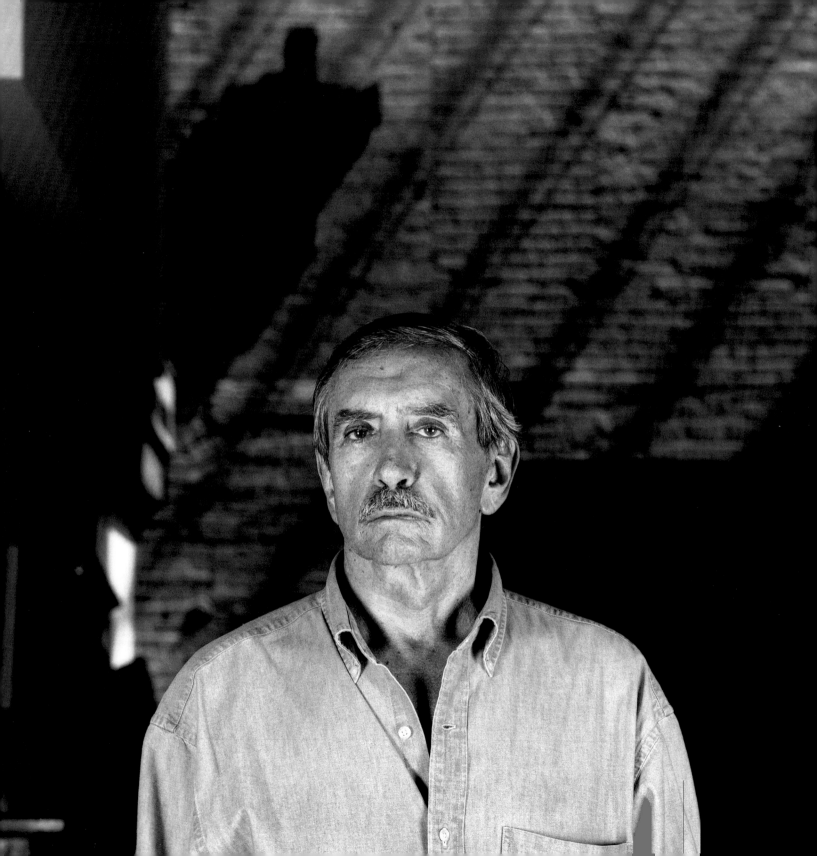

EDWARD ALBEE

Born in 1928 in Washington, D.C., Albee is author of numerous plays, including *Who's Afraid of Virginia Woolf?*, *The Zoo Story*, and *The Goat, or Who is Sylvia?* He is the winner of three Pulitzer Prizes, as well as an Obie Award, three Tony Awards, and Best Play awards from the New York Drama Critics Circle and Outer Critics Circle.

EDWARD ALBEE

I wrote poetry for twenty years. Got published, in fact, in a tiny little poetry magazine. And I wrote two novels (one when I was fourteen, one when I was sixteen), which, as I've said, were probably the two worst novels that could have been written by an American teenager—very dreadful pieces. And I wrote short stories and stuff and none of it was any good. I liked it, but I knew it wasn't any good. Finally, when I was twenty-nine, having moved to Greenwich Village and lived there for ten years very happily, educating myself in the arts and in life, I decided to write a play. It was *The Zoo Story*. All of a sudden I knew I had written something that was good. And not just because I had written it and I liked it, but I knew it was good. And I was right. So I kept on writing plays.

Everybody has an age when they can start writing like themselves. Up until that point you write like other people. It's the way the mind works. Mozart, for example, was writing great music when he was twelve. But Bernard Shaw didn't write his first play until he was over forty. Every mind works differently.

The mind has a couple of elements—the conscious mind and the unconscious mind. The unconscious mind is that with which we don't always have full communication. That's about ninety percent of the thinking part of the brain, and I'm sure that's where most creativity goes on. The conscious mind absorbs and puts into the unconscious all of the techniques that one needs, all of the reading that one does, all of the experience and the craft and the art of writing that one is exposed to. With any luck that goes into a kind of stew, and it starts forming itself into individual creativity. I'm aware that I have a play forming. But when I start putting it down on paper I'm surprised by how much I know about the characters and about the play, its manner, its style, its everything else. I'm surprised that I know so much. So the unconscious is the wellspring of creativity.

I hate the question, "What is the play about?" My answer to that is always that it's about an hour long. I know where it's starting. And I don't make huge revisions. I think I wait a long time before I write anything down so that the more coherent part of my mind, the unconscious, can do most of the work. But there's a lot of craft involved. I have to control the duration of scenes. I have to make sure that they're dramatically viable. But my standard is always this: when I write a play down on paper, I see it and I hear it as a performed play, being performed in front of me. I become the audience. I see myself as the audience of the play that I'm writing. So if I, as the audience, am interested, and not bored, then I make the assumption that other people will be interested as well.

Each play should be the first play I've ever written. It should be the first play that anybody's ever written. That way you don't have anyone to imitate. I listen to a couple of Bach fugues, which clears my mind very nicely, and then I write the first play that anybody's ever written. That way I'm not influenced by other playwrights. And if I hear other people's voices coming in there, I stop until they go away. Just go outside and walk around. We all have influences, but you have to keep them under control. I know who I've learned from. Every once in a while, I'm aware, "Oh, you're getting a little Becketty there—make it you, make it you."

I invent all of my characters. I make tests to see how well I know them. If I have four characters in a play, I will go down to the beach in Montauk and walk for an hour and construct some situations and improvise dialogue for them. If I know them well, they can handle themselves in an improvised situation. If I don't know them well, they can't. It's very much the way an actor does actor's improvisation toward getting into character. So I improvise with them to find out how well I know their voices and their minds. And if I do know them, then I trust in them for the situations of the play.

To my knowledge, I have never written about myself. If I did that, I couldn't be objective. Somebody's got to control what's going on. I let my characters do what they want to, but I observe them pretty carefully to make sure what they're doing is not too far off. There was an interesting case with my play, *A Delicate Balance*. There's a subsidiary character, the alcoholic sister Claire, who (I discovered when I was writing Act One of this three-act play) wanted the play to be about her. I didn't, so I kept taking her offstage and not letting her come on until she was ready to behave herself. That's one time I had to control it that way. But if characters in a play of mine start behaving in a way

that I am a little surprised by, I'm not going to stop them. Why should I impose? They're three-dimensional people, they have their own mind, so to speak. Even though it's my creative mind, it's their character's minds. Why would I get in their way?

I don't think a play should go into rehearsal until it's ready to open, basically. If a playwright can't hear a play while he or she is writing it, then there is something seriously wrong with the playwright. If you can't see it, you can't hear it while you're writing it, then you don't have your technique under control. I am as much of an audience as I need. I'm pretty critical of myself. When I read a play by somebody, I read it and I see and hear it being performed. I don't need someone to be performing it. It's nice to have it performed, but a play does not come to life only in performance, because a play can be lousy and work very well on stage. It may come to life only in performance to those people who can't see and hear it by reading it. Because plays are literature. They have the extra virtue of being able to be seen and heard by people who don't know how to see and hear them when they read them. No play is any better than it is on the page.

We playwrights are all basically messianic. We feel that we know truths that we damn well better share with other people. I say this basically as a joke. But I'm convinced that we wouldn't write unless we felt the need to set people straight about certain things. Otherwise, why waste your time? Who writes about stuff that's been settled, unless you're just writing escapist shit? I think we probably are trying to communicate our sense of how life is lived as opposed to how it should be lived.

You should put down what you hear and what you see, as accurately as you hear and see it. This should give instruction

to the actors and the director as to the nature of the character. Because everybody talks differently and if you can be helpful, that's fine. They used to say that a lot of actors—particularly Actor's Studio actors—when they got a script would black out all of the stage directions and all of the author's indications as to how people spoke. One interesting thing happens when an actor does that: it takes them about a week longer to find the character. Do you think that Beethoven would write four bars of music without indicating what was fast, what was slow, what was loud, and what was soft? Why should I? Why should any playwright? A playwright is a fool, or lazy, or incompetent, if he thinks, "Oh, what I've written is just the skeleton for other people to put the flesh on." That's preposterous. That's not doing your job properly.

The most important thing for me about playwriting is its relation to musical composition. When I was quite young, I started drawing. I was maybe five or six. I started writing poetry when I was eight. When I discovered classical music I wanted to be a composer. I listened to a great deal of classical music but I never became a composer because I wasn't supposed to be. That's not where my talent lay. But I did become aware (and I've talked to other playwrights about this) that writing a play and writing a string quartet are very, very aesthetically similar actions. A play is both seen and heard, exists on a page but can also be performed. The durations of a play, the durations within a play, are all very similar to the durations within a piece of music. We playwrights, if we hear what we're writing very carefully, we notate durations and intensities just as precisely as a composer does—loud, soft, fast, slow, agitated, pacific. We make all those indications because we're hearing what we're writing. We hear the sounds of what we're doing, very much the way a composer does. And the structure of a play is very similar to the psychological structure of a piece

of music. That's why I'm so happy that I listen to so much classical music. But I never listen while I'm writing. I don't want to hear other people's rhythms. I want to hear my own.

A playwright also has to know a good deal about the visual arts. When he writes a scene, there's backdrop and people moving. It has to do with painting and sculpture and dance, as well as classical music. It's the only thing that combines so much of the other arts, which is one of the things that's exciting about it.

I would rather be alone when I'm writing. There's an intense concentration involved, which is why you can't do it for more than two or three hours at a time without getting a headache. And the reality of what you're doing has got to be more real than anything else. If you can't put yourself in that state of suspension, you probably shouldn't be writing at that time. If you're preoccupied with other things, you shouldn't try to write.

I never know how long anything takes me to write, because when did I start thinking about it? (Long before I was aware.) When does writing begin? When you're thinking about it, or before you're aware you're thinking about it? Or only when you start writing it down on paper? I can get to a sense where this play wants to be written down and so I'll start doing it.

I write fairly quickly. *Zoo Story* took three weeks to write. *Virginia Woolf* took three months. I can usually get a play done in a couple of months. I've never had writer's block (despite the opinions of some critics). I don't get frustrated in the writing process. It's only when other people get involved—actors, directors, critics, audiences. Because it's not collaborative, it's interpretive. Writing is not a collaborative act, unless you happen to be Kaufman and

Hart and you're writing together. With a rotten play, almost any interpretation is going to be better than the play. But I have never seen a performance of *Uncle Vanya* that has made *Uncle Vanya* any better than it is. The better the play, the less help it needs from interpretation. Most interpretation of the best stuff is willful, and quite often distorted.

Having your plays performed is nice. Not many people read them, so it's a form of sharing, I guess. But there are perils there because you have to work with directors and actors who sometimes aren't very good or are wrong-headed. I find most of what I see deplorable. But then again, most art is lousy. Good stuff is rare. Most people have no taste and a lot of people like that. Also, commerce comes in and a lot of people do art that is only made to be sold. I think it's a waste of a lot of time. I try not to. I can tell pretty much whether something is going to be interesting. I feel lucky if in New York there are six, seven, or eight things that are worth looking at, maybe. Less good stuff happens on Broadway than used to. Much of that is economics, what people are willing to invest money in. It's a terrible shame. It used to be that things didn't cost so much to do, when you could do a play like *Virginia Woolf* on Broadway in 1962 for $42,000. Now it would cost close to two million dollars. Inflation hasn't gone up that much. It discourages people from taking chances.

Until Bush gets finished with us, we're still a democracy, and we're free to make as many aesthetic mistakes as we wish. And if we wish to have arts that are only junk or escapist, we're free to do it. It's our buck, so to speak. If we were educated to want something better, then we'd want something better.

Of course, there are things I enjoy beside playwriting. I swam with dolphins. I've done gliders, I've been up in a balloon, but I haven't done skydiving yet. I love spending time underwater, too. I wish I could be a fish. And a bird. Something that would go down and live in the water. I talk about that in a play called *Seascape*. But you can't worry about stuff that you can't do. So I will stick to skydiving and playwriting.

As a playwright, I'd like to get better. I'd like to remain pertinent. I think I've got my craft more under control. But I don't think about myself in the third person. It's very dangerous. Then I would have an opinion of myself—and that could get in the way.

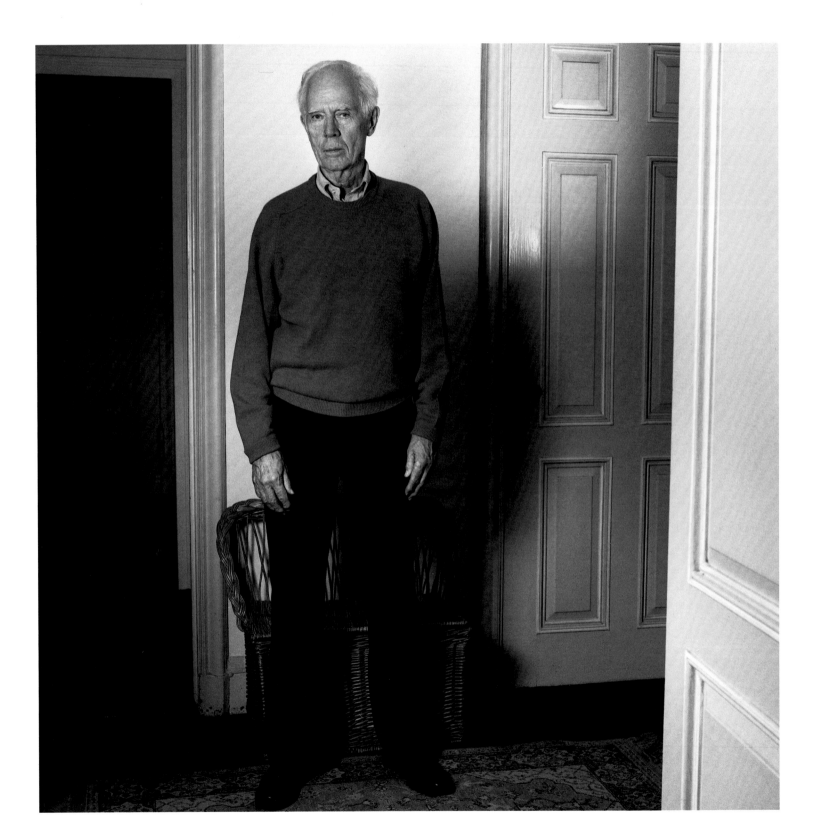

ROBERT ANDERSON

Born in 1917 in New York, Anderson is the author of numerous works, including the play *Tea and Sympathy* (1953), and the novel *Getting Up and Going Home* (1978). He received the Writers Guild Award multiple times and was elected to the Theatre Hall of Fame. He received the William Inge Award for Lifetime Achievement in 1985.

My father didn't want either my brother or me to be businessmen. He said, "One day they come in, and they don't like the color of your tie, and you're out," which is essentially what happened to him. He retired, but he was urged out. My brother became a doctor, and I became a playwright; but I don't think my father ever considered playwriting a profession.

I attended a private school in New Rochelle, New York, and the woman who ran it loved the theater. All the classes from kindergarten to the eighth grade put on skits or playlets each Friday. She would take groups of us down to New York City—forty-five minutes away—to see matinees. Once, she hadn't checked out the play, and it turned out there was a lot of "wrestling" on the couch between a boy and a girl. At intermission, Miss Thornton leaned over and told us, "Of course, you know that's not real life."

At Harvard, I acted in a play my freshman year. When I was a sophomore, a fellow student who had acted with me in this play asked me if I would like to go across the river to Boston and try out for a part in a play at a girls' school. I said, "Sure. At least I'll meet girls." I crossed the river, and I met a lot of lovely girls—as we called them then—but I also met Phyllis Stohl, the woman who was directing

ROBERT ANDERSON

the play. She was ten years older than I was. I fell in love with her instantly. I acted the leading part in several of her productions, walked her up Beacon Street to her apartment after rehearsals, invited her to dances at Harvard, and we were married when I got my master's degree in 1940.

I sensed even back then that you could make a killing in the theater but not a living, though I didn't say that until many years later. So, after my master's, I worked for my Ph.D. and I passed the orals the night before I was commissioned in the Navy. I was assigned to a brand-new battle cruiser, the *Alaska*, fitting out in the Philadelphia Navy Yard. Phyllis had discovered an Army-Navy National Theatre Conference Playwriting Contest for servicemen. While we were getting the *Alaska* ready for going into the Pacific, I managed to write a play. I was at Iwo Jima when I learned I had won the prize for the best play written by a serviceman overseas. Somehow, though the kamikazes were coming in on all sides and we were operating sometimes in mined waters both at Okinawa and Iwo, I did not worry too much about what I was going to do after the war. I was going to be a playwright.

My prizewinning play, *Come Marching Home*, was produced by the Blackfriars' Guild in New York in 1946. I was also lucky enough to get a job writing for "The Theatre Guild on the Air." Radio was great in those days. I wrote for Deborah Kerr, Richard Burton, Helen Hayes, and Humphrey Bogart. Every great star appeared on radio in those days. It was a great experience. I did adaptations of plays, movies, and novels; and to do those for an hour, you learned a great deal about structure. Structure seems to have gone out the window. I saw a play a couple of seasons ago, a play with many scenes. At the end of one of the scenes, my wife and I turned to each other to say, "That was nice, wasn't it?" We looked up, and the actors were taking curtain calls. It

was the end of the play. There was no sense that it was the end of the play, the end of anything. It was just over. It's like that famous story of the young novelist who brings his manuscript to his editor and asks, "How long should a novel be?" She says, "Well, I don't know, maybe three hundred pages," and he says, "Then I guess I'm finished."

Some years ago, I came across two passages I have made into signs to post over my desk. Renoir used to tell his painting students, "First of all, be a good craftsman. This will not keep you from being a genius." Then there is the critique of another French artist, André Derain. Late in his life, he had an exhibit of his later work, and a critic wrote, "The skill of his hands could not make up for the emptiness of his heart." Those two passages say it all. You need to know the craft, and you've got to write out of your heart. You've got to write something that's meaningful to you.

My earliest plays are meaningful to me, but obviously they didn't have the sort of passion behind them that *Tea and Sympathy* had. Phyllis had a wonderful phrase about *Tea and Sympathy*: "Ah, youth, that happy time when I was so sad." I was a loner at Exeter. Everybody thinks that I'm the boy in *Tea and Sympathy*. I am not, but I knew about loneliness. Arthur Miller said that he is in every play he wrote. That doesn't mean he was writing about himself, but every writer should be—in some sense—in every play he writes. It's an attitude. It's a point of view. It's a voice.

When I took a course with Robert Frost at Harvard, he read my poems and said, "Don't be first to be second." Of course, we all start out being "second," influenced by writing we admire, but it subtly changes as we discover our own voice. When I am "in the mood" to write, I sometimes look over some journals I've kept for fifty years or more. Sometimes, I've outgrown old feelings or have written

them out of my system in earlier work—plays, movies, novels, TV—but then I may come across a series of underlined entries, meaning, "come back to this some time," though it may be too late.

Another sign I have hanging over my desk—and it's been there for as long as I've been writing—reads, "Nobody asked you to be a playwright." It doesn't help all the time, but, truly, nobody asked me to be a playwright. Sean O'Casey had a sign over his desk that simply said, "Write the damn play." The important thing for me is the enthusiasm of "Now, what are my characters going to say?" It's the surprises. I write to discover what I didn't know I felt or what I didn't know I knew. So for God's sake, write the damn play and find out.

I don't read anything I've written until the whole draft is completed. Someone said, "The act of writing is the act of undoing a dream." If I knew every day how far short I was falling of my "dream," I might not write on. When I was writing *Silent Night, Lonely Night*, sometimes at the end of a day's work, I would push back from the desk and say, "Nobody's going to understand this. It's so personal." It turned out that's exactly what the audience did understand, what they identified with. My brother came up from the South to see my play *Free and Clear* at Long Wharf Theatre in New Haven. At the end of the play, the man sitting next to him said, "That's my family." My brother said, "No, it's mine." That's why the theater is such a wonderful medium, in contrast to the movies. You're not alone. You all laugh together, cry together, and clap together.

JON ROBIN BAITZ

Born in 1961 in Los Angeles, Baitz is known for his plays *Mizlansky/Zilinsky*, *The Substance of Fire*, *Hedda Gabler*, and *The End of the Day*. His work has been honored with *New York Newsday*'s Oppenheimer Award, and he has received Rockefeller and Revson grants, as well as NEA and American Academy of Arts and Letters fellowships.

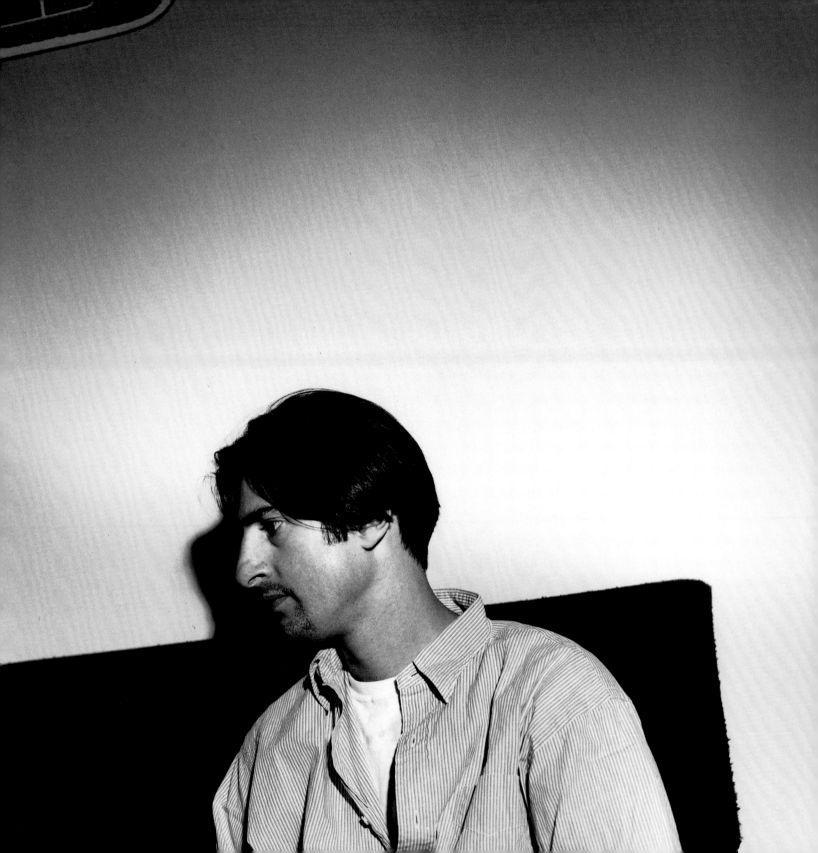

I became familiar with what it felt like to be foreign very early in life. I was seven when we moved to Rio, where there was no English, only Portuguese. I just sat and watched for a while. I didn't speak a word of it, for months and months and months—just listened, which has basically been my mode ever since. Then suddenly, one day, I opened my mouth and I was speaking Portuguese. From there it was back to L.A. for a little bit, where I was again foreign completely. I had actually forgotten English by that time almost entirely, and I had to relearn it. But then we went off to South Africa, where I spent seven years being foreign every day on every possible level—foreign, sexually confused, lonely, disconnected, trying to be good at South African sports like rugby and cricket, which I never quite got the hang of. Cricket itself was another foreign language—all ritual and timing. The strange morays of the country made me feel even odder and more out of place. And so the sense of being an outsider looking in was bred into me, probably from the time I was a year old.

For years, I had no idea who I was, so I hid behind this idea of being an observer, and turned that into a little job called being a playwright. In my early twenties, I had flunked out of school and I wasn't doing anything in particular, but I loved the way people talked. That was the one thing that excited me. I related to the music of language, and

JON ROBIN BAITZ

I thought I could get to know people really well by their rhythms and by their idiosyncrasies, their verbal characteristics, their little traits—the pauses, the dots, the dashes. I was working in Hollywood as an assistant to some particularly florid and funny and disgusting producers, and I started jotting down their palaver, and then I just turned that into a play. I just turned their nonsense into a play— the semi-criminal cabaret that they would do every day, I turned into bits of a plot. I didn't even have a plot, really, I just had dialogue. They were providing the plot themselves by being criminals.

I was a bad actor at high school (Beverly Hills High the last two years). I was really thin and gawky and gangly and concave, yet castable. But I felt on some level that it wasn't the right job for me, like I should be writing. I was too self-conscious then to be an actor, but I wasn't too self-conscious to be a writer. A writer has a modicum of control or pretends that he does. An actor has less of that; an actor is being carefully posed, managed, told where to go and how to do something. A writer gets to hide behind layers of cloth between him and the rest of the world, and dictate, which was a very good job for me. Sometimes people tell me I should be a novelist, but I have zero interest. I love actors and hanging out and connecting and laughing and talking to them. I love the way they speak and I love stories unfolding in real time—so I knew right away that I was doing the right job.

In all my experiences, I've tried to learn the rules of the system and how to either fit in or subvert them subtly, rather than ignoring them. Because the system in my own family was so convoluted and labyrinth-sized. Byzantine even, the system by which one survives. I saw my father operating within his own corporate system, struggling for identity, struggling to hold onto his sense of himself, his

individuality, his uniqueness, the things that made him special, but struggling very hard against a giant system. I saw the system of my mother's world, of being an American housewife abroad, entrenched in the corporate culture, and her own bizarre psychiatric cabaret, not fitting into the deeply conformist world of those American wives. I saw schools in South Africa where corporal punishment was the norm, wondering, "How do I get through that? How do I learn the machismo or sense of humor in order to operate safely or to survive?"

Systems are everywhere. In my writing, I try to explore the danger of following the systems too closely, and believing in them and in living by them and the danger of not trying to break them. In every one of those plays, from my first to my last, the most dangerous thing a person can do is conform.

I tend to ignore criticism. I'm sort of good about it all, but there's one thing, there's a particular critic, a minor critic, a sort of bloated, minor pseudo-academic critic, who for years has been writing the same thing about me, at a free newspaper. You would think it wouldn't matter to me, but he keeps saying the same thing, which is that I have "daddy problems." It's a vast oversimplification of an important truth. Yes, I got daddy problems—bingo—and that's what I'm working through.

These little bits of biography have been a big part of trying to mature as a writer. *The Film Society* was sort of a self-portrait, really, of kinds of failure. I was very much that schoolteacher at the center of that play; kind of a dreamer, haplessly looking for escape, fighting his worst nature, his spongy soft nature, which he felt to be imminently corruptible, trying to avoid becoming corruptible. The next play was one which eventually became *A Fair Country*

—a sort of a giant diorama of the Baitzes in South Africa, and then *Three Hotels*, which was more of the same—an executive for a milk company in hotel rooms in the third world talking about marketing baby formula, based loosely on my father. The reaction? Well, my father was very proud of what I was doing, and he said he was very challenged by my interpretations of things, my simplifications, my oral chastisements of him. My mother would come see things and fall down in the lobby of the theater and break her ankle, and this happened more than once. There were physical mishaps. My dad once said to me, about *Three Hotels*, "This play makes me feel so guilty and I can't figure out why." But in fact I had written it, in a way, as an act of revenge on his part. So people became kind of cautious around me, and I started to hear from various people, "You won't write about me, will you?" If you're writing something, all writing is autobiographical, and you come face-to-face with how difficult it is to know yourself.

I think being a playwright today means you do have to be responsible for the amazing good luck of getting a bunch of people together in order to watch something happening live rather than staying isolated at home, in their houses. You have to take a certain degree of responsibility for being part of a dying art at a brutal time where the political is all around us but never really as big a part of our daily lives as it should be. I feel like people today like to be somehow political, and I don't want to waste the opportunities that I have. I still want to be funny, I want to be entertaining, but I want to be dealing in truth. The truth as I see it, the lies as I see it, the tragedy as I see it at the moment.

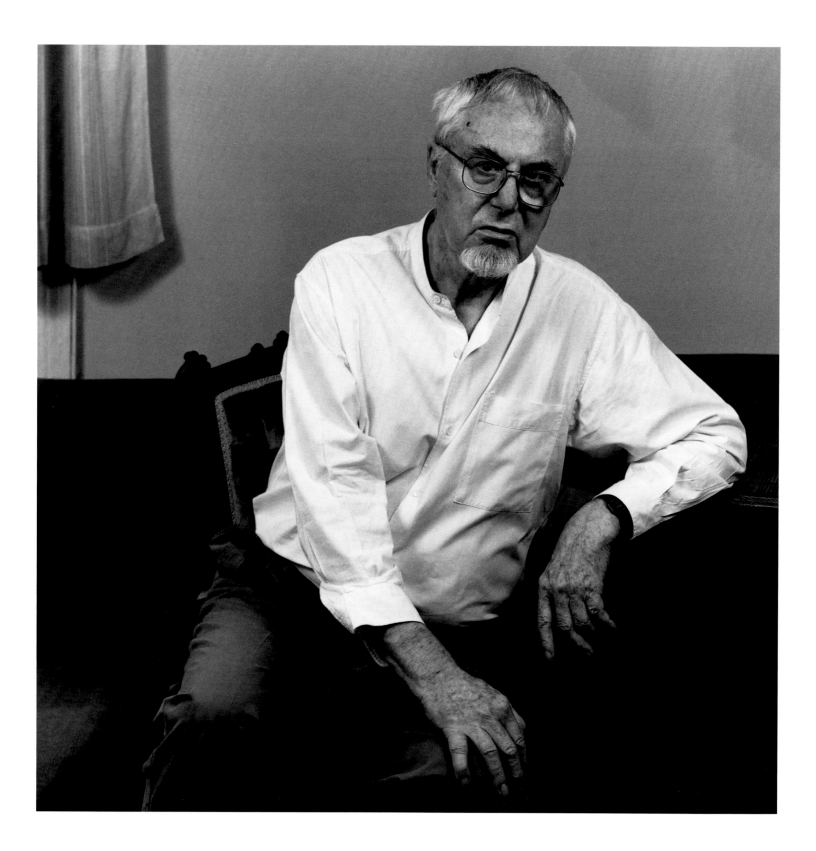

ERIC
BENTLEY
Born in 1916 in Bolton, Lancashire, England, Bentley became an American citizen in 1948. He is a critic, scholar, teacher, translator, performer, and playwright, and his numerous works include *A Century of Hero-Worship*, *The Playwright as Thinker*, *Lord Alfred's Lover*, and *Are You Now Or Have You Ever Been....* In 1998, he was inducted into the American Theatre Hall of Fame.

Eric Bentley

Rather than providing us with an interview, Eric Bentley gave us *Eros Two,* with the late Arnold Black's music, as his contribution. As for his thoughts *on* playwriting, he has published a whole book of them (*Thinking about the Playwright*, Northwestern University Press). According to Mr. Bentley, these lyrics are rumored to be a kind of Eric Bentley credo.

EROS TWO

1.
On Mount Olympus one fine day
Eros (Amour, amor, amore)
Looked around
And found
Stretched out in an arbor there
Venus Urania, Fairest of the Fair.

2.
Nine days later (odd but true)
Venues gave birth to Eros Two
And he was born (this too is odd)
A full-grown god
His father's passion in his face,
In his body all his mother's grace.

3.
But amour, et.cetera, was not his thing
He liked to dance and sing.
Rather than amour, amore
He'd write a sonnet or a story
Then, afterwards, dine
With the Muses Nine.

4.
As for his arrow (Cupid's dart)
He therewith impales your heart
With the love of art.

EROS TWO

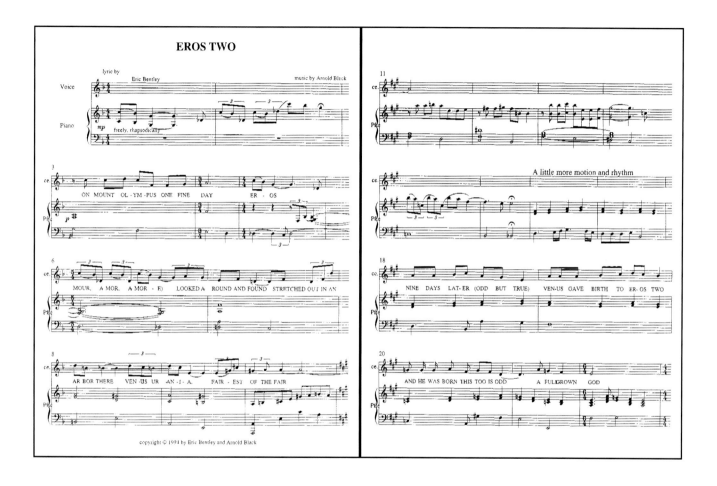

copyright © 1994 by Eric Bentley and Arnold Black

27

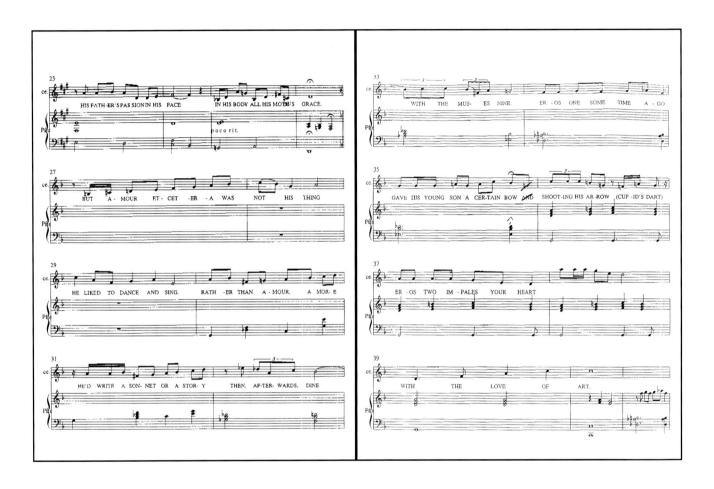

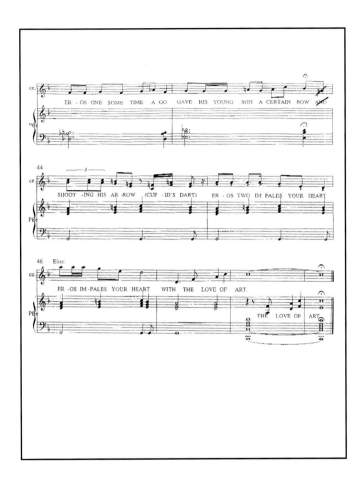

ERIC
BOGOSIAN
Born in 1953 in Woburn, Massachusetts, Bogosian is an actor, playwright, monologist, and novelist. His works include *Talk Radio, subUrbia*, *Humpty Dumpty*, and *Pounding Nails in the Floor with My Forehead*.

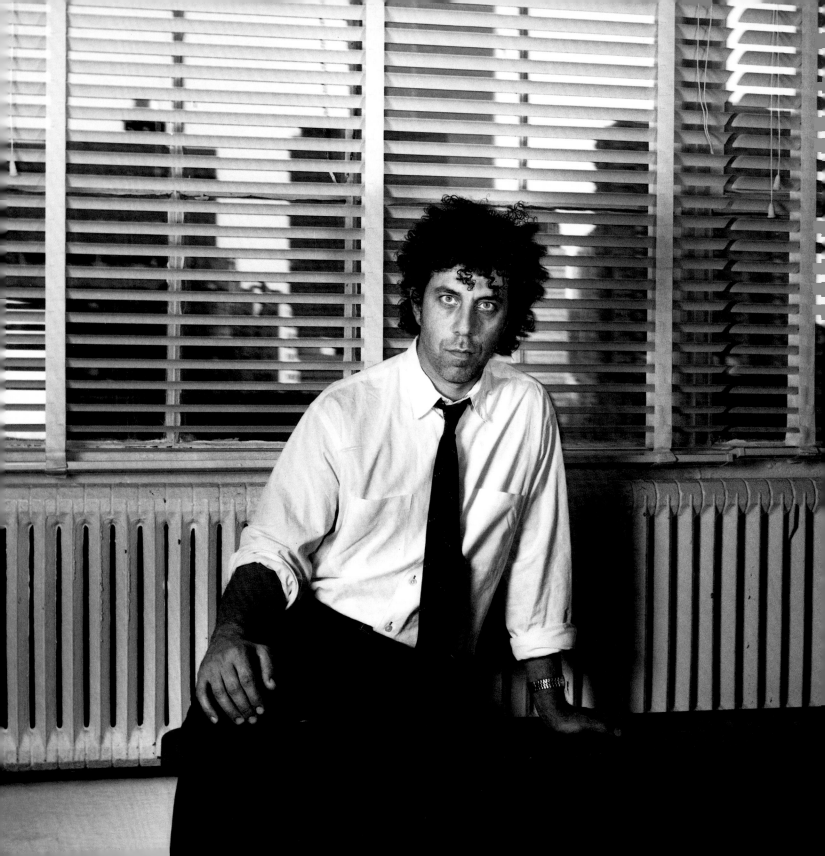

ERIC BOGOSIAN

Where does all my energy come from? I think I have my own natural energy—I'm a pretty wired person to begin with. But I made a conscious effort in the seventies, which seems like a long time ago now, to really move away from theater that I felt was stodgy and slow and move toward theater that reflected my tastes. What we were seeing on stage in theatrical venues could not hold a candle to the kind of energy that was happening in certain live performances at music concerts and in the clubs downtown.

I was being influenced by what was happening in the music scene, but also what some of the visual artists were doing was very interesting. Perhaps the guy that influenced me the most was Richard Foreman. He said something: "I make the theater that I would like to see if I were sitting in the audience," which seems like an obvious thing but I don't think it's that obvious. People often make work that they think will be in some way successful, that will turn on an audience but not necessarily themselves.

Because of the nature of what endures, we think of theater in terms of the scripts that we have. We can look at something by Ibsen, we can look at something by Beckett, and we have very little record of what those performances look like. Theater, like live music, is what's happening at the time that it's happening. That's theater. We're so used to things being recorded that we equate the two. So that if you filmed a theater piece and then you watched that film, you'd think, "Oh, I saw theater." But you didn't. You have to be there. It's a completely different experience. What's happened is the medium becomes defining for the thing itself. The overwhelming media that we know today is the two-dimensional media, the media of film and TV and recorded music, so we tend to think in those dimensions. A movie is some flat screen that you're watching and the sound that's coming at you. What about the presence of the

other people in the audience? What about the smell? What about the humidity in the room? If you're at a really exciting theatrical event, the whole thing becomes part of it. When you're watching something on stage, you're not watching a specific directed point of view the way you are in the film, but a general event. So I feel that as a playwright, I am trying to create the architecture or the blueprint, for an event. Of course I should be skilled in my writing, just as the stage designer should be skilled in the stage design, but nobody goes to the theater for the sets. No, you go to see people performing. So I'm trying to create the excuse for people to get out there and perform their asses off. That, ultimately, is what makes for really exciting theater.

I'm not a performance artist. I was never a performance artist. Performance artists are artists who do performance, and for me, as a trained actor from the time I was in high school, it's hard to use that term. It means to me somebody who's kind of amateurish, doing something in a novice or in a primitive way. For me it was never that. Look, the first thing I worked on was Shakespeare as a kid.

If you want to call me names, "monologist" seems to work pretty well. Of course, it does sound kind of boring. Again, it gets back to not what's on the written page, and not what does it say, but how is it done. Now, there are enough people out there who have kind of picked up the style that I used, which I picked up from the visual artists, which was to take one character and just butt it up against the next without any intermediary: "Hi, I'm Eric Bogosian and I'm going to do some bits for you now."

Now to settle the question once and for all, I have absolutely stopped making solos and won't perform them any more, because it's very difficult for me to continue working on plays the way I do, which is 'round the clock, non-stop, year–in, year–out. I have them put on in all the regional theaters, and I don't need to carry this mantel—which I guess I'm never going to be able to shake off. So for my own need, I have to say: "I'm not a comedian, I'm not a performance artist."

My favorite theater experience ever was *subUrbia* at Lincoln Center. And I think it just happened to be a wonderful confluence of the cast, director, and stage designer. Everything got lined up and was moving along wonderfully. I had a spot up on the balcony where the audience doesn't sit in, but is for tech people. I would sit up there and watch the play, and I could get completely wrapped up in what the actors were doing—they just thrilled me. Suddenly it dawned on me that what I had done was written about a moment in my life that had happened seventeen years earlier, when I had dropped out of college. What had happened was I had started working on this play and done all kinds of rewrites and cuts and edits, but I never understood that I was writing about that summer that I spent on the corner with my friends as a dropout in my hometown. But one night I was watching the play and suddenly it went—bang—oh, that's what I wrote. And it was a strange moment, to see what I had written—because that's the way I write. I don't see what I've done, I didn't know what I was writing until it was there in front of me unfolding. I didn't set out to write that. But by removing things and keeping other things, slowly but surely, I had ended up with this story.

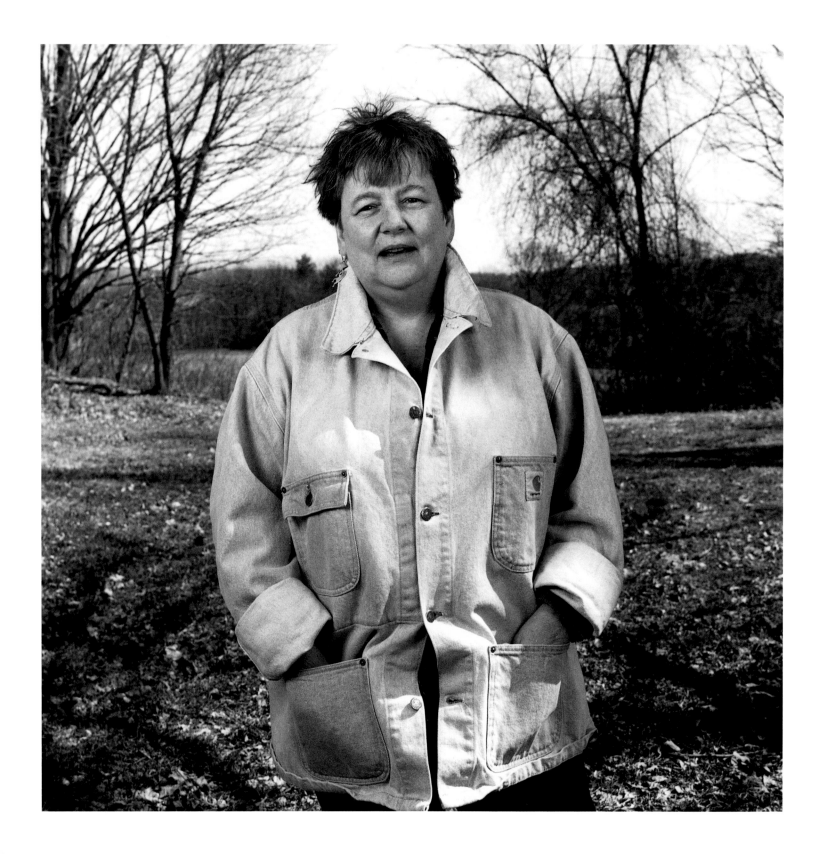

CONSTANCE CONGDON

Born in 1944 in Rock Rapids, Iowa, Congdon is the author of numerous plays, including *Gilgamesh*, *Cassanova*, and *Tales of the Lost Formicans*. She has received Oppenheimer and Weissberger Awards for Playwriting and is currently the playwright-in-residence at Amherst College.

My father was a welder and a carpenter, so the idea that somehow you make the arts a career is not an idea I was raised around. Although my father told me, in his last years, that he always wanted me to be a painter. I thought he meant a house painter. He didn't, he really meant a painter, and that shocked me. It goes just totally against everything that I grew up around, but he didn't want to pressure me so he kept it a secret—that's very sweet. But I think he was assuming that after this I'd get married and then I could be a painter. I was about twenty-one or twenty-two. I had gone back to school by then to finish my BA. That's when he told me. I was so shocked.

One night, on the way home, I just started hearing people talk in my head and I couldn't help myself, so I pulled over to the side of the highway and started writing some dialogue. In the car. I'm sitting here writing it, and then the police come up and the policeman wants to make sure I'm alright, because, you know, here's this woman sitting, and he just appears and he says, "Are you OK?" And I'm like, "Yeah, I'm just writing." And he says, "Oh, OK." And he left me and I wrote that passage or two or three. It was the beginning of my first play. That was it: the voices coming on and I was basically writing it down. That's where I really began to believe in the whole thing. I couldn't help it. The voices would not shut up, so I was compelled to write them down and it really was a matter of kind of catching up with what was running around in my head.

I can remember, it was about six months ago and I was taking a shower and it started, and I remember thinking, "Oh, crap. Oh, no." And I had to get out of the shower, and dry off enough to get to the word processor. So I'm standing there, wrapped in a towel, typing away, because you can't help yourself. If you let it go, there's that fear it won't come back. The impulse is so strong. That's how I've

gotten the beginnings of plays or parts of plays. Sometimes a long monologue will come out of me that's just filled with rancor and I'm like, "What in the world is this?"

I remember I was staying at New Dramatists in New York and was sharing a pay phone with six other playwrights, one of whom might have actually been August Wilson. He used to stay there a lot and we'd see each other a lot up there. It was great. It was kind of a playwright's dorm. Actually, that was when August started to make some decent money. That's when he was at the Edison Hotel. At one time, I came into a room to spend a couple of nights that he had just vacated and he left me this sweet note saying, "Open the desk drawer." I open the desk drawer and here was a huge doobie. I mean, a huge one, and I lit up, thinking, "Oh, ok. I can relax." I took one toke and I don't know where I went. It was the strongest stuff I'd ever had. And I'm writing in my journal and I still have the entry where I was writing, and all of the sudden the line just kind of goes up in the air, off the page.

I don't really get ideas; it's the people. The characters are really what I write from and then ideas come from them. But my students reconnect me to my own work in a very fundamental way because they ask these fundamental questions. They're beginning to write in a dramatic form and so their questions—I have to answer these questions—just make me really get down to the basics all the time. They keep me attached to the writing. I concentrate on the act of writing and the work and what the theater really is. And there's a lot of advantages to not living in New York, because I just don't hear the gossip. I'm thankfully out of the loop. That's just wasted energy. I'm not reading my own reviews because they haunt me and I have an indelible memory so I'll always remember certain phrases. I have friends who read them for me and tell me if there's

anything in there I can use. And guess what? There hardly ever is. But I'll periodically, and it still happens, fall off the wagon, so to speak. I'll see something in the *New York Times* and I just can't help myself, and I end up reading it and I get so furious. It's just so difficult to see good work being trashed and bad work being lauded. And then, they'll like something but it'll be for the wrong reason, and that just throws me into despair. So I just need to stay away from it for my own mental health.

I don't think people realize how difficult it is financially. But I'm glad that I've chosen this genre, or this genre chose me, because what I get back is just immense. And every time I pass a remainder table with all the novels, I think, "Yes. I made the right choice."

Anybody can do it. All they need to do is make themselves do it and that is by just not leaving the computer. You know, sitting there and not even saying I'm writing for an hour, but write and say, "I'm going to write two scenes. Period. I am." And then you just give yourself deadlines every day. You give yourself a time constraint. Because that's all you have, what's on the page. That's really all you have. The rest is not silence. The rest is the chaos of your brain. The fertile chaos of your brain that, unless it's focused, just remains fertile chaos. An idea is like standing on the steps of Carnegie Hall whistling as opposed to being inside and playing a full piece. They're fine. But they're only ideas.

My Amherst College students, they've made a life of taking tests and making A's and I knew that when I was going to start teaching playwriting here I was going to have to find some way to disengage the left brains and get them writing from the right. They obviously, like most all those in the educational system, had been using analysis, critique,

and that's what we're taught and that's perfectly fine. That's important for democracy, certainly, but they also become so hypercritical about themselves that they can't write. And I just force them. I took it from a basic idea about teaching acting, that acting, itself, is doing, not feeling, so I make them do. I give them different circumstances and a couple of characters and a few questions and then I say go. They have to do. They have to write it.

With that time pressure, things come out of you that you just didn't realize were there, but you don't have time to say, "That's stupid," or, "That's racist," or "That's sexist," or whatever. You just have to be going forward. They write actual plays, like a four-scene play. And then I ask them to not revise it, but to take it back home, type it up, and bring in a copy for each actor to read, and then we read them. They are amazed at what just came out of them. I used a lot of that myself. You know, you get desperate enough, you finally just sit down and the fear of being bad is overridden by the fear of not getting it done or the fear of never doing it. So I just start writing.

Constance Congdon

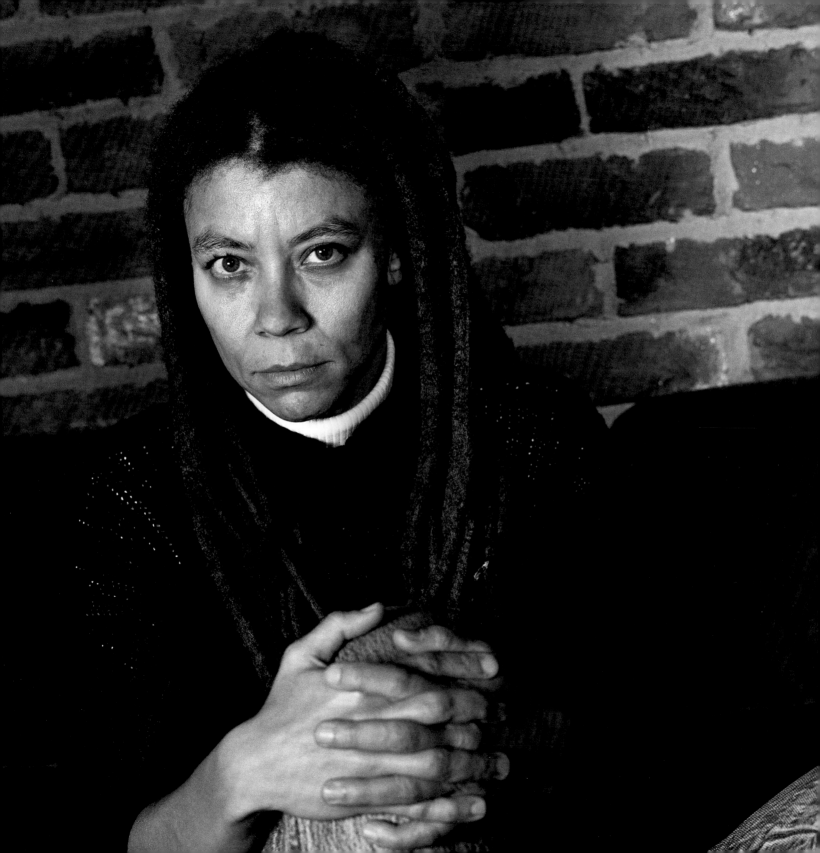

KIA CORTHRON

Born in 1961 in Cumberland, Maryland, Corthron is the author of many plays, including *Breath*, *Boom*; *Life By Asphyxiation*, and *Come Down Burning*. She is the recipient of numerous honors and awards, including the Mark Taper Forum's Fadiman Award and a National Endowment for the Arts/TCG residency.

I grew up in a small town in western Maryland, which is like ninety-seven-percent white working class, and almost all of my teachers were white, except for my Home-Ec teacher in the seventh grade—and I did not do well in Home Ec, so it wasn't the greatest relationship. It wasn't until my first semester senior year of college when I took a screenwriting class that I had another teacher who was black, and he was not the best teacher. A lot of students didn't like him, but I always defended him—even though he was as much a jerk to me as to anyone else. My next semester, I took a playwriting class and the teacher was also black. She was wonderful, and it was then I realized it was hard for me to admit that the only black professor I had ever had was an asshole. I wasn't even conscious of it until she was so wonderful, and I realized I was only defending him because he was black.

I remember the first day of class. She came in and sat at the teacher's desk, and she just seemed really tough. There were twenty-five students in there, and she said she expected every week to have seventy-five pages from us. This one student raised his hand—he was kind of terrified—and he said, "Typewritten pages?" And she said, "Is there any other kind?" At that point, she said there were "too many fucking students in here," and she was going to leave the room and when she returned there had better not be more than half still there. So she left the room and this mass exodus of students left with her. But I stayed to see how it works. When she came back a few minutes later, she said, "You've just witnessed great acting. I expect three type-written pages from you every week."

Our final project was to put on fifteen minutes of the play we were working on. I'd been writing about a Vietnam vet coming home. Everyone else's play lasted five minutes and mine went on for half an hour. With everybody else's play,

when the lights came up, everybody jumped in and said really nice things. But when the lights came up on mine, there was silence. I didn't know what to make of that at first. I had heard this woman sighing and I was thinking she was so bored—but she was actually crying. When people finally spoke, they would say one word, like, "poignant," and at that moment I was hit by the fact that I had actually affected this audience. It meant so much more than if the entire class had said, "Oh, you're such a great writer." The fact was that the audience couldn't say any-thing—they had connected so much. I've been writing for the theater ever since.

When I write, I always try to go beyond my experiences—that's why I do all this research. I always go into characters that have little to do with me personally, but with whatever political issue that I'm dealing with. On the other hand, by making them human, of course, a lot of me is in those characters. I've written about police brutality, and I'm not a cop, but a lot of qualities of that cop are what I know. But to just write what you know is really limiting.

Once I pick a topic, I do the research, and once I do the research, I have an idea for the beginning. But then the play takes on a life of its own and becomes its own entity. With *Breath, Boom* the main character is a leader in a girl's gang, and she's a very violent character. So first, I did a lot of research about girl gangs. But something that has nothing to do with my research, but certainly influenced the play, was the experience I had when I taught a playwriting class for high school girls in jail at Rikers Island. Those girls—they were kids—really ran the gamut. Some of them were in there for prostitution, and some for very violent crimes. The interesting thing about the more violent girls is that they would write plays about really nice people. I rarely heard very violent things from them, because they wanted

me to think of them as nice girls. And when I found myself writing about this very violent character, I remembered that—how they wanted to be seen as nice.

Something will just strike me. I'm not sure when I decided I wanted to write a play about girl gangs; it was just something that was of interest to me. I'm going to write it whatever the ramifications, and see what happens. The play I just wrote is probably my most controversial play. It's all about McCarthyism—how it wiped out outspoken blacks in the entertainment industry. I also wrote about black unions, and the play goes back and forth in time until 2001, and it becomes a 9/11 play. I wanted to write about how we still live under the legacy of McCarthyism in this country. Suddenly, all of these Arab characters appear who are arrested. But even if there is something that is very controversial, I don't think there is anything that you can't write—at least, I don't think there is anything I won't write.

When I write, I'm so focused on the world of the characters that I'm writing about. I feel like I create this world and every audience member is invited into this world. If you want to, you can say, "I don't get it," and come out of it, but it's your decision. I offer the invitation, but I'm not going to make it palatable for an audience outside of this world. I'm going to make the world true to what it is.

It's important to leave the audience with some hope. If the audience leaves just devastated and hopeless, then there is no action for them to take. The opposite of that is to force hope when it's not there. If I start out with a situation that's very devastating, there may be just an inch of hope, but I want to give the audience something. For most of us, even if we focus on the bad things, there is something there that we can latch on to.

I think what surprised me was that I thought that everybody wrote about issues like this. That's interesting to me—the issues of the day and how they affect us as human beings. I always say that if just one member of the audience leaves the show thinking a little differently than when she or he came in, I feel it was successful. There is something I want to say, and at the very least, if that person hasn't changed his mind, they're thinking differently. At the very least, they're beginning to dialogue. That's why I do it.

KIA CORTHRON

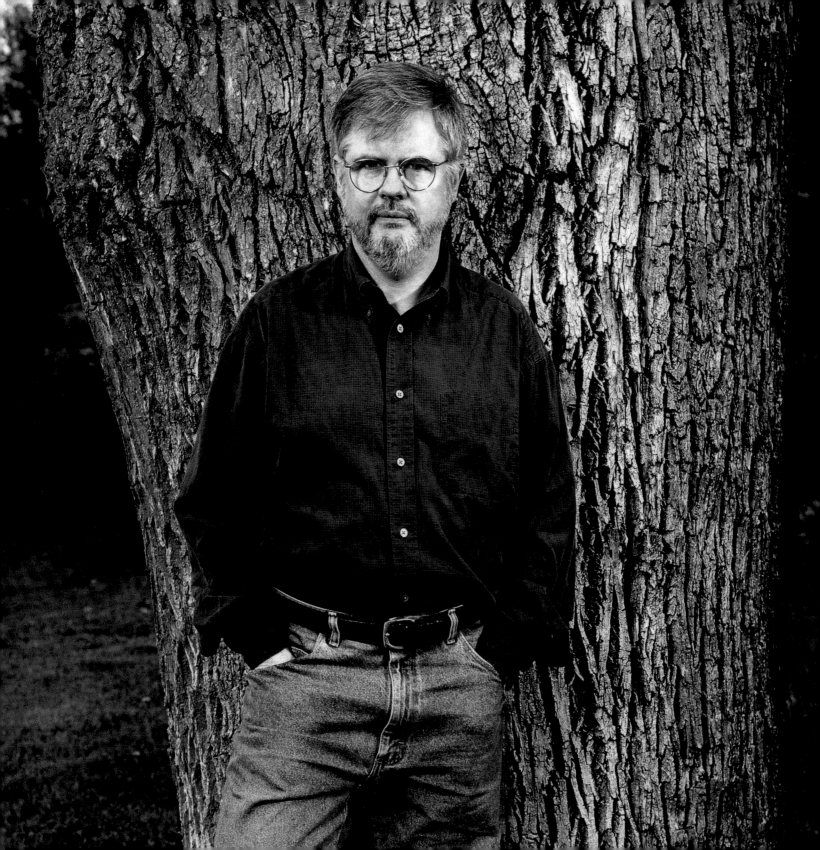

CHRISTOPHER DURANG

Born in 1949 in New Jersey, Durang is a playwright and actor. He received a Tony Award nomination for his book of the musical *A History of the American Film*, and has written numerous plays, including *Sister Mary Ignatius Explains It All For You*, *The Marriage of Bette and Boo*, and *Betty's Summer Vacation*, each of which received an Obie Award. With Marsha Norman, he is co-chair of the Playwriting Program at the Juilliard School.

CHRISTOPHER DURANG

I like to laugh. I remember being taken by my parents to Broadway shows and also to movies a lot. I remember seeing a Bob Hope movie, *Alias Jesse James*—I keep meaning to re-watch it and see if I still think it is funny—but as a child I thought it was hilarious, and I remember I had a really big laugh. I also remember a married couple that was sitting nearby saying to my parents as we were leaving that they enjoyed hearing my laugh, which is nice because I've actually been in theaters where people are made annoyed by my laugh. Also, actors know when I'm in the house. In rehearsal, I am able to laugh at the same joke over and over. After three weeks I start to not be able to, so I have to let them know that when they don't hear me, it's not them. I just need to go away for three months and then I'll be able to laugh again.

My parents brought me to the movies and they had, both of them, a great difficulty getting anywhere on time. Back in the fifties, they would let you come into the middle of the movie and stay for the next show to see the beginning, which obviously they don't do anymore. So I would say that somewhere between half and two thirds of the movies I saw, I saw that way. I actually think I got good at figuring out how stories were told from doing that. When I was in second grade, for some reason, I wrote a two or three-page play which my school put on. Whatever possessed me to do that? It's hard to know. But from this very young age, I started to think to myself, "Oh, that would be fun, to be a playwright." And then I kept writing through grammar school, and each time I wrote, they got longer.

When I was writing in my twenties, it tended to be my most absurdist plays that were written then. I didn't actually know why I was writing the way I was; I just was. I found absurdism a little funny, but some of my plays were very out there and dark, and some people find them strange. I would so often be asked, "Why do you write this way?" And I really didn't have much of an answer. Then as I got in to my thirties, it started to get clearer that I was writing about the family psychology that I grew up in. I was writing about it unconsciously, mostly. When the characters are as crazy as they are, say, in *Titanic*, waiting for the ship to sink and it keeps not sinking, they weren't remotely like my family in reality, but in terms of the inner workings.

I'm an only child, but my mother had many siblings and my father had many siblings and the families were all very intertwined. I was normally the observer who would watch people interact and fight and make troubles and so forth. As a child, I found it very overwhelming and depressing to deal with these family interactions, but as a playwright, when I was unconsciously writing in absurdist ways about frankly similar psychological interactions, I was creating these crazy interactions and controlling how the audience was introduced to them, and it gave me a sense of making order out of crazy behavior. Probably the most crystal clear aspect of that is the play *The Marriage of Bette and Boo*. Although it has absurdist elements, it has many realistic elements in it as well, and that *was* based on my parents' relationship. That gave me a real sense of making order out of crazy behavior.

The Marriage of Bette and Boo was a really long process of many years. In fact the very first time I wrote it I was still at Yale, in my early twenties, and Edward Albee has this house that he lets writers stay at and I got nominated to go along with another writer, Albert Innaurato. I just wasn't having an impulse to write anything, but I guess I was in the habit of telling people stories of my family over dinner, so Albert said, "Well, if you're having writer's block, why don't you write about your family?" And I wrote a one-act version of that play as an exercise, genuinely intending for it never to be done, because, in the first version, I actually used everybody's real names. My parents were both alive at that point. I wrote this one-act version and I showed it to my teacher and, lo and behold, he showed it to the director of the school and suddenly they were going to do a production. And so I said, "Uh…rather than that play, wouldn't you do this other play?" And the director didn't want to do the other play, so I let them do the play. I just didn't tell my mother or father about it. They certainly didn't see it at that time. My father never saw it. But it was the first play of mine that audiences felt a sense of compassion for the characters as well as, in the midst of the craziness, comedy. I was aware that it was a play that audiences seemed to like, and it seemed like a bigger audience liked it than had liked some of my earlier absurdist plays.

The opening night of *The Marriage of Bette and Boo* was intriguing for me personally, as a playwright and an actor. This was at the Public. It was a very intense but satisfying and happy production experience. It was just an extraordinary cast—Joan Allen, Olympia Dukakis, Mercedes Reuhl, to mention the most famous members—and it was a happy cast. Everyone liked each other, and it was just very harmonious. I had been nervous about playing the autobiographical part of Matt, but Joe Papp thought I should be in it. I had at that point worked with Jerry Zaks so many times that I was able to say to him with a fair amount of sincerity that the play is more important than me being in it, and if it's not working out, you can come to me and say it's not working out, and I'll still be the playwright. It did go well, and I thought that my part went well, too. My character got to talk to the audience in the opening speech. It's actually not a funny speech, but I did discover in the first previews that the seriousness about it was funny. The speech was only about five sentences long, and I discovered that at the end of the third sentence is when the audience normally would laugh, and so I got very used to taking a breath there and letting them laugh.

The opening night audience, as sometimes opening night ones can be, was attuned to the speech very quickly. Instead of laughing at the end of the third sentence, they laughed in the middle of the second sentence. So I was in the middle of a sentence when they laughed, and that can trip you up. But, instead, I ended up pausing and smiling because they had gotten it so fast. It was like saying, "Oh, you got that already?" And the laugh got bigger because I did that. Playing with the audience and their laughter is almost like cresting with the wave or something. By acknowledging that they interrupted me, I sort of cemented this rapport. It never happened again, that particular laugh, but it gave me an especially good show where I just felt the audience was on my side and in synch. It was this odd opportunity that I managed to take advantage of intuitively. I could have ignored it. I could have done nothing and just held for the laugh and then finished the sentence, or I could have gotten thrown and tried to talk louder to shut them up. But instead, I was loose about it, and I'm not always the loosest performer, and it just felt lucky. It meant that I heard what they heard. It's a tiny thing, but I'll always remember it.

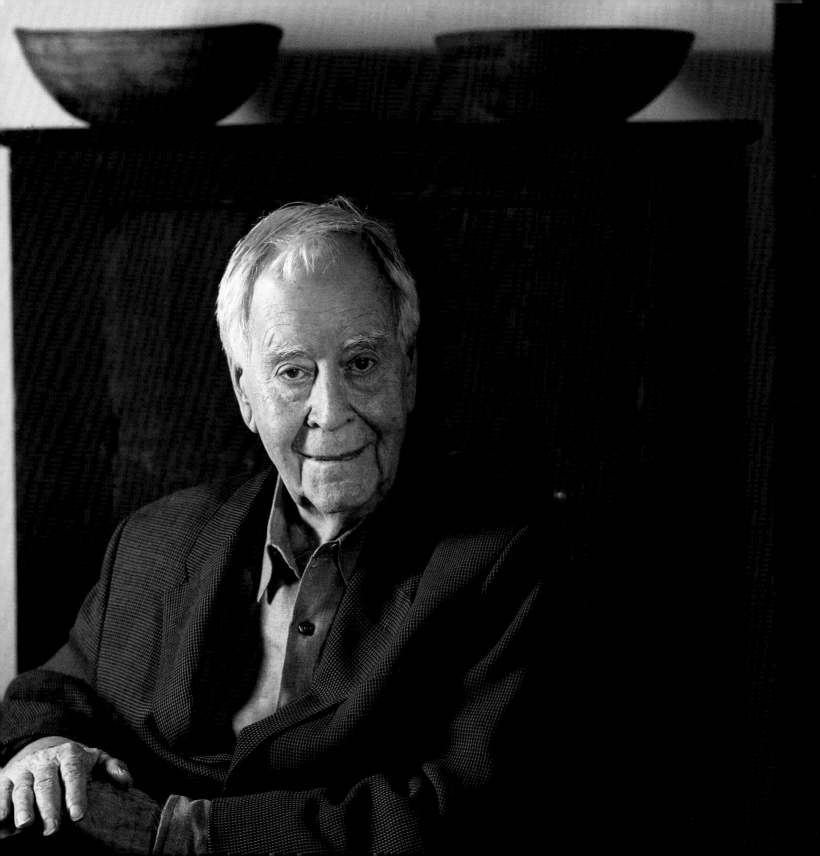

HORTON
FOOTE
Born in 1916 in Wharton, Texas, Foote is the prolific author of the Academy Award-winning screenplay *Tender Mercies*, as well as the adaptor of *To Kill A Mockingbird*. In 1995 he won the Pulitzer Prize for Drama for his play *The Young Man From Atlanta* and has acquired numerous honors, including two Academy Awards, an Emmy, and the Screen Laurel Award from the Writers Guild of America.

HORTON FOOTE

I don't think you choose your subject matter. I think it chooses you. I started out as an actor doing improvisations as part of the American Actors Company. And I was doing all of this stuff about my hometown in Texas. I used the real name of the town, the real names of people I knew. There's some great advice, which I instinctively felt, which is that you should write what you know. So I began this long journey writing about this place I called home. It had just taken hold of me in a curious kind of way. I don't know how to explain it except that I just didn't have any real appetite to write about anything else. Why should an audience care about people in a little Texas town? Well, because I'll make them care. My job is to involve the audience in my ideas, in my story.

With anything that you write, the style makes the difference, makes it yours. I experimented a lot with different styles of writing when I was younger. I've done over sixty plays, and when I was home recently I decided to reread some of them. I was surprised that something essential was always there. With some of the plays, I was amazed—it was like reading a stranger. But there were certain things that made me know that, yes, this is mine.

Sometimes I complain about it, but I really welcome collaboration. I come alive when I'm with other people in the theater. I'm really addicted to it. I was an actor and I work a lot with actors. People are always surprised that my plays are as complicated as they are, but actors understand that. I welcome different actors. I've seen really great actresses do the same part and they were really different. I love it because they are bringing something of themselves.

Having been a screenwriter and written for television, I still feel closest to playwriting. I accept the limitations of the stage; I embrace them. Sometimes the simplest way to

express or convey something is the strongest and that is what playwrights, working in the theater, must learn to do. I don't think there are any ideas that can't be expressed on stage. How to do it—that's the challenge.

In some ways, it's easier to do more because of technology, but at the same time, it's so much more expensive. And it shouldn't matter to the art, but when I'm writing, I know that when I add something, that's another, say, $15,000 for the production. It's hard not to be conscious of that. Even when I'm doing a commission for a regional theater, I'm aware of it. Things have just gotten so expensive. But I don't censor myself.

The first adaptation I ever wrote was for the screen, and that was *To Kill A Mockingbird*. I met with Harper Lee and I realized that Maycomb, Alabama, was my town, too—all these people, I know! See, I was born in this small town— I'm the fifth generation, so I write often about people who have long been dead, who I never knew but who are very real to me because of the oral tradition that's been kept alive in my world.

When I first started, I had to be in New York. But after awhile it became a distraction. So I took my family and moved to New Hampshire. I didn't go south, because the civil rights issues made it a place I didn't want to be. Also, I couldn't really go home to Texas, because I knew so many people there. They would always want to get together, to talk, and I certainly wouldn't want to be rude. Now so many of the old people are gone. But I go home and there's this mystique about me, and it somewhat bothers me. I don't know why it should, but it does. New Hampshire then seemed to be the right place. I got a lot of work done. I wrote *Tender Mercies* there. It was a very fruitful time.

Ultimately, I did go back to Texas. It was time. I hadn't been writing that much. Plus, I wanted to get back to this house that I had inherited. And it was a good decision. I think the material I'm working on now is a direct result of that return to home—in a different way from my earlier work that was also about home. I think I have more demands. Time is getting short, and I'm very selective about what I spend my time on. Also, I've returned, but what I remember is not necessarily there—the people certainly aren't—and I'm not one to try and recreate it. I'm not a sentimentalist. Never have been. Because God knows, that would be horrible. That said, sometimes I write about what I remember—but not what I physically remember, what I remember mentally and emotionally. That's the truth of what I remember anyway.

When I began writing, I thought if I didn't spend time at it every day, I was cheating. But I realize now that half of writing is thinking. I'm an obsessive writer. If I get started, it's very hard for me to let go. Some people start at eight in the morning and stop for lunch. Not me. Once I start and I feel it's going well, I can't stop, any hour of the day. I wish I wasn't like that. I'd love to have regular hours. Everything I do is hand-written—and I have a very good secretary who takes it from there.

So I'll keep at that. I always want to be a better writer. I hope this next one will be the best I've ever written. I don't think I've written my last play. I hope I don't ever feel that way.

RICHARD FOREMAN Born in 1937 in New York, Foreman is a pioneer of avant-garde theater, having directed such plays as Bertolt Brecht's *The Threepenny Opera*, and Suzan-Lori Parks's *Venus*. He has authored many works including the *Bad Boy Nietzsche* and *Unbalancing Acts: Foundations for a Theater*. He has received numerous honors through the years, including the MacArthur Fellowship from 1995-2000 and the Edwin Booth Award for Theatrical Achievement.

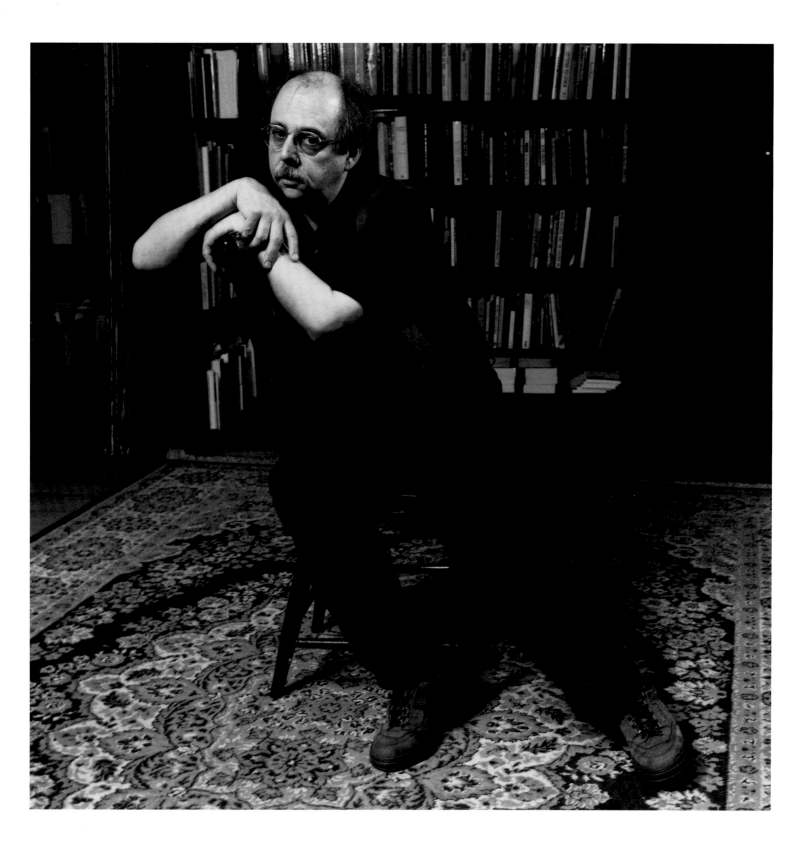

At Yale, I learned that you don't write plays, you rewrite them. I remember coming home one day after writing and rewriting a lot of plays, one of which was to be optioned in New York, thinking, "This is ridiculous." If I walked into a theater tonight, what would I really like to see happening? I sat back and closed my eyes for about ten seconds and I had an image that is not unrelated to what I have been doing for the last forty years. I saw people staring at each other across the stage. That's the tension. Not much happening except that. I started writing plays out of that kind of awareness.

I don't know how one defines experimental. My theatrical strategies are all compositional ones, poetic strategies, rather than the narrative ones that most theater is based upon. That's why it seems experimental, but it isn't really. I am interested in rendering the impulse of consciousness colliding with the world and trying to make that collision reveal something about the transcendent—about an energy that engulfs the individual. That's all that I am interested in—colliding with the world, much like a scientist who runs an atom through a particle accelerator to cause a collision that produces a tiny explosion, so one can see the building blocks of the universe itself. Similarly, I write a series of collisions with the world, and in those collisions lots of things are generated which, I hope, capture something of the cosmic energy that enfolds our daily life.

What motivates me is the hunger for something that I am not able to grasp—something that I think is out there, but that I am not satisfied that *anybody* grasps. I read a great deal, and in the final analysis nothing satisfies me. Something is missing. My life is dedicated to trying to grab a hold of that "thing."

It's all impulsive. I write lots of theory, but that's after the fact. When it comes time to actually make art, I blank out my mind. And I don't rely on theories. Now, after forty years, I have become a certain kind of person who has been conditioned by much thinking about art and philosophy. But I don't consciously apply any of that when I am making the art. It is all instinct and impulse.

It is a kind of ecstasy. The ecstasy of hovering over your subject and just being very alert, illuminated by the particular thing that you are watching. On my website, I make available all my notebooks from which I have taken material to make my plays over the last twenty years. People are free to take that material, and to collage their own plays from it, just as I do. Sometimes people stage my plays as published. But when they do, I ask them to use only the dialogue. I ask them not to respect my stage directions or even the assignment of who is speaking which lines, but to invent their own scenario from the language of the play.

RICHARD FOREMAN

I was proud when I started getting awards as a writer rather than a director, because I have always thought I was first and foremost a writer. But it is a different kind of writing perhaps, and it is true that many of my greatest fans through the years have been poets, rather than other playwrights. For the first couple of years of my theater, within twenty minutes most of our audience would walk out. Perhaps the plays were a little more difficult in those days. But after I did a successful musical off-Broadway, and then *Threepenny Opera* at Lincoln Center, people began to think—"Maybe we can't treat his work with such contempt." These days, I have no idea how my audience is really reacting. It's obvious that there are still people who get very irritated with my work. They think I am something of a phony. But on the other hand, I have a dedicated following—so it is a mix.

When I started writing the strange kind of plays I write, nobody else would direct or produce them. I was a member of the Actors Studio and the New Dramatists, and people thought I was talented. But no directors dared to touch my plays. So, inspired by the underground filmmakers who were making their own movies, I decided I would do the same thing and make my own productions. I wanted to make art that was as personal and as much under my control as a painting is under a painter's control. And that is what I have been doing ever since, trying to craft a deeply idiosyncratic personal vision—because Lord knows, there isn't too much of that in this world any more.

I have always been interested in elitist and esoteric art. That is almost a curse word today, to be accused of being an elitist. I think it is very important that elitism—in terms of quality—exists side by side with all kinds of other things. I recently read an article about contemporary serious music. And people say, "You see? Advanced music—there is no audience for it anymore. The composers are just writing for each other." Well, what is wrong with that? Why should everybody like all kinds of art?

In writing, what I am thinking about is the language occurring in my head, much the way a schizophrenic might hear internal voices. Then I pick out certain pages to collage together and make a play. Then I decide how many actors I can afford, and then I decide who can do which lines of dialogue. I am a pretty organized person, but I look at my art as a chance to make myself be less organized, and invoke the energies that result. If I would accuse myself of any fault, it's that I'm overly organized.

I used to write almost every day but now I must confess that I don't. I am interested in finding another way to create things. I still write, but not with great regularity. It's very strange, but my experience has been that when I am directing a play, people are amazed at my energy and concentration. Yet when I am not directing a play, I become so lethargic that it's hard for me to even get up off the couch. With no specific task or deadline, I just sit at home and read, take a nap, watch a movie, and I get physically weaker and weaker. I used to say to my wife, "I don't know how I am going to do it this year. I am so exhausted." And then, the first day of rehearsal, suddenly I am full of energy.

There are some people who think that for all these years I have just been trying to do things that shock people, just to be different for the sake of being different. Well, that would be a very boring thing to do. I work out of a desperate spiritual hunger. I make something that represents what I think is missing from my life, and I make what I think is most beautiful and energizing. I hope that there are some other people out there who will find beauty and energy in it. That is why I do it.

MARIA IRENE FORNES Born in 1930 in Havana, Cuba, Fornes emigrated to America in 1945. She is the author of many plays, including *Tango Palace* and *Fefu and Her Friends*. She is predominantly known for her avant-garde work in the theater and has won nine Obies.

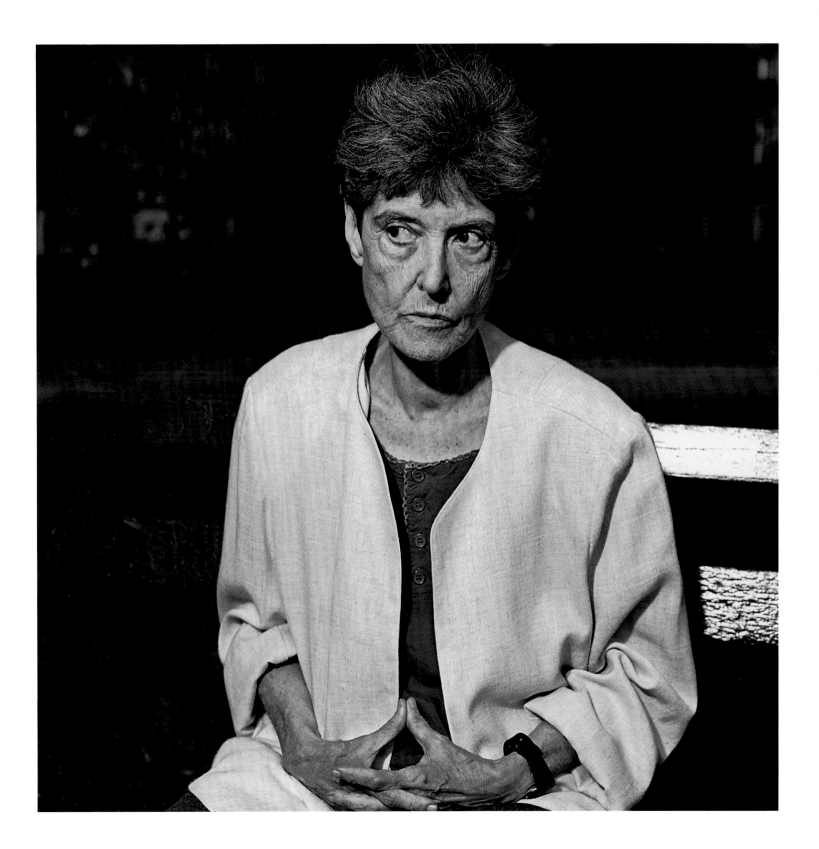

Maria Irene Fornes

When I think of what playwriting is like for me, what comes to my mind is when children play. When they play a game, they have to believe. When they are playing cops and robbers, they really have to believe that they're going to be arrested. Otherwise they don't enjoy it. They don't play it in order to show somebody how the game is done. They play because they want the thrill of running away from the cops or the thrill of being the cops and shooting at the bad guys. They believe in the reality of what the game is.

Of course, when you are writing a play, this is not you. You don't believe that what you are typing in the typewriter is really happening, but your emotional system is actually as engaged in what you are inventing. You are so engaged that you experience it. I remember once I was sitting across the table from a friend of mine, who was waiting for somebody who was coming to pick her up. She was sitting across from me, reading, and I was in the middle of writing. After a little while, I looked up for a moment and she was staring at me. She looked scared. So I said to her, "What

happened?" She said, "Well, what happened to you?" I said, "To me? What do you mean?" And then I realized I was crying. And I was crying because I was writing a desperate scene. In it, somebody—I don't remember now what the scene or the play was—somebody was dying, or somebody was desperate, because she or he was left by a beloved. It was grief. And I was feeling it. The characters had taken over. I had stopped controlling it, manipulating it. That is what you have to look for—you have to look for the state, that mental state, which is exactly like daydreaming.

It's very important to get into this relaxed state. When I started teaching I would have my whole writing class all on the floor doing yoga for fifteen minutes. Someone would pass by and look and see somebody on the floor. One time, one of the teachers ran in and said, "What's happening?" And I said, "Writing."

I don't have writer's block, because I developed a technique to get myself into writing. I started with meditation, visualizing. Two things happen. One is you have to go more gently internally, like to think of what a character looks like or the person's profile. All these things are slower and more gentle. If you think, "I must finish a scene," you're putting pressure without the result. You are pushing the whole mountain. It's a pressure that is not in any way making a dent, and the brain gets solid. You do not work for results. You have to be moment to moment, in the moment. You cannot be there, you have to be here.

There was a time when someone would say, "You're working for results," and I would think, "How could that be bad?" But I understand now, because you have to be with the moment. I learned to use that in my own writing. The characters don't know what's going to happen to them next. They live moment to moment. They are planning,

but they don't know how it is going to come out. Sometimes you might say, "At five o'clock, I am getting up and going to that corner and have to make a call from there at two minutes after five, and if I don't I'm in trouble." But in real life, it is very seldom that you have to work for results in that way. Even when you go to work everyday at the same time, you never know, because if you are a little late, maybe you will meet the person who is looking for you to give you a hundred thousand dollars. We have no idea that anything is going to happen around us.

I started out as a painter. I never went to the theater. Why did I start writing? I used to know why. It was in France that I saw Ionesco, and I saw these plays in French. I didn't speak a word of French. But I felt like what I was watching was a miracle. I had never felt that way about painting. So I didn't decide it, it decided me. I didn't have to think about it. I just started writing.

The sense of form in painting is much larger than in writing. Sometimes I used watercolor paper. Or a drawing, or portraits. I think I shifted to playwriting when I saw the avant-garde painting, because avant-garde was probably more my call. It just happened to be that writing was more my form. I'm more of a talker and a thinker, and at that point I already had two languages—poorly, because my English wasn't good yet and probably still it isn't very good—but I had two languages, which is quite an advantage. It's a double possibility. And I understand voices.

I'm Cuban, and there was somebody who said to me, "One can tell you're Spanish from your plays." And I said, "Really, how is that?" Because I cannot tell. I know that there are things I am interested in, things I am not interested in, but whether a person can tell by reading a play of mine that this person is not American—that's a style of the work rather than the accent of the language. So I said, "You mean, the subject manner, the spirit of the thing? Or the language?" And she said, "The language." I said, "There is a foreign accent in my work?" And she said yes. And I couldn't believe it. I just couldn't believe no one had mentioned it before. It was in the sentence structure, the way people organize language, which I find interesting.

I remember one time a friend of mine was waiting—a different friend from before—she was waiting for a telephone call for her that was coming to my house and I was in the middle of writing, finishing something. I don't remember if it was by typewriter or by hand, but suddenly I start mumbling. And she said, "Did you say something?" I said, "No." Because I hadn't said anything. I was not talking to her. I wasn't talking to myself. It was the characters talking to each other.

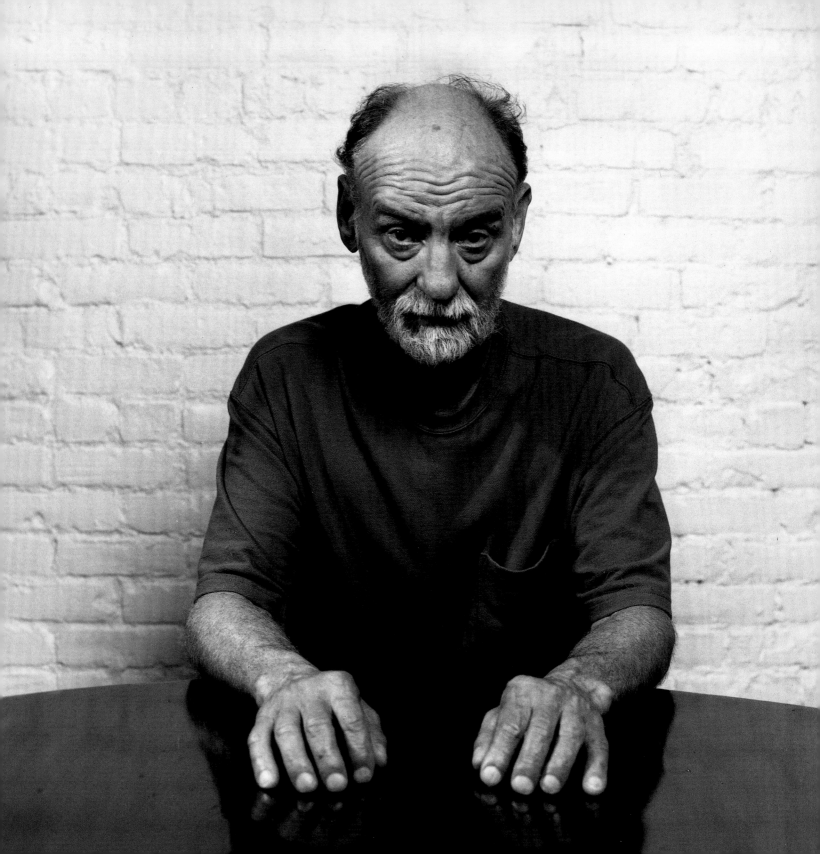

JACK GELBER Born in 1932 in Chicago, Gelber wrote numerous plays, most notably *The Connection*, as well as *The Cuban Thing* and *Sleep*. He won three Obie Awards for his 1959 off-Broadway production of *The Connection*. Gelber died in, 2003.

I didn't enter the theater world as a fan. I entered the theater world as a way of expressing myself, and it came out in theater terms and was appreciated in theater terms. So success bred the illusion that I could do more, and I did more. My first involvement was probably 1956. I was in New York writing short stories and a friend of mine from the University of Illinois asked me to help him paint a set that he had designed for a small theater company. I saw the production, *The Shoemaker's Predacious Wife*, and I thought, "Gee, this is not like the Broadway theater I've seen. This is intense. This has got some feelings that are palpable here." At the same time, I was extremely unhappy about the way in which drugs were portrayed in the popular press, the way drugs were perceived in the world of movies and theater. We had a completely artificial view, not from the inside, not a report of what's really going on at all. I was very unhappy about the way jazz was sort of relegated to background music in movies, and I thought it ought to be center stage. So I wrote *The Connection* based on my anger, my unhappiness, my zeal to set the record straight, and that started me working in the theater.

JACK GELBER

Like all young writers in New York or anywhere, we wondered where we would get our plays done. We tried to send them out by mail, we entered contests, we talked to people, we pestered people, we tried to figure out where our work fits in. In this case, I was very lucky to have been introduced to the Becks, who ran The Living Theatre. In 1958, sometime in the late spring, they read my play, and liked it. We had a handshake agreement—no lawyers, no agents, no papers. They were going to do my play on Fourteenth Street and Sixth Avenue in their newly renovated space in the old Hecht's department store.

If you can remember the sixties, there was a very deep-seated urge for everyone to express him or herself. With almost democratic despotism, people asserted their version of what ought to be right. The writer took just one more chair in that debate. I knew that what I was doing was something no one was doing. From the inside it didn't feel like I was challenging the convention of theater. I didn't know the convention of theater. To be very honest, my theater experiences were quite sketchy. I didn't have a bunch of conventions that I thought I was going to break at all. From the inside, when you do something for the first or second time, or when everything is new, you feel that you're inventing the wheel yourself. For example, when accused of breaking the fourth wall, I did my homework and discovered that the fourth wall was broken almost as soon as it was invented, and that we can find plays in the literature from the 1600s on, in which people are jumping off the stage and going into the audience, playwrights having actors planted in the audience. It's been going on for four hundred years. I did not invent it

When I read a play, I had a very firm picture of where everybody would be on stage, even if they don't have any lines. I knew how far away the characters were from

one another. I knew their psychic distance and physical distance both. I knew what attitudes they had, and I knew how they were reacting. Did I train myself to that? No, I just knew that, and I just sort of assumed for many years that this was the case for everyone. One of the primary places I took from was the radio. My training is in the ear as opposed to the eye, when I say "see things." There used to be a boxing announcer named Don Dunphy, and after he described a Jake LaMotta–Ray Robinson fight, the next day we would say, "Did you see it on the radio?" Because Dunphy would paint these pictures, but it was all aural, and so I heard it, but I also saw it—I used imagination.

When you talk about any play, rarely do you have someone who has the insight into what it is to create, as to opposed to criticize. One of the things you have to teach young writers over and over again is not to be their own worst critics. Not that you shouldn't judge your work and change it, but to examine it like a critic would examine your work, and that is not the job of a creator. I think it stops people from being as good as they can be. It inhibits rather than opens up. After all, we're all critics. I've never been to a theater performance in which not everyone had an opinion, and usually diametrically opposed to one another. That's par for the course, whether it's the woman handing out the programs or the patrons or the guy sweeping up the stage—everybody has an opinion.

I think Edward Bond said something like this, "I'm hopeful despite the evidence." Edward Bond, please forgive me if I've misquoted you. I'm hopeful despite the evidence. I'm not Marxist in my analysis of the economic playing fields in capitalism, but there is something about our version that uses economic determinism as to who will and who will not rise in the art world. It's as simple as that. What sells in the marketplace is what is going to survive.

What does not will be sunk. Now, is that a good or bad thing? Well, there are some good things about it, but there are an awful lot of bad things. It's just very harsh.

I have always maintained that the journalistic function of the theater has mostly been robbed. Shakespeare gave the news of the day. This day and age, people get their drama of the news from television, so we're really not going to be able to inform people in the same way. There are exceptions, and these exceptions are notable, where we learn something about soccer, or corruption, or executing criminals, or 9/11. There are some venues where the theater can hit home. I think the religious origins of the theatrical impulse really remain and the best you can hope for is to involve and engage the theater audiences so they have an opportunity to examine themselves and their behavior and the behavior of others. But I don't think you can persuade people to enact different laws about drugs after they see *The Connection*.

I have come to the point where a lot of things happen in my plays that are character driven. I devise these characters and they sort of lead me instead of me leading them. Yes, it's all me. But I feel I'm going to be true to that creation, that character, and not respond the way I would like to respond as an individual. That's another thing the critics don't get right at times, the difference between the playwright's opinion and the character's opinion. Sometimes they will ascribe to the playwright the opinions of his character. This is a common fallacy, and there's nothing I can do about. It's a measure of their effectiveness that critics and others are so upset. I once had a character in a play that said something that was nonsense scientifically and the next day one of the critics said, "Mr. Gelber ought to take a physics lesson."

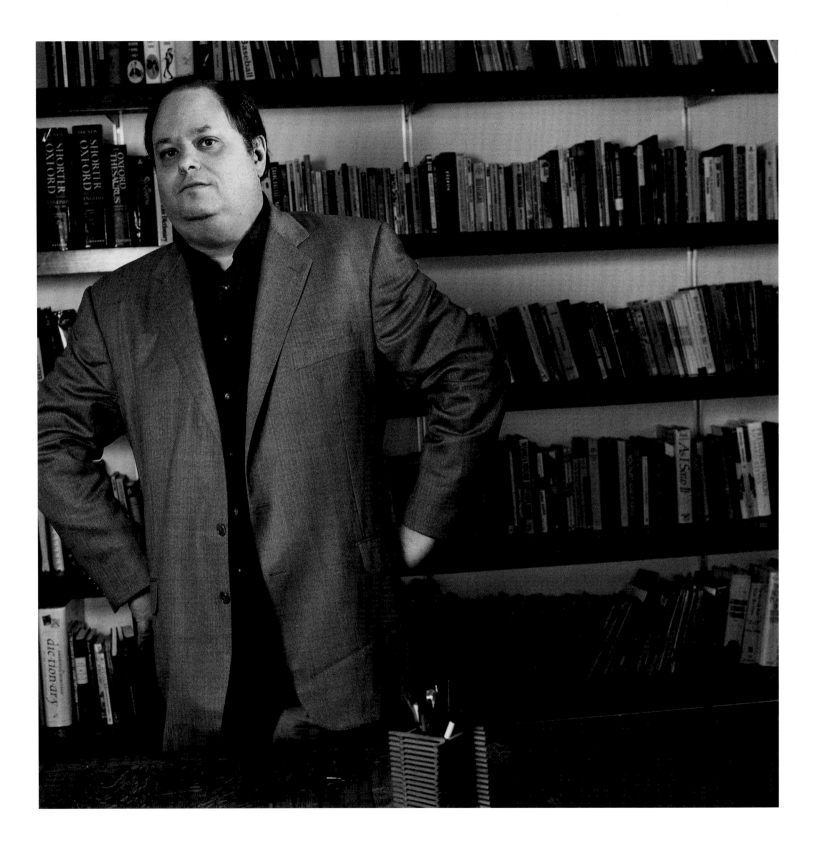

RICHARD GREENBERG

Born in 1958 on Long Island, New York, Greenberg is the Tony Award-winning author of *Take Me Out* and numerous other plays including *Three Days of Rain*, *The Violet Hour*, *The Dazzle*, and *The Bloodletters*. His many prestigious honors include two Pulitzer Prize nominations, the Oppenheimer Award, and the Drama Desk Award.

RICHARD GREENBERG

I am a serial obsessive. With baseball, it hit me all at once and monopolized me within two weeks. I couldn't focus on anything else. I was bored one night and I was just changing channels, and I turned on this game. I thought, "Why don't I just try watching a game? Why don't I just see what it is?" It was fascinating. And then I did it again the next day, and then the next day, and the next day, and then suddenly, there didn't seem to be a point to anything else. It just overtook me. It turned out to be incredibly rich, and also kind of a Wordsworthian sort of trigger. So I just started writing scenes, not really knowing where they were going. At a certain point it reached a critical mass, and I thought, "I can't not write this play." I can never remember when a plot actually emerges—that just happens. That was the beginning of *Take Me Out*.

When I was five years old, I had a very terrifying kindergarten teacher. She was good, but she was scary. Once, she called my house, to make sure I had permission for a field trip. I picked up the phone, and she asked me if I could read yet. I said yes. It wasn't true. I was terrified. So I made my parents teach me to read that night, because I was afraid she was going to test me. She didn't, but I became "the kid who could read." So by first grade, there was this aura. I was the literary one, the one who learns to read really fast. What's funny is that until then, I had a real scientific inclination. That's what really seemed to compel me. But then I had this reading reputation, and I really do think that sort of determined my path. It's all an accident. I was writing, because I was a literary guy.

So I've always been writing, but I never intended to be a playwright. I meant to be a novelist. But once I was in graduate school at Harvard in the English and American Literature program, and I had no intention of completing it, I just realized I was killing time. One night, I was halfway through a novel by Henry James, and I was meant to run this seminar on it the next day, and I realized I was not finishing the book. Then I realized I was not going to the seminar the next day. Then I realized I was no longer a Harvard student. But I was still hanging out in Cambridge, and living in my dorm, and I needed something to do during the day, so I wrote a play. And it was just sitting there. I remember saying to my sister-in-law, "I think I'm gonna apply to Yale Drama School." And she told me it was a cop-out, for some reason. But I said, "No, I think it might be a good idea." So I got into drama school with the one play I had ever written. Playwriting felt natural, more natural than any other writing had felt. And I liked it a lot, so I just became a playwright.

One of the formative experiences as a playwright was watching *The Forsyte Saga*—all twenty-four episodes. They decided to just run it round the clock on PBS, in one

day. It was a generational epic. And I'd tune in, and I'd watch a little, and then I'd go out and mow the lawn, or go to the library, or have lunch, and then I'd come back a few hours later, and that baby from an earlier episode had grown up and just been killed as a soldier in World War I. So it was this incredible synopsis, and there was something infinitely moving about all of this unraveling in a really short time. There was something about the baby who was born at two p.m., now being dead at seven p.m. I loved this idea of time as something you can rush, and that's something you can do in playwriting. Instead of dealing with an hour, we're going to deal with forty years here.

When I first started, I was afraid of the people who were right behind me. I was fiercely protecting my turf. But for a while, there was no one. The generation right after me went missing. They all just went to Hollywood or they all just wrote for TV. Then I got scared that there was no one. I was of the last generation of playwrights for too long a time. I was ten, twelve years into my career and nobody younger had come along, and that really got me scared. That was much worse than the other. Who wants to be the last generation of playwrights? Because then the theater goes away. I didn't want to be the last of the last ones to write plays! I wanted plays to go on. By the time I was getting to be thirty-five and still there was no one, it was disturbing. But now, there's a bunch of people—and that's good.

I have friends who've had colorful lives. I've had friends who've fallen off mountains. (I do, I have friends who have fallen off mountains!) I know people who've been in prison, who embezzle, been in political cults—I have not fallen off a mountain. I just went to a lot of schools, and then I started working. It's not that same vividness and it wouldn't be that interesting as a play.

I stopped reading reviews in 1988. I have this play that I no longer discuss, which was the best and worst reviewed play of the season. There was very little middle ground. There was 'Bravo,' or, 'You should die.' I just didn't really know how to deal with that. It was before I knew who I was. So I depended on how I was reflected for a sense of self. I was annihilated by that; it was unbearable really. And I thought, this is not a good idea. What I need to do is stop reading all this stuff, and sort of invent a core, become a person, and just act out of that. Even though I don't think now a review would have the capacity to knock me for a loop, it turned out to be such a good policy that I've decided never to change it. I just don't read them. And I'm not wasting time mourning, anymore.

I have this reputation for being inward. I guess the word they say is reclusive, but I'm not really. Of course, it can help if people think you are. "He's a special case. This is hard for him." You get out of a lot of stuff. I think parties are boring. You can't really have a conversation. People in this job, they gather at certain places and behave in a certain way and somehow feel insulated against death. That kind of fabulousness I find a little depressing. So I spend a lot of time not hanging out. It's nice to know I could be invited to the fabulous places, but at the same time I think that the fabulousness is illusionary. Of course, the opening night party tends to be fun. I have all these friends who are really beautiful women who come, and I like really beautiful women. For whatever reason, I just do.

Also, I have never worked on a computer. I write by hand, because I can write at the speed of conversation. In fact, my computer physically broke once, and I was so happy, that I just threw it out. First of all, I had been bankrupting myself, because I was an insomniac and there was nothing better to do in the middle of the night then spend three

hundred dollars online, mostly at Amazon.com. I think Amazon.com misses me. I have somewhere an almost life-size poster of Scott Brosius, the Yankees third baseman, whom I loved. What am I going to do with that? But at two in the morning, it seemed like a very good idea. Now, it's planted in a closet somewhere, but I can't just get rid of it. I loved Scott Brosius.

I don't drink heavily enough. That's actually one of my problems. I tried to drink heavily in my youth. I drank heavily for five years, and then made the sad discovery that there was no possibility of my becoming an alcoholic. I realized finally, after five years of getting drunk every day, that I didn't have the potential to be an alcoholic. It was quite disappointing to me, because I wanted to be somebody else's problem. But I was always completely functional, so I stopped. Now I just drink normally, which is how my Jewish genes disposed me. Drinking heavily is nice—it's very calming—though it seems to require a genetic predisposition. My behavior proves that some people just don't have it in them. I was very young when I was attempting that. It's not the sort of thing I would think is a good idea now.

Writing plays has saved me, because otherwise what I would do all the time would be pure delusion. I would be in the world of pure madness or delusion, because I just go making up scenes. And I can tell myself it's all leading toward a play. That's what I do. I walk around thinking about things and creating scenes and bits of dialogue and daydreaming. If I go out, almost any stimulus can detonate, because after spending a lot of time inside, you go out, and things are different. When I read Jane Jacobs's great book, *The Death and Life of Great American Cities*—and I had read it to enable me to write *Three Days of Rain*—it explained to me that for all of my aversiveness to people,

to noise, I really am a city guy. Just walking down the street can be incredibly satisfying, just because of what it's like to be in a city. All the architecture, the things happening—I find that to be an event. Just going to get milk at the corner can be completely satisfying and can trigger something inside me. So I do like walking around. I really like walking around, daydreaming.

It's fascinating when I see my daydreams come to life, and occasionally they really do. We did the first production of *Three Days of Rain* in Costa Mesa. There's an extended sequence, in the second act, where these two characters, played by Patricia Clarkson and John Slattery, fall in love. It was a hard thing to get. It was extensive, it was nuanced, it was a brand new play. It took a long time of building and creating. During the last dress rehearsal, I watched it, and the scene happened between them. It happened in the most delicate and profound way. This scene had meant so much to me and I thought I was going to be speaking only to myself when I wrote it. But these two wonderful actors struggled for it, and they found it. They made it happen. It was just an extraordinary thing to see. It was beneath the dialogue. It was written so that they don't really admit it, but it's happening. And it's an extraordinarily powerful thing to watch two people actually fall in love in front of your eyes—and to believe it. That was amazing.

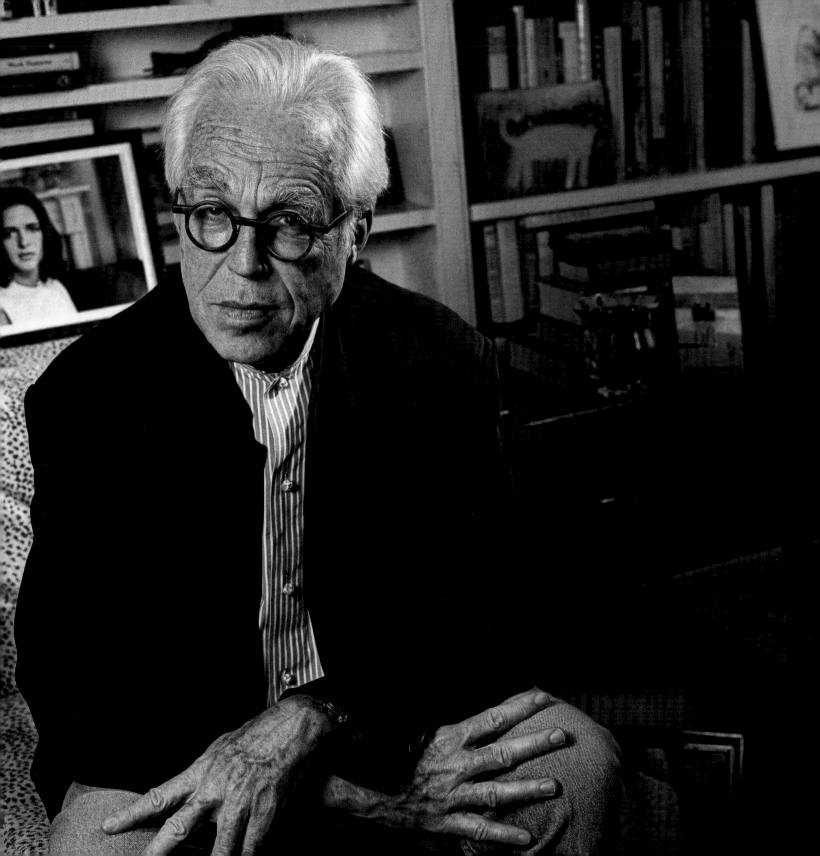

JOHN GUARE Born in 1938 in New York, Guare is a celebrated playwright of such titles as *The House of Blue Leaves*, *Six Degrees of Separation*, *Four Baboons Adoring the Sun*, and *Moon Over Miami*. He has won several Obie Awards, a New York Drama Critics Circle Award, and an Olivier Best Play Award.

JOHN GUARE

When I was fourteen and read *Three Sisters*, my world changed. I didn't know that a play could be about that much yearning and loving and just wanting to get out, events that were my secrets. That power was the essence of the theater and that's never changed for me.

When I finally finished the torture of nineteen years in school and then time in the Air Force reserves, I got to Europe where I knew my life would begin. I would find my story and start the play that would prove I was a playwright. After all, I was already a playwright with a degree from Yale School of Drama to prove it. I just had nothing to write about. I went to Paris and started hitching. Months later, I got to Cairo and I checked in at American Express. My parents had sent me a thick letter from New York saying that while I might think I'm out seeing the world, the world had come to them in New York. They actually saw the Pope this close in the flesh on Queens Boulevard. The Pope himself had come to New York, for the first time ever, to stop the war in Vietnam and bring peace to the world and they had seen him drive by this close. They described the event with such passion—not to mention all the clippings they enclosed—to tell me what I had missed. I realized I had my subject. Had I been in New York the day the Pope came, I would have hidden out and laughed at my parents' fervor. But in writing to me, they had revealed a side of themselves that I had never seen before. And I started writing *House of Blue Leaves* in Cairo that day in 1965.

I never wanted to write a novel. I love the very limitations of writing for the theater. You have ninety-nine pages to write your novel. Time is the enemy in the theater. The curtain goes up—bang! You're off and running. Every performance has to feel as if it's never been done before and the audience is seeing it for the first time. The craft of

playwriting is learning how to make them react, not the way they expect, but the way you intend. You do have to listen to them. Those dread moments when you can tell the audience is lost and you think, "Why are they lost?" and you realize, "Oh. I forgot to say they're in Chicago."

Once a playwright uses stylistic devices such as direct address to the audience or songs in a way that works, the writer has to stop using them before they become crutches. We have to keep giving ourselves new challenges, painting ourselves into new corners in the pursuit of developing new techniques, new tools to get out of those corners. After I wrote *Bosoms and Neglect*, I realized my plays had essentially been about New York and New Yorkers and a lot of writers were drawing water from that well. I wanted a world that was entirely mine. I loved nineteenth century novels and decided to write the equivalent for the stage. That became the three plays of *Lydie Breeze*. And putting myself in that historical world let me come a few years later fresh to *Six Degrees of Separation*.

Have I been surprised in the theater? All the time. Do actors surprise me? In *Six Degrees of Separation*, we had lost our lead on the first day of rehearsal and thought we might have to close the play down; but Stockard Channing, God bless her, came in and opened with only two weeks of rehearsal. She was as I intended. The actress and the part coincided perfectly. Among all her gifts, she understood the world of the play; she grew up on Park Avenue. The play concerned a young man who wanted into her world. Where Paul was from and where Ouisa was from were two completely different planets. The play opened and the response was a writer's dream. Stockard could only give us the six weeks of playing as she had committed to doing a movie and had to leave for a spell. Swoosie Kurtz, God bless her, took over. What was thrilling about that change

was—which I had not seen coming at all, this is where the writer is surprised—Swoosie is from Nebraska, and no matter how much she looked the part—her hair was perfect, her accent, her style were perfect—but she was as much an outsider in that world on Fifth Avenue as Paul was. Stockard's Ouisa and Paul looked at each other from two different planets. Swoosie's Ouisa was as much of an imposter in her world as Paul was. Nothing was changed. It was just the subliminal force that these extraordinary creatures called actors can bring to a part. That's one example of a role being given two completely different spins—one of which was not my intention—and coming to the same conclusions.

There's only one lesson to learn from Shakespeare: no stage directions. Everything has to be in the text. You have to write a play that can be done on a bare stage and the audience will know where they are. You have to make the language of your play as rich and dense as possible. I don't mean prolix. The language can be as spare as a Pinter play. The responsibility of a playwright is to use language to create a world that generates energy. When you hear a play working, it takes on its own dynamism. That's the playwright's responsibility: to make a text that can generate and focus that energy.

A play is life and death. It's a battle with that audience out there whose only correlation is a bullfight or a prize fight. When something doesn't work, we say, "They slaughtered us last night," and we mean it. But when it does work, oh, when that lightning hits, the only response is, "We killed them."

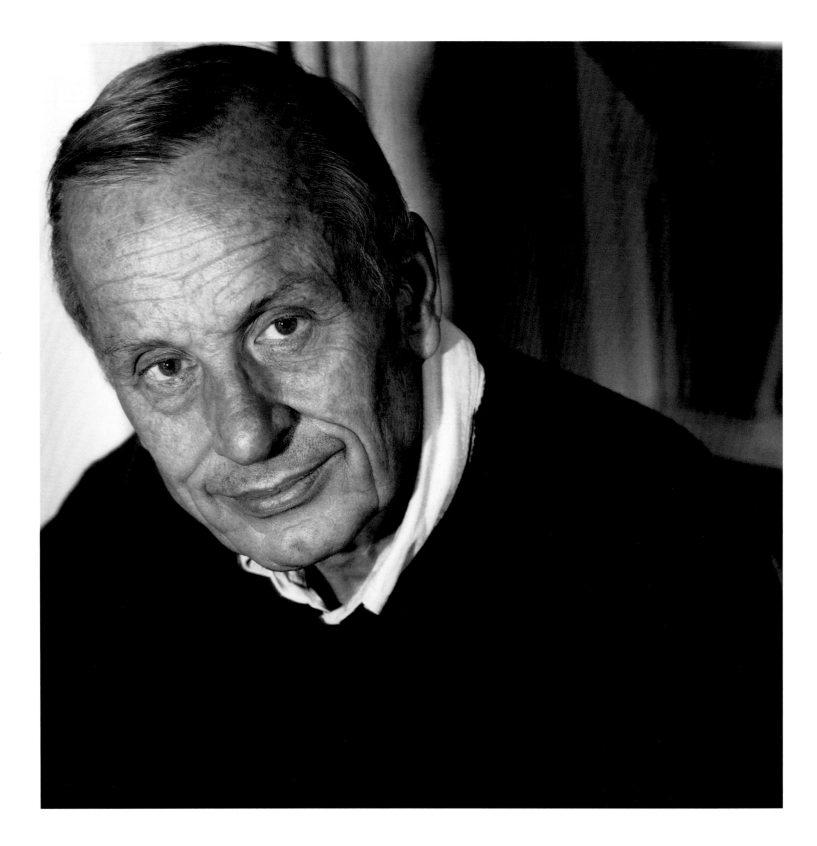

A.R. GURNEY

Born in 1930 in Buffalo, New York, Gurney has written many plays, among them *Scenes from American Life*, *The Cocktail Hour*, and *Sylvia*. He has also written three novels, a few television scripts, and the libretto of *Strawberry Fields*, a one-act opera. He has received a number of honors and awards including a Drama Desk Award, and was inducted into the Theatre Hall of Fame in 2004.

When I was very young, I got a little marionette stage from the Schwartz catalogue and I used to put on little shows for my family. When I got older, a group of us put on these puppet shows every Saturday afternoon for the neighborhood kids. The gang didn't think I was a good enough writer, so I couldn't write the shows—but I could design the scenery. I never took drama seriously until I went to Williams College. I was two years behind Stephen Sondheim and he opened up the college musical, and made it much more serious. It was no longer guys playing girls with hairy legs, the campy kind of stuff. He told a serious story. When he graduated, that heavy mantle fell on my shoulders, because I used to hang around the theater a lot. I put on reviews for a couple of years. I wrote some skits and some songs and some of my friends did them. We certainly couldn't equal Sondheim, but we had the same kind of satirical vision that he had and we tried to emulate that on stage.

A.R. GURNEY

In the Navy during the Korean War, I was on a large carrier. One of my jobs was to entertain the troops, so we put on musicals. I found people who had talent; there was a huge ship's band that used to play the national anthems whenever we came into port. They also had a few arrangements of show tunes, so I wrote new lyrics and we put on reviews. Then I went to the Yale School of Drama and the first show I had seriously done was a musical.

I never wanted to write. I wrote occasional poetry and stuff for the college magazines. But all the way through school when I was growing up, whenever there was a composition to write—in those days you had to write much more in grammar school—I wanted to write a play. I wanted to make a more public utterance, and I wanted to get the laughter of my class, and if I wrote a play I could read it out loud and get laughs from my friends. I think I wanted to be an entertainer, and I was too chicken to be a stand-up comedian. I picked that up from my father, who was a wonderful after-dinner speaker in Buffalo. Whenever they needed a master of ceremonies, they would get my father. He was a wonderful impromptu speaker. I couldn't do that, but. I thought I'd outflank him by writing plays, which was a public thing, and be funnier than his speeches.

Writing those reviews at Williams was the first time I tried this for a large audience, and I really got a kick out of it. I did more at Yale, and had quite a lot of success. I wrote the first musical ever done at the Drama School, and also sold a couple of things to television. I had also done the book for a musical version of *Tom Sawyer*, which was done at the Kansas City Starlight Theatre, before an audience of five thousand. That was a real thrill. But then, oddly enough, after Yale I went completely dry. I thought, well, I've told the world everything I have to say, and so I started teaching. I loved teaching at MIT. I loved the Department of

Humanities and I loved the serious books that I was teaching, and out of that, I began to take myself more seriously as a playwright. I had a colleague there who was also a writer. He said, "When are you going to stop being a teacher who writes and start being a writer who teaches?" What he said and how he said it and what was happening to me at that time really affected me. I began to realize I had a subject—and that was the culture of the world I grew up in, and how it was struggling to maintain itself or systematically destroying itself as the world changed around it.

I found myself writing a play called *Scenes from American Life*. It kicked around for a while, went to Tanglewood, went to Buffalo, played in Boston, and finally ended up at Lincoln Center. I realized that subject was worth mining for a little more material. For about twenty years I tried to do exactly that, and I felt very lucky that I had a subject, because many writers don't, and no one was touching this at that time.

I was forty years old by then, and that's when some people throw themselves on the analytical couch. Well, I didn't, because I didn't have to. I began to look more seriously at the world I grew up in partly because I was so far removed from it. In Boston, at MIT, I had colleagues who mostly had nothing to do with that kind of world. At that time, we were still in Vietnam. The Nixon administration was being pretty tough on the protestors, so I saw kind of quasi-fascism occurring in the country. I thought, "My God, what have my people been doing about this?" My people, my culture, who had held all the reins—or at least I was brought up to think we were holding all the reins—how did we just let the country slip out of our hands?

A little later we were going through an energy crisis. Carter had been elected, my family and I were living in a big old house in Newton, Massachusetts, and we were spending huge amounts of money heating the damn thing. So we got rid of our dining room, which we never seemed to use except to fold laundry. That was quite a room to give up. I started thinking about how large a part of my life had been spent in rooms like that when I was growing up. So that triggered a play called *The Dining Room*, which helped my reputation.

I used to be called a "chronicler." It used to anger me—it made me look like a historian too much, not a playwright. But maybe they were right to call me that, because the world was changing so rapidly around me, and my children were growing up and bringing entirely different assumptions into the house. I became continually and cumulatively aware about how different the world was when I grew up compared to the way I was living now. The material almost emerged naturally. There's always a tension in my life in the new thing I'm trying to do and the old themes that keep creeping in. As I continued to explore this theme, I tried to push against the walls of theatrical form.

The thrill of theater for me is creating a sense of community and cooperation with an audience. The community you create in the process of rehearsal precedes all of that. I love that whole process. I love working with the designers, with the director, and with the actors. I don't allow them to say, if they're advertising a play of mine, "A.R. Gurney's such-and-such." I don't like that. It's not just mine—it's by me, with so and so in it. If there are stars above the title, fine, they deserve to be there, but I don't deserve to be there. "William Shakespeare's *Romeo and Juliet*" as opposed to "John Webster's *Romeo and Juliet*?" I don't think so. It's normally *Romeo and Juliet* by William Shakespeare, and I like to be listed the same way, because that puts me below the title and suggests we are all in this thing together.

JEFFREY HATCHER

Born in 1957 in Steubenville, Ohio, Hatcher has written extensively for film, television, and theater. His titles include *Scotland Road*, *Tuesdays with Morrie*, and *Female Stage Beauty*, adapted for the screen as *Stage Beauty*. He is the recipient of numerous grants and awards, including a MacArthur Fellowship Award, and is a member and/or alumnus of The Playwrights Center, the Dramatists Guild, the Writers Guild, and New Dramatists.

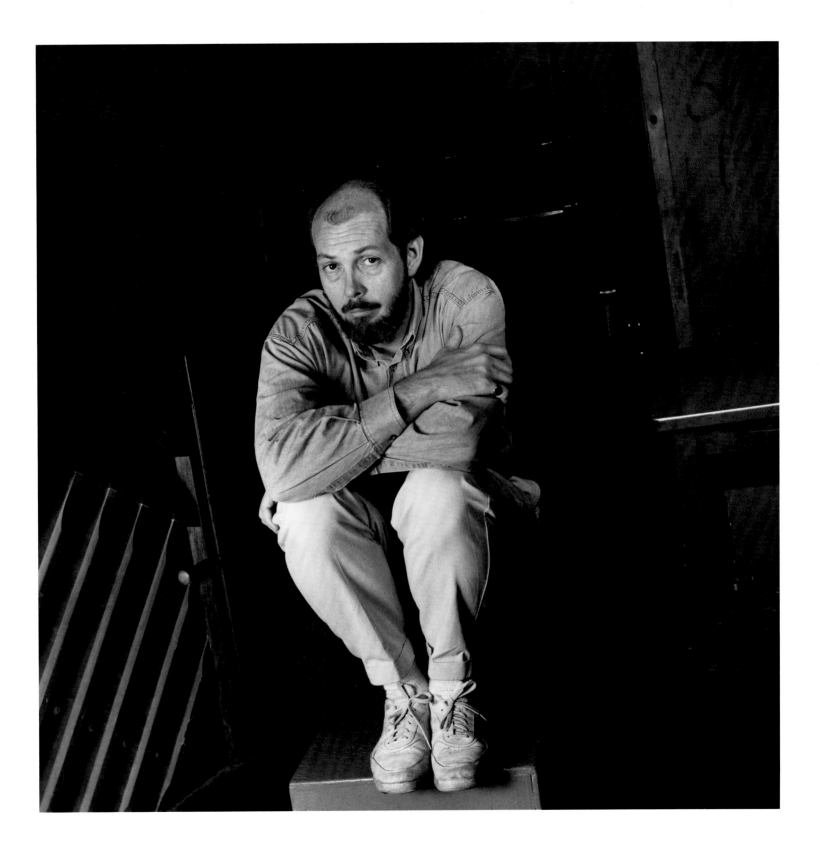

The playwrights of the thirties and forties had a very slick, svelte look. They were all very well manicured, as if the goal was to look like Philip Barry. The sixties and seventies crowd was much scruffier looking. Most of the playwrights I bump into have the same look: lean and dark. They seem to want to ape software entrepreneurs. I would almost suggest that writers who have so firm a physical image of themselves, like Shepard or Mamet, write to match their photographs. If you think of the Mamet plays that we think of as "Mamet Plays," they look like that stocky guy with the black leather jacket and the cigar, just as Shepard's plays seem to suggest that lean, Gary Cooper, revisionist Western look. I don't fit into the current mold at all. I'm trapped somewhere between looking like G.K. Chesterton and Jimmy Buffet, and that works fine for me.

JEFFREY HATCHER

I was a classic Anglophile kid. I grew up wanting to have an English accent, which made me a very peculiar little boy in Ohio. I'd lock myself in my bedroom and play all the parts in *Sleuth* for my tape recorder, as if I was doing my own radio play. It was either serial killer or playwright —my life was headed in one of two directions.

I tried to write one short story when I was a kid. I was two pages in and I was still describing the main character's face. It was pathetic. I realized I just didn't have the knack for prose. If I had a talent for anything it was going to be dialogue and dramatic structure.

I started out as an actor, but even then my introduction was as a playwright—or rather as an adaptor. When I was in fifth grade, the teacher said, "You've got forty-five minutes to perform a play in," and I thought, "Oh, we'll have to do a very short *Hamlet*, and it's a famously long play." I knew what plot points were important and what weren't. Also, I knew we had to give the audience some of the famous speeches. Even then, I knew "To be or not to be" was one of the greatest hits. You could cut it, but they're going to be pissed off that they didn't get to hear it. One of my best friends, who was blond and thin, got to play Hamlet. I got to be the Ghost. I realized early on that I wasn't the star type—if anything I was a character actor. All through high school, college, grad school, and New York, I was the guy with the cocktail glass or the villain with the winged collar. It became apparent to me that my role was not going to be center stage. The playwright, vital as he or she is, is still not center stage.

I wrote a play based on what happened to my mother when my father died, *Three Viewings*. The main character talks about how, when her husband died, he left her with debts and mob connections, and terrible, horrible things

she has to deal with. Those details were very particular to my mother's story, so I made them particular to the play. I often meet women in their fifties or sixties who have seen the play, and either their husbands have just died or their fathers have died, or something similar to the play happened. It's never the exact same specific story but it's close enough to suggest that they're all inside the same emotional state and they see themselves and their situations reflected in the play.

If I get an idea, very quickly I'm envisioning stage movement, a couple of plot moves, maybe even the ending, in an instant—my mind is alive with just a few of those key elements. I say to myself, "Ooh, let's get this down on paper." If I get an idea and I fret and fret for six months or a year, trying to figure out what the structure of the whole thing is, then it's probably not an idea worth pursuing. It's not a matter of more time or more thinking or harder work. It's just not the right idea for me. I don't trust it. If I forge in without a clear idea of where the play's going, it's bound to be cheesy or forced.

I envy novelists in one sense. They have a direct connection to the reader. And though the reader will bring certain predispositions and prejudices to the experience of reading, the words typed out on that piece of paper are as direct a communication as a writer can hope for. There are no "interpretations," no "intermediaries." We need actors, directors, costumers, the whole shebang, just to try to get the ideas across. Having said that, and having envied novelists their advantage, I still don't want to describe what the trees look like, or what "Joe" was thinking that day as it rained. I think it's just miserably difficult stuff.

Audiences are never aware how a performance changes night by night. Last night, one of the actors did something in the show different—it was the very last performance—and

I just thought, the audience will think that's what happens every night, that that's what the writer intended there. But it was really just an aberrant moment. The actor did something that he tended not to do and it colored the whole event. But the audience will never know that. It made a moment seem darker than it was supposed to be. It just fascinates me, and when I'm an audience member, I assume that of other plays, too. I say, "Oh, that must be what they want me to see. They showed it to me, so they must have meant it." But as the playwright, I'm backstage wailing, "Aw, gee, we can't get this right!"

What's funny is that during rehearsal you lose the central position of author. Rehearsals are almost always a negotiation. If you're lucky, good, savvy at the game, the production will be a vivid version of what you'd imagined—maybe even more than you'd imagined. But in most cases, the writer is simply another collaborator, along with the director and the actors and everyone else. And then the reviews come out, and if it's a new play, the critics write about the script as if they're absolutely certain that you were in the central authorial position the whole time. So you see yourself being discussed in ways that you never intended. You say, "I was in charge of that moment? That expression? That bit of staging?" It's like you'd been forgotten for a long time and then suddenly you're back there—center stage—and all they can talk about is you.

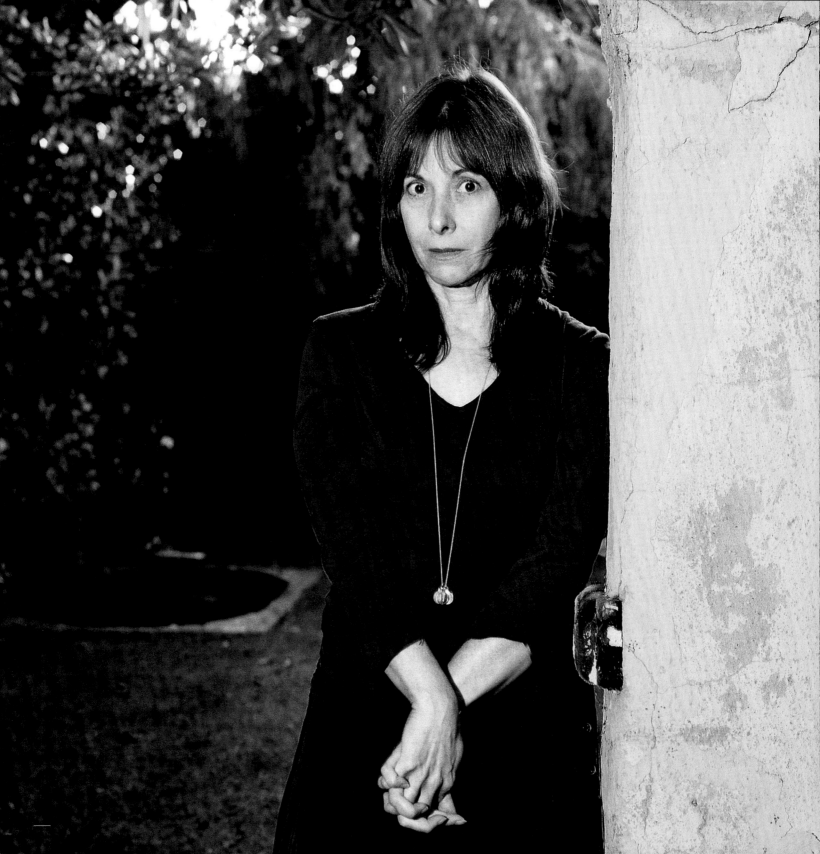

BETH
HENLEY Born in 1952 in Jackson, Mississippi, Henley is a Pulitzer Prize-winning playwright. Among her titles are *Crimes of the Heart*, *The Miss Firecracker Contest*, and *The Debutante Ball*. She received the New York Drama Critics Circle Award for Best American Play in 1981.

Beth Henley

I'm lucky, I guess, that I can make a living in writing. I don't think I could make a living at anything else, because I like being alone a lot. I love imagining characters and dialogue. I like doing research. When I'm researching for a script I learn things in more acute ways than I do when I don't have a purpose.

My mother was an actress. She was doing children's theater and she was playing the Green Bean Man. I remember when she'd pick us up for carpool, and she was all green, and I just thought, I want to be part of a world where I could be green.

In sixth grade, I wrote a play, *Swing High, Swing Low*, that was not ever performed. We tried to perform it, but we got boys involved, which was a little overwhelming and it all fell apart. It was a musical, and the plot was about Dolly, this girl who moves from this small town to be a beatnik in New York, and when she enters the beatnik café, they all sing "Hello, Dolly" to her. I don't know if it would hold up under any sort of legal scrutiny. After that, I decided I probably was not going to be smart enough to be a writer. All the writers I was reading I was so impressed by and so overwhelmed by. I didn't make great grades in school, and I can't spell.

In my senior year in high school, I took an acting class at the local community college and that was a lifesaver. It was kind of a dark time growing up in Jackson, Mississippi, and I didn't really connect with a lot that was going on at school and in the world. It was a very volatile time and the Vietnam War was going on and the political views that dominated the town, well, it was basically apartheid. I did not know how to come to grips with any of it. The freedom marches had been through the city, there were riots, they were bombing synagogues. My sister's fifth-grade teacher was shot on the back of a motorcycle trying to put crosses on somebody's yard for the KKK. Something about hypocrisy and secrecy have always haunted my writing.

During college, I was taking summer school in Shakespeare and I thought of an idea for a play. I got very excited about it; I got that thing you get when you can't stop thinking of something, ideas keep coming that keep evolving and I thought, "Oh, I've almost got this play written in my mind," so I took a playwriting class the next semester. That play, *Am I Blue?,* was actually produced later in New York. But at first, in college, I was sort of in denial about being a writer. I was in my nihilistic phase. I had the play done under a pseudonym, Amy Peach. I remember my mom felt sick, because she had told people I had a play being done, but when she brought back the playbill, it only said "Amy Peach."

I didn't think it was very good, really, and I was too terrified by it. I still feel that terror, sort of like if you're giving a party, and you make people pay to come to the party, and they're all there to see you. It's this grave responsibility. Would what was in my mind, or in my heart, be interesting enough for somebody to spend two hours looking at? But there are two versions of me. There's the person who writes it, who doesn't give a shit, who's just trying to write whatever she needs to write. Then there's the poor person that has to sit there every night when there are people coming in, and she does not want to be there.

I came out to L.A. and I wrote a screenplay. It was called *The Moon Watcher* originally, but was made later as *Nobody's Fool* with Rosanna Arquette and Eric Roberts. I really wanted Sissy Spacek to do it, because I loved her. I tried to get the script to her, and her agent said they'd love to read it after it had a producer. So I tried to get a producer, and they said they wouldn't read it unless it was submitted by an agent. Then I tried to get an agent and they said, "Well, we're not taking any new submissions." Thank God, I was so stupid—I never would have come out to L.A. But then I thought I could write a play, and at least I could produce it. My friend was producing his plays for $700 or something, so that's why I wrote *Crimes of the Heart*, and I wrote it deliberately cheap. It was only one set, modern day, and in the first version, I didn't have them cutting the cake, because I thought that would be too expensive.

You want your plays to be able to hold up, so that they can be read and understood, the tone of them, and the energy of them. When you get to three dimensions, it can be frustrating because it all has to be like a poem from beginning to end. If somebody messes up something with any of the elements, it's like fingernails on a blackboard. It's hard, too, because you have to find people who understand what you are trying to do to a degree and can help enhance that or at least make it as good as you wrote it. I loved working with the actress Susan Kingsley, who did Meg in the first production of *Crimes of the Heart* at Louisville. I remember she was able to do stuff with props that I've never seen before and that I've never seen since. She's doing a thousand things at once, but still hitting the beats of the scene. It was technically controlled, but gave the impression of being completely reckless, and it seemed inevitable and genius. She just embodied the flavor of this character. I had not gotten as deep as she went.

Mostly I love what I do because nobody's watching you all day long. You can sit around in your sweat clothes, lie around, eating almonds and looking at things. I can read books, like I'm reading a bunch of astrology books now, and write when I want to write, and just contemplate, because life is contemplation. While I'm alone I whiten my teeth. I can wear that teeth whitener thing. I've got the perfect job to do this teeth whitening thing. I can just wear this thing when I'm writing and nobody will see me. Another thing about being alone, if I just want to stay all day and look at pictures of stars or supernovas or globular clusters, that's a good thing.

I know I want to write one more play. And then I ask what is it going to be about, and I have no idea. I have no idea. I know I want to do it, and I love that feeling that there's something else I want to write.

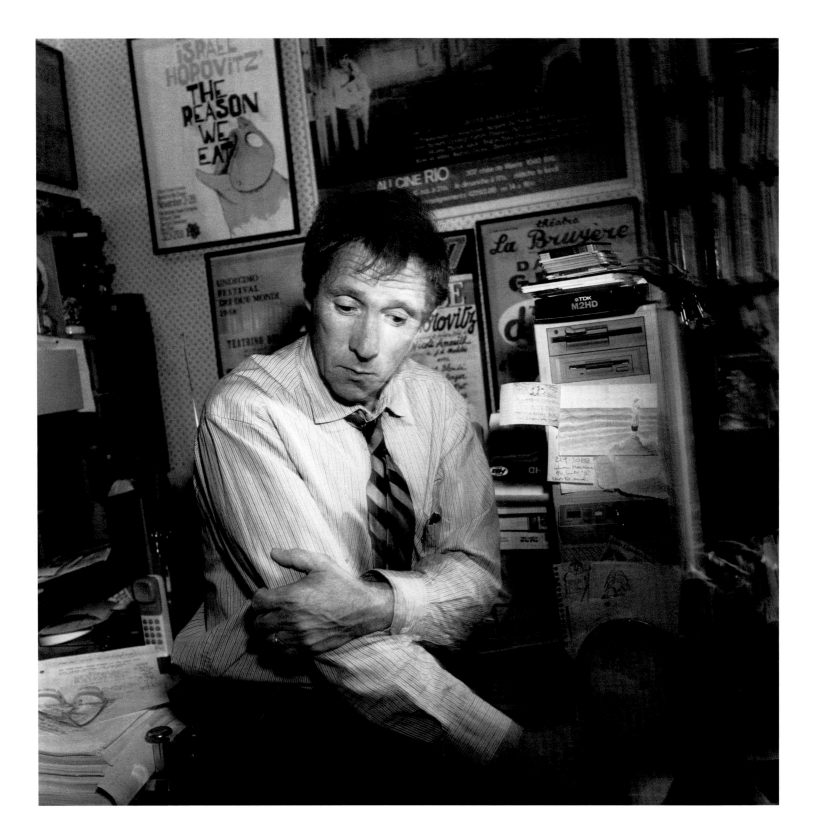

ISRAEL HOROVITZ

Born in 1939 in Wakefield, Massachusetts, Horovitz is the author of over seventy plays, including *The Indian Wants the Bronx*, *Park Your Car In Harvard Yard*, *My Old Lady*, and *First, The, The Last, And The Middle: A Comedy Triptych*, as well as *Line*, the longest-running off-Broadway play in history. He has won two Obie Awards and a New York Drama Desk Award.

The first play I wrote was called *The Comeback*. I was seventeen years old. I wrote a novel when I was thirteen—*Steinberg, Sex, and the Saint*. I sent it off to a New York publisher and got a rejection letter back from a kid who had a summer job reading manuscripts, praising it for its wonderful childlike quality. He had no idea I was thirteen. It was the unkindest cut of all. I figured I had failed at prose fiction, so I wrote a play. *The Comeback* was produced in Boston, when I was still seventeen. I acted in it opposite my friend Peter MacLain. I can remember vividly when *The Comeback* opened, nobody said, "It's a good play," but many people said, "It's a play," and I thought, "OK, great, I've written a play, so, I'm a playwright. I know who I am." And I've never looked back, ever.

ISRAEL HOROVITZ

When I was a high school kid, thinking about going to college, my father earned his living as a truck driver. He told me, "There's no possible way I can pay for you to go to college because I'm going to go to law school at night." And he did. He studied law, nights, at Suffolk University in Boston, took the bar exam and became a lawyer—at age fifty. I went to Salem State College, which cost $100 a year. I was on a track to be a junior high school teacher, and after a few months, I thought to myself, "I'm not ever going to be a junior high school teacher." So I quit and took a paying job.

I had a brief (teenage) marriage that ended in annulment. At that point in my life, I was already writing plays. I worked as an extra at the Cambridge Drama Festival, where I met a guy who'd gone to The Royal Academy of Dramatic Art in London. That sounded like paradise, so I applied for admission to Royal Academy of Dramatic Art, and, by God, I got in. I went to England from 1961–63. While there, I did a lot of writing. For the first time I felt I was really on my way to a life I could love. In London, I was dead broke, and could only, legally, take a paying job that no English person would want. That was the law. I found such a job —as a barman in an American Air Force Base in West Ruislip. It was beyond horrible.

While studying at the RADA, I bought my morning meals at the Commonwealth Institute on the Kensington High Street. It was dirt cheap—fashioned from last night's unsold food. I was standing in a line of mostly students waiting for this place to open, and noticed a young Hindu kid in traditional dress at the back of the line. It was England, so nobody was speaking to anybody else. We were just standing there, waiting, wordlessly, when, suddenly, a car filled with Teddy boys pulled up to the curb. (Teddy boys were circa 1961 skinheads). They started yelling from the car at this poor East Indian kid, yelling really rude

things like, "Hey, sahib, move your fookin' elephant!" It was horrible. We suddenly realized that the Indian kid was in fact incredibly happy that someone was making contact with him. To our amazement, he started bowing and laughing and waving to the Teddy boys. He seemingly didn't care what they were saying to him. He simply basked in the imagined warmth of human contact. His chummy response to the Teddies was so totally off-putting, they ultimately drove away. Everybody in line was thinking the same thought: "What the hell just happened?" We had absolutely no idea why he was happy, why he could conceiving comport himself as he had. As I was the only American, I was the only one to ask him, directly "Why?" He answered me, directly, with a barrage of Hindi. He couldn't speak a word of English, didn't understand a word of the Teddy boys' insults. And that is, in a nutshell, where *The Indian Wants the Bronx* was born. I started writing the play, immediately. I just transposed it from London to the streets of New York City. When I say I started writing immediately, I mean immediately—that night! I couldn't get the incident out of my head—it was such a shock.

I can remember Samuel Beckett saying to me, "For a writer to explain how he writes is like a snail explaining his shell." Doing so is ridiculous. One writes because one writes. It's not a choice. It's something stamped on your forehead when you're born. I knew very early on that I wanted to write. That was always my talent. I could run and I could write. I had those two skills as a kid. I was quick, I was a sprinter. I entered public speaking contests when I was thirteen or so, delivering speeches I had written. And I would win these contests—trophies, scholarship money. Life is like that. Somebody loves you, you love them back. Your country loves you, you love it back. You stumble upon something in your life that gives you reward, somehow you love it back. As a playwright, I have a chance to say something about

life, to express myself. You know how lucky that is? To have a chance to express yourself in this life? Remarkable! We're all just trying to get something done before the earthquake hits. Somehow, that happened for me.

In the summer of '68, we were invited to take *The Indian Wants the Bronx* to the Spoleto festival it Italy, along with my play *It's Called the Sugar Plum*, and a new play that became *Morning* of the Broadway triptych *Morning, Noon and Night*. So, there we were in Spoleto, Italy—me, Al Pacino, John Cazale, Jill Clayburgh, all these unsophisticated, unknown kids. We traveled to Italy with absolutely no idea what we were getting into. Spoleto was a really hot theater festival, back then. We were seen and reviewed by a huge number of European drama critics, and we were a hit. Everybody's career was suddenly international. We had no plan for this, whatsoever. It just happened.

In Spoleto, the French actress Eleanor Hirt introduced herself to me and asked if I would like to meet Samuel Beckett. "If you would like to meet Mr. Beckett, he would like to meet you." When my heart started beating again, she told me to be in Paris on Tuesday night, July 8th, and Beckett would meet with me for thirty minutes precisely, at la Closerie de Lilas. We could talk about anything but the way he wrote. I somehow got to Paris on that night, and I met Beckett. I was twenty-seven, he was nearly sixty. We stayed together for four hours, talking and talking. When we said goodnight, I asked him, "Do you think we can be friends?" He answered with a smile, "I think we are." We stayed friends for nearly thirty years, until his death. It was remarkable good fortune for me. I kept going back to Paris to be close to him. I've had thirty-something of my plays translated and performed in French, thus far. I've directed nine or ten of them. It was absolutely the start of it all. Remarkable.

I didn't speak a word of French when I first went to Paris, and there's an excellent language-story in this. I borrowed an apartment owned by the French journalist-novelist Claude Roy, who'd translated my play *Line* into French. Claude and his wife, the actress-playwright Loleh Bellon, were on an extended stay in Japan, and I was able to use their apartment for seven weeks. Claude had a bright range bathrobe that hung on the back of his bathroom door. My daily routine in Paris was to wake early, go out running along the Seine, then come back to Claude's apartment by 8 a.m., shower, put on his orange bathrobe, sit at his desk, and write until noon. I noticed that my writing was going really, really well. When Claude returned to Paris from Japan, I told him, "I've got to get a bathrobe like yours. I hope you don't mind that I wore it, every morning, while I was writing. It's a lucky bathrobe. I want one of my own." He told me, "Oh, that's easy. You go to Printemps, the department store." I didn't speak a word of French, at that time, so he gave me instructions: "It's not called an orange bathrobe in French; it's called a *peignoir en l'orange*." I wrote the words down, and asked, "How do you ask, 'How much does that cost?'"? He said, "*Ça coute combien?*" Alas, I didn't write that down.

So, off I go, to this big department store where I say to the doorman, "*Peignoir en l'orange?*" I figure out he's telling me to go up to the fourth floor, so up I go. It seems like I'm in bedding-pajama territory. This is good. A really fat little saleswoman comes over, and I say to her, "*Peignoir l'orange?*" and *voila!*, she comes with an exact duplicate of Claude's orange bathrobe. It was that easy. So, now I have to ask "how much?" because it occurs to me that a lucky orange bathrobe could cost $400 in Paris. With a certain panache, I ask her, "*Écoute bien, madame?*" Unfortunately, "*Ça coute combien?*" means "How much does it cost?," while "*Écoute bien, madame!*" means nothing but "Listen carefully, lady!"

It's close, but not exactly it. So, this little lady says, "*Comment?*", meaning "What?" She leans in for my answer, and I repeat, "*Écoute bien.*" In no time, I have ten people around me, saying, "*Qu'est-ce que vous cherchez, monsieur?* (Sir, what do you want?)" to which I repeat, "*Écoute bien.*" They all lean in and listen. Finally, a manager comes over who speaks English and he says, "What do you want?" And I say, "How much does this cost?" He tells me $80—and that's how I bought my orange bathrobe.

Time has passed. When in Paris, these days, I am able to speak French, think in French. I dream in French. In fact, if I'm talking to someone who's speaking Italian, I answer in French. In Mexico, recently, I started speaking French to a local bus driver, because it's the only language I have that isn't English.

It's one of my life's great miracles, really—someone asks me, "Do you want to meet Beckett?" and now my walls are covered with French posters because I've spent a third of my life there.

What I admired most about Beckett wasn't so much his work, which, of course, I admired, enormously, but his unflappable integrity. He really was what he claimed to be. There were no wrinkles there. It was astonishing to know somebody like that, who really was an artist, in spite of what the world was around him. Granted, he was living in Paris, in exile; he wasn't living in America. It's tough in America, it's a very tough place to be an artist, to keep your wits about you.

The wonderful thing about a play, I suppose about art in general, but plays specifically, is that people sit in the audience and, in a sense, rewrite the play so that it applies to their particular lives. There can be a great consensus of

opinion about what a play's about, or, as often, very little agreement. It's really important that an artist communicates. That's why we're alive. I believe this. So, my play *Line* is clearly about competition and about being number one, and how people use that obvious information while watching *Line* is, ultimately, up to them. *The Indian Wants the Bronx* is certainly about racism and it was written in 1967. But, consider how ironic it is that in the year 2006 we're profiling brown-skinned people on the streets of New York, not because they're East Indians, but because we think they're Al Qaeada. Just after 9/11, I saw a turbaned Hindu driving a cab and a well-dressed man spit through the window of his cab. It can be shocking, living here in this enlightened country of ours.

I think it's my job to take an audience to an unexpected place. Someplace they don't expect to go, to be guided somewhere. That's what an artist does. Sure, another playwright will look you straight in the eye and say, "That is total bullshit; that's not what an artist does—an artist expresses himself and walks away." In Freudian terms, I grew up watching my mother open the door and say to a seemingly endless supply of friends and family, "Come in, and I'll give you a meal." I have that same impulse as a playwright.

Do I love the audience? Yeah, yeah, I do. I may have had fifty-plus plays produced in my lifetime, but it still thrills me. I came out of a *My Old Lady* rehearsal at the Promenade Theatre, and there was the first person to buy a ticket, this nice lady, getting soaked in the rain. I gave her a kiss on the cheek. I was so happy that she was there; it was delightful that she was there. So, please, what am I, too important to say, "Thank you for coming to my play?" I think not.

I tend to write serious plays, I tend to take on life's problems as I see them. I believe it's important to take an audience on a difficult journey, I really do. And I dearly love watching audiences leaving the theater, actually talking about the play, actually engaged in conversation, talking applying the play to their lives, arguing about it. It gives me some gauge as to whether or not I've taken them where I wanted to take them, or not. It's great. Not only do I not mind if the audience is critical—I love it when they are. I love hearing it, especially those old New York theatergoers, who never fail to amaze me with their after-show comments. I saw an over-long, over-bloody production of *Medea*, recently, and dogged an elderly couple from the theater, eavesdropping:

> *Wife:* "That was good. I thought that was good.
> Did you think that was good?"
> *Husband:* "It wasn't played the way I see *Medea*
> played in my imagination."
> *Wife:* "How so?"
> *Husband:* "She was fat."

Four hours of *Medea*, and "She was fat."

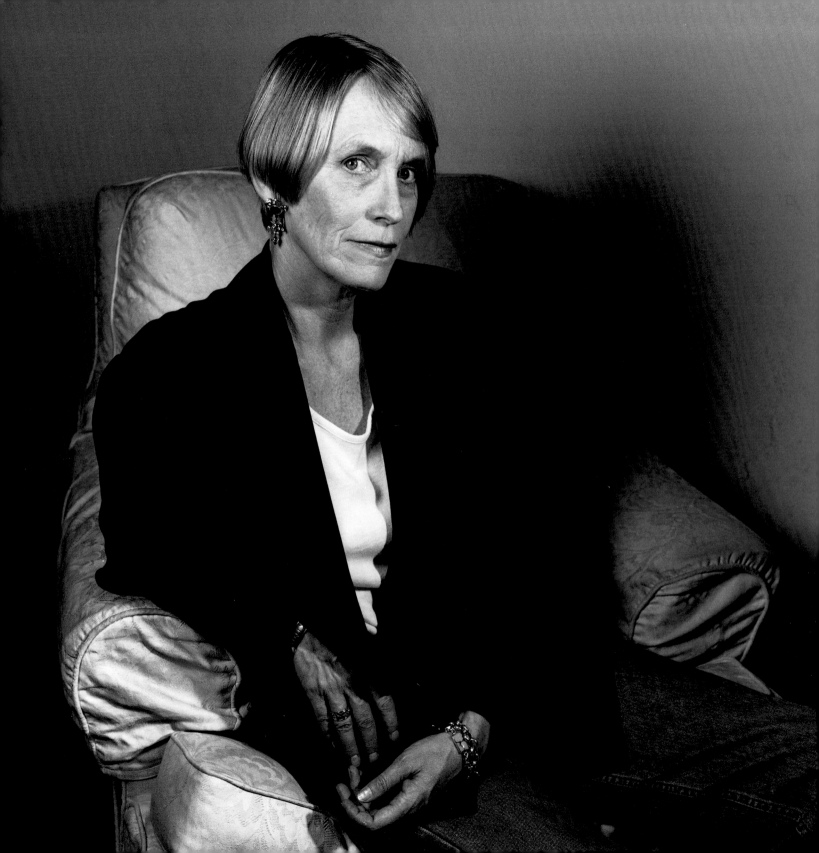

TINA HOWE

Born in 1937 in New York, Howe is the author of such plays as *Painting Churches*, *Pride's Crossing*, and *Coastal Disturbances*. She has been awarded an Obie, two National Endowment for the Arts fellowships, and was the 2005 Inge Festival Honoree for Distinguished Achievement in the American Theatre.

One of the joys of being a playwright is having the power to give meaning to the randomness of it all. Finding the transcendent moment amidst all the horror, revisiting old panics and humiliations and boogying on them until they become something else entirely. There you are sitting in the dark amidst all these strangers watching your life story, and they have no idea the person who lived it is sitting two seats away. It's that tension between being an exhibitionist and being totally invisible that's so exciting.

People often ask me if my plays are autobiographical. I have this wonderfully glib answer that evades the question, but sounds profound. "It's all true, but none of it happened." If you say, "I made it up," they feel cheated, that the play was a trick. But if you say, "None if it happened. It's pure fiction," then they miss the hand of the artist. It's the way we interpret our lives that makes the result artful. That's the essence of the form—that we get to scramble our triumphs and disasters and invent. The writer's the last one to know what it all means. That's why she writes the play in the first place—to have the actors and audience tell her. If she knows all the answers beforehand then why write the play? Why write any play?

I come from a family of poets and fiction writers. I was supposed to follow in their footsteps, but there were too many words to choose from. "He walked into the room. He slid into the room. He tiptoed into the room. He inserted himself into the room…" I got so caught up in all the verbs at my disposal, I could never get to what he did in the room! When I was a senior at Sarah Lawrence taking a fiction class, a large rubber stamp was made that said, "Worst in Class." It was vigorously applied to my forehead every time I read. So I began writing a play, figuring I wouldn't have to describe anything, but could just get to the heart of the matter. I'd never studied playwriting,

mind you. I knew nothing about the form. I just knew that plays were about people doing things. So I wrote a typically sophomoric piece about the end of the world featuring talking pigeons and dethroned kings and queens. It was written in a Beckettian style and since I'd never read Beckett, you can imagine how dreadful it was! My dear friend Jane Alexander was our star actress at college and since she wanted to direct it, we were given carte blanche. The theater department thought she was going to act in it, and since everything she touched turned to gold, they said, "Yes, yes, you can do whatever you want!"

As it turned out, she ended up starring in it anyway since the leading lady got sick on opening night. The production was a triumph largely because of Jane. They had to drag me off the stage with a hook, the reception was so enthusiastic. The event marked me for life. The following year I went off to Paris to write the great American play. Something I've been struggling to do ever since.

The first thing I think about when I start a play is the setting, because the setting dictates the subject and how the characters behave. I'm particularly drawn to unlikely settings like museums, restaurants, and camping grounds. There's nothing I like more than hearing the audience gasp when the curtain goes up. Whooooosh…! They're suddenly at the beach with their feet in the sand! The visual element is crucial to me. And since I like to end my plays with a moment of transcendence, I'm always struggling to come up with a real *coup de théâtre*. Like a child doing heart-stopping somersaults on a bed (that's actually a trampoline) or a swimmer jumping off a cliff into the arms of her family below.

I write every day, because it takes the pressure off. So you have a bad week or year; there'll always be another week

or year. Once you surrender to the dailiness of the process, you can forgive yourself when the work is trash. Since self-loathing is the writer's worst enemy, it's important to be able to step back and say, "It will come in good time. Don't panic." There's this great quote by Wendell Berry, the poet and novelist, that I print out in an enormous font and give to my students every semester: "There are, it seems, two Muses: the Muse of Inspiration who gives us inarticulate visions and desires and the Muse of Realization who returns again and again to say, 'It is yet more difficult than you thought.' This is the Muse of Form…. It may be, then, that form serves us best when it works as an obstruction to baffle us and deflect our intended course. It may be that when we no longer know what to do, we have come to our real work and that when we no longer know which way to go, we have begun our real journey. The mind that is not baffled is not employed. The impeded stream is the one that sings."

It's when you're the most confused and ready to chuck the whole thing that the light dawns. In fact, if you don't go through that spasm of despair, the play probably isn't worth very much.

When I write, I invariably play one of my Bach CDs. I have an obsession with the St. Matthew Passion and have been playing it maniacally for the past four years. For the previous twenty years, I was besotted with Glenn Gould, the rabid Canadian pianist who plays like a drowning man. But one day I suddenly couldn't take it anymore and it's been the St. Matthew Passion ever since.

If you were to ask me what my lifelong ambition is, it's to have a play produced in Paris, in French, at some little theater on the Left Bank. Because since seeing Ionesco's *The Bald Soprano* when I lived there after graduation, I've

always wanted to have one of my plays run next to his. My sources of inspiration have always been more European than American. Well, maybe someday.

I'm not perceived as an avant-garde writer, but as this tall waspy woman who writes lyrically about class. But underneath it all, I'm an anarchist who likes nothing more than shouting, "But the emperor isn't wearing any clothes!" I mind my manners though, and never make a peep until I've put on my hat and white gloves.

TINA HOWE

DAVID
HENRY
HWANG

Born in 1957 in Los Angeles, California, Hwang is best known for his Tony Award-winning play, *M. Butterfly*, and has written numerous others, including *FOB*, *Golden Child*, and *Family Devotions*. He attended the Yale School of Drama and, in 1981, received his first Obie Award.

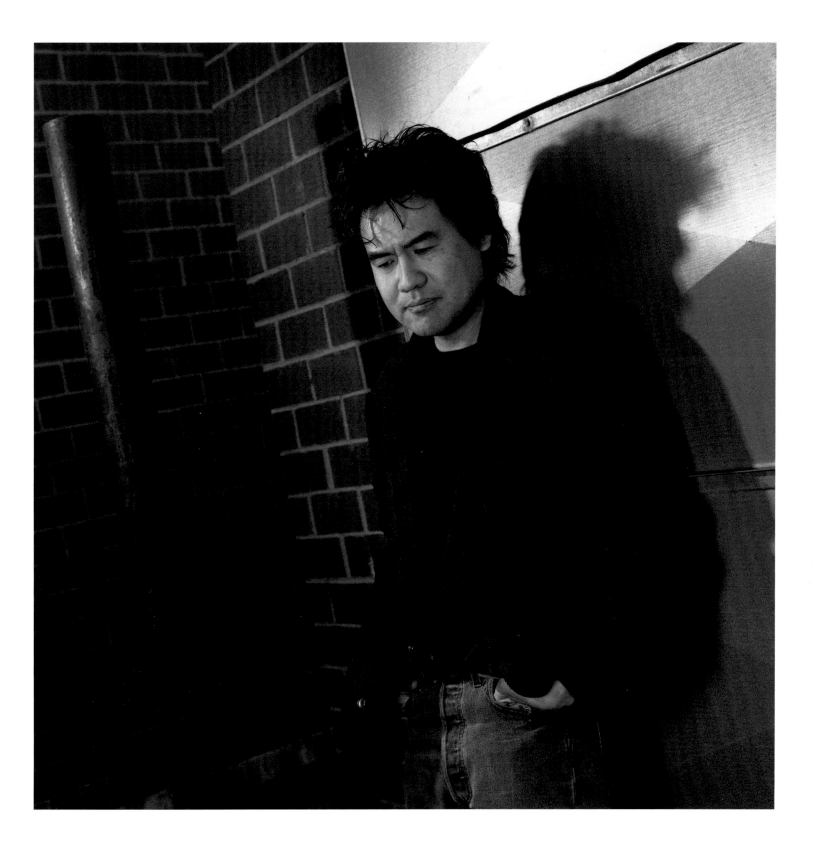

When I was a freshman at Stanford, they had us fill in a little form that said, "What are things you might be interested in doing that you hadn't done before?" I put playwriting. So evidently I had some interest in the theater, from having really seen very little. I really didn't have any background in theater. Somehow I was attracted to it, and it was in my sophomore year that I really started to try to write plays. Between my junior and senior years in college I went to the first Padua Hills Playwrights Festival and I took playwriting from Sam Shepard and Irene Fornes. By the time I got to Stanford again I started writing a play to do in the dorm, *F.O.B.* The very next year, *F.O.B.* got done at the O'Neill Festival, and then we got interest from the Public. It was very fortuitous, having my first play accepted to the O'Neill. Had it stopped at the O'Neill, that would have been already a wonderful foot in the door for someone who was twenty-two, but then it ended up going to the Public, winning an Obie—I had a career before I knew it. I always feel that I didn't really know I was going to be a playwright until after *Rich Relations* failed, until after I had a flop. Once I had the flop, I realized, "Oh, it's still really important that I do this." My commitment to this profession had never really been tested. I mean, it's easy to keep doing it if you get good reviews in the *Times*.

There are two things about playwriting that interest me. One is that I've always been attracted to the idea of creating a world and then having that world come to life in front of me. This is interrelated with the notion of ritual. I grew up with a very weird religious household, and so I think I've always been conscious of the role of ritual and its relationship to spirituality. The theater is a place where those sorts of things come very naturally. You can deal with transformation, you can deal with spiritual issues, you can deal with metaphor, all much more easily and naturally than you can, say, in film. Then, when people like Shepard started teaching us to write more from our unconscious, a lot of the Asian-American material started coming out on the page, which I had not known I was interested in. I just wanted to be a playwright, I didn't have any notion I was going to end up writing about some of these East-West issues. But when I began trying to find out what was inside me by revealing that on the page, I realized that I had all sorts of interest in my background, my ethnicity, whatever you want to call it. I was born and raised in L.A. and my parents were fairly assimilationist in terms of wanting to be American, and my childhood took place at a certain time when it wasn't hip to be ethnic. I tried to ignore my ethnicity. It would not have occurred to me that I would wind up writing about this part of myself that I was trying to deny. Of course, in retrospect, that's exactly the part of yourself that you should write about.

I like being able to be part of a collaboration, I like being able to set a foundation which inspires another artist, which inspires a director. Different playwrights have different degrees of tolerance about messing with the text. I tend to be encouraging of messing with the text. I've seen some productions of my plays that have been like deconstructions of the plays. Sometimes, I'm not exactly sure what relationship that has to the play that I wrote, but I still think it's really interesting. I'm still really glad they did it. I saw a production of *M. Butterfly* in Moscow that was just wild. I wasn't really sure what it had to do with what I wrote. I don't speak Russian. But I'm not one of these playwrights who feels it's a particularly literary form. In the final analysis, I don't think it's about the words on the page. It's about creating the theatrical moment. You do what you have to, to make the moment work theatrically and the words serve that. But the words, to my mind, are secondary. I would like to see it once the way I envisioned it, but after that, it's fair game.

Most plays begin in my mind because there's something I don't understand, so I write the play to find out how I really feel about it on an unconscious level. There's some question I want to answer for myself. It's a question that I feel on some level I'm capable of answering, or at least capable of exploring and understanding a little more deeply than I do. When I worked on the revival of *Flower Drum Song*, I got this whole new perspective on stereotyping. I used to feel that you should try to counter the stereotypes. Now I feel it's a much trickier thing than that. Stereotyping is basically a dehumanization, and it doesn't matter what the specific image is. In the fifties, when my parents came to this country, people thought Asians were poor, uneducated, menial workers—laundry men, cooks, etc. So they might have thought, wow, if people would just think that we were smart and wealthy, all our problems would end. It's almost like each generation's breakthroughs become the next generation's stereotypes. And you just have to keep re-fighting the battle, continuously. It's not a battle that ever ends. When I think about it that way, I have great respect for performers who did nightclub acts in broken English on Ed Sullivan. Because by 1970 or 1980, that stuff seemed really demeaning. But it had meaning in 1960.

Anything can be demonized. It's probably slightly better to be demonized as smart than stupid, but if anything, racism against Asian-Americans has become more similar to what's traditionally been the construct of anti-Semitism, more than the way blacks or Latinos are looked at.

I feel like my work has gotten a lot more tolerant since *M. Butterfly*. The early sort of Public Theater plays were very much assertions of Asian-American identity. We exist, we have a history, we are people, all that. By the time of *M. Butterfly*, I felt like I was making a statement about East-West relations and delusion. Ever since I've been working on things which attempt to understand both sides of the picture, embrace the ambiguity. *Golden Child* is a good example.

As I've gotten older, it's taken longer to finish a play. *F.O.B.* took like three weeks, *Butterfly* took about six weeks. *Golden Child* took three months. Mostly, it's completely intuitive. I come across an idea for something, it excites me, and I bet I could spend a lot of time with this. Sometimes I'm wrong. Another analogy is fishing. You go fishing and sometimes you catch a fish and sometimes you don't, and sometimes you have to throw it back.

I think there's something very important about the presence of the physical body, and certainly as this applies to issues like stereotyping. I've come to the conclusion that the enemy of stereotyping is humanization. The more you can humanize a character—because stereotypes essentially reduce people to types—the more you can reveal the different facets and make a character completely human. It doesn't matter if that character is a laundry man, or a gangster, or a computer scientist. It doesn't matter, so long as that person seems human. On stage, you start with the advantage of having an actual human being up there, who is interacting with the audience. That, in and of itself, is something of a humanizing act, before even a word is spoken.

DAVID HENRY HWANG

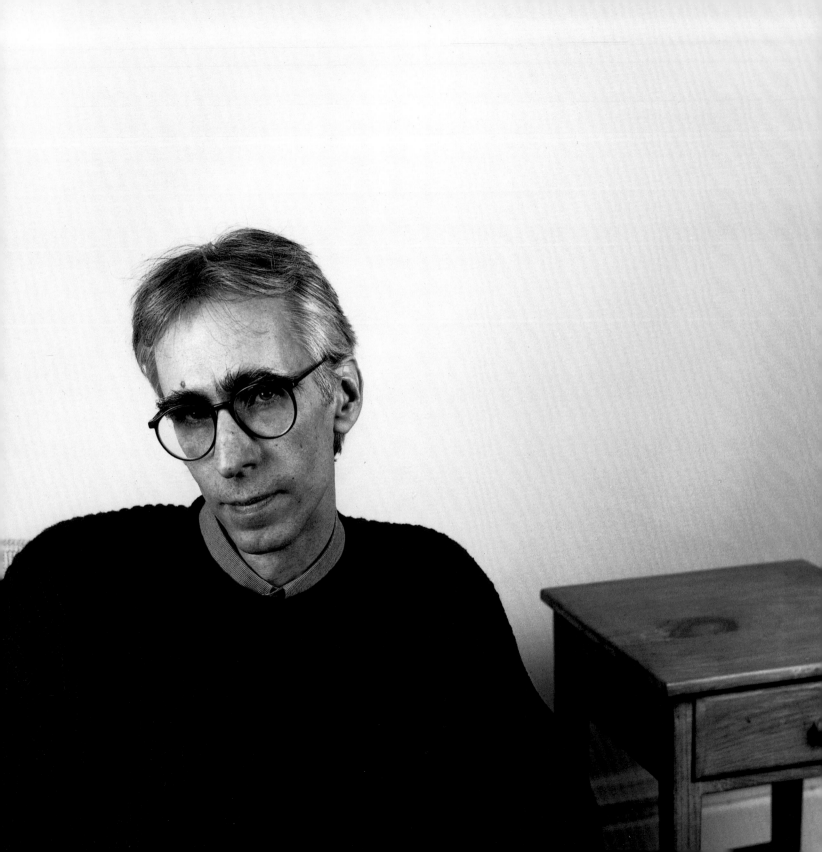

DAVID IVES Born in 1950 in Chicago, Ives is author of numerous plays including *All in the Timing*, *Philip Glass Buys a Loaf of Bread*, *Polish Joke*, and *Don Juan in Chicago*. He has received many awards and honors including a Guggenheim Fellowship, the George and Elizabeth Martin Playwriting Award from Young Playwrights, and the Outer Critic's Circle's John Gassner Playwriting Award.

I wrote my first play when I was probably about eleven. I took an ancient, bloody, three-hundred-page crime thriller named *Mr. Strang* from my parents' library and adapted it into a fifteen minute play for my scout troop. So you might say I got started early in the short form. Naturally, I was going to play the lead myself. What I didn't realize was that everybody in the cast had to have a copy of the script. So I learned my lines and gave the script to the next guy, and he lost it. It's still probably my best work.

I started going to the theater when I was in my teens. By the time I was seventeen, I had read half of Western literature, because in my neighborhood I had nothing else to do. But somehow the theater seemed more thrilling than books, because it was alive and happening right in front of you. I was already writing plays by then. Two or three of them were done in little venues at Northwestern while I was there. I was hooked.

I think Aristotle once said that witty people are witty because they're melancholy. It seems to be true of most American dramatists as well. I won't name names. I didn't really write comedy until I was well into my thirties. Comedy is something that I came to quite unexpectedly, or is it vice-versa? What I enjoyed was drama—and I mean serious drama—so it was odd to find myself suddenly writing comedies, and such peculiar ones at that.

DAVID IVES

In terms of process I'm an anomaly because I still write everything in longhand. If I don't write it longhand it won't be any good. If I write it at the keyboard, it will come out superficial. So all of my plays are handmade, the old fashioned way. I don't like sitting in front of a typewriter because I feel like it's waiting for me to do something. A computer screen and a blipping cursor are even worse. Mallarmé talked about the paralysis of the blank page; I have paralysis of the computer screen. I can't do anything on a computer except transcribe. On the page, I tend to pack a lot into the margins, and you just can't do that on a computer—I mean keep every one of your wrong thoughts in view. Sometimes they turn out to be right and good thoughts. The speed of my pen is the speed at which I think, and anyway I can write anything in longhand faster than I can at the keyboard. And then the silence of it is just very nice for me. Yes, the silence of the pen is much nicer than the hum of the computer.

I have a table that I've been writing at for years. I like the size of that table. It weighs a ton and is very solid and it doesn't blink at me. I can spread out on it—all the drafts, the dictionaries and thesauri. I've written under the light of the same gold lamp for decades, too. I don't know what I'd do if the lamp ever broke. Stop writing, I guess. I always use blue Bic pens and college composition notebooks—we all have our fetishes—and I can't write on yellow pads at all. I usually write after breakfast until two or three, and then in the evening if I'm onto something. I don't write well in hotels. I've never written anything on the road except *Time Flies*. John Rando and I were about to put up an evening of my one-acts and we needed one more play. I told John I'd had this idea for years about two mayflies on a date who realize they've only got twenty-four hours to live. He said, "Great idea. When can you write it?" I said, "I'll have to write it on my honeymoon." So I went off to

Mexico on my honeymoon and every day I'd fax John some pages about those two mayflies in love. That's about the only thing worth anything that I haven't written on the table.

I don't usually start from character, or story. I start from an idea of some kind, or an image. Three monkeys sitting at typewriters, for example, trying to write Shakespeare. I wanted to know what those monkeys would talk about, so I wrote *Words, Words, Words*. *Variations On The Death Of Trotsky* came out of an article in *the New York Times* that said Trotsky lived for thirty-six hours with a mountain climber's ax in his head. It was one of the funniest things I'd ever read. I was laughing about that article with a friend of mine that morning. "What do you talk about when you've got a mountain climber's ax in your head? What sort of food do you eat?" "Fast food, obviously." That friend had a birthday coming up, and I wrote that play for him as a birthday gift, never thinking it would be anything more than a sort of party favor for a pal. He said to me, "You know, this play's really good. You should do something with it." So I did.

Writing comedy is partly a way of amusing oneself. Cheering yourself up. Here you are, sitting in a room all alone, conversation is low, so under the circumstances you might as well have a witty conversation as a serious one. Or at least try to find out what the difference is. For inspiration, I often rely on the three B's: bed, bath, and bus. The shower, for example, is a very inspiring place. I sometimes shower twenty hours a day, looking for ideas. Once I have the idea, I write it down and take a lot of quick notes and sit on them for a while. Not in the shower, needless to say.

The collaborative process is the real heart of the theater. The theater is this wonderful little temporary world where you have intense semi- or quasi-erotic relationships with people for two months, then you go away and start a new little world somewhere else, with different people. Serial polygamy. You get to know a lot of very interesting people very intensely, and very, very fast. Every show is like a little democracy, in the sense that in the end everybody working on it has to get along in spite of differences and everybody has a valuable talent to contribute, even the stagehands and ushers. No matter what you may feel about somebody's personality or how they irritate you, you must come together with that person and find a way to work. That's why theater is the most civilized and humane of the arts. It demands that you recognize there are other people in the world besides yourself and they have ideas that are as good as yours. Maybe even better.

I've long been fascinated by the fact that democracy and theater both came into the world at the same time and place, 2,500 years ago in fifth-century Greece. And it's not an accident, because democracy and theater work on the same principles. Democracy is a form of rancorous, cantankerous, constructive group-thinking, and so is the theater. If our so-called leaders in Washington wanted to encourage good citizenship, they'd make sure that every high school has a well-endowed drama program. Kids in high school or college who are in theater seem to have a different level of socialization. They have better and more sensitive antennae to the world and emotions and people. What's a play but a way to learn about these things? And isn't every play, and the production of every play, a cautionary tale?

Robert Frost once said something to the effect that poets write poems just to create a feeling of delight in themselves. With a little bit of luck and skill, they pass that feeling on to others. By poets, of course, I mean playwrights. What was it Lorca said? "A play is a poem standing up."

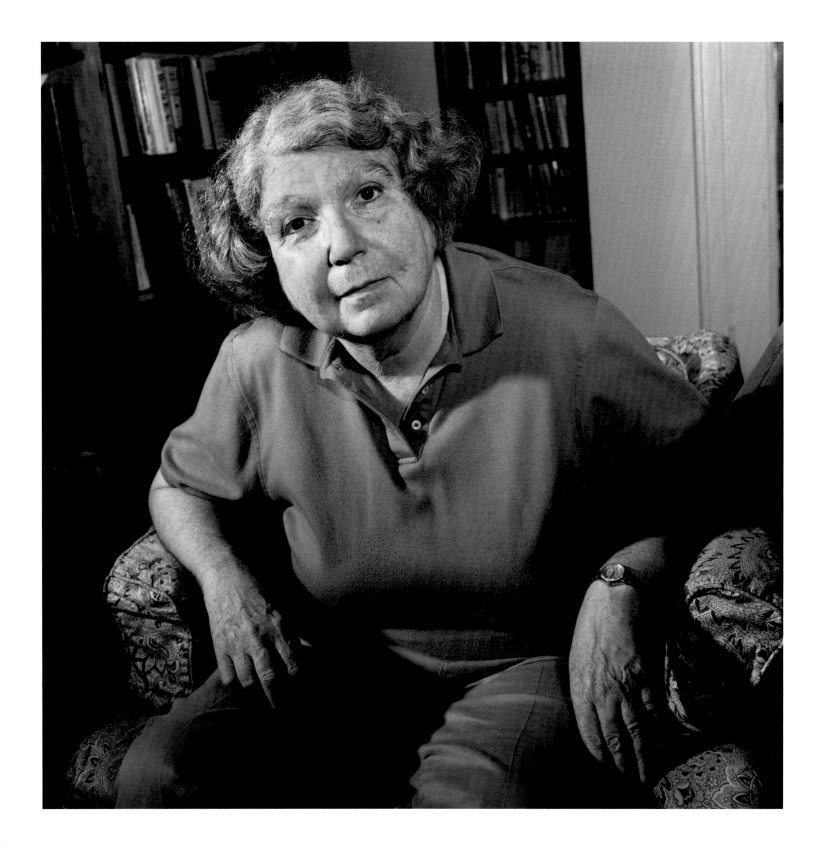

CORINNE
JACKER

Born in 1933 in Chicago, Jacker has written numerous plays, including *Domestic Issues*, *My Life*, *Harry Outside*, and *Terminal*. She has received many honors including a Rockefeller Grant and an Obie Award.

CORINNE JACKER

I started writing at the age of nine. I was a child actress. I started writing plays for school. When I was twelve, I felt very mature because I adapted *The Sea Gull*. I made the main character an actress of a soap opera who lived in Lake Forest, a suburb of Chicago. I thought that was all very brave. When I was in college, I took one writing course. I took a course in playwriting, and I got a D, but they gave me a C because I wanted to go to graduate school. I always knew what I wanted to do—I just didn't know how to do it.

When I was twenty-four, I came to New York. My husband's former roommate was married to Nora Hayes. She said she had a friend who was looking for a play and asked if I had any. I said, "Of course." The next week I wrote it. It was an adaptation of *Pale Horse, Pale Rider*. Several things happened. It opened during a blizzard and a newspaper strike, which didn't help it. Tennessee Williams loved it. Katherine Porter loved it. She brought Robert Penn Warren with her, and he loved it. The reviewers hated it. I was devastated. I stopped writing completely until I was forty, because of the reviews. I stopped writing plays. I wrote some science books. I thought that what I was writing people didn't like. Then I had a friend who, again, asked me to write a play for her. She was an actress; very good. That was *Bits and Pieces*. I just started loving writing plays again.

I really believe if I wasn't a playwright, I'd be called a schizophrenic—I keep hearing voices. I hear the characters talking in my head. My characters write the play. I guess I'm just the stenographer. They almost always surprise me. In *Harry Outside*, I thought I knew what I was doing. Suddenly Harry came in—like he always did in a scene— and there was a guy there I never met before. And he stayed for the whole play.

During the 1980s, I was head writer on a soap opera for years—*Another World*. I hated that. Someone asked me to do it just for fun. I did a sample soap opera script, and a producer, who knew me as a playwright, asked me if I'd like to be head writer. I didn't know what a head writer was. He told me how much money it was, and I was just about broke. After all, there's a saying at the Dramatists Guild: "Four playwrights make a living, and two of them are Neil Simon." That's about it. So, I took the job. When I was going to get a raise, I left. There comes a time with soap operas, and television writers in general, when either you're seduced by the money or you stop writing.

I am from Chicago originally. When I first came to New York, women weren't hired as directors. The same for stage managers. You had to be in Equity, but you couldn't get in Equity unless you had a stage manager's job, and you had to be in Equity to get a stage manager's job. So most of my directing and stage managing was in stock.

I think that I was a damn fool to stop writing, and to wait so long to start again was just stupid of me. I was young, and I had a young person's pride and lack of pride. And for listening to the reviewers instead of Tennessee Williams and Katherine Anne Porter—well, I just was an idiot. I wasted a lot of time being an idiot. But I'm so happy I came back.

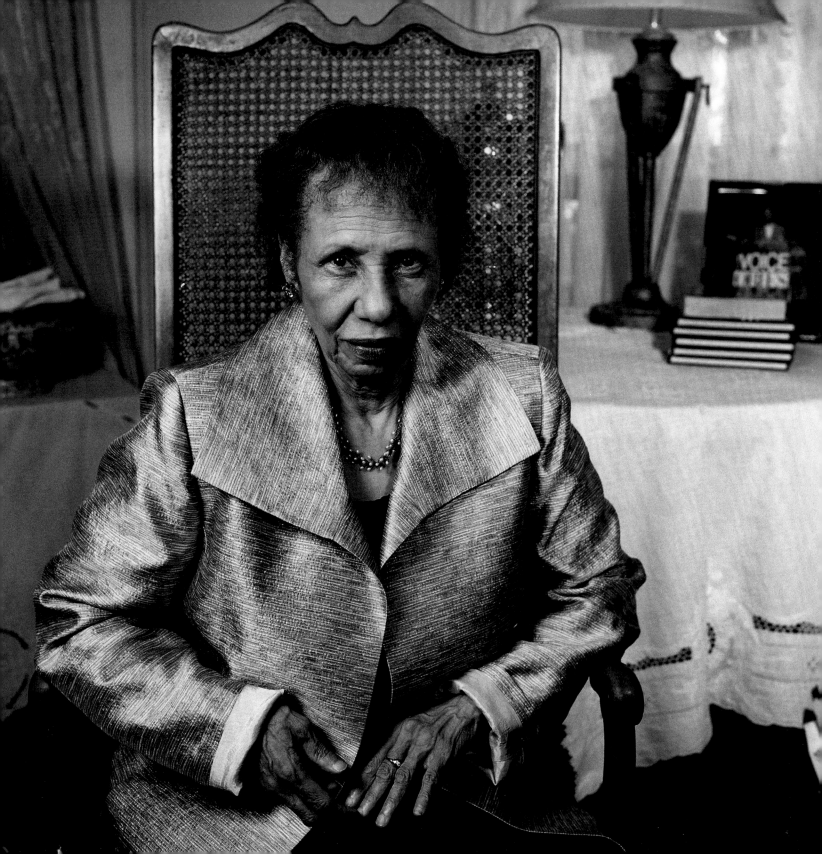

ADRIENNE KENNEDY

Born in 1931 in Pittsburgh, Kennedy is a playwright, teacher, lecturer, and author best known for her Obie Award-winning play, *Funnyhouse of a Negro*. Her other works include *An Evening With Dead Essex*, *The Pale Blue Flowers*, *Deadly Triplets*, and *The Ohio State Murders*. She is the recipient of numerous honors such as the American Book Award for *People Who Led to My Plays*.

At Ohio State, I took a freshman literature course, and we read Fitzgerald and Faulkner and T.S. Eliot in this anthology—I remember, it had a blue cover. It was the only course in college that really interested me. I was sort of adrift, taking courses in elementary education. That blue book with all those people, it was really like a lifeline. And so I'd always remembered those scenes, those poems, those stories. Somehow I began to say, "Maybe I could do that."

My father was a social worker. He gave a lot of speeches, and I was always drawn to the written word in that regard. My mother was a fifth-grade science teacher, and she used to tell all these stories about growing up in Georgia. She was just a really good storyteller. She could tell great stories about what happened when she went downtown that day.

I tend to see my childhood with my parents in Cleveland in the 1930s as magical, because my parents were so dedicated to black culture and they were so dedicated to their children. I, in particular, was the object of a lot of their hopes and what they dreamed about achieving. I turned out to be this child who could read every book in the school library and do all these academic things and they went out of their way to expose me to a lot of people in the black academic world. My father went to Morehouse, and my mother also went to a university, and so if Marian Anderson or Philippa Schuyler or Paul Robeson came to Cleveland, they took me to see them. I grew up in an immigrant neighborhood so it was also very important to my parents that I have Italian friends and Jewish friends. All these people were living together and I found that quite magical.

When I was twenty-two or twenty-three, I was at the New School and I wrote a play called *Pale Blue Flowers*—it was a total imitation of *The Glass Menagerie*. It was as much like *The Glass Menagerie* as possible. My teacher said it was the second-best play in the class. And there were about a hundred people in the class, so that was a big deal for me. That was the first time I'd ever competed a play. But then I got sidetracked because I spent almost three years on a novel while I was in the writing program at Columbia University. And again, my teacher there, he was just crazy about it. He said I was such a genius. He sent it around to publishers—and nothing happened. So I gave up, really.

Soon, my husband got a grant to go to Africa. We were out of the country for thirteen months, in Africa and in Italy, and it just totally changed my work. I'd never been out of the country, and it was a very political time in Africa. Ghana was just recently freed from the British, so I got to see a country that had just been freed from colonialism. Those are probably some of the most important days of my entire life. For an American black person who grew up in Cleveland—I knew Ohio, I knew Georgia, where my grandparents lived, and that was about it—for me to go to Africa at the height of its political victory over the British totally changed my life, just to see the world from that point of view. Most American blacks can trace their ancestors to West Africa. So being there just totally changed me. That's when I started to write *Funnyhouse of a Negro*.

When Edward Albee produced it a couple of years later, it was a very dark experience. A few influential people liked that play, but everybody else disliked it. And they disliked that person who wrote it. I was just this little, quiet person, and suddenly people were saying, "Who is this woman who can write this play—the heroine has such hatred!" It opened and closed very quickly. It was something that haunted me, because black people disliked it and they disliked the heroine who killed herself because she was conflicted over race. People said it was pretentious. "Why is she speaking in poetry? What was she doing? Why did

she do that?" Blacks really hated the fact that she discussed her hair and her skin color—her black father, her yellow mother. I was really unprepared for that response. That took about a decade to heal. It really did.

I think my writing was considerably weaker before I started weaving my dreams into it. I seem to be haunted always by images, by past images. I would say that is really Adrienne —at any given moment, I could be haunted by some past scenes in my life. That comes very naturally to me and that's really who I am. And it can be a source of pleasure and, of course, not so much pleasure.

I try to have a lot of silence in my life, as much as a person can have. I know that out of that silence something very fruitful is going to come. For the last forty years or even longer, I seem to have my best ideas between four and eight in the morning. I don't sleep that much. I sleep about four hours a night. I don't know how I survive. But I think that's when my writing reached a turning point. I would wake up, and I would write down my dreams, and in every play that I have, there are a lot of dream images.

I've taught writing and literature for many years, and I like teaching undergraduates very much. I find, as I guess zillions of people have before me, that I learn so much more than they learn. For me to be at a seminar table with ten undergraduates who are in love with life and literature —it's just pure heaven. Ideas just seem to flow out of me.

People treat me really nicely when I go to these schools. I probably get a sense of who "Adrienne Kennedy" is. They always put me up in lots of beautiful places and they sort of honor me. I need that. When you live in New York, unless you're on the front page of the *New York Times* every five seconds, you start to feel like a failure. At least I do. But

I get to go to these schools where people would really treat me like a guest, a distinguished writer, have receptions for me. That has been very fulfilling for me.

With my students, I also always teach texts that deal with race: Baraka, Derek Walcott, Ntozake Shange. I always teach people who've explored that subject. I'm not going to be teaching this fall, and I miss those texts very much. Those texts I find very sustaining.

I'll be seventy-four next month, and I'm still totally preoccupied with race, and the injustice of race—race in America, race all over the world. I still feel that I'm a combination of my parents. They were totally preoccupied with race. My mother taught in a dense black neighborhood in Cleveland. She was always trying to help black youth. My father was always trying to help black youth. Race is the thing that drives me. I would have given up if I didn't have that. Whether I'm deluded or not, I feel that I'm contributing to the illumination of black people. I always feel like I'm on a mission.

ADRIENNE KENNEDY

109

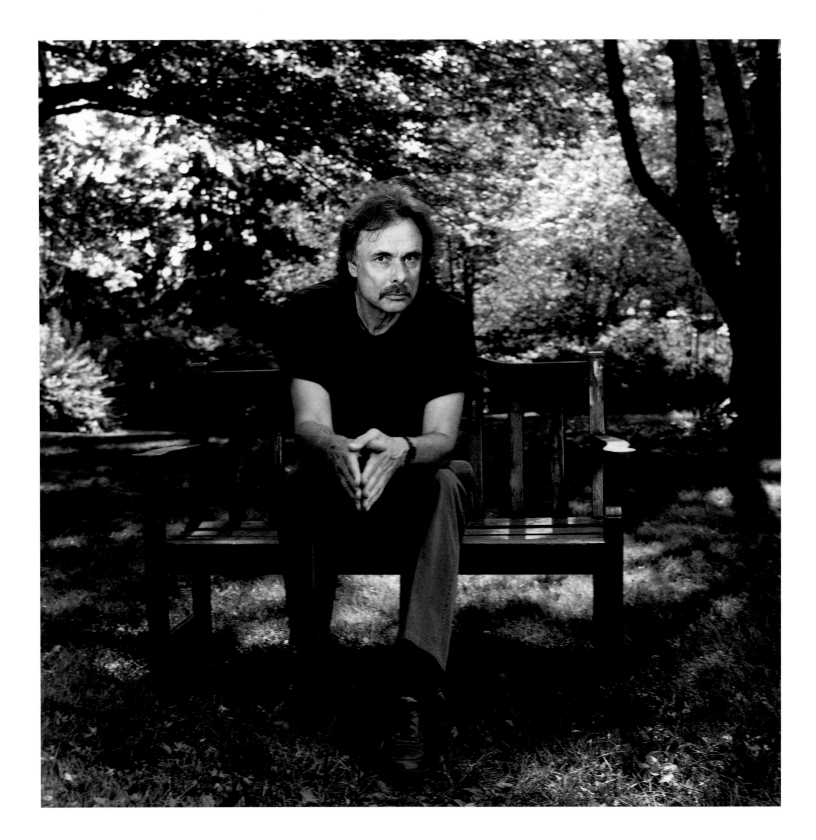

ARTHUR KOPIT Born in 1937 in New York City, Kopit is the author of *Oh Dad, Poor Dad, Mamma's Hung You in the Closet and I'm Feelin' So Sad*, as well as numerous other plays, including *Indians* and *Wings*, both of which were Tony nominees and finalists for the Pulitzer Prize. He also wrote the book for the Tony-winning musical *Nine*, as well as books for several other musicals.

ARTHUR KOPIT

Playwriting is not a career choice the way, say, screen-writing is, or even, nowadays, professional poker. As the playwright Robert Anderson once famously said, about playwriting: "You can make a killing, but you can't make a living." It's something you do because it's what you love. It's that simple.

To a disturbingly large degree, the success of any new play is very much a roll of the dice. Assume the play is excellent. Luck is still a factor. A bad production, over which the author may have little real control, can kill any new play, no matter how strong the text. But even if the production is first-rate, not every critic will recognize that, so which critics see it, and write about it, is another ingredient beyond the writer's control. The fact is, there's so much that's out of your control, it's scary. So it's always somewhat of a surprise, I think, for a playwright when he writes something that turns out to be a great success. I mean, yes, absolutely, excellence is a part of it. But so is luck. Complacency is not a worry in this business.

When I went to college I thought I was headed toward a career in engineering. That pretty much ended on my first day, at my first class, which was in advanced calculus. I volunteered an answer to a question about non-Cartesian coordinate systems that I thought sounded pretty good, as I heard it emerging from my mouth, but which turned out to be totally and humiliatingly wrong. If this class had been in fiction, I'd have gotten an A. But in calculus, I was in trouble. So I dropped the class and took fiction. As they say, one thing led to another, and pretty soon I was writing plays, largely because there was so much undergraduate drama going on, a good part of it devoted to new student work. I just thought, wouldn't it be fun to see a play of mine done! So I wrote a one-act, and what immediately surprised me was that the writing of it was far more fun, at least for me, than writing short stories, which is what I'd been doing up until then. So I submitted it to a college-wide playwriting contest, and lo-and-behold it won, and was produced, and was a huge success, and I was hooked. So I began writing more one-acts. By the time I graduated, six of them had been produced, and I knew without a doubt that this was what I was going to do.

I was in New York in the sixties when there was an explosion of creative energy, fueled in large part by Vietnam, drugs, music. In the theater, a new kind of play was happening. People realized serious theater didn't have to be on Broadway, and off-Broadway was born. Suddenly, plays were being written by writers who weren't interested in "well made plays." It wasn't conscious. It was writers simply seeing the potential of theater, and writing what they believed. Beckett, Ionesco—they changed it all. Genet's *The Blacks and The Balcony*, Jack Gelber's *The Connection*, Albee's *The Sandbox, Zoo Story*—these were pivotal works that marked the emergence of a theater and a force that had not been felt before.

If a play is powerful it's because of what's under the lines as much as the lines themselves. That's why great plays can be done in so many different ways, and still be faithful to the text. Good plays are open to varying interpretations. Some writers say, "No, I know what I want. This is it and it's set," while others discover different things about the play as they go along. I followed my own strange muse in my writing, never thinking about the audience. For example, it never occurred to me for a nanosecond that my play *Oh Dad, Poor Dad…* had any commercial potential whatsoever. That has to be the case. You have to write for yourself, and it doesn't mean you're always right, but if you start thinking about what the audience wants, you're in trouble.

Indians was based on my feelings about Vietnam, and came from an immediate, very powerful, visceral reaction I had to an article in the *New York Times* about a stupid, minor but bloodthirsty event that happened in Saigon. I'd seen a lot of antiwar plays that infuriated me because they made me think there has to be something to the other side. I just didn't like propaganda plays, even if I agreed with the writer's political point of view. Write an op-ed piece if you must, but don't use the theater as a venue for political argument. It's an arena of exploration that can be about hubris, the consequences of denial, the corrupting effects of power, the dangers of certainty, what happens when you have to believe your god is right no matter what. As a writer, you have to come at it from within, and bring some insight. Ideology has no part of that.

For me, a play begins with a question. There has to be something in the writing that I need to discover that I don't already know. If I know everything in it, then why am I writing it? If I'm commissioned and it's a TV movie then it's fine, I'm writing it for the money. But in theater? That's different. Writing plays is risky because the writer has to go into the unknown. You cannot be in full control of your play—it has to show you something you didn't expect. And no safety nets are allowed. It's mysterious. I don't know any playwright who knows exactly why he writes plays. You can't pin it down, but I know that when I've seen a play that is extraordinary, it moves me in a way that films cannot. I enjoy film. No, I love film. I think most writers, if they want to spend an enjoyable evening, will say, "Let's go see a film" before they say, "Let's go see a play." Because if the film doesn't work it's no big deal. But if a play doesn't work, it's profoundly disappointing.

For me, dialogue is the surface. There are certain playwrights who are very skillful, and successful, and I admire their work, but I'm just not very excited by their work because I sort of feel what you see is what you get. I'm more drawn to plays in which the characters are not fully aware of what they're doing. As in real life, language is used to communicate, yes, of course, and the language used can be dazzling and thoroughly enjoyable. But just as often language is used as something to hide behind, in order to keep others, or even oneself, from knowing the truth. What's really happening is under the language. That's where the real danger lies. That's what I am looking for.

HOWARD KORDER

Born in 1957 in New York City, Korder is the author of, among other works, *Boy's Life*, *Sea of Tranquility*, *The Lights*, and *Search and Destroy*. He has received the Obie Award and a Guggenheim Fellowship and has been nominated for multiple Drama Desk Awards and for the Pulitzer Prize for Drama.

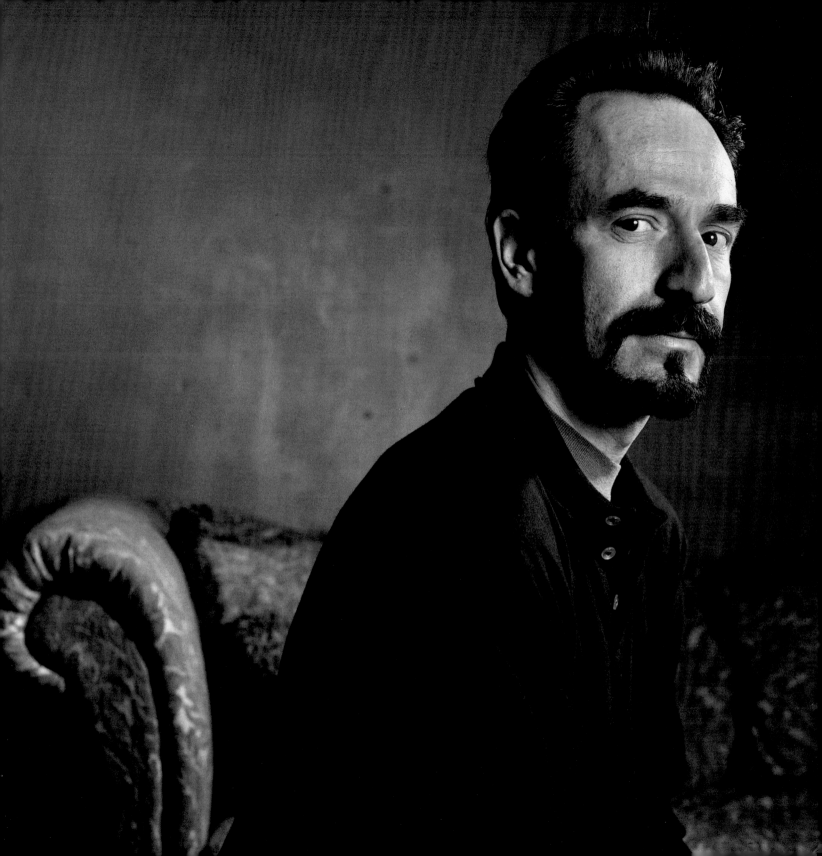

HOWARD KORDER

Who do I write for? I think you're always writing for yourself. I don't mean that you're just trying to please yourself, or indulge yourself, or elevate yourself above all criticism. I think you're always writing for yourself. But in the end, your sense of what is important, or moving, or funny, or beautiful, is the only thing you have to rely on, although it is, paradoxically, not subject to your control. You do have to work out in your writing how to get other people to follow what you're on about, and that's craft.

Why do I do it? To quote Elvis Costello, "It was a fine idea at the time, now it's a brilliant mistake." I suppose I had, early on, some vague desire to change the world, or at least to offend as many people in it as possible. I've become utterly disabused of the notion that I know more than anyone else, and very resistant to theater that is eager to teach me something or correct my thinking. My self-appointed task is to try to write well, keep myself interested, and get at what I think is the truth of a given situation.

Neither society nor theater could survive without evasions, elisions, euphemisms, half-truths, hedged bets, and outright deceptions. Language is an absolutely brilliant device for not revealing what you really mean.

Reading a play can be a very pure experience, and you are free to stage it in your mind as you see fit. But if you write plays hoping that they will be produced, with any luck you will eventually find yourself in a position where you will need to explain, elaborate upon, or possibly defend your work to your collaborators in order to make it live. Keeping in mind that theater is a resolutely physical medium, operating in real time and space, through the coordinated efforts of a large group of people, helps you stay honest.

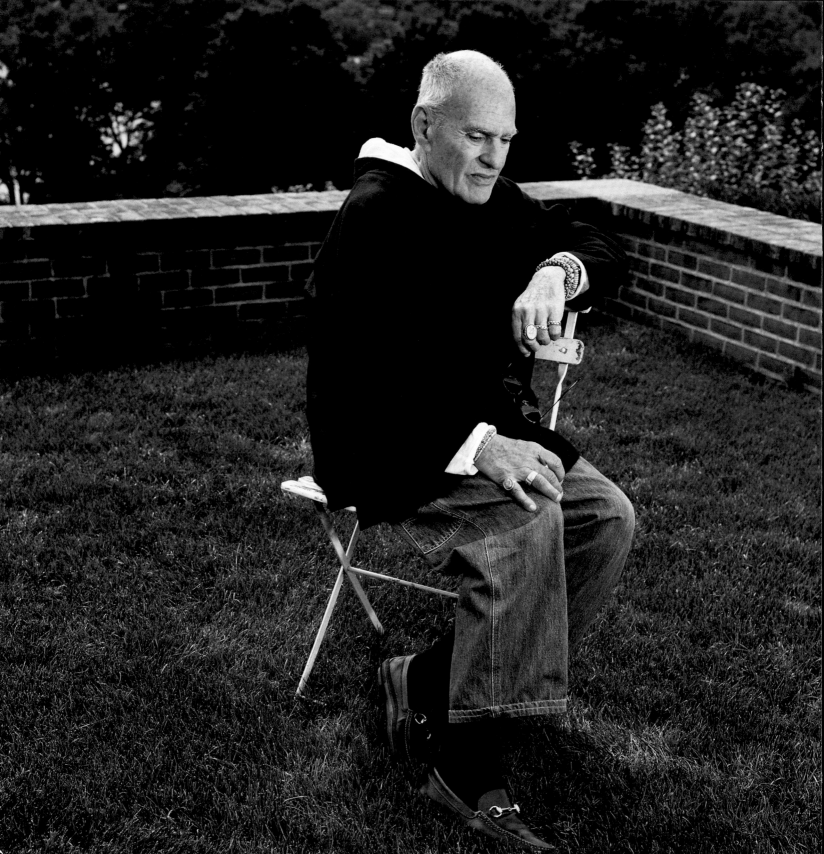

LARRY KRAMER

Born in 1935 in Bridgeport, Connecticut, Kramer is an award-winning author of numerous works including the novel *Faggots*, the screenplay adaptation of D. H. Lawrence's *Women in Love*, and the play *The Normal Heart*, which was named one of the 100 Greatest Plays of the Twentieth Century by the Royal National Theatre of Great Britain. He is a founder of both the Gay Men's Health Crisis and ACT UP.

LARRY KRAMER

I did not want to appear in this book. I feel I am in it under false pretenses. I don't like to be called a playwright. It's exceptionally limiting. I am a writer. I write plays, screenplays, novels, essays, journalism, letters, op-ed pieces, e-mails. I write anything I can to try and be heard, to get my messages across. I am not interested in writing which does not and writers who do not say anything important. I know "important" is defined differently by every writer. But I know what I consider important and I recognize it when I see it, which is not very often. There are not so many writers out there that I consider say anything of importance at all. I loved the theater once upon a time, but I don't love it anymore. It no longer interests me. I believe it is becoming more and more irrelevant, in this country at any rate. Since so few people go, it's no longer useful as a means of getting my messages across. Also, since there are so few movies that are embodiments of intelligence and challenge, I don't like writing movies anymore either. Writing movies is like writing a comic book or drafting a blueprint. It is all surface and no substance. I wrote screenplays for about fifteen years and made a lot of money, more than I have ever made from my plays. Writing plays is infinitely more difficult. It is very hard to write a good play—not that anyone notices.

As some have noted, I am what is referred to as a "message queen." I try to write as well as I can, but I do not consider myself an artist, though I would like to be remembered as one someday. I think I am a good writer (though I do not believe that others do). I believe because I speak loudly and bluntly as I try to enunciate the monstrous hideousness and evil of the world in which I live that this obscures for many people the quality with which what I say is written. Political writing, if that is what I do, is not taken seriously in America. Message queens, no matter how well we write,

are rarely considered as also purveying and aspiring to art. Too bad. I work very hard on my writing. I believe words are very precious and valuable and I try to love every single one of them as I put it into its home.

Since I feel that theater and movies are in no condition to house or challenge my intellectual, political, emotional, and spiritual demands, that leaves prose. Books somehow have a way of staying intact and, for me at least, in print. Because of wonderful Grove Press, most of my stuff is still in print. My novel *Faggots* has been in print since 1978 and still sells briskly. *The Destiny of Me* has had exactly two additional productions after it closed in New York. I doubt I shall write another play. One has to be pragmatic and practical, particularly when one's days are numbered.

I am now deeply immersed in something I call *The American People*. Or I may call it *The History of the American People*. I have been working on it since 1978 and it is now some 3,000 pages. I hope it will be some 4,000 pages by the time I am finished, which will probably be at the time I am meant to die. It is play, it is screenplay, it is essays; most especially it is history. Some will want to call it a novel, but I believe everything in it is true. It is meant to be a vessel for what I have managed to learn about my country in my lifetime thus far, rendered with whatever art and craft I have acquired. An "envelope," Virginia Woolf called her books, for what one wants to put into it, she said. I revel each day in the challenge of it, in the chutzpah of what I am trying to bring off. If writing is meant to help the writer stay alive and vital and useful, as it must be for me, *The American People* is all this for me.

Joe Papp once told me, "If you don't offend someone, you haven't done your job." Everything that I have ever written has been attacked, including *The Normal Heart*, and especially by my essential audience, i.e. gay people. What I am writing is offensive to many gay people because I am so critical of us. It saddens me that so many of us can't get beyond that. They simply did not know what to do or say about my last book, *The Tragedy of Today's Gays*. I think gays are the saddest thing around, and no one sees this.

I'm still writing because that's what I do. It's a noble calling and trying to lead a responsible life is very important to me. So please don't call me just a playwright. It took me a long time to be able to say, honestly, "I am a writer."

TONY KUSHNER

Born in 1956 in New York City, Kushner is most prominently known for his epic two-part play *Angels in America: A Gay Fantasia on National Themes* for which he won the Pulitzer Prize. Other titles include *A Bright Room Called Day*, *Homebody/Kabul*, *Caroline or Change*, and the children's book *Brundibar*, illustrated by Maurice Sendak. Other honors include two Tony Awards and the National Foundation of Jewish Culture's Cultural Achievement Award.

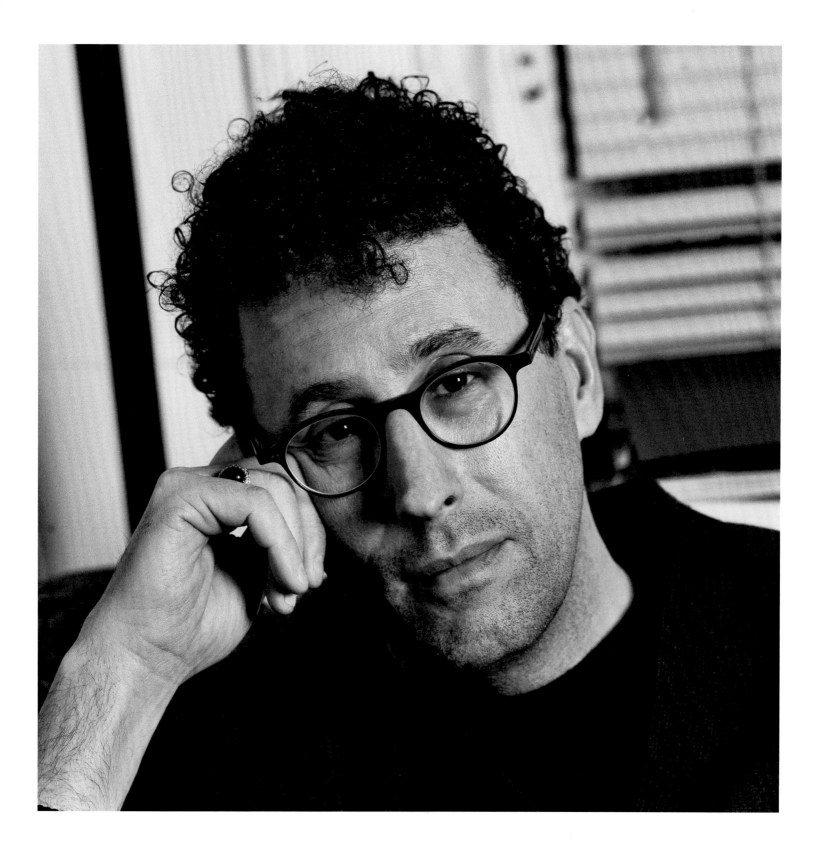

TONY KUSHNER

Marx says that the smallest reducible unit of humanity is two people. You can't really reduce anything to a single individual because it's an abstraction. There's no such thing as an individual in complete isolation. Humans are in a sense defined by their dependency.

I'm drawn to the dialectical nature of theater. The traditional dramatic narrative form that I work in proceeds through dialectic, through argument between opposing points of view. It's very much a form about embodied ideas more than narrative, which is what I think that I have a talent for and an interest in. I'm somebody who's drawn to abstract thought, but interested in personal psychology. I'm more interested in interrelationships.

I think the backbone of theater is not so much the unfolding of a great story as it is the unfolding of a great dialectic, the development of an idea and its progress as it bounces back and forth between a protagonist and an antagonist. I think that that's the heart of drama. I think that's what the audience really follows more than the unfolding of a narrative.

I think what I'm proudest of in *Angels in America* is it does not take one simple idea. It's a response to Reagan, it's a response to the epidemic, it's a response to being gay during a time of considerably greater oppression than now, although we're still in a lot of trouble in a lot of ways. And there's still a great deal of homophobic oppression in American society and certainly all over the world. But it's a response to those things. It isn't prescriptive in any way. It takes those political issues and my response to them as starting points and explores both political and even theological and emotional, psychological responses to political circumstance as deeply as I was capable of doing it. I think that when a playwright does that, you produce a work that has value to those who are struggling with similar issues, in that it helps you think about political issue, in rich complicated ways, by posing questions you haven't been able to articulate, or having known that you've shared with other people—doubts, skepticism that you share with other people, conundrums that you share with other people. Theater helps audiences understand that there's a commonality of confusion, which I think is critical to political thinking, and much more useful in a certain sense, at least in certain arenas, than being told, "this is bad and this is good and this is what we have to do to get out of it"—especially about problems about which the answer is elusive. I think that there are issues that have simple solutions, but they're not necessarily best addressed in a play. They may be better addressed in a polemic, in an opinion piece, in a news article, in a speech. The plays that I write, I hope, explore issues that require a kind of broader vision.

You've run into the lifeblood of the play when you've got something that's really tough to solve. People believe the great plays or books they admire or love were created effortlessly. And maybe that was true of Shakespeare. For most people, writing's a tremendous struggle. And part of

the struggle is going to be running into brick walls and thinking, "Okay, why am I here?" What issues, what expectations, what preconceptions, what failure of imagination have combined to create this roadblock? You retrace your steps and reread what you've written and think very hard if you're capable of that and maybe you can get through to the other side.

I was nervous about not writing well, so it took me a long time to get up the nerve to write. I'm still very anxious as a writer and I don't enjoy it very much. So, it's a struggle always and that's a drag. But that's life.

It's like trying to build an island in a middle of a lake. You start dropping stones into the lake and at first all you see is the stones disappearing into the water and it feels like a hopeless task. Eventually, if you have enough stones and you keep dropping them you'll start to find that the bottom of the lake has risen a little bit and eventually you'll have a little mound emerging out of the water and you'll have an island. So it's a long, drawn-out process. It's sort of calling something up from emptiness. It all sounds melodramatic and self-pitying and, of course, that's exactly what it is.

In particular, I remember there was one scene in *Angels* Part One, the courthouse steps scene, Act Two, Scene Seven, that I couldn't solve and by the eighth or ninth draft I had gotten everything about it right except for one moment. There was one sort of glaringly obvious thing that I just finally saw one day that I hadn't seen before. One of the characters was doing all the talking and the other one wasn't. The one that wasn't doing any of the talking had not really spoken very much through the course of the play—Joe Pitt, the Mormon guy. I finally saw it when we were doing it in the first production in San

Francisco. I rewrote the scene and I gave him something to say—I finally realized that he had his own thing to say. And the minute it happened, the play worked in front of an audience as it had never worked before.

I'm forty-six years old now. I was thirty-three when I wrote *Angels In America*. I'm older and fatter and wiser and I've lived through a lot of stuff, so I feel like after a very long time of struggling with it I've shaken off *Angels* to some extent. *Homebody/Kabul* was my first full-length play since *Perestroika*. I mean there were other plays and adaptations and opera libretti and stuff, but it was the first completely original full-length play. It was a big step to take, and I did it and I survived it and it did reasonably well, so I think the next one will be easier. I hope nothing becomes as daunting as the success of *Angels* again. I feel like I handled it. There are people who have had successes like that who simply never write again, who become incapable or obsessed with that level of fame and success. I don't think that's happened to me. It didn't completely transform the way I live. I made a deliberate choice not to allow it to do that.

After all, that's the experience of writing a play. A play is really about the passage of time. It passes literally in front of you and goes away.

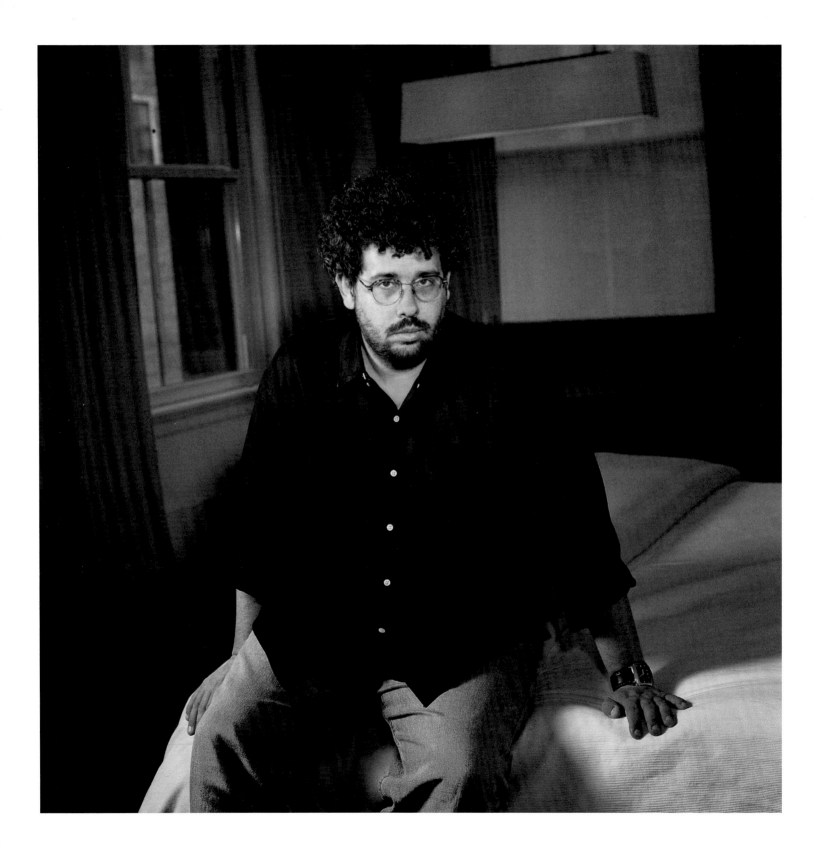

NEIL
LABUTE
Born in 1963 in Detroit, Michigan, LaBute is the author of plays such as *The Shape of Things*, *In the Company of Men*, *Your Friends and Neighbors*, *The Mercy Seat*, and *Bash: Latter-Day Plays*. Also a filmmaker, he has been the recipient of multiple awards and honors, including a scholarship to London's Royal Court Theatre, the Filmmakers Trophy at the Sundance Film Festival, and the Independent Spirit Award.

About fifteen years ago, I took a production that I had done at NYU into an off-off-Broadway house. It was not a very confrontational play, but the subjects were men and women and things that were of the time their concerns, one of the more timely being AIDS. In New York, in the early nineties, that was still a highly volatile topic. Someone sitting in the audience at one point, during one of the evenings, broke the silent pact that an audience generally has with a playwright—they don't talk back. At most they give a heavy sigh, or gather their coat and leave, or more traditionally, wait until the break and then head out. But this person vocalized. He just sort of yelled, where everyone could hear, "Kill the playwright." And I was there. It felt dangerous, but it also felt positive, really interesting, and kind of an important place to get to as a writer; to know that you could illicit something that immediate from somebody, that you were doing your job in a way.

Making contact with an audience like that is a good thing. Not just provoking them, not constantly whacking them with a stick, but finding new ways to engage, however, to break that fourth wall, to invite them into the process, to remind them how immediate the experience is as opposed to any other—that's a playwright's job. I've never felt compelled to coddle an audience, to say, "This is just an entertainment; come and we'll treat you well." If they come, then they're required to be attentive, to be a part of it.

NEIL LaBUTE

I think very often, here in this country in particular, the word "entertainment" takes on only the one meaning—escapist, amusing. "Amusing" is probably the most overworked portion of entertainment, whereas it can mean any number of things—diverting, engaging. I can be as entertained by something very sad as I can be by something very funny; I'm entertained if it is good. That is my criteria for entertainment.

Part of what lead me to writing, and I wrote early, was making little books when I was a kid. Many people do. It only takes a couple of staples and some folded paper, and you're on your way as a publisher. But my sphere of influence was rather limited to the house and my surroundings. I grew up in Washington state, which wasn't a place many would consider the most progressive theatrical center. Even in high school, it was hard to get material that was new or fresh. I didn't want to play Willy Loman if I was doing a scene, or attempt Tartuffe—that wasn't what I should be doing. So I started writing monologues for myself, and then I would attribute them to someone else. In this way, the teacher would not know, in case she didn't approve of what I wrote, and it was only after it was accepted that I let it sneak out that I had actually written the stuff myself.

I certainly enjoyed this new phase in my "career," and I started writing things for other people. In college, this became much more my outlet, to write new material and to put on a play under the stairs, or anywhere I could find empty space. In college, as in life, space was at a premium. There were only so many theaters one could use, and rather than having to go through the whole scenario of submitting a play through official channels, I would just put a play on virtually anywhere. I've always been an advocate of that, of doing whatever I need to get something

produced. I became very enamored of doing things that way—going to the park and doing a play, going under the stairs at the Natural History Museum. Whatever it took to create theater was worth it.

When I write, I love exploring the gray areas where people end up spending most of their waking hours. People make good and bad choices, often many in a day. They're not born good or evil—they just make all these choices and find ways to live within them. As a playwright, if you're not the one who's saying this is good or this is bad, that leaves the viewer to make that decision. They are forced to either not engage with it, or if they do engage, then to say, what do I think about that? I'm not Aesop, so I'm not saying, "Here's a little fable for you." I create a world and let it work or spin out of control as I see fit—I don't level judgment on it.

I'm the first audience. I'm trying to please myself as I write something, be it a play or a screenplay. The longer the characters stay in the room, the more likely it is to become a play. My plays are all sort of talky. I'm not bothered by a scene that takes place sitting around a table for ten pages, as long as I can make it compelling. Theater is not built on this kind of MTV editing that we see in television and movies now, where one must change the image every couple of seconds or people won't remain engaged. I don't believe in it. If what's being said at that table is interesting enough, those ten minutes go by quickly.

When we performed *The Shape of Things* in London, we didn't have a curtain call. That became as big an issue as the play. People feel like they have some right to a curtain call, as if to make eye contact with the actors and say "thank you" is a divine right. But it's like, "Fuck—I can do whatever I want. This is still part of the play, you're still in the house, and what if I don't want you to have a curtain call? I want you to sit with the play, and if it affected you, let that linger."

There's no topic that I'm afraid of. Is there a child-killing, sleep-with-your-dog subject that I think is off the map? No. Whether I have an appetite to do it or not is the question. But, for example, I never thought, "Oh, maybe I shouldn't go in that direction" with *The Mercy Seat,* which centers around 9/11. It seemed like such a time of unification in this country. An overall heroic response of a city and our nation, but the writer side of me said, "Bullshit." Not everybody was out there passing out food. Not everybody was running toward the rubble and offering to help. I think a moment like that is white hot in the way it defines people. It either makes you that much more of who you naturally have shown yourself to be, or you find hidden reserves of either heroic behavior or absolutely unheroic behavior. The writer in me believed that an interesting story was to write about somebody who, during a national tragedy, could worry more about what was important to them, which was their own adulterous relationship.

There are probably some directions that I wouldn't necessarily find myself wanting to go in—what someone might find distasteful—but then again, I'm not particularly taken with *Carousel.* That's not a story that I would've wanted to write, either. You have to fall in love with whatever you write; it's a love affair. It's not a flirtation, it's not a tryst. You have to want to stay with it. An idea comes to me, and it either sticks or it doesn't. It's worth my time, it's worth me telling, or it's not. It'll drift away. Ultimately, it's only the stuff that remains, the stuff that clings to me and says, "I need you. I need you to tell this." That's what makes me put pen to paper.

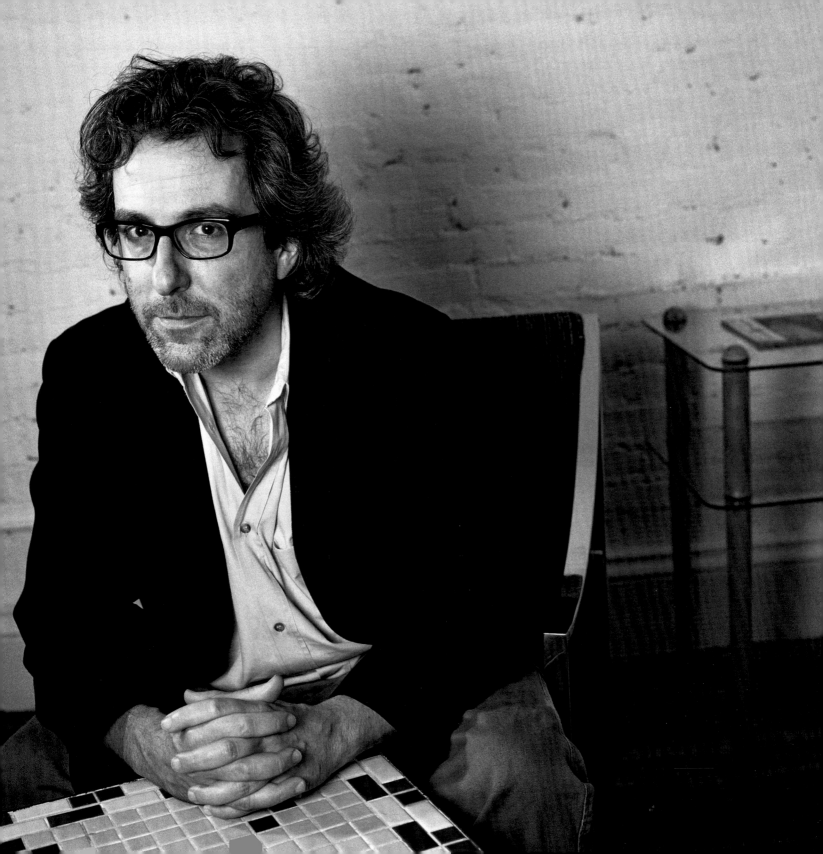

WARREN LEIGHT

Born in 1957 in New York, Leight is the recipient of the 1999 Tony Award for his play *Side Man*. Other notable titles are *Glimmer, Glimmer, and Shine*, *Stray Cats*, *Trepidation Nation*, and the film *The Night We Never Met*, starring Matthew Broderick and Annabella Sciorra.

WARREN LEIGHT

It shocks me how much time I spend *not* writing. I've been a deadline writer since I was eight. I'll tell someone, "I'm coming to your conference," or I'll organize a reading for a play I haven't started and invite people. That happened with my play *No Foreigners Beyond This Point*, which was commissioned by Center Stage in Baltimore. That was something I had wanted to write for a long time, and I just never got around to it. They called and there was a workshop scheduled and they said, "Can you give us an early draft?" and I said, "Not really," and they said, "Well, how many actors are you going to need?" and I said, "Oh, I guess eight." And they said, "Well, what ages?" And I said, "Well, people are doubling." I was just fumbling. But once those people were hired, that's how it had to be. The worst thing in the world is to be told you can write about anything you want, and take all the time you need in the world to finish it. Not for me—I'm better off with a few simple guidelines.

I was always going to write for a living. I remember I was in my senior year in college, and I was taking a creative writing class from Tobias Wolff, and it was me and a bunch of jocks, and Toby was just giving out A's to any jock. He wasn't really working them hard. But I was taking it very seriously and I said to him, "Listen, I have to go to law school, but I really want to write for a living. But I have to take care of my folks, and I can go to any law school, so…Can I do this for a living?" He said, "Don't ask me that." I said, "No, no, I need to know." He said, "You can't ask me that." I said, "Well, I've got to go to law school then." He said, "Well, OK, you can probably write for a living." And I said, "Well, OK."

I had a job in publishing after college, and I sent an article out to the *Village Voice*, and they bought it for one hundred and fifty dollars. I met the editor and I said, "So, do you think you'll buy some others?" and he said, "Yeah, OK." So I quit my job. That was about twenty-five years ago.

I had majored in journalism and my journalism teacher said, "You get the best quotes of any writer I've ever seen," and I thought, "Oh, they're going to figure this out after a while." I mean, I tended to know what people *meant* to say. I did an article about comedy in New York and I met this cabaret act, High Heeled Women, and I went out with them after the show and they asked me what I thought, and I was like, "It was pretty nice, but you know you have the joke in the wrong place on this sketch." And by the end of the evening they hired me at ten dollars an hour to write material for them. I would just book jobs. I knew I had to make six hundred bucks a month to live on, so my price for everything was six hundred dollars. I'd write a horror movie for six hundred dollars or a corporate trade show for six hundred dollars. I just took jobs and it eventually evens out and you do okay. Playwriting seemed to me to be a huge indulgence, so I did almost everything but playwriting, while mostly enjoying playwriting more.

I admired playwrights, but I had no idea. I hadn't gone to Juilliard. I hadn't gone to Yale School of Drama. I wasn't in those worlds. The introduction to theater was all these cabaret acts, which were live audiences every night in mob-run clubs in the Village or Midtown, where some club owner guy would grab you by the neck and push you back towards the booth and go, "It better be funny, kid." I used to work for an all-female cabaret act and the credit I got was, "The girls write all their own material." But two of those people became some of my closest friends in life. What came back at me was the experience of immediately working with an audience. I was writing another hour of new material every three months.

I started to get more movie work, writing screenplays that didn't get made, and getting well paid. I started to do one-act plays, which is the way in, since no one will produce a full-length play, especially by an unknown writer, but everybody does these evenings of one-acts. I got into Naked Angels, which was a theater company, and what I found about theater was they would do it the way I meant it to be written. And when I wrote for movies or TV, most of the time it didn't get made, and if it did get made, I was humiliated, mortified. Plus, I found that I liked working with actors. I liked being in the rehearsal room a lot more than I liked taking meetings with development executives.

I was at a dinner party and there were all these really successful screenwriters, and each one was more bitter, depressed, and drunk than the next. And I thought, if everything works out, this is where I am in ten years. And I'd been going at it for a while. So that's when I started to work more on *Side Man*. I had been fooling around with it as a screenplay and I thought, "No. They'll ruin it." So I started to work on a play.

Once it won the Tony, the regionals all did it, but a week before then, it didn't have one offer. I originally sent it out under different names, so my joke is that there are still theaters calling me up to turn it down, not realizing. I did get a call from one theater—it had been on their desk for eight years and they finally got around to reading it, and they asked if they could do a reading of it. And I said, "Actually, it's already had some productions," and they said, "Really?!"

Fundamentally, *Side Man* was the story I had avoided writing for the longest time [The story is about the playwright's father, a big band musician, and mother.–Editor's note]. I had written everybody else's life story. I had written every cabaret singer in New York's life story for them. I had written corporate speeches. But I had avoided writing this for a bunch of reasons. But also, I think on some level, had I written it sooner, I don't know that I would have understood it. Emotionally, it was good to get perspective, but also, had I written it sooner, it wouldn't have come out as a play. It would have been a screenplay. I would have lost the rights to it, or it would have been reassigned to somebody. All the notes I got when I wrote the play—people said, "Well why are these *white* jazz musicians? Shouldn't you make them black? If you make them black, we'll do your play." And I could say, "No." My other work is the work that people are allowed to piss on. This is mine.

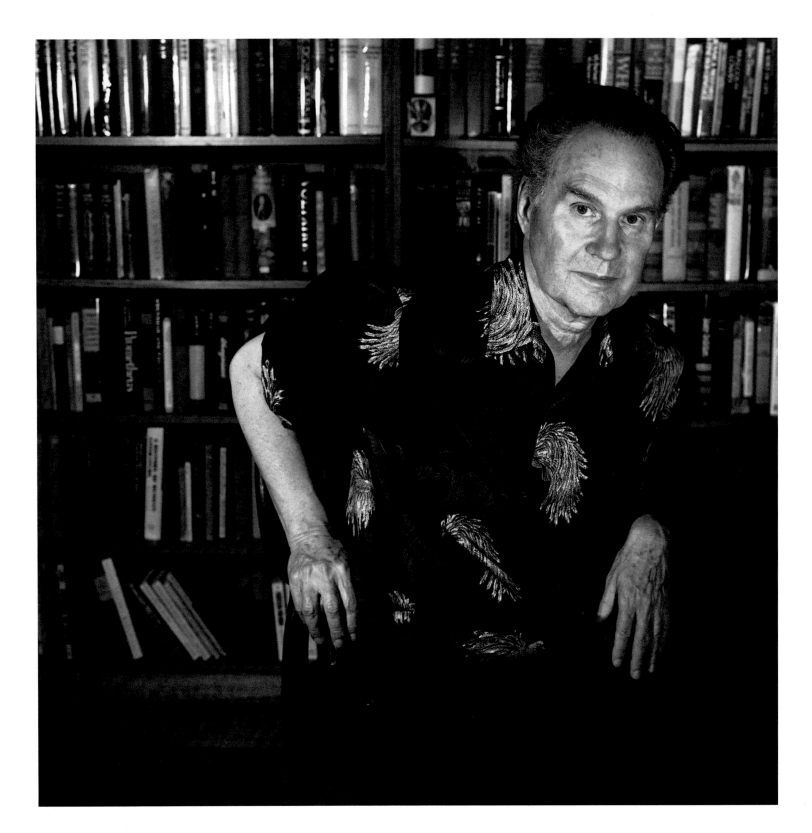

ROMULUS LINNEY

Born in 1930 in Philadelphia, Linney is the author of three novels, many short stories, and numerous plays, including *A Lesson Before Dying*, *True Crimes*, and *Songs of Love*. He is the recipient of numerous awards and honors, including recent induction into the American Academy of Arts and Letters, two Obie Awards, and the National Critics Award.

Logistically, I was an actor first. I acted all through college, very happily. Then I came to New York—I'd been in the Army, and I came to New York, and had a life change and became a writer.

I never thought being a writer was anything that I would ever be able to do. Then finally the notion was, "Well, I'd better try this because it is about the only thing that was left." Henry Miller says, "If you just get desperate enough, you will write." I think that was right. When I was at Yale, I directed for my thesis a play by Eugene O'Neill, and I did a pretty good job of it. But I sat back and looked at it, and I realized that my direction—I was really trying to make that play look like I wrote it. I thought, "Well, I'd better be honest about this." I had to say, "Stop it. It's his play, not yours. Write your own."

I remember when I was a kid, I'd skip school and come into New York to see plays, and I remember one of the plays I saw was a very old production of *King Lear* with an American character actor named Louie Calhern, who was an odd choice. He wanted to play Lear, and he played it.

ROMULUS LINNEY

He was a big man; he played a very gentle Lear, an unusual Lear. It was a kind of a crazy production, but for half an hour after that thing was over, I was in a state of bliss, very close to some kind of state of being that I suppose Buddhists call enlightenment—I don't know what the hell it is, but it's an experience that there's no other substitute for, that kind of profound moment in the theater that is so pleasurable, so wonderful, that you're hooked. That's why people who love the theater do *love* the theater.

My earliest memory in the theater was sitting at a dress rehearsal of *Our Town*. My mother was playing Mrs. Gibbs, and I was sitting there bored. I had some little chocolate cupcakes that I was going to eat when I got bored. I suddenly got all involved in the play. Mrs. Gibbs had a son in the play, and I got involved. "Wait a minute; that's not your mother; that's my mother. What are you doing?" Then when they're all in the graveyard, there's my mother, dead on the stage. I realized my mother will die, and I will die, all these things will happen as they do in that great wonderful American play. I was profoundly moved, and I wept all over my chocolate cupcakes. I was eight or nine.

I lived in rural America in the thirties—I was born in 1930—so for the first ten years of my life I was living in the western mountains of North Carolina, which was very, very remote then. Then in Madison, Tennessee, which was like a little New England town, outside of Nashville. I was in the Depression in rural America. I didn't know anything was depressed. I had enough to eat, and I had clothes. My father was a doctor, a leading citizen of the little town. When I was thirteen, he died. That was a transforming incident, and still is. When you're a boy at thirteen, you're at that age when you just about have to stand up to your father. When death clawed him down, you're torn to pieces because half of you, as long as you live,

will always mourn your father. My father was a very good man, and he loved me, and I loved him. But on the other hand, he was my father, and I was having to stand up to him and there were probably a lot things we were going to disagree about. Half of you mourns him deeply, and the other half is glad he's dead. That's hard for a thirteen-year-old boy to face. When that happens to you, you aren't much interested in philosophy any more; you're not much interested in religion any more. You feel that something has happened to you that was so real and so profound and so hard that you spend the rest of your life—well, I spent the rest of my life—writing about it.

When my play about Frederick the Great was done in a beautiful production in Vienna, they had a meeting, and they asked me why an American would write a play about Frederick the Great. My answer was, "bird dogs." They translated it, and everyone was, "What's this?" The last years of his life my father raised bird dogs, and we would run them in the field trials. I saw the love that men had for their dogs that is very different from the love they would have at home. I explained to them that Frederick the Great had a terrible time with his father, and it conditioned all of his life. That's really why I wrote the play. Within my historical plays, there's always an emotional, personal reason why I write them.

My play about Byron is really about my daughter Laura Linney. You wouldn't think so when you look at it. It's a play about Byron and his legitimate daughter, Ada, Countess of Lovelace, but in reality it's all about me and my daughter. I wrote the play when she was young. Then later on, when she was at Brown University—she acted in all the plays—people at Brown knew about this, so they did the play for her at the end of her senior year at Brown. She played the part. That was a very interesting thing. People sometimes say to me, "When are you and your daughter going to do a play together?" And I say, "We've already done that."

I was born in Philadelphia. My father was a resident physician there. The Depression hit, and he couldn't get a practice going in Philadelphia. So we moved to Boone, North Carolina, where his father's relative had a big house. Those are the voices I heard around me as a child. I notice that in my writing, in the Appalachian plays, the dialogue is just a little sharper, because mountain speech is very unusual. There's a rhythm to it. My family goes back, way, way back. Basically Welsh, I believe, then English, going back to 17-something, when they came, just a straight descent. The figure who's most interesting is my great-grandfather, who was a very colorful man. He was a lawyer, fought in the Battle of Chancellorsville, came out of it a young man, and became a mountain lawyer and was very successful. He was a United States Congressman for three terms; quite a figure in North Carolina politics and jurisprudence at the time. When his wife died, he bought this mountain. He lived up there in the summers with his dogs. There are lots of descendants who are up there. He was called, "the Bull of the brushes." He evidently did pretty well sexually, I guess. His name was Romulus Zachariah Linney.

I used to be fairly athletic. I like to swim and do sports a bit. I like to drink. I liked to screw around when I was young. I'm a selfish artist. My wife is a philanthropist and a person who is devoted to doing good for other people. I'm afraid I'm not; I'm just a selfish artist.

Anybody that I know who are artists—and I don't mean to use the word "artists" pompously—but people who are serious artists, I like to say to them, "What would happen to you without this?" And they say, "I'd be dead." So, that's really it.

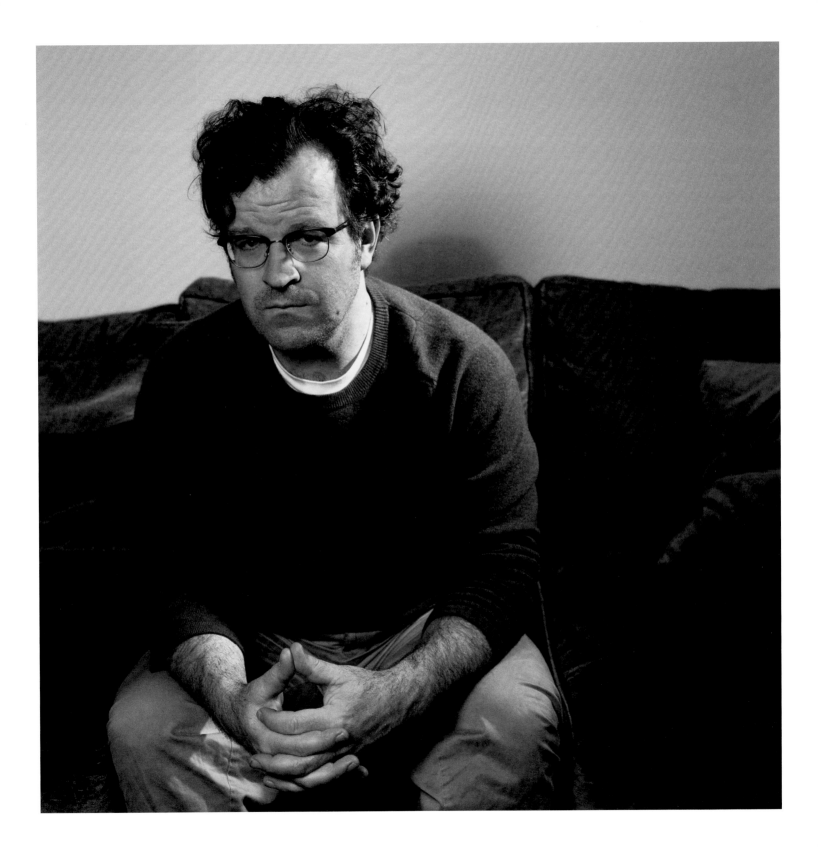

KENNETH LONERGAN Born in 1963 in New York, Lonergan is best known for his play *This Is Our Youth*, as well as numerous others including *Lobby Hero* and *Waverly Gallery*, and the films *Analyze This* and *You Can Count On Me*. He is the recipient of the Best Feature Award and the Waldo Salt screenplay honor.

I almost always start writing with an idea for a character or characters. If I don't have a vivid picture of someone in my mind, as vivid and specific as my mental pictures of the real human beings I know, I can't even get started. I have a relatively easy time thinking up characters I like, and a comparatively difficult time finding how to unfold the story in a way that organically taps into whatever it is I am trying to write about. What usually happens is that I get a picture of a character or characters, usually in some kind of initial situation or setting—like a teenage kid has stolen money from his abusive father and goes to his somewhat bullying friend's apartment to hole up until his father catches up with him, which he is bound to do. That was pretty much the genesis of the plot for *This is Our Youth*. Over time, it felt right for the play I wanted to write because at age thirty-two or so I got interested in the life that we had led in the early eighties on the Upper West Side of Manhattan, and in that particular subculture in general. I had neverseen my little piece of the world put on stage before, and I had never seen (although I'm sure one existed) a play with just three teenagers in it. For a long time, I thought the father would eventually show up and be a character, but that didn't work out—or rather, it turned out to be unnecessary or not right for the play. I didn't start with the plot or the structure—which I consider to be two different things—but without them, no play. Just like there's no play without life-like characters. There are some exceptions, I think, though they are very rare—even the most apparently shapeless plays turn out to have their own specific architecture if they're any good. And if the characters are not life-like or are somehow not imbued with the usual human qualities, and the play is still good, I swear it's because the author is somehow truthfully expressing his or her humanity through the stylization or non-reality of the play. Most plays that take an inhuman or dehumanizing approach are pretty ghastly. For me,

the initial ideas that are the ones which are followed by a larger structural idea that takes me to the very end in my imagination. In the case of *This is Our Youth*, the main character loses everything during the course of the play. The structure is the systematic divesting himself of all these things he cares about. It also happens to be the story, the emotional story of the main character, which is why I'm very happy with it. But I have a notebook full of ideas that have no structure.

I don't think comedy and drama are as discrete as they're supposed to be. Comedies that have no emotional content tend not to be as good as comedies that do. (By emotional content, I don't mean that at some point the play must become serious and there will be a humorless dramatic monologue or a sudden leaden-footed moment of tenderness and mutual appreciation between the characters. I mean emotional content as it is expressed through comedy.) And dramas that have no humor almost never work at all. I think it's because if something is all serious or all funny, it's is somehow patently not like life, and you feel that when you are watching it.

Except for writing excercizes or assignments, I don't think I've ever started with a theme and tried to imagine a story or characters that would fit that theme. But interestingly enough, a theme will always emerge, and I have found the more I leave it alone, or the more I let it sit in the back of my mind, the more naturally and interestingly it will emerge. Somebody once told me that somewhere in the overall composition or design of every painting is a smaller version of the composition—a shape or shapes somewhere in the painting that mimics the overall design. In my play *The Waverly Gallery*, I was interested in really going in detail by detail. Only later did I realize that, without me deliberately orchestrating it at all, one of the themes of the

play that emerged was the narrator trying to make sense of this horrible, irredeemable tragic thing that happened to his grandmother, something that happens to millions of people—she loses her mind and dies, kicking and screaming all the way. He is telling the story to us by going into as much detail as he can, because he figures if he can't do anything about it, he can at least tell about it accurately. The painter has no perspective on his life, and the narrator has no perspective on what happened until the very end. That is a very strong thematic chord running through the play that I had no idea was there until I had finished writing it.

Since everybody has, by definition, a unique perspective on the world, everybody notices different things. We're all looking at the same world, but we are all seeing different things based on who we are, where we're from, our capacity for seeing, who we know. So just telling a story, just picking at it, just by consciously—or better still, unconsciously—selecting some details out of the mass of life that other people have probably noticed too but maybe didn't notice in that particular combination—just by doing that, you've managed to point something out about the world that nobody else has ever pointed out in quite that way. You've managed to (partly) bridge the enormous gap between your imagination and everybody else's. Not because you know anything more than they do, but because you've managed to translate your perspective into something they can feel instinctively is truthful, whether they recognize it or not. I think that is very exciting. It's part of the great fun of being able to work in the theater.

KENNETH LONERGAN

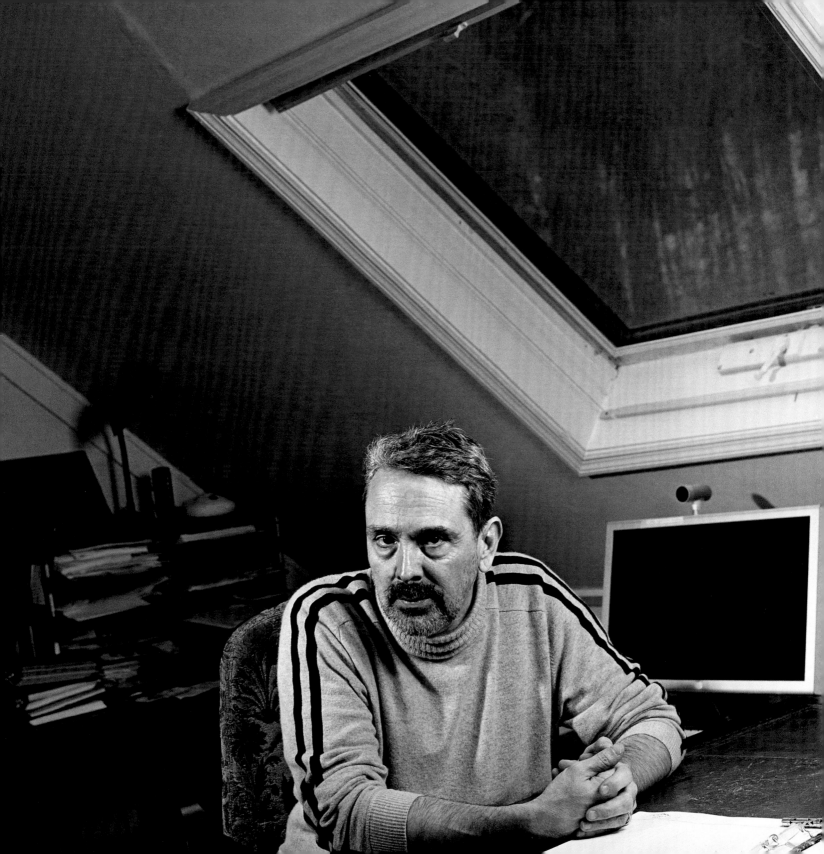

CRAIG LUCAS Born in 1951 in Atlanta, Georgia, Lucas has written numerous plays and screenplays, including *Reckless*, *Prelude to a Kiss*, *Small Tragedy*, *The Dying Gaul*, and *The Secret Lives of Dentists*. He wrote the book of the musical *The Light in the Piazza* and the book and lyrics to *The Listener*. He has received numerous awards and honors, among them the Excellence in Literature award from the American Academy of Arts and Letters.

CRAIG LUCAS

Almost as far back as I can recall, writing was part of my life. In the fourth grade, my friend Anne Pierce and I wrote a Shakespearean love tale called *Peanut Butter and Jelly*—our answer to *West Side Story*.

I am at my desk anytime between 7:30 to 11 a.m., and I am often there until 9 p.m. or later, especially if there's a deadline or I'm doing revisions. I write on an Apple. If I'm traveling I carry a notebook made by Hartley & Marks that lies flat and has nearly-invisible lines. Many writers procrastinate—as I did for years—but I've discovered that it's possible to make writing the thing you do while you're procrastinating something else. For diversion, I walk in the woods with the dogs, read non-fiction, check out Craigslist to see if anyone rich, intelligent, young, and good-looking wishes to spend the rest of their days with me and my boyfriend.

Rarely is loneliness an issue. Writing, one is engaged with what at first appears to be "the Other," though the more one works in a particular region, the less "Other"-like the "Other" becomes. The full panoply of voices begins to chime in, and the warring perspectives make for a crowded life through most working days. Each strand of research leads to another, books and articles infinitely expanding, and the worlds inside them slice through the cord of needing to be with others. Plus I'm on the phone with friends half the time anyway, and this way you don't need to bathe before paying a visit.

I keep my ear and head, my eye, and my emotions open to things that stick, keep coming back, insisting upon themselves. If you use up enough of what's been swimming around in that backwater, a lot of other anomalies tend to swim in and take up the space.

Life, of course, is a big messy admixture of joy and sorrow. Directly alongside birth and infinite possibility and scientific wonder and creativity and community exist death, disease, and drama critics. Our life span, our income, even to a certain extent our health, do not lie entirely within the province of our control. Sorrow is inescapable, but there is joy in sorrow, too. In the attempting, the simple act of reaching for something, whether or not it is achieved, there lies an ongoing possibility for joy, best expressed, paradoxically, in full participation in that theatrical event of deepest of sorrows, tragedy. Why should it be that we come out of a great performance of a great tragedy elated and happy to be alive? Happier, in fact, more grateful than ever to be here in this moment. Gratitude for all of life is something art can enable. Included in the things that offset the pain and horror is theater—the public, civic event, the entire community coming together to entertain one shared experience, one single dramatic action. What does it mean to be the son of a salesman who is dying Willy Loman's death? Bring a thousand people to that event, and if they participate, they will not be able to walk away announcing that the play "succeeds despite its politics," as one ubiquitous bystander recently announced.

People say I was a funny baby and a funny kid (though I don't remember childhood as being funny; I thought it was scary). My mother had an exhilarating freedom in her humor, a wily, mischievous strain of playfulness, the wicked glee in violating certain taboos and mocking shibboleths. She was a bit of a trickster, a terrible and blundering joke teller, famous for her public butchery of every dirty joke she tried to retell, and she was my whole universe —the mainstay, the atmosphere I breathed, my love and personal complexity, my villain and lover. There is no one I miss more, especially late at night when she and I would drink and put on music and dance and tell stories about our horrible relatives and the humiliations of living. I guess she was the romance of my youth. Being sober must mean that I am in recovery from that. And sometimes I slip.

The point of a play is its journey, what's at the heart of it, how it views the human condition; what inevitable choices it leaves us with. What are we to do in the real world, how are we to live?

Anything that can be dreamed can be dramatized. That's all a dream is, really: a play written in the unconscious and fully performed before a captive audience. But if each of us is witness to the dream, to its intended audience, then who is the dreamer of the dream? Who wrote it and how can they perform it for themselves? The idea that there are at least two of us operating within sleeptime, two participants inside each human being, is...well, that would be something worth expressing on the stage.

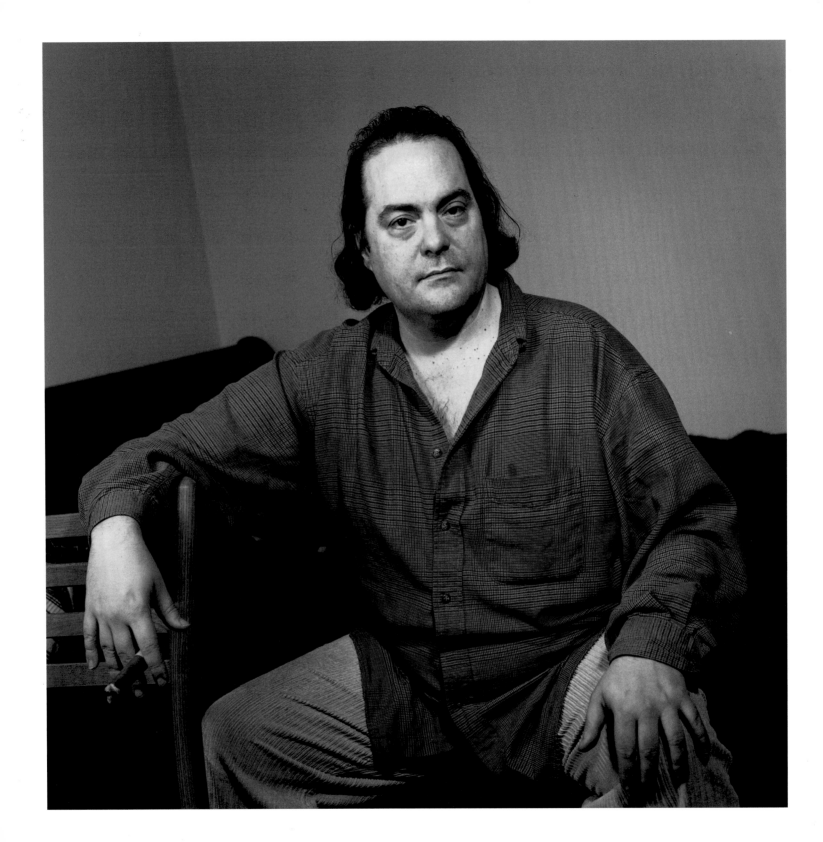

EDUARDO MACHADO

Born in 1953 in Cuba, Machado came to the United States at age eight and is the author of over thirty-five plays, including *Havana is Waiting*, *Rosario and the Gypsies*, and *Kissing Fidel*. He has received numerous awards and honors, including grants from the National Endowment for the Arts, the Rockefeller Foundation, and the National Endowment for the Humanities, and he serves as head of the Columbia University Graduate Playwriting Department.

EDUARDO MACHADO

The first thing I ever got myself was when I was five—I designed a desk, and I had it built for myself. So that's a weird thing for a five year-old to do. Obviously, I had plans. I commissioned it with a guy who made furniture and they asked me what I wanted, probably for my birthday, and I said I wanted a desk. It was made of very modern wood, a little Scandinavian-looking desk. I don't think that's what most kids want.

I became an actor because I was too afraid of writing in English, because my first language is Spanish, but I still wrote all the time. I would write lyrics to songs. I would write dialogue, and I would always tear it up. Then I started acting with the Padua Hills Writers Conference, which was started by Marie Irene Fornes and Sam Shepard, and I just started to get to know writers and I saw that they couldn't spell and that they didn't punctuate well. All the things that you don't see when you're doing Brecht because Brecht has been edited and I thought, well, maybe I can do that. And I went to one of Irene's classes, and I wrote something, and she made me read it, and she told me it was good.

A psychiatrist that I was going to told me to write a letter to my mother, and I resisted it for about a month, but then one night I sat down to write a letter to my mother, and I must have stayed up until seven in the morning, and that was when I started writing this play. I finished it that night, this one-act play. It's called *Embroidery*. I sent this play to the NEA and I forgot all about it, and I got a grant, but I was completely an unknown and I thought, well, maybe it's something I should do, because in acting it's never this easy. I was twenty-five.

That play was about a woman who had lived above us when I was a kid and she had hung herself, this Cuban woman. In her letters, she had said that she had tried to pump air into her kids' veins to kill them before she killed herself, because she thought life in America was too awful. It just made a real connection for me and from then on I just kept writing and writing and writing. There was something about being able to say things that I really felt through somebody else. And I wanted to tell her story. And it all just came together that night and from that moment on. Getting that NEA grant made me feel like I had a responsibility. They told me that I had talent and I just felt like I really have to not waste this money.

All of a sudden everyone in New York was taking me seriously. The first time I got a good review from Frank Rich, I said, "Who's that?" And they all looked at me. It all happened very fast, and I thought that was the way it happened for everybody.

I was a Peter Pan child. This was a special program and it got all these kids out of Cuba. I came here with my brother and we lived with my uncle. I went from being a pretty well-to-do kid who could buy a desk to a very poor kid. I never felt like I fit in. I didn't really feel like I was Cuban and I didn't really feel like I was American. I actually never felt like I fit in before I became a playwright. And then I had a definition for myself, which was playwright.

I have a very complicated relationship with Cuba. You'd have to read all my plays to figure it out. Five years ago I went back to Cuba, which I don't think I ever would

have done if I hadn't been a playwright. I wrote this play, *The Cook*, in Cuba. I remember one day, that I finished writing; I had been writing for five hours. I got into this car and I drove to a bar in the town where I'm from, to a bar where Hemingway would hang out. (One of many bars where Hemingway would hang out, but in this one he would hang out a lot—it's where he wrote *The Old Man and The Sea*.) I remember I ordered rum, and I drank it, and I felt complete satisfaction that I had beat all the systems. I had beaten Fidel, who didn't want me back for many, many years—he didn't want any of us back for many, many years. I felt like I beat him and his cynicism. And I felt like I beat America, who still doesn't want me to go there. And that happened because of my writing. And I was writing a play that I really believed in because of what I had experienced. Not just because of what I used to be or because I'm angry with my dad, or all the reasons why people become writers in the beginning. It was a whole different thing. It was really, truly satisfying. It was complete personal satisfaction. Which ten, five years before I would have told you was impossible. The things that you think are unreachable suddenly become reachable. That's a big shock.

I write about Cuba now to end the embargo, which is a whole different reason than to long for it, to try to remember it, to wish I was there. Now it's a very political reason. I can't believe the human suffering that the embargo gives people on both sides. I can't believe the human toll. I've seen what it does to families, what it does to people in Cuba financially, to avenge for what the people in my family feel is so extreme. It had destroyed people for the past forty years and I'm part of that destruction.

I write for Americans. They know very little about Latin America. I write for myself. But if I were just writing for myself, I'd be a poet. Playwrights write for other people. I write for actors that I love. I write for Cubans who hate me. They're especially tormented about me. I think it's good that they're tormented about me. I think it's a good thing. And I write to try to say what's happening in a century of exiles or immigrants. I think my plays are about that because most people I know are exiles, immigrants from somewhere. That's a world condition, and the fact that embargos almost never work against any country, and yet we do it and do it and do it. And countries do it to each other. It's really the tragedy of the last century and rapidly becoming the tragedy of this one.

I've had many theaters tell me, when I first started writing, if you don't write "magic realism" you're never going to get produced. I said, "Well, when I see somebody walking up to me with a bleeding heart, I'll write about it. I really will. When that really happens, I'll do it. But I'm not going to do it just because you think that's how I'm supposed to write." That's insane to me. If my plays don't have poetry in them, people get really upset, because Latin people are only supposed to have poetry. Well, sometimes my characters don't speak that way. Sometimes they do, sometimes they don't. That doesn't mean that it's a minus. So the prejudice is so big and it's so ingrained. It's such a big, huge wall that if you were to become agitated by it on a personal level, you'd just be pounding your head against this big, huge wall. It's not going to move, so you've got to sneak in through the cracks, and do the most you can do, and that's what I do.

Theater is finding the limited way to say the right thing, because it's a very limiting thing. It's stage and it's light and it's blackouts. Give yourself limitations, and you'll be able to go anywhere.

WENDY MACLEOD Born in 1959 in New York, MacLeod is author to numerous works including *The House of Yes*, *Juvenilia*, and *The Water Children*. She received a Special Jury Award from the Sundance Film Festival, and she is the playwright-in-residence at Kenyon College, her alma mater.

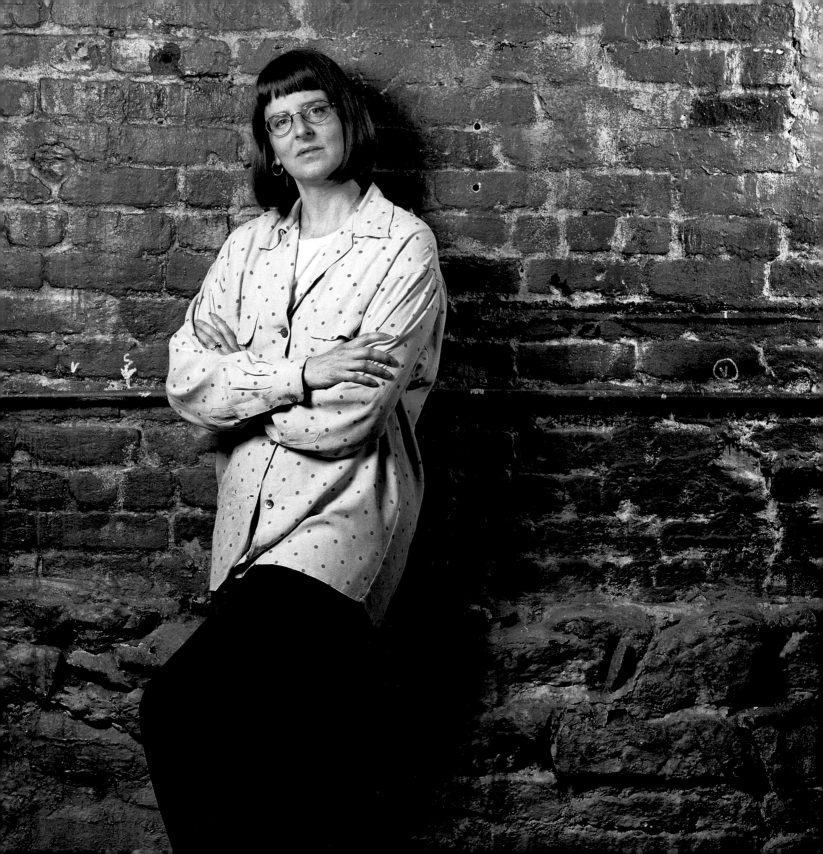

WENDY MACLEOD

I think there is something very special about the theater, which is that the lowest common denomination is the human body, and the fact that the audience is sharing the same space as the performer. You're sharing this moment in time. I like the fact that actions and speech imply what somebody is feeling, as opposed to trying to articulate what somebody is feeling. There's that tension between what's on the surface and what's going on below that I find an interesting challenge.

As a kid, we did plays in the basement. I remember in particular doing *Beauty and The Beast*, and I was playing the Beast. I made myself the Beast by saving all the cut hair from different haircuts and putting it on my face with scotch tape. At the moment of the reveal I ripped off the scotch tape. It was low budget.

My father is a funnyman, so whether it's genetic or simply environmental, I grew up with a sense of fun. That's important, because good writing always involves something unexpected, some kind of inversion of the formula. I think that comedy comes out of inversion in the same way. You can't say that all good writers are comics, but I think that's kind of the principle at work.

I don't go into a play knowing what ideas I want to explore —I kind of sidle towards it like a crab, in a sense that an image sticks with me, or a line of dialogue sticks with me, or sometimes it's just a title, as with my play *Juvenilia*. Right now, in my head, I'm fixed on these two children that I see on the beach every summer. The older child is a little girl with Down's syndrome and the younger brother is a so-called "normal" child. Right now, I'm thinking about what it's like to be that boy and be responsible for your sister who is older than you and yet behind you in certain ways. Right now, that is something that is churning, and I haven't begun to write it. But that's how it works for me.

I've always been very interested in our world and what's funny is that I live in this little bubble—it could easily be 1953 here in Gambier, Ohio. It's very charming and very removed, but I think that helps me get some kind of distance. And that's important, because I think what I'm doing is trying to tell the truth about things. We have these kind of idealized notions of what it is to be young—"Isn't youth great?"—but I remember quite vividly that it was not great. You always wish you were more beautiful and the promise of young love isn't always delivered on.

Getting political comes out of the desire to tell the truth. In some ways, good writing is inherently political. You know, I don't want to see another mom character that's like a mom. I want her to be a three-dimensional woman. I want my woman characters to be effective, and I want people to just talk in the racist way that they actually do talk when their African-American friend isn't in the room. I feel like we have to acknowledge what's going on, and we have to make our characters as rich and interesting as people are. Ultimately the way the story ends is its political content.

What you're hoping for as a playwright is to be produced at a nice off-Broadway theater, or a large regional theater and they pay you well and treat you well and can hire good

actors, but that's not where your audience necessarily is. A lot of times you'll end up having the big success at a storefront theater in Cleveland. In fact, one of my plays was done in a bar in Washington and was a big hit because the tickets were ten bucks and my audience showed up. I've learned that sometimes it's the young upshot company with no money that's going to best serve the play.

I think my audience is a more adventurous audience. It's people who can go with the idea of a play about anorexia being a comedy. Or that a brother and sister can actually be in love and reenact the Kennedy assassination. It's going to be an audience that enjoys being shocked and provoked. To some degree, people go to the theater to illuminate their own lives. So a lot of times, the plays that are successful are the plays about middle-aged white people going through marital crises, and a lot of those plays are very good. *Dinner with Friends* is a very good play, and *Sight Unseen*—these are the kinds of plays audiences have responded to because they're seeing themselves on stage, and I don't belittle them in any way. But I think there's that kind of natural hunger to find themselves on stage—so when they find a teenaged anorexic instead, they're not necessarily going to go along for the ride.

One of the things that interests me is when you're in a room, whether it's at a dinner party or a meeting or whatever, and you will notice that somebody is always playing towards somebody in particular. They're orienting themselves towards that person. Sometimes it's sexual attraction, and sometimes they're orienting themselves towards the person with power, because they want to be promoted. But I will notice that there are these undercurrents that are going on in any encounter and that fascinates me. Our syntax reveals our souls in some ways. Our language is the way we put things together, and the way we put things together arrives at meaning. I'm fascinated with the limitations of language. People feel so much more than they're able to articulate. We spend the summers up in New Hampshire, and sometimes in the little local paper there will be a heartfelt poem in honor of a father who died or something like that. The poem is just awful—egregious—but that's not to say the person isn't feeling something enormous. I find something really touching in the fact that we feel more than we can say, or that we feel more than we're allowed to say, even when we're articulate like Edward Albee characters.

I pay attention when people are talking to me. The way a play starts for me is like me transcribing voices. I hear people talking, I try to write down what they are saying. At a certain point, I figure out how many people are talking—who they are—and a play begins. Also, years later I will realize who the voice belonged to. I wrote a play once about these two men. One was an older divorced man, and one was a younger man whose marriage was breaking up. It wasn't until years later that I realized that the older man's voice was that of my father.

But I love it, because speech is so lively and interesting and silly—how can you make up stuff as fresh as what we hear everyday? As a teacher, I've noticed that the kids that are the most successful listeners, or maybe the most successful at recognizing good material, will then go on to be the best playwrights. Maybe there is a correlation between finding good material and writing it. There is one person I know, and I'm just not playwright enough to take him on yet. His speech patterns are so insane that I haven't even tried yet. But I can't wait. He's real, and he's so much more interesting than anything I've ever written!

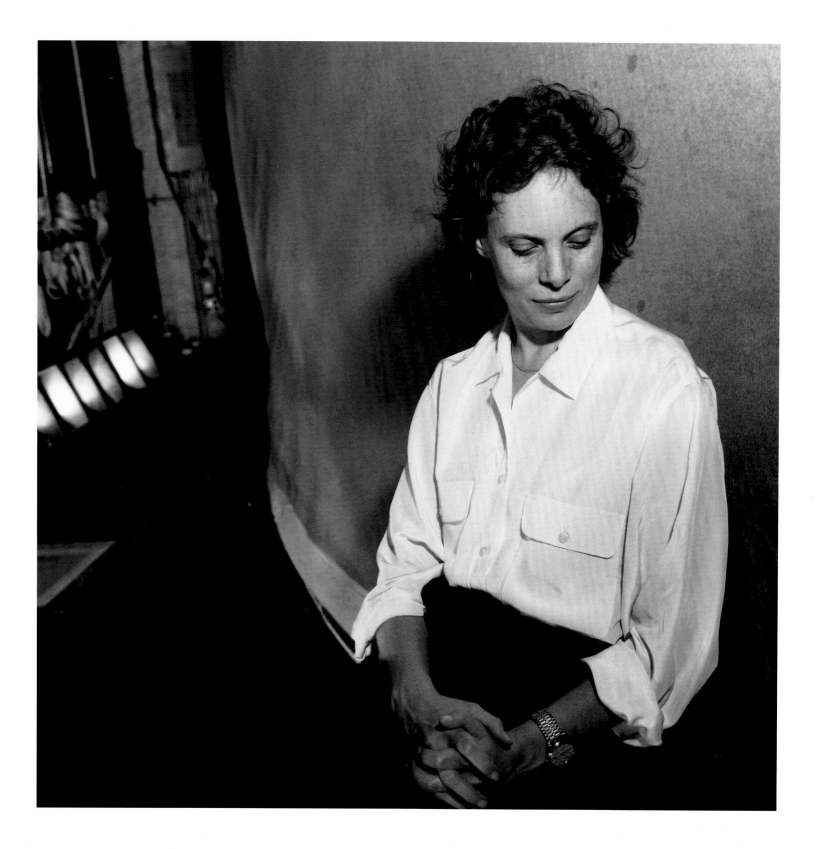

EMILY MANN

Born in 1952 in Chicago, Mann is a writer, director, and producer, and the recipient of many awards including six Obies. She has written numerous works, including *Still Life*, *The House Of Bernarda Alba*, *The Cherry Orchard*, and *Having Our Say: The Delaney Sisters' First 100 Years*. She is artistic director of the McCarter Theatre in Princeton, N.J., for which she garnered the 1994 Tony Award for Outstanding Regional Theater.

My first play, *Annulla*, was based on the aunt of my closest, dearest friend in college—she was a survivor of the Holocaust. She was a fascinating, dowdy old lady, who I just fell in love with and who helped me understand my own life better. She changed my life. Basically, every single play has changed my life through the people I've met or the ideas I've had to grapple with, the feelings I've had to grapple with. So *Annula* started me on this road.

I've always written—since I was a little kid and I could hold a pencil, I was always writing short stories and poems, and all kinds of things. I was acting and directing plays. I was acting at fourteen, and directing at seventeen. When I went off to college, I didn't think I could ever make a life in the theater. I didn't know anyone who did. I didn't understand that. And then for some odd reason, I decided I would. This was at Harvard in 1974, and it was before

Emily Mann

I was graduating, when a professor said to me, "Well, you know, you can't really do that. Women don't direct professionally. They don't direct plays professionally. You're very talented, but you should think about children's theater." And I thought, "Oh, I don't like children's theater." Not that I have anything against it, but I don't like to do it. I thought I could do whatever I wanted to do, and being told I couldn't just made me mad. So off I went, and did. I wanted to direct new plays, and there weren't that many that I liked. At that point there were the trailer camp plays—you know, everyone was in a trailer, angry, white ethnic, working-class, lots of drinking, smoking, tattoos, and anger. I just didn't relate to it. I thought, "The people I know and meet are more interesting than the people I'm reading about in these plays."

At about the same time, it was my junior year in college, and my father, a historian, had been made head of the oral history project for the American Jewish Committee. They were asking survivors to do testimonies and my father said, "That's great, and I'll help get it started—but it shouldn't be done by historians. The interviews should be conducted by people who are either relatives or close friends. It should be intimate, it should be truly revealing." I came home and there on his desk were all these transcripts, and I was looking at one of them and it was amazing. It was written like a play. It was a young girl and her mother, sitting in a kitchen, and she had described the kitchen just like in stage directions, and she said, "Mommy, I want to ask you things I've never felt I was allowed to ask you." And it was an amazingly moving interview and scene, and one of the things I remember most about it was she finally was able to ask her mother clearly the question she'd always wanted to ask her—how did you survive when the whole family died? She had been a ballerina in the national ballet of Prague and she said, "I thought of a moment of perfect

beauty. I pictured myself onstage with my partner trying to perfect a turn on point and I looked at the light hitting a certain way, and how my whole body would turn and twist and how that would catch the light, and I thought of that beauty. I knew everyone was dying around me, and I just kept my mind on that. It was a kind of self-hypnosis, and I am convinced to this day that's why and how I lived." And I was a mess, I was crying. I went to my father, and said, "This is one of the most beautiful scenes—can I put this on stage?" I wanted to direct it just as it was written, maybe edit it and shape it, but basically just do it. And he said, "No, that belongs in the archives of the American Jewish Committee, it belongs to the young lady who conducted the interview, and it's not anything you can have." Now, I think I probably could have gotten the rights, but he said no. But then he said, "Why don't you do your own? Why don't you go out and make your own interviews?" I remember a light bulb went off, and I thought, yeah, I've got to do that.

I was born blessedly, only seven years after the Second World War. I knew a lot of kids who were survivors growing up. It's just very present in my life. When I was eleven years old, my father just decided he was going to take us all through Europe. In the back of a car my sister and I were reading the whole time, we'd go from place to place (we were all over the continent) and it was the best education I ever had. What I remember most is my father giving me *The Diary of Anne Frank*. She was exactly my age. We never made it to Anne Frank's house—I got too sick. I thought I was her. That happens to a lot of kids. You just internalize history. I certainly did. I still do. I do this with plays and characters. I've had to learn as I got older how to protect myself. I used to take on other people's feelings and other people's fears and needs. I was just like a little over-sensitive child. I've learned, as I've gotten older, to put up

some kind of barriers so I didn't always absorb everybody's feelings and pain. But I think that is the curse and the blessing. It's been an instinct of mine all my life to put myself in another person's shoes. I can see the world through another person's eyes, and when I meet people that are telling me their story, I can often internalize their lives and I try to do it in their own words, because I feel like it's the most honest way to go. It's that simple. They're all so personal, these plays. That's what's so interesting. They're about other people, but they are incredibly personal.

Every one of my plays has come to me in a different way. Every single one of them. Either the story of something that happened or the person themselves has somehow gotten hold of my heart and I just can't shake it loose. There's someone you fall in love with or someone you become obsessed with or someone you feel great tenderness for and you need to protect. Often what happens is that the stories find me, or the characters find me. I can't shake them or I can't stop thinking about them—I get gripped and I have to write the play. It takes a lot out of me; it can take a few years out of my life—a lot of emotion, and a lot of angst, work, pain. I resist as long as I can. Sometimes it's rage. For my play *Greensboro*, I met the head Klansman, and it was utter rage. I thought, "I'm in a room with the devil." And then I thought, "Can I write from that feeling? I don't know." But somehow, I did.

I love the combustion that happens both between the live actors in performance on the stage, and between them, the story, and the audience. Because it's live, there's a conversation going on between the audience and the stage, and thus between the playwright and the audience. My plays often take down the fourth wall, so there's a direct connection between the actor and the audience, between the character and the audience, and I like that direct connection. That

also makes it different at every performance, because the audience is different at every performance, and in some ways the actor might be. So there is an electricity that forms on the best nights. And even on not-the-best nights, something's going on that's undeniable. A lot of my plays are not only stories about characters and emotions, there's often a political and social context and content. It becomes a kind of platform or jumping off point for a longer conversation. Hopefully, it's stimulating and challenging an audience to then go out and want to be thinking about it and talking about it. Because I don't do agitation propaganda, there's no easy answer for the audience, and hopefully I'm asking the right questions in the plays. Hopefully what I'm doing isn't advocating one point of view, but showing there are many ways to look at a particular set of questions, ideas, events—so let's talk about it. Let's think about it. Let's go deeper in it. Hopefully, it's subtle and complex, and asks more questions than it answers.

One of the things that's thrilling is: when you've finished a book, you've finished a book, but plays don't get finished. Plays are a blueprint for a live event. They're a form of liturgy, and yes, they can be appreciated, but they are meant to be performed. It's just amazing to have your work scrutinized by other brilliant artists who bring it to another level. It's fantastic. Plays are based on real life. Of course, that brings up the question of what is real life, and if you look at it under a microscope, what does that tell you about the truth or falseness of it? I like doing that. A lot of people believe in what they're telling you in the moment, but what they're telling you in the moment might be false. That's always interesting—what people think is true and what really is. Some people live their lives on the line, and that's interesting, too. I think *Uncle Vanya*'s built on that premise. Chekov knew about that.

Joe Cortfall was directing *Still Life* in Paris, and he would not let me into rehearsal at all, and I was quite shocked. Then, opening night, he wanted to change the last line of the play. I said, "You don't get to do that. You tell me why you want to do that and we'll discuss it, but unless I give you permission you can't do it." And he was doing his big old French," Silly woman, I'm so great and you are not" act. The line of the play was the Vietnam vet saying, "I didn't know what I was doing," and Cortfall thought it was getting him off the hook too easily. I said, "I don't think it does." So we talked about it and talked about it and finally I said, "Let me see how you're ending it," and I looked at it, and it was brilliantly staged. And all the way through, it was, "I don't know, I don't know, I didn't know what I was doing." So I said, "Okay, we'll end it on that line 'I don't know…'" And he said, "Oh, brilliant," and he did it. Well, it was brilliant. It was totally the play. Got the same laughs at exactly the same moments that I did. People cried at exactly the same moments that I did. By the end, he had punctuated all the silences with screaming Algerian rock music, so he had made it about the French guilt about the Algerian war as opposed to the Vietnam War. Sort of a trial play to the nation, talking to the nation about the war. It was so true and so beautiful, and then they all pulled me on stage, because in Europe they bring the author on stage, and I was rocking back and forth with them which was really scary. It was a great night and the only time in my life I had been absolutely just the author. It was an enormous triumph. It was great fun. I loved it. I was very young. It was a long time ago. I'm just remembering it. Wow.

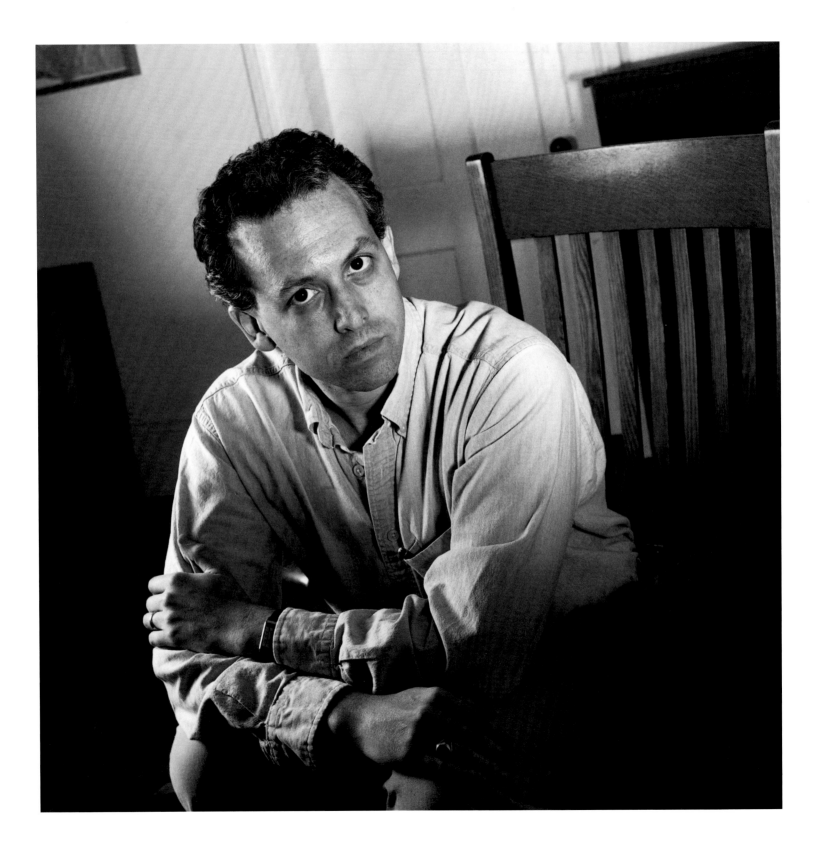

DONALD MARGULIES

Born in 1954 in Brooklyn, New York, Margulies has written many plays including *Brooklyn Boy*, *Sight Unseen*, and *Dinner With Friends*, which won him the Pulitzer Prize. He has received numerous other honors, including a Lucille Lortel Award, an American Theatre Critics Award, two Los Angeles Drama Critics Awards, two Obie Awards, two Dramatists Guild Hull-Warriner Awards, and five Drama Desk Award nominations.

DONALD MARGULIES

Drama is not real life. I've never attempted to capture real life, but to create a heightened view of life that allows us to see the familiar in a new light. What isn't said—the text that lies beneath the surface—is often much more fascinating to me than language that is spoken. I'll use overlapping in my dialogue because the sound that words make when they bump up against each other—the cacophony that occurs, the aural collage—is sometimes more evocative, and more interesting to me, than the explicit words themselves. Hearing every word of an argument is not as important as the music it makes.

In my earlier work in particular, I was fascinated by the lyricism of everyday speech, the inadvertent poetry of seemingly inarticulate characters. I learned a lot about language, and about dialogue, in those early efforts, especially how the attempt at self-expression was often more revealing than cogent speech.

If I gravitated toward "intelligent" or educated characters over time, it was because I found that it forced me to be more rigorous when exploring two sides of an argument. I discovered that getting into the head and under the skin of my characters made for a more fully dramatized conflict. I don't know my characters all that well when I begin a new piece. The more I write, the more I understand them and, as the drafts progress, I get a greater sense of who they are and what they want.

All of my plays seem to deal with loss in one way or another. Loss—of someone, of some object, of some intangible thing, of one's way, of one's values—surfaces from play to play. Some take on more directly the mysteries of family life, and the complicated bond that exists between parent and child. Sometimes, as in *Collected Stories*, the characters are not related by blood but they share a bond that is certainly as

powerful as that between a mother and daughter. *The Loman Family Picnic*, *God of Vengeance,* and *Dinner with Friends*, for example, all have to do with family life and values and loss, but they all could not be more stylistically dissimilar.

I set out to explore a problem or conflict as truthfully as I possibly can. Attempting to illuminate the truth is the essence of making art. If you're not telling the truth, if you're evading the truth by being glib or by failing to be rigorous, your audience will know it. If you haven't gotten to the core of your story, you have not only cheated them but yourself.

In a question and answer session after a radio performance of *Dinner with Friends*, I was asked, "When you were writing this, did you say to yourself, 'I'm gonna write a hit'?" I replied, "Absolutely not—anybody who does that is looking for trouble." I couldn't possibly do that. All I set out to do was write the best play that I could at that particular time in my life, with the experience and skills I had acquired, and hope that it spoke to other people.

Writers find inspiration in different kinds of places. I tend to write close to the marrow of my own experience, or at least begin there, and then transform it into something else. Once I hit on the structure of the play, once I'm satisfied with its shape and feel somewhat confident that I know how to build it, I'll start writing. It's then that I feel that I truly have a new play. The particulars may change, but the armature will generally remain constant. When I set out, I often don't know where I'm going. I don't like to know; I'll figure out the ending point once I'm underway. Getting there is the fun of it.

Sight Unseen began as a very different play. Originally it was called *Heartbreaker*, a multi-scene play that had a couple of scenes that were clearly stronger than the others, and those are the scenes that became the germs for *Sight Unseen*. Once I found the cubistic, time-shifting structure of that play, the ending became clear to me, and I worked toward that.

I never seriously entertained writing anything but plays; I don't really know why that is. I had been exposed to theater at an early age and found it exhilarating, but it wasn't until I was around twenty, and a disillusioned art student, that I tried my hand at playwriting.

When a play works, when you see it come to life on stage much the way it presented itself in your head, there's nothing more thrilling. Fairly early in my career, I had that with my off-Broadway debut, a play called *Found a Peanut*, which was produced by Joe Papp at the Public Theater in 1984. It was a glorious experience. Everyone was so committed and contributive, so kind to each other, that the work took flight. I loved the way it looked, the way it was lit, I loved the way it sounded, even. The ensemble playing was delightful. I feel so honored to have had that experience early on. I wish we could go downtown right now and see it. For me, it was a perfect realization, as ephemeral as a dream, and I took great pleasure in it.

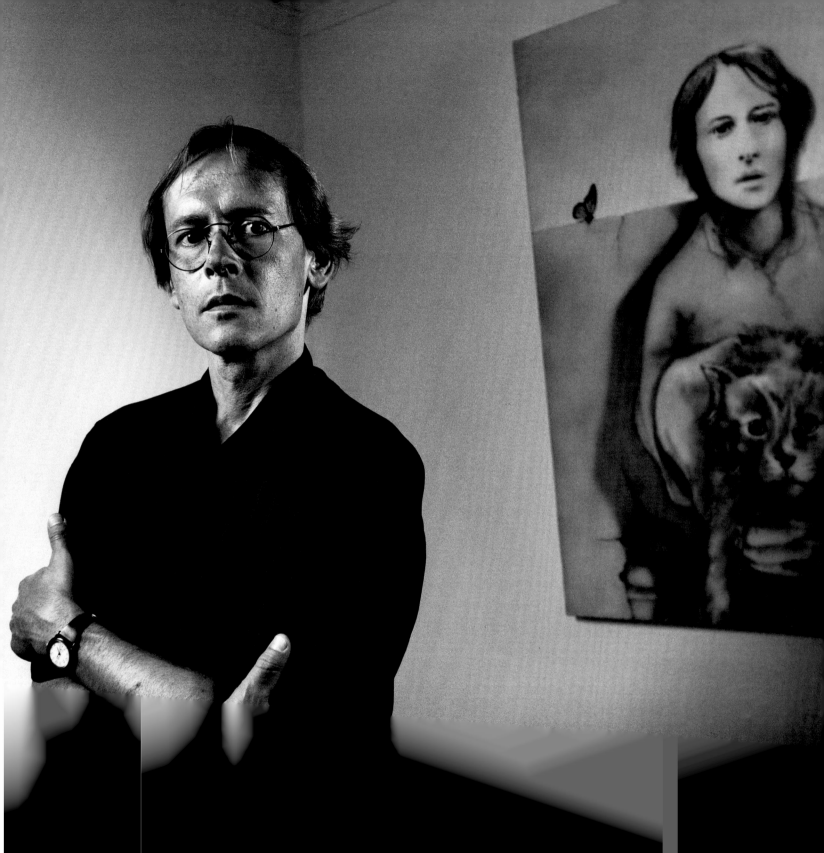

TIM
MASON
Born in 1950 in Sioux Falls, South Dakota, Mason is the author of numerous plays including *Six*, *The Fiery Furnace*, *Babylon Gardens*, *Levitation*, *Mullen's Alley* and *The Less Than Human Club*. He has won the Kennedy Center Fund for New American Plays Award, the W. Alton Jones Foundation Award, and the National Society of Arts and Letters Award.

Becoming a playwright makes not a lot of sense in my life. The theater was not an influence. Movies weren't. I barely watched television. And yet, when I was fifteen, I suddenly got rabies for theater. I had to be an actor. I just started reading audition notices and showing up for auditions, whether they had parts for a fifteen-year-old boy or not.

By nineteen, I was an actor at the Minneapolis Childrens' Theatre Company, and the artistic director prodded me to write a play for the coming season. So I began with reading adaptations of classic works of children's literature for the stage, and then I wrote a great many of those myself. Everything that I wrote was produced professionally and quite well. More importantly, I had deadlines. I knew that a cast would be assembled and they'd go into rehearsal on a certain date and tickets were already being sold to something that hadn't even written yet.

Eventually, a few years later, I went off to London to write grown-up plays of my own. I had no connections, but I had this place to live for very low rent in North London. I wrote *In a Northern Landscape* there, working in a flat that had no heat, only an electric fire that I could barely afford to keep running. So I'd warm up my fingers and then turn it off and then type until I couldn't anymore. It was a good year.

TIM MASON

For the first time, I was writing and there wasn't going to be a production. I had no deadline or boss or income. So that's when I learned to play psychological tricks on myself. I'd get up early in the morning and I'd walk with all the rest of the working droves up the hill to the Underground station. They'd all go down and take the train, and I'd walk back to my flat and start work. I've been doing this kind of "commute" for twenty-some years now.

Whether writing for an audience that is young or an audience of adults, I've only ever written to entertain myself. Fortunately, I have a pretty intimate relationship with my inner child. A friend of mine once said, "What's inner about it?" I'm always seeking to frighten myself or make myself laugh, no matter what genre I'm writing in. As to the deeper question of why, I'm pretty sure various childhood traumas led me to believe that human discourse is not to be trusted. That's so revealed in the language of the stage, where there's a text and a subtext, and the lie that reveals the truth. But people have to communicate even if they don't trust communication, so I think becoming a playwright was a means of saving my life, of actually being able to communicate even though, back then, I distrusted the whole shooting match.

The collaborative process is another example of how the theater rescued me from the silence of my childhood. It put me in a community, and that was one of its great virtues for me. There are times when I'm not happy with an interpretation. There are times when I'm astonished at how the interpretation is so much better than my original vision. It's a dirty art form, in a sense. It's muddied up with many hands and that also makes it so exciting when it works.

Some plays catch me by surprise. I was walking through the Metropolitan Museum of Art with a painter friend of

mine and suddenly I stood stock still. I was riveted by a thought that I hadn't been aware of thinking. What if Michael Rockefeller, the son of Nelson Rockefeller, didn't die in New Guinea? What if he chose to stay and let the world think he had died, and what if somebody had found him? I didn't even know that I'd been thinking of Michael Rockefeller. We weren't even in the Rockefeller wing. That was the birth of what became my play *Cannibals*. The mystery inherent in that moment was so exciting. I was just trembling with excitement and it took a few months before I began writing. A lot of times it will be a year, because the subconscious needs time to develop it. The subconscious is a great friend. I can rely on the subconscious to do the work. Even when I have faltered in my faith in myself, the subconscious says, "Don't worry. We're working on it."

Years ago, Marshall Mason at Circle Rep gave me a good lesson. He was very fond of my play *Before I Got My Eye Put Out*, and after reading it he said, "That one character, the fellow's editor—you really don't like him, do you?" And I said, "No, I can't stand him. I think he's at the heart of what's wrong with a lot of our culture today." And he said, "Well, you just can't do that. You can't dislike any character. You have to learn to love every character, even the stinkers." Nobody is a villain in their own mind, and if you get to know someone that you're creating in a genuine way, you have to understand them, and with understanding comes compassion.

In *The Fiery Furnace*, we realize by the end of the play that one of the characters, over the years of the story, has been increasingly beating and abusing his wife and children. He's pretty detestable. But I had to understand his point of view. I had to come to believe, like him, that he was just doing the best by his family against great odds. That's the lie that he created for himself that allowed him to get up in the morning and to anesthetize himself with alcohol throughout the day until he could do it all over again. You have to find a way of understanding everybody.

I think hidden in many of the plays I've written are questions of courage and cowardice. Characters are either called upon to be courageous or rise to that challenge and fail, and it's something that I am always feeling myself. It's important to strive to be courageous, whether it's with political beliefs or just getting through the day.

As a kid, my father and my brothers and I were involved with a camp in northern Minnesota for kids with special problems—blind kids, mentally retarded kids, emotionally disturbed kids, deaf kids, kids who used to be called juvenile delinquents. And from age five, I had lots of exposure to kids with all kinds of things going on. I think it added to the compassion bank.

In *The Fiery Furnace*, Julie Harris's character has a long speech in which she tells about the night the owl stole one of the children's pet ducks. There was Leaky and Deaky, the two pet ducks, and the owl came and lifted one of them up and carried it squawking away. It's a long speech. It's a pretty speech. And Julie Harris, in the course of rehearsal, finished the speech and said, "Well, that's the levitation moment. Did you feel that? It just lifted up off the stage." In every good play, there is for me a lifting-up-off-the-stage moment. That's what we playwrights are always looking for—the levitation moment where the surreal, corporeal self is transcended, our mortality is transcended, our failings and weaknesses are transcended, and we rise up off the stage—and there's an audience there to witness that moment. The challenge is to keep going until the next one.

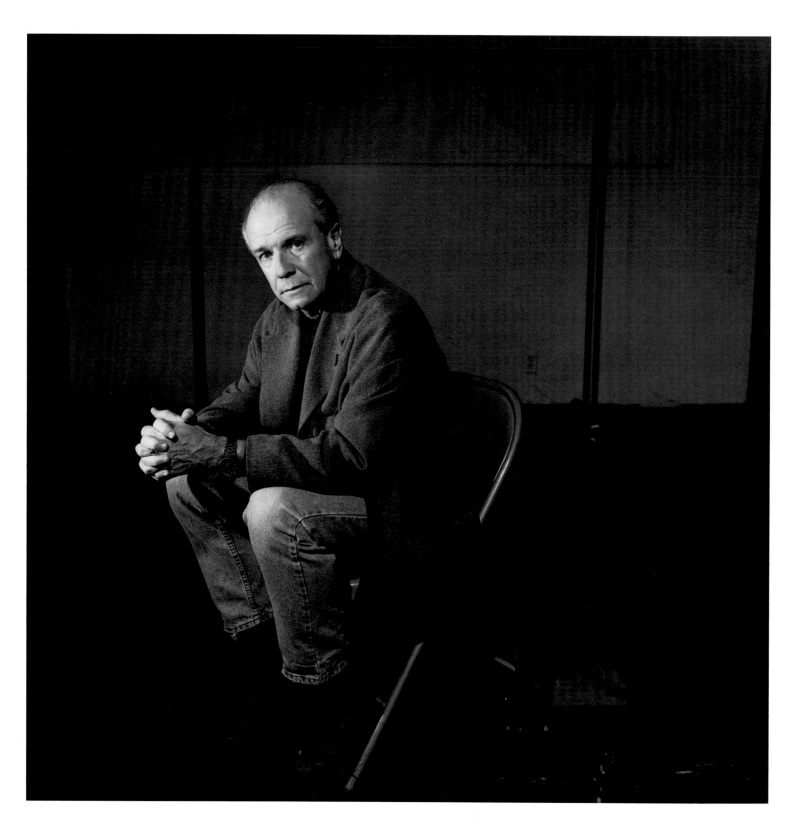

TERRENCE MCNALLY Born in 1939 in Florida, McNally is known for numerous plays, including *Frankie and Johnny in the Clair de Lune*, *Master Class*, *Love! Valour! Compassion!*, and *Lips Together, Teeth Apart*. He has also written books for several musicals including *The Full Monty*, *Ragtime*, and *The Kiss of the Spiderwoman*. He has won four Tony Awards, a Drama Desk Award, and an Outer Critics Circle Award.

TERRENCE MCNALLY

A play is not literature in the sense that it's a polished stone and can never be changed in the rehearsal process. However, I expect every word I wrote to be observed once it's been finalized. I'm also very insistent on observing punctuation. I like rehearsing, but I don't like improvised theater or actor's ad-libbing or actors adding "handles" on lines: "I means, you knows, etc." But when I say I don't think I write "literature," it's because to me working in the theater is so rough and tumble it's more like a body-contact sport than "art." If someone says, "Oh, I've read your plays," that's getting some of the information but not all of it. You are collaborating with other human beings in a very dynamic atmosphere. There's give and take between playwright and actor, text and actor, director and playwright. Literature is more formal. It's something you read in a book and it's just you, one-on-one with the text. Theater, as I said, is an art that involves many, many people, and the final collaborator in the process is the audience. So I don't call it literature. I don't mind calling it show business. Shakespeare was in show business. He also wrote great plays. History has decided to call them literature.

Critics have always, since my first play, reviewed me as a gay man, which I don't think happened to a lot of writers my age. Perhaps I was a little more out at an early age than they were. What does it mean to call someone a gay playwright? You'd have to ask a critic. It's just another pigeonhole. I feel I can write anything I want. As a gay man, I choose sometimes to write plays in which there are no gay characters. Sometimes there are. Some of the gay press berated me for no gay characters in *Master Class*. And I thought, "Well, how do they know that none of the singers who came in to audition for Callas weren't gay?" When you're auditioning a difficult aria for Maria Callas, I don't think your sexuality is an issue. When I want to write gay plays, I write gay plays.

Usually, I put characters in a situation where something is going to happen, as opposed to people sitting around talking after dinner. I mean, if you're going to do that, you'd better have terrorists come in with Uzis pretty quickly. Because real life is not that dramatic. But my plays also do not have a lot of plot. So I try to dramatize the drama in day-to-day life, which is kind of a contradiction—saying there is no drama in day-to-day life, but I try to find it, and find why people make the choices they do. Every time anyone asks you a simple question—"Do you want to eat French or Chinese food?"—there's a lot of history behind your answer, behind saying "Chinese" or "French" on that particular day or not. That interests me, why on a Monday night in May you say "French" and on a rainy night in March you say "Chinese."

You don't write plays to win awards, or you shouldn't. Any time people say, "This is really going to be a hit," they wind up with a great failure. When I wrote *Frankie and Johnnie in the Clair de Lune*, I thought that it would only interest people who were single and over forty. When I wrote

Master Class, I thought it probably wouldn't even be produced, because it's so specific about one thing. And those are probably two of my most performed plays.

I had a high-school English teacher, Mrs. Maurine McElroy, to whom *Frankie and Johnnie* is dedicated. She always insisted that we write what we knew about, that we be specific. When you try to write for the general public ("Oh, this'll lay 'em in the aisles") you're going to fail. The more specific you are, the more universal your work becomes. It's also what you know emotionally, so that you can empathize with a character. I think I would have trouble writing a deeply depressed person, because I've never been that. But the canard that a gay man can't write good women is ridiculous. Or that you can't write out of your age or ethnic group—that's ridiculous. A young man can write great old characters. Our minds are infinite.

I think all of the protest over *Corpus Christi* had nothing to do with theater. It had to do with homophobia and religious censorship. A theatrical work that engages an audience's moral senses—I think it's terrific when you do it. But certainly the atmosphere in which *Corpus Christi* was premiered in New York was unfair to the play. I didn't really see it until last year in Chicago when I could just buy a ticket. They didn't know I was there. It was a good production. But in New York, it was such a crisis every night, with protestors in front of the theater—they were there every night —and the police dogs and the metal detectors inside. That atmosphere is anathema to art, especially with a play like *Corpus Christi*, which was not a protest play. It was a very loving play, a meditation on the life of Christ. It was not an angry play that deserved people outside screaming at it.

My first play had violent responses so I feel like I've come full circle: *...And Things That Go Bump In The Night*.

Some people thought it was very offensive. There were pickets. And there were also pickets saying they liked the play. There was booing and people yelling "Bravo" after every performance. I wasn't expecting it at all. Obviously, you write a play to communicate something, not to have people deride it, boo, not listen to it. That's not the goal of theater. I think the goal of theater may be to get people to change their hearts, which is harder to do than to get them to change their minds.

I feel I can affect people enormously with my work, just on a one-to-one basis. When I get a letter from someone saying what my play meant to them, and how it affected their life, I feel like I've succeeded. When I teach playwriting, if I have one good student in a class of thirty, I feel that's why you do it. And if you write a play and one person out of a thousand is touched by it, or gets it, you have to be proud of that, and say, this is why you do it. Not to win Tony Awards and earn money. Those other things are nice when they happen, but...well, no one is stupid enough to go into the American theater to make money.

There's a play of mine called *Andre's Mother* that I adapted for television. I must have gotten maybe a couple of hundred letters from mothers saying that the piece had helped them understand the pain they had caused their own sons by not accepting them for who they were. And then when these sons died of AIDS, they were completely desolate. Every letter was simply signed, "Pete's Mother" or "John's Mother" or "Billy's Mother"—never a last name. Not once. I just found that very moving. That's why you write plays...and that should be why you're on this planet. You don't have to be an artist. Just tell the truth. Speak in your own authentic voice. Help another person. Reach out to him. Touch him.

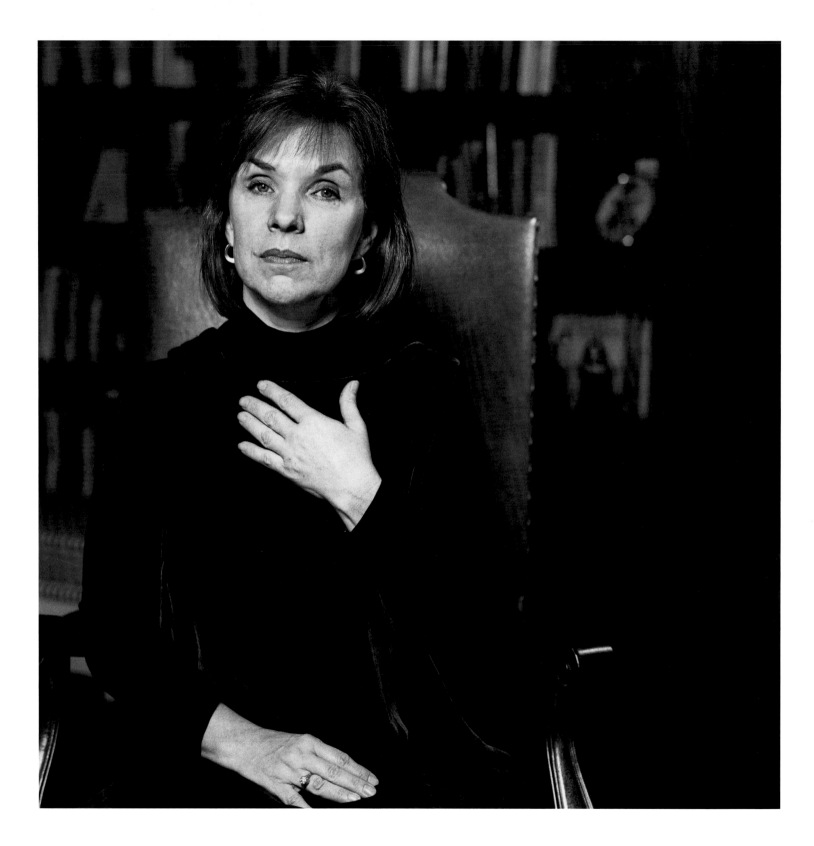

MARSHA NORMAN Born in 1947 in Kentucky, Norman won the Pulitzer Prize and four Tony nominations, winning the Best Play award for her 1983 play *'night, Mother*. She had received great success from her first play, *Getting Out*, and went on to write others, including the books to the Broadway musicals *The Secret Garden* and *The Color Purple*. She is co-chair, with Christopher Durang, of the Playwriting Department of The Juilliard School.

MARSHA NORMAN

Writing plays and musicals and movies feels like a real low-down life most of the time, though truly, I wouldn't trade it. Actually, in one of my lowest career moments—no jobs, no prospects, no ideas for jobs, no prospect of ideas—I had the startling revelation that this was the life where I got to be a writer, that this life was the one I longed for in all the others. But we are a scrappy bunch, playwrights, and can be counted on to dance at parties and be very loyal, though not always on time.

There's this odd idea you sometimes hear out there in the world, and that is that everybody has at least one play in them. There does seem to be evidence for this—all the time, people come up to me and say, "Marsha, I have this great idea for a play." What they hope, of course, is that I will write their idea for them, and make it as brilliant as they would if they only had the time to sit down and get the thing on paper. But, "Alas," I tell them, "the only person who can write your play is you."

On the simplest possible level, a play is a piece of machinery. Like a ski lift. Like an automobile. Like an airplane. All of which may be beautiful in themselves, but which have a single justifying purpose and that is to take you somewhere. In the case of a play, it must take you from where you are when you enter the theater, to where you are when you leave. A play that doesn't take you someplace doesn't work. It doesn't move you. You walk out and you say, "It didn't go anywhere," and you call up your friends and you tell them you hated it and they stay away and the show closes.

You can have the most fantastic Mercedes coupe in your driveway, and the finish can be flawless, and the seats can really be comfortable, and you can even have Harrison Ford sitting in the back seat for God's sake, waiting to talk to you. But if the car won't run, it's going to be a really long

afternoon. Nobody wants to come over to your house to sit in the car. Not for two hours they don't. Even if you've got both Harrison Ford and Tommy Lee Jones in the back seat. Sometimes actors think they can make a play move in spite of itself. But they can't, and eventually, even though they believe in you and your talent, they get out of the car and leave you for some other vehicle, and without actors, you are really truly stuck.

What is a good subject for a play? This is the easy part, actually. Or should be. It's the thing we want but we can't have. I want to avenge my father's death. I want to go to Moscow. I want my husband not to call me his little bird. I want to marry this cute guy from this family that my family is fighting with. I want my sons to respect me. I want this guy Godot to show up. I want to be happy. I want to be King. I want to be dead. It almost doesn't matter what it is that the main character wants. It is the wanting that is the subject of the play.

But the main character doesn't just want something. He *really* wants it. He wants it *now*. I mean in the next two hours. I am not exaggerating this urgency thing. One of the ugliest sights in the world is watching thirteen hundred people, trapped together for two hours, all of whom have paid fifty dollars for the privilege, watching your audience who came in hopeful and happy, watching them turn on a character whose problem is that he maybe wants a little something. We all know what it feels like to want things. What we want from the theater is the chance to see what happens if we ask for what we really need.

Occasionally, some genius writes a play about more than one character. But not often. Most good plays are about one person, and what that one person needs. Anybody who has ever tried to satisfy two needy children at once knows it is

very hard to pay attention to two sets of needs. In life, you sometimes have to do it, but in the theater, you have the luxury of just considering, for two hours, the longing of one heart.

We care about the needs of one person because that is how we go through life. As one person. And when we see what someone else wants, and hear what she has to say about it, and see what she does, then we know who she is, compared to us. Which is how we learn most things— by comparison. Character develops by comparison, too. Moment to moment, we watch the main character as if she were us. As if we wanted to be king, as if we wanted to marry Romeo. And if the writer has done her job, at the end of the play we haven't just watched, we have actually felt what it was like to be Juliet, to be Blanche DuBois, to be Mrs. Antrobus. The playwright's task is to give the audience the experience of being someone else, of living the crucial moment in someone else's life.

Plays seem to unfold on the stage, effortlessly, humorously, carried along by the ticking of the clock and the tendency of people to keep talking. But they are anything but accidental. Good plays answer the audience's questions as they ask them, but not before. They don't burden the audience with information they don't need, and they do provide information, relief, and amusement, as necessary.

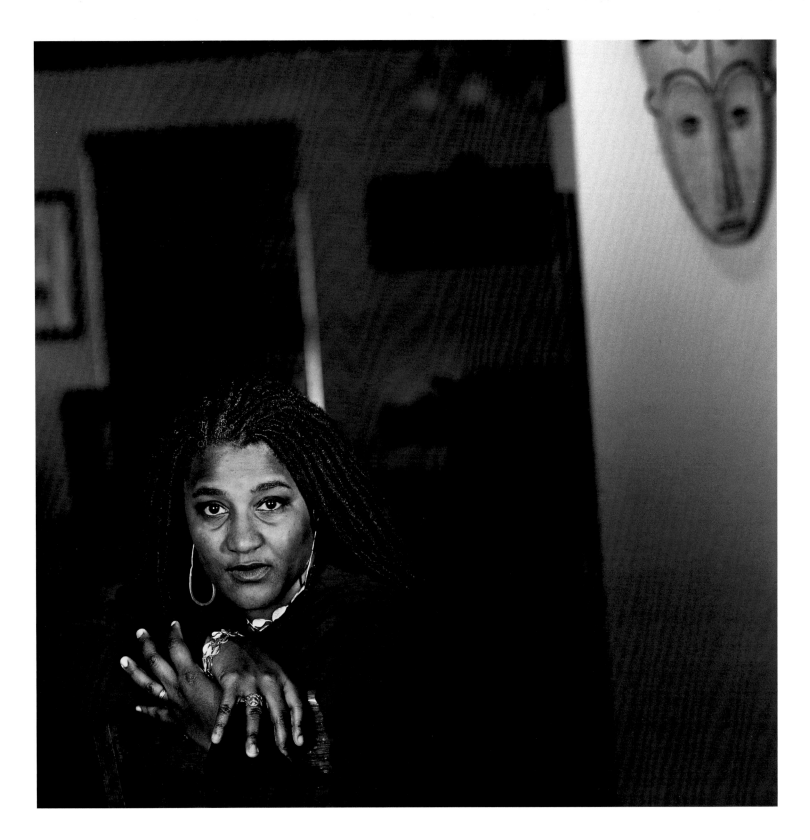

LYNN NOTTAGE

Born in 1965 in Brooklyn, New York, Nottage is the author of numerous plays, including *Intimate Apparel*, *Poof!*, *Fabulation*, and *Mud, River, Stone*. She has been awarded playwriting fellowships from Manhattan Theatre Club, New Dramatists, and the New York Foundation for the Arts.

For me, storytelling began around the kitchen table. My grandmother was an amazing storyteller and also an amazing performer. I imagine had she been born in another age, she probably would have turned to the stage or she would have written. My mother, too, was a very social woman and she always had tons of neighbors and friends who would come by and sit around the table well into the night, talking. I would listen to these women talk for hours and hours, a wide range of women from schoolteachers to politicians to activists to professors to artists. They would tell stories of things they had heard or things that had happened to them, just the stories of life. Some of the stories were so rich and wonderful and subsequently fueled my writing, and continue to fuel my writing. I imagine there are traces of those women in everything that I do, and probably until the day I die there will be elements of things I heard around that table that will color my work. I don't live in that same kind of close-knit community in which friends live right next door, but in some ways the theater has become that community for me. It has become a place in which I can share my stories.

LYNN NOTTAGE

I think I've chosen this medium of playwriting simply because that's how I hear the stories told—in the voices of the people telling them. I'm not someone who necessarily has a really keen eye for detail, and that's why I'm not a visual artist, and that's why I'm not a novelist. I am interested in telling stories that haven't been told, and it's playwrights who are always interested in trying to figure out a way of reinventing the story. And because so few African-American female stories have been told, there's this ripe, unexplored territory for me, and it stretches back thousands of years. I feel blessed that I have so much to write about; blessed and burdened. To understand history, one has to understand personal history, and because there hasn't been a lot of literature that hasn't been on the historic record about African-American women, I feel it is part of my mission to find these stories.

At first, I wasn't sure that this was what I wanted to do. I did it because it sounded like something that—I don't want this to sound haughty—but something that I found I was pretty good at. It seemed like the path of least resistance. At the time when I made those choices it felt like the lazy choice. I applied to graduate school directly out of undergraduate school and got into the Yale School of Drama. I wrote my plays; they got produced. I thought, "Oh, but life should be harder." There's more to life than making up stories and putting them on for an audience and making people laugh. I felt in some ways that it was incredibly decadent and that I needed to have a fuller, richer, life experience. I hadn't penetrated the real world. I didn't want to continue to live outside of the world, as artists do. I felt like I had to live in the world before I could comment on the world.

I applied for a job, and inconceivably I got the job, at Amnesty International, as the national press officer. I had

no idea when I got the job that it entailed an impossible amount of work—and I also met the most incredible people I will probably meet in my entire life, from Nobel Peace Prize winners to award-winning journalists to indigenous folks from Colombia who suffered at the hands of their government. Really fertile minds, people who wanted to change the world. I found that incredibly exciting, and different from the kinds of people in theater. Theater people would speak about wanting to change the world, but here were people that were actually taking steps to try and do it.

It was a twenty-four-hour a day job. I literally had no time to write. That made me profoundly unhappy, and also there were political things going on in the organization that I had questions about. But one thing I did while I was at Amnesty is I produced this evening with the Naked Angels theater company called *Naked Rights*, in which we commissioned a bunch of playwrights to write plays celebrating the anniversary of the Universal Declaration of Human Rights, the document all of the member states of the United Nations have to sign on to. In doing that, I thought, "This is really exciting," because the playwrights had written really imaginative, funny, moving, plays about human rights, and people who would not necessarily read an article in the newspaper about human rights would spend fifteen minutes contemplating those issues in the theater. I realized then that there is a place for what I am passionate about—for my two passions to occupy one space. So I came to that conclusion and I came back to playwriting.

I realized at some point that I had to embrace the notion of being a playwright in order to become a playwright. That was the turning point for me, emotionally and intellectually. I can't even tell you specifically when it was. For a long time my identity was sort of amorphous and I always got a

little embarrassed when I was at dinner parties and people were saying, "What do you do?" It's like, "Well, I temp," but that didn't seem right because I'm not a professional temp. I'm a playwright, but I always felt apologetic when I said that, because they'd then say, "Well, what have I seen that you've written?" And I'd be like, "Oh, I don't think you've seen anything." And they'd say, "Uh huh," and they'd walk away. But I thought, at some point I'm going to assert myself as a playwright, and I'm going to fill that identity in, and I'm going to deal with how people respond, and say confidently, "You have not seen anything that I have written, but I am still a playwright. I'm writing plays." I think August Wilson said something like this: "A writer writes." And if you're not writing plays, you're not a playwright. You don't have to be produced, you're just writing your plays, and as long as you're writing plays, you're a playwright.

In *Intimate Apparel*, there's a moment I had written on the page which is a silent moment. The rest of the entire play hinges on this silent moment, but the actresses who had been playing the role couldn't understand how a silent moment could be the most important moment in the play. But I remember sitting at the Mark Taper Forum with *Intimate Apparel* and Viola Davis looked out into the audience and she did this moment, and I was like, "Oh, my God. It is exactly as I had imagined it." And I thought, "What are the chances of that ever happening, that the moment is what you imagine it to be?" That was incredible.

But I get most excited when I first hear the voice of a character in my mind, and I think, "Ooh, who's that? What's this going to be about? Oh no. It's going to be two years of my life." When that new play comes—and I don't know why it comes, but it's just there—that, for me, is the best.

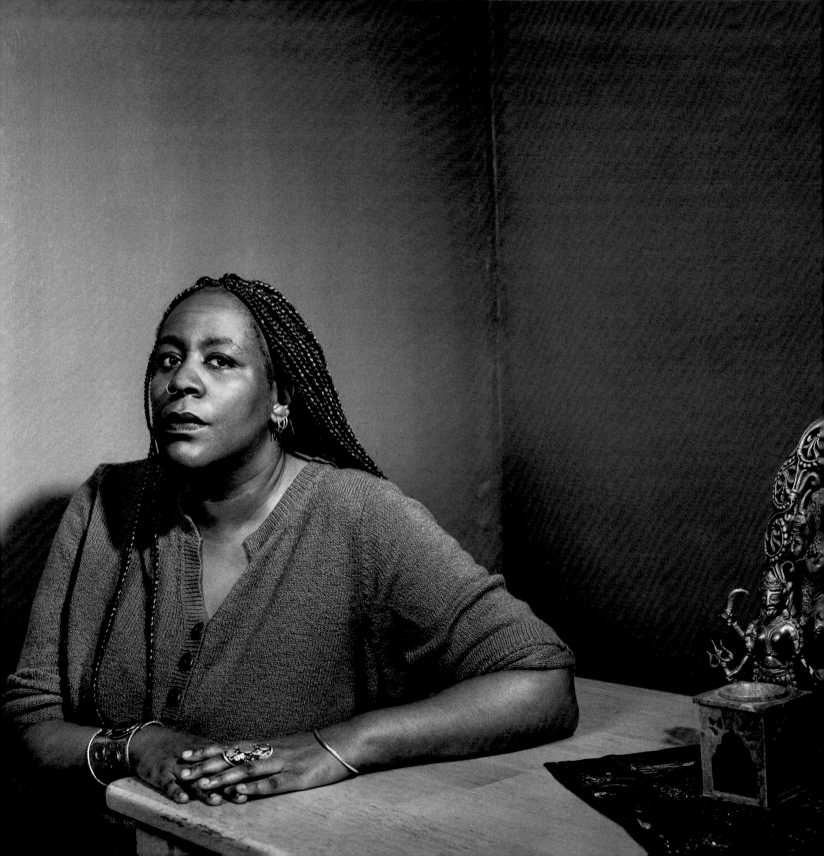

DAEL
ORLANDERSMITH
Born in 1960 in East Harlem, New York, Orlandersmith has written and performed in numerous plays, including *Beauty's Daughter*, *Yellowman*, *The Gimmick*, and *Leftover Life to Kill*. She is the recipient of an Obie Award and a PEN/Pels Literary Award, and has toured extensively with the Nuyorican Poet's Café thoughout the U.S., Europe, and Australia.

Dael Orlandersmith

When I was fifteen or sixteen I became a member of the Nuyorican Poets Café, and that's when Miguel Punara wrote *Short Eyes*. He formed this group which was specifically for Hispanic and black kids or white kids who didn't do theater in a linear way. To make a very long story short, I began to do other theater down in the Lower East Side. The stuff I wrote was poetic monologue. It was always meant to be performed. I've always written poetry; some people have gone so far as to call me a musician. I listen to music and I try to write like a musician, so it depends who you're talking to. I've always written poems and I've always written characters. I guess they are poetic characters, for lack of a better term. I was always in love with actors. This was in the late sixties, early seventies—on T.V., you would have Steve McQueen week, Paul Neuman week, Brando week. And the first thing I ever saw Brando do was *Fugitive Time*, written by Tennessee Williams, *Orpheus Descending*. I was like, "What is this? Incredible."

I began to write out of necessity. I'm glad I can write because of the stuff that was available to me as an actor, like playing the overweight welfare mother. I was asked to read for certain things and I was like, "You've got to be joking!" Or the script was cool, but to make it more "authentic," all the s's and the g's would be taken out and "honey" and "child" would be thrown in, and I was like, "I cannot fucking do this anymore. This is fucking sick." That's part of the reason I stopped auditioning and said, "I'm going to write my own stuff."

When I first started writing, I said, "This is *a* story, not *the* story." Writing for an entire race or writing for an entire sex is crap. If we're going to look at "black theater," if you're going to look at it in that regard, well, what we always see is the Southern experience, or the urban ghetto experience, or the church experience. The church experience is either

Baptist and/or Methodist. I'm a recovering Catholic that leans towards Eastern thought, but I have respect for all religions. There are black rock and rollers, there are black jazz musicians, black opera stars, black Europeans. When we just keep ourselves in a box we're playing into the bias. What I try to fight, and I fight it vehemently, it is a given that I'm black and female, but whatever someone's concept of that is, I've been fighting that a lot. That gets on my nerves. A friend of mine, who is gay, was told, "You know, you're a very good writer, but you don't represent our people well," and I said, "That is playing into the very thing you're trying to get out of." Jimi Hendrix didn't become a brother until after he died. Years ago, when Whoopi Goldberg was dating Ted Danson, and they had that whole "blackface" thing, Roseanne Barr said something really hip, and a lot of people got mad. She said, "Black people don't realize it, but Whoopi Goldberg is not making fun of black people, she's making fun of white people, because I'm telling you, as a white person from Utah, a Jew from Utah no less, this is the way people think." But a lot of people didn't get that. It's trying to sever someone's voice. There a lot of people I don't like, but to sever their voice is to sever mine.

Right now, I'm fighting other people's perception of what they think I should be. I wrote this play called *Rawboys* with Irish characters which, justifiably so, got mixed reviews. This one woman, she gave me a racist review. I'd like to kick her ass. She hated the play—she has the right to hate the play, but her thing about it is, "There's enough self-loathing Irish people, they don't need a Black woman to jump on the cudgel for them." That's really fucked up. She was saying, how would I like it if someone made a general statement about all African-Americans being lushes. It's like, "You really don't know what you're talking about now." It was really strange having to go through that.

People do have an expectation of what they think I should be writing. When people look at me, they go, "Dael, what made you write that play?" Why can Edward Albee write about the life and death of Bessie Smith, Neil Jordan, *A Crying Game*? I mean, we can give many examples. As someone who's on the planet and in the world—why not? Why can't I write this piece about Irish people?

I'm not interested in the beauty queen. I'm interested in the beauty queen if she gets her face slashed. Now you're gonna have to ask, "What are you going to do now, darling?" Being a beauty queen, that's easy. But what are you going to do when your breasts begin to sag or you get your face slashed? What are you going to do then? That's what I want to know about. I would like to sit down with the person who has to lose everything and has to build it back up. I believe in rights of passage. Let's say that you lost everything you ever had, and you had to fight to get that back—what would interest me about you is your inner life. You have to take a good hard look at yourself and say, "You know what? I can't slide. Now I'm getting my ass kicked, but I'm going to survive this. I have to look at my own ugliness. I have to look at my own greed. I have to look at my own stuff. The stuff that people tend to suppress and hide." I'm not interested in victimization; that's really easy. Most people can tell you a hard-luck story. But what about the evil within yourself? What about the vulnerability, the loneliness, and the depression within yourself? Those are the people who no one watches. I'm interested in what people think and how it applies to all of us.

People talk about the rhythm in James Baldwin's work. There's a lot of music in James Baldwin's work, there's no lie, there's no doubt that there is. There were country rock and blues influences in Sam Shepard's work. This is pretty amazing. See, we always talk about what separates us, but

what links us, too, because of and beyond race, ethnicity, and gender. For instance, I can look at *Long Day's Journey into Night*, and I know that play. I lived what was in that play. By that I mean, I grew up in East Harlem and the South Bronx, surrounded by a lot of junkies and alcoholics. I've known a lot of people in the New York streets like that. I remember the first time I watched it—it was one of the 4:30 Movies of the Week. That was Katharine Hepburn week. They showed it in two parts, and the whole time, I'm going, "I know this man." That's the stuff that interests me. Those are the voices that are "other." Other voices, but we're doing the same thing. When I saw *Death of a Salesman*, there was an older Jewish gentleman wearing a yarmulke and an Indian gentleman next to him sitting behind me. Both these cats were in their seventies and they both teared up, and I'm listening to them talk—they weren't together, but ended up talking. The old Jewish guy says, "Every time I see this play, it just makes me think of my father." And the Indian gentleman goes, "I'm thinking about my father, too," And I thought, that's what it's about. That's what it's all about. I'll never forget that.

I saw David Rabe's *Pavlo Hummel* many times when I was a teenager. I had a major crush on Al Pacino, who was starring in that play. We all did. He has this one line, "I want to get laid," and from the balcony, we're all like, "Come up here, we'll get you laid." It was ruthless. We snuck in to see it all the time. I was sixteen, and what happened was people would go out for intermission and you'd go in. And no one knew. But I will always remember, just watching that, it was like, "Shit," because people were taking chances back then. Now what's happened with Broadway, it's almost like a film. You have to have a name attached to it, there's nothing but revivals being done. And if it is a new play, it has to be safe enough for the audience to walk out with that awful word: hope.

All these people, especially American audiences, are looking for hope, but hope in all the wrong ways, at the expense of looking. Human nature is comprised of both the dark and the light. There's good, there's evil. There's happiness, there's sadness. Things cannot exist without the other. Hope has become this gratuitous Dr. Feelgood formula for everything, at the expense of truth. And that bothers me. Hope means we can wriggle in our seats, and I'm looking at you and everybody, because you've given us permission to wriggle in our seats, because we've recognized something within ourselves and all of us have this. That's what I mean when I say "fuck hope." The role of theater, to me, is not just about entertainment, it's about showing us ourselves and there's a dark nasty part of ourselves, but it's also beautiful and mysterious. It's great and it's gorgeous. You're supposed to be learning about stuff, and sometimes that stuff is uncomfortable, but it's okay if all of us are uncomfortable. Then we become comfortable with being uncomfortable. You're supposed to be uncomfortable. Life is uncomfortable. I like that. That's the stuff that interests me.

I don't want my work to be seen as alternative work. But also people have this perception about people who come from a certain place, and sometimes it's just not right. I remember in the South Bronx, we'd have these guys on the corner near my friend's house drinking all night long—four, five o'clock in the morning these guys are still out there. Ray and Anthony. Ray was Puerto Rican and Anthony was black. Ray would start singing Sinatra. And I heard Ray say, "My boy was Frank Sinatra. But no one's gonna buy the fact that I was Puerto Rican and I wanted to sing this." I would sometimes sit on the stoop and listen to these guys talk and, man, the stuff that I learned! I mean, somehow Ray made this connection between Sinatra and Stravinsky and to this day I'm trying to figure out how that is. But when he said it, it made perfect sense. They could

talk about all kinds of music and make these incredible ties. I remember Anthony said something like, "I really wish I pursued piano because I'm a Baroque freak, man!" People, no matter where they come from, are multi-textured, multi-layered. They're not just this one thing. Sure there are social ills. Of course, there's violence—it's a given all that shit is there. But those are the people that I'm interested in, too.

I remember being an outsider, too. When I would come downtown, people couldn't believe I liked rock and roll. I was hanging out in Max's and was seeing bands like the Ramones, the Talking Heads. I was going to CBGB's. One time I danced with Lou Reed. It was at the Ocean Club. Back then disco really separated people. Disco was really for blacks, Hispanics, Italians, or Asians. You'd show up at CBGB's and they'd be like, "We don't play disco here." "Do I look like a disco queen to you, motherfucker?" Then I'd be dancing with the bands. I became cool all of a sudden. But then I'd go back home, and everyone was like, "Oh, man, you're into that whitey shit." There was that. Not necessarily in my immediate household but the surrounding area. So I'm interested in the outsiders. I'm interested in the people who are on the fringe, people who have to invent themselves, who've been forced to invent themselves—and in that regard it is all autobiographical, too.

SUZAN-LORI PARKS Born in 1964 in Kentucky, Parks won two Obie Awards and the Pulitzer Prize for *Topdog/Underdog*. Some of her other numerous works including *In the Blood*, *Getting Mother's Body*, and *Fucking A*. Additional awards and honors include grants from the Kennedy Center Fund for New American Plays and the New York Foundation for the Arts, as well as a MacArthur Fellowship.

Suzan-Lori Parks

While I was a student at Mount Holyoke College I had the fortune of taking a short-story writing class with James Baldwin. We sat around this big library table and he sat at the head of it. Every week one or two of us would read our work, and whenever I would read, I'd gesture a lot and perform all the voices and act out all the parts. At one point Mr. Baldwin asked me, "Have you ever thought about writing for the theater?" And I never had thought about writing for the theater, but I thought about it after that.

I write plays and novels and screenplays too. I also play guitar and write songs. The theater was a great place to spend my early writing years. Writing plays is the best training. You have to be vigorous. You have to be rigorous and flexible, strong and gentle, hard and soft, at the same time. You have to be able to be alone and write, and yet you've got to be able to be with people and stage the thing. Sometimes they'll give you constructive or less-than-constructive criticism—you've got to learn how to roll with that.

I'm writing a play right now—I was working on it when I was coming down the elevator. "They regard the painting."(That's the stage direction I just wrote.) I figured I'd do some work on it while I was riding in the elevator, and I had a minute. My writing process is less of a drive to write about an issue and more of a desire to follow the play. That's one of my theories on playwriting: the play is already written. What the writer does is follow the play/get out of the way. You're not making it up so much as you're digging it up. It's already there, you just dig. You just follow. So today, coming down in the elevator, I was following the play and I heard a line. I was having an interview, eating lunch, hanging up the phone, putting down the leg of chicken, standing up, putting on my jacket, coming down here, and I wrote some words, too—four words, whatever. I like them. Then I wrote a little dialogue.

I write pauses into my plays. They're called "spells." They're moments of great energy—often moments of emotional transition. In the text you'd just be seeing the character's name and no dialogue. On stage the actor could be standing still or they could be moving, but there'd be silence. The silences are just as important as the words. The words lead up to the silences, or the silences burst open into language. There are places in my plays when spoken language can't contain the energy—that's when the characters sing. Yeah, characters in my plays often explode into silence, or into song.

Corduroy and velvet feel different to the touch and it's the same thing with a novel and a play: they feel different to my writer's touch. My novel felt thicker: there was more to it. Yeah, more words, but also, unless you're reading aloud, a novel is a very loud, very wordy, but silent event. Weird, right? Plays have more space, more breath. So the novel, as it comes to me, would announce itself differently than the play would. The song announces itself differently than the screenplay or the essay. They feel differently, sound differently, right from the first instant, right from the jump. So I don't get confused. I always knew *Getting Mother's Body* was a novel, *Topdog/Underdog* was always a play; *Girl 6* always felt like a movie, *Yazoo Avenue* was always a song. I was

listening to them, right from the jump, so I didn't confuse them with their cousins. What's cool is that the writing process for each medium is similar, and different too—but more the same than not. You know that Michelangelo painting on the ceiling of the Sistine Chapel? God reaches out to Adam, Adam reaches out to God. That's what all writing is like for me. I'm just an Adam, reaching out to God.

When I was just starting out in theater, I was pretty ignorant and thought it was just this goofy scene filled with people who wore funny hats and spoke in affected voices: "Dahling, Dahling, Dahling," all the time, and I wasn't into that. Now I know theater is full of people with tons of energy and dedication, who work long hours for little money to produce brilliant and gorgeous works of lasting value. I think lots of people who look at theater from the outside get the wrong impression about it. And what's really trippy—lots of people don't consider plays to be literature, because they just don't know. I feel like theater is this beautiful living thing that existed long before we did, and we've all got lots of catching up to do.

With *Topdog/Underdog*, the title came first, years before I started writing the play, years before. I had it as a Post-it on my wall: "*Topdog/Underdog*: cool title for a play." And then, two or three years later, I was talking to a friend and said, "I have a crazy idea: two brothers—Lincoln and Booth," and then I made that drum-roll sound and we started laughing. She said, "You ought to go home and write your play," and I went home and started writing it.

For me, writing is not so much a choice as it is a necessity. It's like having a cold, having the flu, being grabbed at the back of the neck by a strong and unchanging hand. Writing is the only thing that will get that flu out of your system, get that hand off your neck.

I love Eugen Herregel's *Zen in the Art of Archery*. He talks about learning archery, not in order to learn how to hit the target, but rather in order to learn how to understand the mind. That's why I'm a writer. I write to show things, tell stories, yes, but underneath all the waves and all the layers, I practice writing in order to understand the mind.

My most magical writing moment so far was when I was writing *Topdog*. I sat down and could feel the play pouring into my head, like it was silver liquid being poured into the top of my head—that's what it was like. And that was pretty great. But then, a few days later, when I'd finished the play, I had to work on another play and the process didn't feel like silver liquid at all. It felt like digging in the dirt, but I wrote anyway. I'm not afraid of getting the words wrong at first. I enjoy writing more than I enjoy writing well.

When I was growing up my mom and dad would tell me, "You're hard-headed." They're right, but I'm also very patient. I'm not in a hurry. In 1990 I won my first Obie Award. I was one of those writers who had eyes only for her work and none for the awards so I didn't even know what an Obie was. I was so out of the loop. It is a great honor and I was very fortunate to win one early on, but still, I'm not in a hurry to get anything. Success is great and the attention is great and the Pulitzer is wonderful and heaven-sent and the MacArthur grant is a blessing, but I love the writing moments best. Whether it's the silver liquid or the ditch digging. Either way it's always like, "Wow! Wow!"

Now I'll go back in the elevator and keep writing.

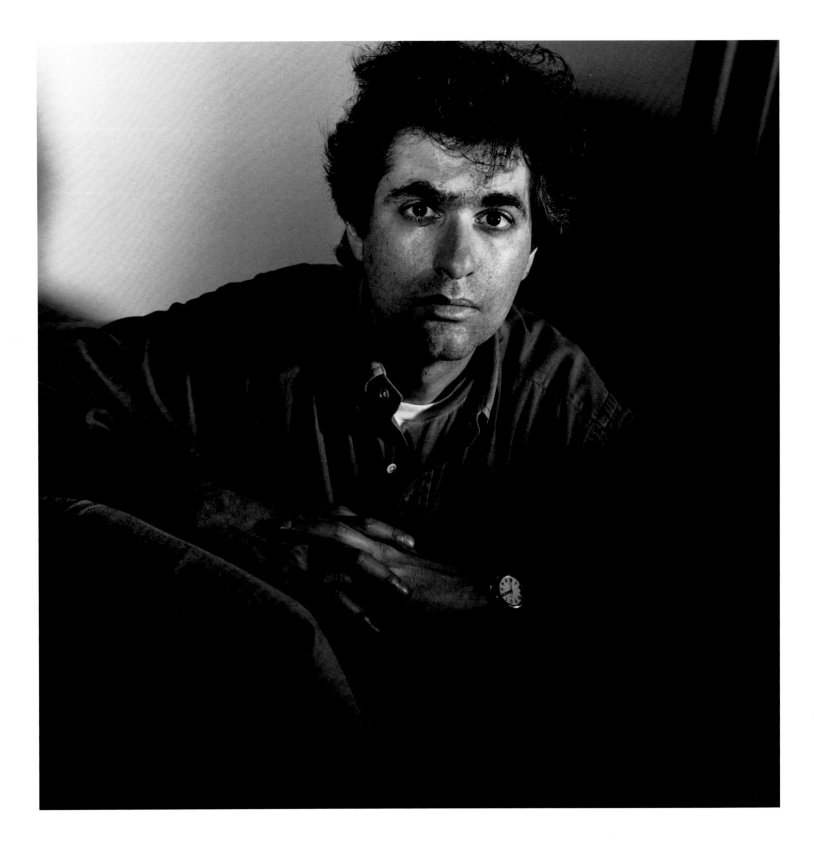

PETER
PARNELL Born in 1953 in Queens, New York, Parnell has written numerous plays, including *QED*, *The Rise and Rise of Daniel Rocket*, *The Blue Angel*, and *An Imaginary Life*. As a co-producer for *The West Wing* he received an Emmy Award and has also been granted awards from the Fund for New American Plays, two NEA fellowships, and a grant from the Guggenheim Foundation.

The creative impulse was very strong in me as a kid. When I was little I started drawing and writing poetry. It was almost an escape into a kind of fantasy place. Even to this day I'm not a writer whose strength comes from social observation. It's not that I don't observe—I do, but coming from a different impetus, which is more imagination based. I started reading plays very young and I was starting to picture the stage in my head very naturally. It's a facility you either have or you learn how to have. When I was a kid, if I couldn't afford to go to a play, I could read the script and it was like going to the matinee. I could sit in the chair and I could imagine everything.

I met Israel Horovitz while I was still a senior at college. He came up to teach and he said, "When you move to New York, you should come be my assistant. You should get involved with the Actor's Studio." He became a kind of mentor. I was friendly with Wendy Wasserstein, and she knew him, too, and then once you do that you feel part of a community.

Each play for me starts differently. I wrote a play called *Romance Language* many years ago and I started with an image of Walt Whitman laughing in a graveyard and that is not in the play at all. I knew that I was interested in Whitman as a character and I was interested in the tapestry of trying to write a big play that would be both about what was happening politically and what was happening creatively with a bunch of literary characters, real and fictional. But that grew out of the voice of Whitman, and Whitman is the central point of view of that play. I worked on a play called *Hide in Hollywood* which began with James Whale making monster movies in a very bizarre world of Hollywood in the forties, and the inner monster of the monster that's being depicted, and the fact that he was both closeted and yet open in certain ways.

The challenge for me has always been to find a personal stake for each play, which is what will give it its urgency or relevance. The audience should be aware that the play has an urgency to it. When you feel that, you're not watching a pageant, simply a history being unfolded for you. You're watching something that has the immediacy that affects you. That is the challenge, how to personalize the play for myself so that it feels both like a fresh approach to something and yet is using these characters, these stories, from the past. I tend to get really intrigued by the struggles and the interests and the desires of real people who were going through whatever they were going through then, and how that may relate to us now. In the case of *QED*, I was approached to write a story about Richard Feynman, and I was given the materials to do it, and it was one of the hardest things I ever tried to do. I thought, this has to hold up for the two hours of undivided attention that the audience is giving it. The fact that it was a real person, and that I'd never actually written a real person whose family was still around, was a different challenge. I wanted to create a real character.

I liken the process to going down a tunnel with a flashlight. You know the tunnel is there. It has a form. That is, you're in something but you don't really know where you're going to go. I wrote four or five completely different plays, not even drafts, in the case of *QED*, because I couldn't find it. In one version I had eight characters, ten characters. There was a version that went back in time, forward. There was a version in split time. Just doing all sorts of things because I couldn't find the fundamental conflict in the guy himself. It took me a long time. But, that said, it's not a cold calculated thing when it's a play of your own invention. In other words, I might now be able to look at a draft and say, "Oh, what if I totally ransack this and turn it around." I'm not afraid of doing that anymore. I'm aware that I can still

do that and hopefully not lose what is special or the impulse that made me want to write the thing to begin with.

Yes, you do write what you know. But you know your dreams. You know your fantasies. You know things that you are not always in control of what they mean, but you feel them. I think that's what you know, too. What the play is really about is that thing that hopefully speaks to the present moment, to the people in the audience. All of that other stuff—depending on what kind of play it is, if it's a historical play, a play about science—just requires that you sound like you're an expert in that. The fun is becoming that, creating that world as rich and as specific as it can be. I have grown to love creating that world, whether it's getting involved in theoretical physics, whether it's getting involved in American history, whether its getting involved in English history, biology…whatever it is. Those canvases are interesting to me because I may not have seen those canvases portrayed on the stage as much as what John Guare calls "the kitchen sink drama." Nothing wrong with a curtain coming up and we're in a middle-class living room, but it's not the only place, obviously, that the play needs to take place. So I'm interested in those other areas, and I love immersing myself.

The more that I can learn about the world around me is incredibly invigorating to me. With *QED*, the number of physicists and scientists and people who knew specifically that man who became the character in the play, just expands my horizons personally in a way that I find very, very exciting. And the more that I can try to understand the varieties of the human experience through that—not to sound high-falutin'—but I think that is what the audience comes away with to some extent. I mean, I hope that's what's happening.

At the opening night of *QED* in Los Angeles, being with Alan Alda and Gordon Davidson, and meeting Stephen Hawking and having him talk to me about what he liked about the play and what the play brought home to him about Feynman, who he had never met, was absolutely extraordinary for me. I have a photo of meeting him. He was darting all around in the little wheelchair at the party, and then there was this little moment where I just sat alone with him and we just talked. That was a great memory.

There are several plays that are in my head that I am apportioning the time for, figuring out now how will I do these to pursue them. Who knows if they'll come about, but to pursue them. Beyond that I get very jazzed up by these specific ideas as they come to me and they stay with me. In other words, it's not like I wake up and go, "Oh yeah, I'm going to write a play." They stay with me for a long time, months and months and even years. I would like to keep having those ideas and getting to explore them.

PETER PARNELL

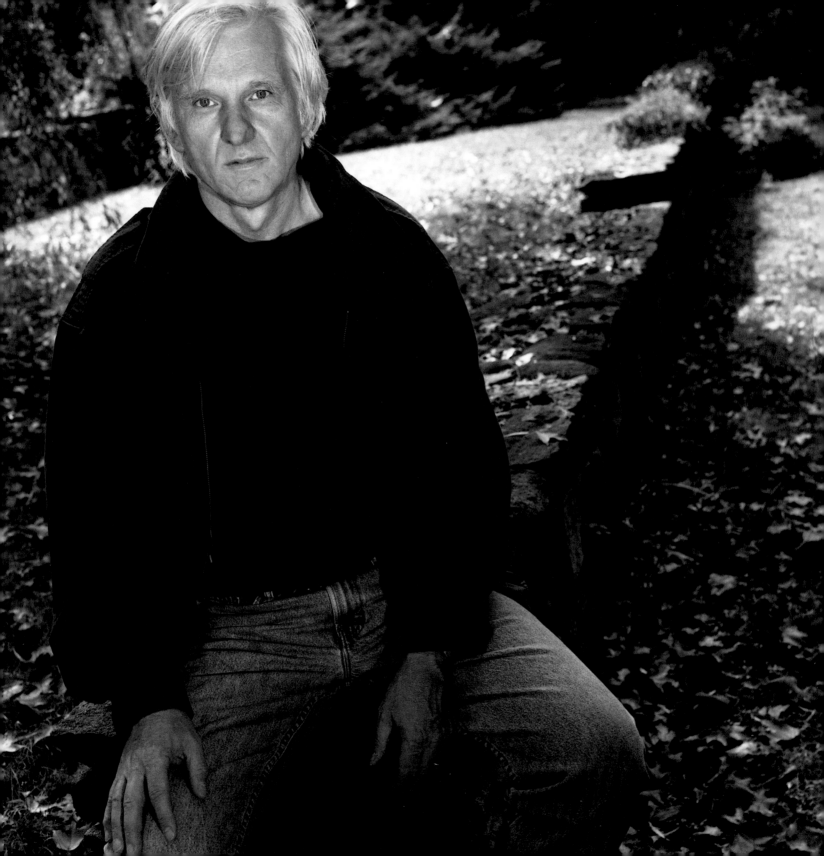

DAVID RABE Born in 1940 in Dubuque, Iowa, Rabe has written a vast array of plays including *Sticks and Bones*, *Streamers*, *In the Boom Boom Room*, and *Hurlyburly*. In 1993, he published his first novel, *Recital of the Dog*. A book of stories, *A Primitive Heart*, was published in 2005. He is the recipient of the Tony Award, as well as multiple Obie, Drama Desk, Variety Poll, New York Critic's Circle, and Hull-Warriner Awards.

DAVID RABE

I grew up in the Midwest: Dubuque, Iowa and was a teen-ager in the late fifties. I've really never figured out exactly how the shift toward writing happened, especially for theater, because I had no exposure to it. What I did or didn't know about wanting to write remains hidden prior to somewhere in my junior or senior year in high school, when the death of the actor James Dean was the catalyst. What he did was show that certain parts of my interior life that I felt were not of use in the world—parts I thought needed to be disowned, or hidden could be of use. Seeing those movies, and knowing he was dead somehow led me to realize that if I managed to make my way in a creative field, it would be possible to take that inner life and make something out of it. How conscious I was of this at the time, I don't know. But that was the turning point.

I started off thinking I wanted to be an actor. By the time I graduated high school I had begun to act in plays. When I went to college, I had a football scholarship to a small college in my hometown and I took it, but then dropped it almost immediately. I started acting, writing. I found writing plays very difficult. As time went on I wrote more and more fiction and some poetry. Later, when I was in grad school I kept trying to write the same play that I'd started in college over and over. I did a second play, but struggled. I dropped out of grad school and after a year or so of knocking around, I was drafted. This was 1965 and I shipped to Vietnam in 1966. When I came home in '67, the anti-war movement was gathering shape. I'd gone to Vietnam in full support of what we were doing. I was in the army, I was going. But afterwards, when I thought about it all and looked at the life people were living in the states, it became clear something was wrong. I drifted around and decided I wanted to get out of my hometown, where I'd ended up after discharge, and I went back to grad school at Villanova. Once I was there, one of the teachers told me I should write about the war. It didn't seem possible —not that I wasn't thinking about it, but it was overwhelming—but he harassed me about it, and so I started. Something in the army experience had knocked out of me whatever was tying me up and inhibiting writing. I found I didn't have the patience to write prose. But plays would overtake me, almost explode out of me. I'd been fortunate in Vietnam, getting assigned to a hospital unit. I doubt I would have survived combat. But I was given enough shock by the experience I did have that a lot of things I'd accepted as "valid," about life and people, these conventional, standard ideas, were revealed to be artificial, even deliberate lies, and I was released. It had to do with very intimate changes inside me that only became clear as I wrote. And the plays—the first was *The Basic Training of Pavlo Hummel*. Then *Sticks and Bones*. I'd write part of a draft of one, put it aside and start something new, then go back to the first one. In the actual act of writing, I began to see what I had to write about. The first piece I wrote was a twenty-minute one-act that a couple years later evolved

into a longer one act and some seven years after it was started it grew into *Streamers*. Not that there was some, "Eureka! Now I see, now I can do it." In fact, what went on in my head was more like, "Who am I? What am I? How am I going to survive?"

After grad school, I worked as a journalist for about two years in New Haven. I liked the job, but couldn't do any other writing at night or on the weekend. So I went back to Villanova, this time as a teacher. I had already completed *Pavlo* and *Sticks*. I had a portion of *Streamers*, a draft of *The Orphan*. I was submitting *Pavlo* and *Sticks* to every theater I could think of in New York and to all the regional theaters. Both plays were turned down everywhere—even at the Public Theater. I don't know what possessed me to send them again to the Public Theater. I just felt Joe Papp was my only hope. So I did. As it turned out, Joe hadn't seen them the first time. One night, while I was still teaching at Villanova, my phone rang, and when I answered, the guy on the other end said, "Hello. This is Joe Papp."

The start of writing *Hurlyburly* was a cynical impulse one day of thinking I'd write something conventional and straightforward—this play about a bunch of friends and one of them dies and everybody cries. But once I started, the whole thing took off on me, and I was writing like a madman. Not very conventional, and out of my control. It was a thrilling thing to write. The experience behind it had come maybe a decade earlier as I was getting separated from my wife, and there was an interlude when I lived in L.A., trying to get movie jobs and make some movie money.

There were other plays, of course, before and after, failures that I adored, like *Goose and Tomtom* and *In the Boom Boom Room* and successes like *A Question of Mercy*. But all along, certain aspects of theater—mainly the need to be with the audience as they watched my work—were never comfortable. Actually, I often found that situation excruciating. This was due, of course, to the nature of my plays. I'd write a challenging, confrontational piece and expect people to show up glad to see what I was laying open in front of them. I'd be surprised when they were horrified. With the first plays, especially *Sticks and Bones*, many in the audience were anti-war and would expect an anti-war message, but then the play would shift ground under them and they'd end up facing something disturbing, very primordial, such as a family advising their son, a returning Vet, to slit his wrists, so they could all feel better. During previews of a play, there's work to do, so there's no escape. You have to be there with an audience. And of course there might be satisfaction in challenging the audience, since the plays clearly had that intent, but instead I just felt weird and uncomfortable. On the other hand, I always loved rehearsal and seeing the actors find the play and bring this living quality to it. In a successful production, there's a point late in rehearsal, when the text, actors, and direction amplify each other, and this force bursts out of the combined energies and it has a unique dimension that exists only there—in that sphere—with actors on stage. I remember it vividly in *Pavlo*—not that I hadn't seen it before or didn't see it later, but this memory is so vivid — the way in a late dress rehearsal it suddenly transformed and became a kind of creature that was alive in a dreamlike way, filling those particular two hours with life. Then it was gone, it was over. That's uniquely theater.

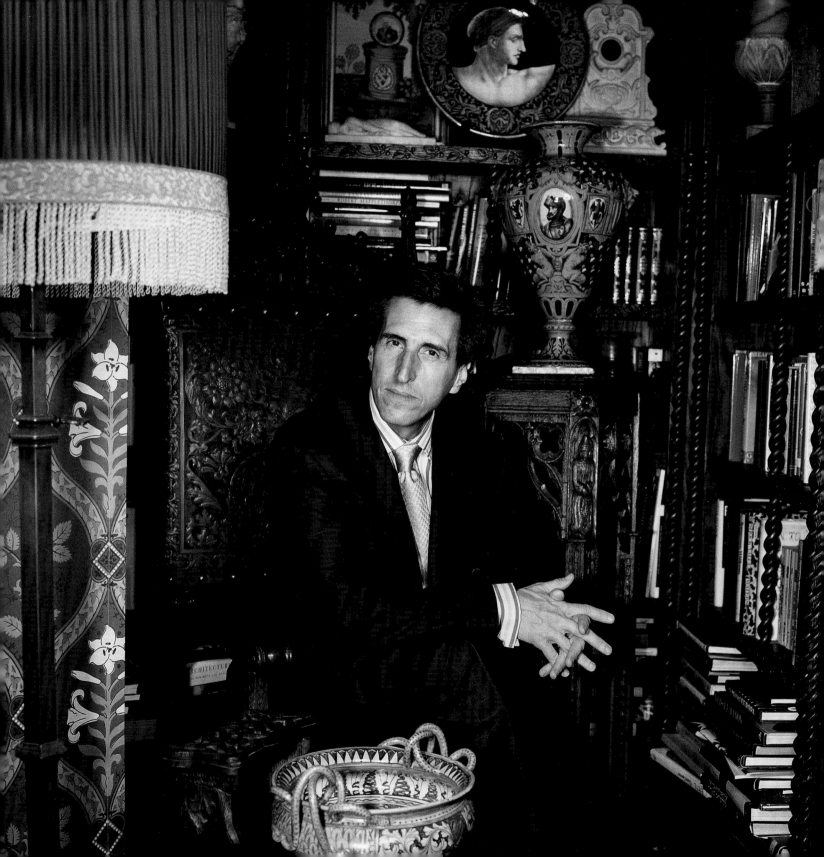

PAUL
RUDNICK
Born in 1957 in Piscataway, New Jersey, Rudnick has written plays and screenplays for over three decades. His titles include the plays *I Hate Hamlet*, *The Most Fabulous Story Ever Told*, and the Obie-winning-play-turned-film, *Jeffery*, as well as the scripts for the films *The Addams Family Values*, *In & Out*, and *Sister Act*.

There was an essay that I wrote, when I was five or so, in which I did claim that my dream was to become a playwright, and the interesting feature of that is that I had not yet seen a play. So it was a truly conceptual dream at that point and remained so for many years. But whatever that theater rat gene is, it was incredibly present in my particular bloodstream (and still is).

I grew up in New Jersey in the suburbs, and my parents were big theater fans. And I am forever grateful that they took both my brother and myself to the theater constantly. I think that is an amazing gift that any parent can give. But I sure responded. They didn't know what they were doing. They lived to regret that. I realized that it's far more troublesome to tell your parents that you want to be a playwright than to tell them that you're gay. Gay people can still earn a living. But God bless them, my parents have never been anything but wildly supportive. And I guess that's because they were theater fans, too.

Piscataway is in Central Jersey, and it is, of course, an old Indian name, and it is one of the few places that the Native Americans have never asked for back. But there were some very wonderful people there. It's easy and deeply necessary to bad-mouth New Jersey, but I had a perfectly fine childhood there. The suburbs are designed for the absolute worship of children, and I took full advantage of that. And I was probably one of the few gay Jews in Piscataway, but there was actually very little discrimination, because there was absolutely no awareness of what a Jew or a homosexual might be. People in the town might be busy being racist or anti-Italian, so they didn't have time for that.

I was always such a theater hound. I did school plays, community theater in junior high, high school, college, you name it. I always felt absolutely driven to be a part of the theater. I always felt from the time that I could remember that New Jersey was sort of a holding pattern, that at some point a shuttle would arrive, and I would climb aboard and it would take me to New York. There are plenty of people who are very content in New Jersey, which has a few wonderful features. But I knew that there was a studio apartment with my name on it.

My first produced work was probably when I was at Yale, and it was something unfortunate. I had a wonderful advisor during most of my college career in the drama program, and he left during my senior year. So I was feeling very bereft and very abandoned, through no fault of his, and I had to write a play as a senior project. I was feeling so infantile that what I did was I spent an angry weekend and I wrote down everything that everyone had said to me—gossip, filth, bad jokes, good jokes, you name it—and called the play *Dirt*. It was literally not a play. It was a tantrum. I handed it in to my new advisor, a man who had no particular experience with me. Unfortunately, he adored it and insisted that I produce it as part of my senior program. I had not foreseen that—I thought that I was making some kind of rude gesture. So what I did was I ultimately staged the play as part of a party. I passed out invitations all over campus, inviting people to a gala event without my telling them that a play was involved. Everybody came and got good and drunk, and at midnight I said, "Okay, everybody's got to sit down on the floor or on a folding chair—find a space," and we performed the play. To make sure the people's attention would be kept, I would just drop in, for absolutely no structural purpose, a filthy joke or a filthy song. Because the audience was so inebriated, or stoned, they had a perfectly delightful time. That was probably my first produced work, but certainly nothing to be proud of, and certainly not a good spending of my parents' tuition money or my student loans. But

I had a good time. It was a good lesson in keeping the audience's attention, no matter what.

One of my favorite parts about the theater is comedy, in the sense that the audience response is absolute. They laugh or they don't. I come from a Jewish family where humor is always prized. I am grateful for it, especially as an antidote to self-pity, as a way to get over yourself. If you can make a joke, nothing can be quite so terrible. It was a great tradition to emerge from.

However, in playwriting, you want the highest stakes possible. So even if you are dealing with comedy, it will only be truly effective if it's a situation that could play equally well with a tiny twist as tragedy. People's lives have to be at stake. Otherwise it's not going to be particularly funny. It could be mildly amusing, but if you want hardcore comedy and you want the play to matter, then you better also have something on your mind. One of my favorite parts of the human condition is that ability to find comedy just about anywhere, and to find it constantly intertwined with tragedy. In real life, none of it is separate, so it's strange for theater to limit itself to be simply applied comedy or desperate tragedy.

My play *Jeffrey* was a comedy about AIDS at the height of the AIDS epidemic in Manhattan. People felt that seemed impossible (or certainly in the worst possible taste). I think *Jeffrey* was made possible because there were some magnificent plays that preceded it, like *The Normal Heart*. Theater was the only way any information was getting out about the AIDS crisis. The TV networks, movies, every other art form or form of journalism wasn't touching it, so those plays were absolutely necessary. I thought, "Gee, I am a comic writer; will my particular voice have any place in this moment?" I had so many friends who were sick, who were dying, who were friends or family or lovers of people who were sick or dying, who were insanely funny. And before there were any treatments, often humor was the only weapon we had. That's where *Jeffrey* came from.

There is a moment in the first act when one of the main characters suddenly announces that he's HIV-positive. Every night in the audience there would be a gasp, and you could feel people imagining, "Okay, this is no longer a comedy; this has now turned the corner." But the moment was immediately followed by three huge jokes. There was this wonderful sense of dislocation—it's okay, we can find comedy here without in any way trivializing the subject matter, but use comedy as tribute to what people are going through at that time.

When you are looking for subjects, writing about your friend in your living room pales very quickly compared to real issues of life and death, and the AIDS crisis has certainly supplied that in tragic abundance. So *Jeffrey* was the first time that I actually felt proud of something that I had written, because I used every part of myself in that play. Whether it's a good play or not was almost beside the point.

PAUL RUDNICK

Plays come from all sorts of places. Another early play of mine, *I Hate Hamlet*, takes place in an apartment and the main character is visited by the ghost of John Barrymore. I was living in the apartment that John Barrymore had lived in. It was right off Washington Square park, a wonderful top floor of a brownstone that Barrymore had remodeled in a kind of bastard Hollywood Jacobean, so it felt like the set for a bad Sherlock Holmes movie. When I was first looking at the apartment to see if I was going to take it, I mentioned it to a wonderful woman named Helen Merrill. She was my agent at the time, a legendary German character, and when I said that I was looking at this apartment that John Barrymore once lived in, she looked at me and said, "Perhaps you have found my hairpins." It turned out that she had an affair—not with Barrymore, because she was a little too young for that—but with Barrymore's son-in-law. So suddenly I thought, "This feels like a play. This cannot be ignored." I thought if I ever was looking for omens, when you've lived in John Barrymore's apartment and your agent had sex there, something is leaning on your pen.

When people use the word "stereotypes," sometimes it strikes me as an odd form of self-loathing. There's this understandable, but in a certain sense useless, desire for idealized gay role models. Because for so many centuries, all of the gay characters have been the butt of the joke, or have been the serial killer, or have been presented as diseased pariahs. In my work, the gay characters are almost always the heroes. But what I never wanted to do was to deny the reality of gay lives. I wanted to celebrate that. So if I have gay men who are flamboyant or who are effeminate or who are funny or who are hugely sexual, I see all that as a great strength. But that can make people very nervous. In *Jeffrey*, two of the leading characters are an interior designer and his boyfriend, a chorus boy in *Cats*,

and it would worry certain humorless gay politicos. They think, "Oh my God, is that the face that we want to present to some mythic mainstream America?" Whereas I thought, "First of all, how dare you insult the interior designers and chorus boys of America! Those guys are much tougher than you are! Those are my heroes. Those are two of the smartest, strongest characters that I have ever written, so I find anyone thinking of them as stereotypes to be an insult and a mistake."

I believe if there's a political platform that could be destroyed by humor, then it wasn't very strong to begin with. When my play *The Most Fabulous Story* was done, my favorite protest was by a group called The Society of Mary—which stuck me as the gayest possible Christian organization. They sent me thousands of identical postcards from people who had never seen the play but had simply been assigned by their leader to write to us. And the tone of the letter was basically, "Jesus is our Lord Almighty and a God of absolute love and all-affirming compassion, and He wants you dead." So there was this strange, fundamentalist contradiction on all of these happy postcards. But I loved the notion that a centuries-old religion could somehow be threatened by Paul Rudnick's little off-off-Broadway play. I wish I had that kind of power. It's funny when insanely powerful organizations, political parties, religions, you name it, suddenly become quivering virgins in the face of a ninety-eight-seat theater. It tickles me. But I also know I'm on to something if I'm making people nervous. Often I find if there's something in a scene that's making me uncomfortable, I will write directly towards it, because that's where the good stuff is.

I've always been both awed and appalled by writers who say, "I write from nine to twelve, I take forty-five minutes for lunch, come back, and work until six." I think, "Why

don't you work at a bank? Why did you ever become a playwright if you are so disciplined?" The deepest and most primary pleasure of being a playwright is lying on the couch reading magazines. *Us Weekly* is the soul of the American stage. My schedule has changed quite a bit over the past years, but I used to write very late at night, after I had read every magazine, watched every TV show, when no one was awake to call, and after I'd eaten everything in the house. You learn in the Great Golden Book of Playwriting Lies to say, "I'm working all the time, even when I'm out at the amusement park having an ice cream cone, or out at the bar getting sizzled. My characters are speaking to me, therefore I'm working." That's a convenient excuse. I mean, I think it's true but I wouldn't want to try to present it to the unemployment office for compensation. It's a very loose occupation. But that's the excitement of it. The challenges are constant.

You just write, and if you fail, you bury this turkey and move on. I've known almost no deeper satisfaction than burning 300 pages of typing, knowing no other human being will have to suffer through this thing. One of my particular nightmares is that I write some horrible play, some ungodly piece of crap, and I get killed in a car crash, and people will find this manuscript and imagine I thought it was good. What if they have some horrible misguided sense of pity and say, "We should stage Paul's final testament." That audience will be sitting there going, "Thank God he's dead. I bet he was a suicide."

I used to have a rule that you were not allowed to walk out on anything in the theater. Well, I got over that one. I was once at some hideous off-off-Broadway conceptual piece that had been hugely praised in the press. There were about twelve people there, and I was with a friend, and I thought, "If I leave during intermission there are only going to be ten people here and those actors are going to notice and think we are horrible human beings." Then I thought, "No, I'm sorry. This is now a medical issue. If I stay, I will die. I will suffocate, and I don't want them to find my body here and say I was killed by theater."

I do read my reviews, because sometimes even bad ones can be helpful. There are certain people's opinions that I respect. But it's good to only read reviews once. You will obsess over them, and if you read them more than once, you will memorize them. I never believe people who say they don't care what the media says. Once I went backstage, to see this very famous actress after a Broadway play, and she had just gotten very bad reviews. I was with her agent and he alluded to the reviews, and the actress said, "I have no idea what they were. I never read reviews." Then there was a knock on the door. It was a director who had just directed this actress in a movie, and he said, "You were good tonight—the *New York Times* said you were terrible." And the actress snapped, "Not the Sunday *Times*!" I wanted to applaud. I thought it made her so much more human.

I can have enormous pleasure from sitting on my couch writing, because you can have the particular madness of imagining that your words are brilliant and that the audience is laughing and applauding wildly, because no one has actually seen a word of it yet. But then there's the more kind of high-wire thrill of actual performance and there's nothing comparable, especially with comedy. When you're at a play (whether I have written it or not), and it's a comedy and it's working and it's cooking and the audience is with it and you've got a brilliant cast and the audience response is driving that cast and the play itself even higher —that's why theater will never die, no matter how many obituaries are printed.

CARL HANCOCK RUX Born in 1970 in Harlem, New York, Rux is a multidisciplinary writer and performer who authored the Obie Award-winning play *Talk*, a novel, *Asphalt*, and a multi-media opera oratorio entitled *Mycenaean*. Among his many awards and honors, Rux is an artist in residence/curator at the Miami Performing Arts Center and the recipient of the New York Foundation for the Arts Prize. In 2005, he released his first CD of original music.

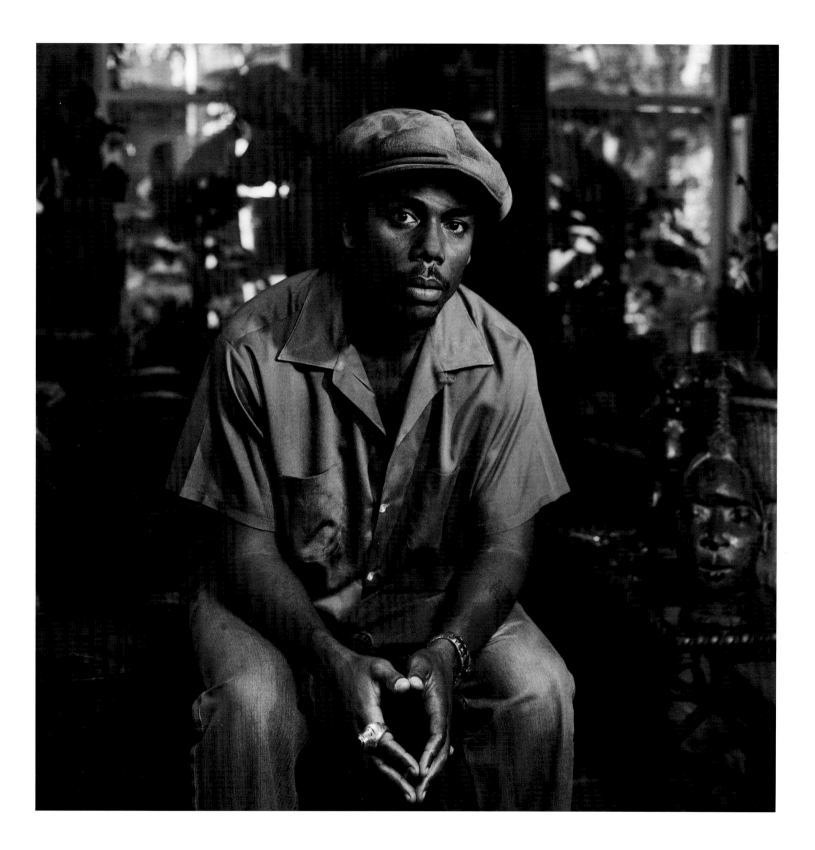

CARL HANCOCK RUX

I kept a diary as a kid and on the first page of my first diary—I think I was eleven—I wrote, "My name is Carl Stephen Hancock and when I grow up, I will write a novel called *A Novel by Carl Stephen Hancock*, and I will write a book of poems called *A Book of Poems by Carl Stephen Hancock*, and a play called *A Play by Carl Stephen Hancock*. My name has changed and the titles of those books aren't what I predicted, but I did accomplish the goal. Makes me laugh to think that children know their intentions in life. It's when we grow up that we get a little confused or sidetracked with too many options. Fortunately for me, I'm still doing what I always wanted to do. That's a gift from the universe.

Growing up in Harlem and the South Bronx in foster care, being adopted at the age of fifteen, dealing with very serious familial issues like my biological mother's schizophrenia and institutionalization, my adoptive parent's alcoholism and domestic violence, my brother's death from AIDS—all of it impacted me in ways I couldn't have imagined when I was experiencing those things. It wasn't just the tragedy that impacted me, but the beauty I simultaneously experienced with all that ugliness—my parents' love of jazz music, books, the pulse of New York City, the art that was being made. I found relevance in the sometimes strange juxtapositions existence brings. The state of the nation, realms of pop-culture, the war in your living room are all happening at the same time and I believe they have everything to do with each other—the dramatic possibilities are endless.

I reunited with my older brother when I was just starting college, and it was a really amazing experience, but it was like a play. It was a brief experience because he became severely ill due to AIDS complications and I became his primary caretaker. I knew nothing about the bureaucracy

of health care, and AIDS-related illnesses or any of it, but I had to find out very quickly and lobby for my brother, and argue in hospital waiting rooms, demanding that he be treated whether we had all of his health insurance papers or not. I then began to understand that I'd grown up in a bureaucracy. I'd been fed and clothed by taxpayers, and our birth mother was living in a city-owned institution for the mentally ill, so I needed to begin to know the politics of our existence the same way some people know the small town they grew up in. My art has become a reflection of how our personal lives are affected by political realities in one way or another.

My adoptive mother loved to hear Billie Holiday or Dinah Washington or King Pleasure sing, not simply because they had pretty voices but because of their phrasing. She would always make a big deal out of how a singer phrased a lyric and how lyrics had different meanings depending on who sang it. In theater, I began to fall in love with the human voice, how actors could make a monologue symphonic. The words meant more to me when I felt the actor was totally connected to the sound of words. At the Nuyorican Poets Cafe, I began to read poetry but I had no intention of sounding like everyone else. I didn't want to imitate the other poets or simply read the words as I had written them on the page. I wanted the audience to hear the words, but I also wanted them to experience the tonality of my impulses when I first wrote the poem. I wanted them to be inside my head and hear the music I was hearing. I wanted my poems to be songs or arias of ideas. It was a great thing to do, to really pay attention to the instrument of your voice in order to communicate words. In my play *Talk*, I wrote the text in a way that demanded the actor try and find a melodic composition in order to relay the text. Reg E. Cathy turned into Charlie Parker to deliver a monologue about Vietnam and the civil rights movement.

James Hemelsbach became a gospel preacher in order to hypothesize the relation between early twentieth-century European art movements—Dadaism, Cubism, Surrealism—and the influence of African culture on those forms. The language is dense, but the music is what lifts it out of its heaviness and lands it in our ear in a way we weren't expecting.

When people ask me "Who is your audience?" I'm always stumped, because that assumes I already know my audience. I don't write guest lists. I simply invite everybody and anybody who will come to it. I don't think Euripedes, or William Shakespeare, or Edward Albee, or Adrienne Kennedy, or Caryl Churchill, or even August Wilson had me in mind or knew who I was or who I would be when they wrote their plays, but I take those plays personally, as if they had been written for me, and only for me.

James Baldwin used to tell people that his characters would reveal themselves to him. He'd be working on a play or a novel and over breakfast with someone tell them what "so and so" (a character he was creating) told him about themselves the night before, or what they didn't say. As if they were people he'd actually met who slowly revealed parts of themselves to him, or held back information all together. I feel that way as well. I become an active participant in the lives of the characters I write, and no matter what I intend their lives to be, they take control of their own destinies. Sometimes I'm as shocked as anybody to see what the end is going to be.

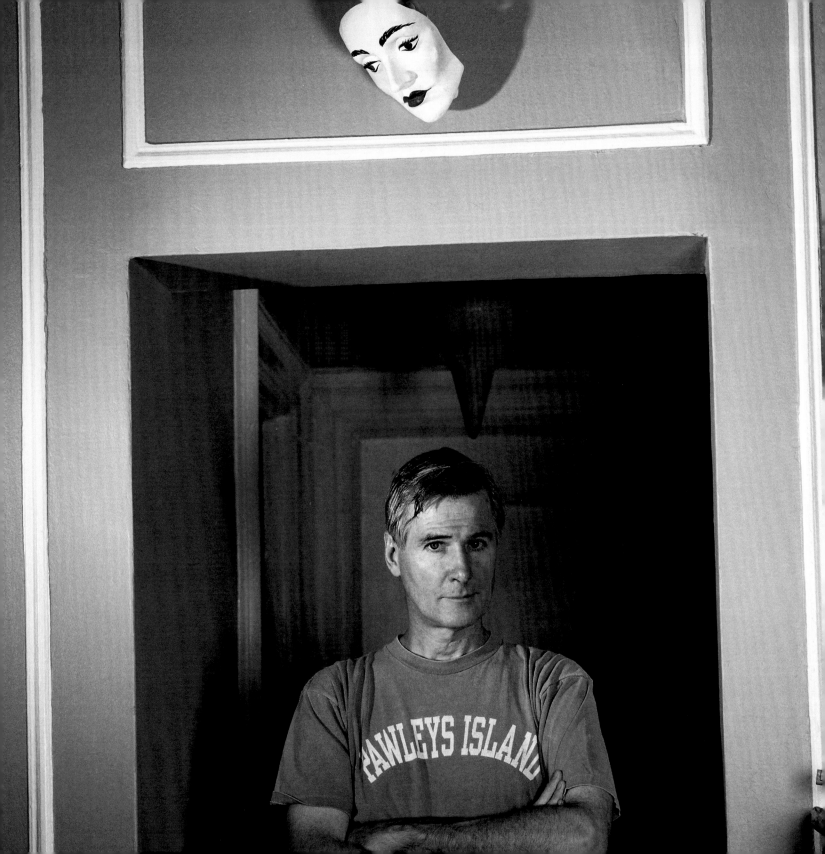

JOHN PATRICK SHANLEY

Born in 1950 in the Bronx, New York, Shanley won the Pulitzer Prize and a Tony Award for his play *Doubt*, and his many other works include *Danny and the Deep Blue Sea*, *Savage in Limbo*, *Italian American Reconciliation*, and *Welcome to the Moon*. He has written eight original screenplays, including *Joe Versus the Volcano*, which he also directed, and *Moonstruck*, for which he won an Academy Award.

The first half of my artistic life was spent in struggling to understand and accept who I was. The second half of my artistic life has been to continue running to catch up to the changes that take place internally, so that I can continue to represent accurately who I am to me and to other people. But in the process I've become very aware of the world outside of me. Now, for the first time, I feel like responding to things far from my living room. That's interesting to me.

I see life as walking down a road—and that's a choice. You walk down that road and you respond to the landscapes that you pass through. If there are landscapes that you find to enjoy, you enjoy them. But you do not linger there. You continue to walk on and may come to what may be forgiving territory. But you have courage to live your life wherever it takes you. So when writing a play, in other words, I'll come to that surface under the context of my life at any given time, and I'll try to answer those questions in the play—so whatever it is that I'm addressing in the play is exactly what I'm addressing in my life. The result of that inquiry is what I have to live with. I have to act on it, because actions are required in life. You don't simply have new thoughts. You actually have to do things. The plays help me to focus and figure out what it is I need to do. Every play is an attempt to get past an impasse of some kind. An impasse involves the uninteresting things that you can view as obstacles or that you can view as forums, places

John Patrick Shanley

along the road where you're supposed to stop and take in what's going on. You ask your questions about it and have your feelings about it, and arrive at what tactics you need to employ to derive the meaning from it.

To be an artist is a rigorous thing and it is a not always a pleasant thing. Sometimes I've written things about my family, or about my marriage, or about my sexuality, and it might be quite uncomfortable to expose those things to the public gaze. Sometimes I write about things that I don't want to look at, that I don't really want to understand, that I don't want to consciously put on the table, because that's going to cause things to change. And change is a painful thing. But if you're going to go down the artistic path, you're going to have to do that. Sometimes you shudder at what you have to deal with in a given play or a given moment. Very often the question I ask is, "What frightens me? What repulses me?" And the answer is, "That's what I'm going to write about."

You put on plays and you sit there and sometimes you cringe. Not because it isn't working, but because it is working, and it makes you uncomfortable. Sometimes it makes other people uncomfortable. The last play that I did recently had a reading. Everybody there were people I knew, most of them friends. During the fifteen-minute intermission, no one spoke to me. They were uncomfortable. They were uncomfortable with the material. They were uncomfortable looking at the person who generated the material, and I was uncomfortable having to be that person. But that was my job.

The whole notion of story will have a lifelong fascination for me. Stories are an extremely powerful idea for me, more powerful than character, more powerful than language, more powerful than anything else. What is a story? What makes a story work? What is plot? These are questions that I've

studied a great deal, and I went and I read everything that I could get my hands on and I thought about plot. I posed the question over and over again: What is plot? What are examples of plot? I realized that some fairy tales were full of plot, so I read thousands of fairy tales. I read every play ever done on Broadway from the beginning through to the end, basically in order. I read everything that was being produced in England. I read everything that was produced in the English language, basically, just to get it in my bones. You want it in your bones so then you can sit down and you're free.

Of course, sometimes you just can't fucking come up with anything. Sometimes you're writing a play and it becomes dribble. It becomes people saying the next obvious thing that they would say and answering the thing that came before, and they lose the vitality, the faithfulness of the moment-to-moment, and you have to find a way back to that. You can't press yourself too hard. If I do half an hour of good work a day, I know that I'm gulped. I know that I'll be finished really quickly, and that it'll be really good. I don't need to have five great hours a day. You just need to show up day after day. It's really about the other twenty -three and a half hours that makes that half hour be what it is. You walk around and you look at the problem, walk around the problem, you walk around the idea, you walk around in your head, and stuff comes to you.

Robert Bill Goldman, a friend of mine, said, "A writer has to protect his time." I realized, "That's exactly right." So basically what I do is most of the time I tell people, "I can't do that. I'm very busy." What I create is—nothing—maybe for fourteen days in a row. I'm protecting this block of time during which I have nothing to do so that I can go out and read the newspaper and come back here and talk to people on the phone, and look out the window, and maybe, for

half an hour, write. So anybody can look at this and say, "Throw him in jail for being a bum." But in fact, that's what the job is. That's what you need to do, and you have to recognize that that's the job. It's hard for a lot of writers— a lot of writers get blocked because they can't handle that.

Whenever I've made huge amounts of money, I've done everything in my power to get rid of it, because I know it's just unhealthy for me to have too much money. I start to feel bloated and puffy and I can't really move properly. So, I'll get rid of it—I'm very good at that. You don't want it to the point where you can't pay your bills, but those points do come. Then you wake up and you have to do something practical, and it'll break you: "I can't spend another three months interpreting my dreams; the wolf is at the door. Something must be done."

I'm usually pretty sure about where the play ends. But what the last line of the play is, how that works, sometimes it takes me a little while to find. But they do really end for me. My view of life is not that people get married and then they're happy. So my plays reflect that, that there is some kind of open question at the end, because there's an open question at the end unless somebody's dead, but then he slowly walks off stage. *Hamlet* has really no open questions at the end. But look at what length Shakespeare had to go to do that. He really had to stand on his head at the end of *Hamlet*. I write to get past that impasse, to get past that obstacle, to get to a new place.

Savage in Limbo leaves the audience with, "Well, what are you gonna do? The place is closing up soon. What are you gonna do with your life? Are you gonna have the guts to do what's in your heart to do? Or are you gonna narcotize yourself and wait for death? What are you gonna do? Last call."

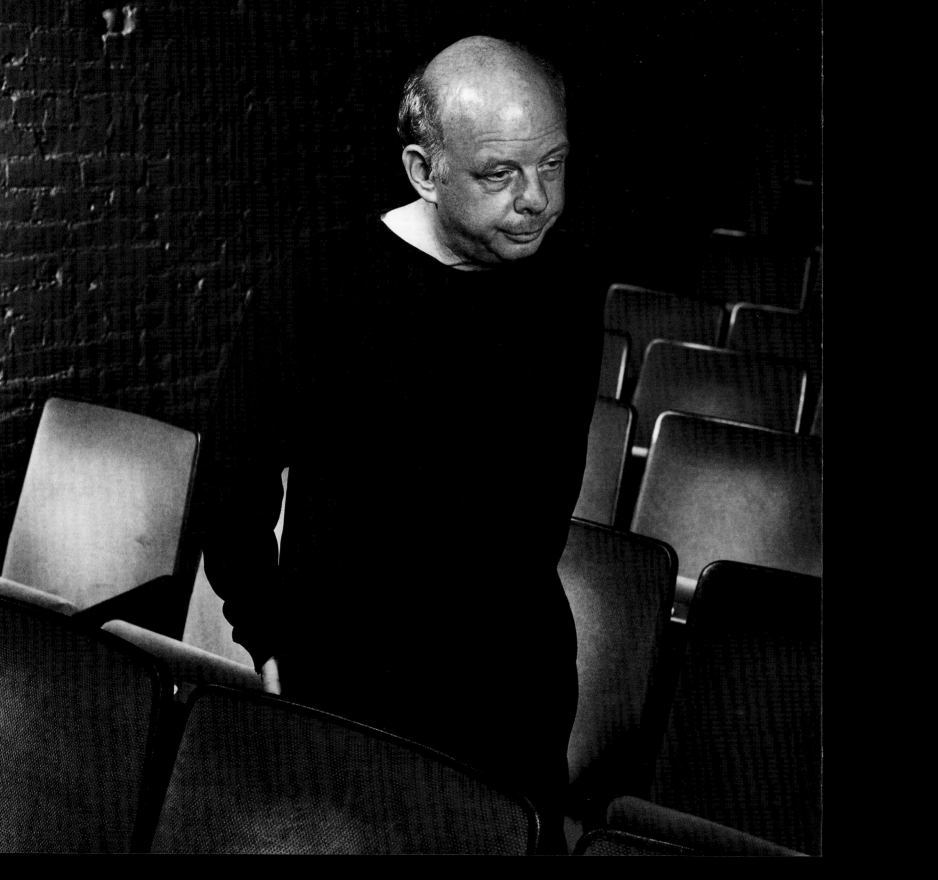

WALLACE SHAWN

Born in 1943 in New York, Shawn is an actor and writer, best known for his scripts *My Dinner with Andre* and *Manhattan*, and performances in numerous plays and films, including *Hurlyburly*, *Vanya on 42nd Street*, *The Princess Bride*, and *The Incredibles*, to name a few. He is the recipient of two Obie Awards for his plays *Our Late Night* and *The Fever*.

WALLACE SHAWN

If you follow certain schools of psychology, people don't know why they do what they do. It takes years of study by experts to answer that. Obviously, sometimes people who are small and believe themselves to be physically weak seek out areas of life in which they might show more promise when they're children. People want attention and people want to be admired and I suppose in school I had certain experiences where I was, as the behaviorists would say, positively reinforced. I wrote my first formal play when I was twenty-three or twenty-four, but I was writing things from the time I was ten. Some of them were plays and some of them were puppet shows. I wrote things in school that were more or less like the plays I write now.

Writing is a whole category of behavior that I would have thought everyone would be involved in, like sex or trying to find food. It's a way of coming into contact with the best that is in you with insights that surpass the insights that come to you in daily life. It's an area in which you can take time to formulate your thoughts. It's a part of my life that I find quite enjoyable, because I can take years to figure something out rather than minutes as people do in daily life. Your mind encompasses more than you have access to on a daily basis, and if you write you can find out about that. It's rather fascinating. I don't know why everybody isn't a writer.

I'm not tremendously interested in the personality that I am, but I can get quite interested in the thing that I wrote, and it's sort of amusing to think that somehow it came from me. There's nobody else in the room, so it must have come from me. For me, writing is more about sentences than ideas or even characters. It's more that a sentence appears and then I might speculate who said it and why. Because what I write is almost always for a spoken voice.

I've always been writing for theater, but it didn't occur to me to be a professional actor. It was the last thing that would have ever have crossed my mind. But then, I had translated Machiavelli's play *La Mandragola* (*The Mandrake*) for Wilford Leach. He got Joe Papp to commission me to translate that play, and then he asked me to be in it. He was offering to pay me to be in the play, and I was very far in debt and, as a matter of fact, had absolutely no prospect of ever making a living in any way. I was even contemplating different types of labor for which I was not particularly qualified, such as being a taxi driver, which was not a good idea because I can't drive very well. So I took the job and then it turned out that the play was quite successful, and that led to my having a career as an actor. The whole experience

of acting did change my writing and did give me a greater knowledge about the use that words might be put to, or what it feels like to say them. It influenced me a lot.

When I was starting out in theater, I was very, very upset when my plays were rejected, and then, when they first were put on, there was almost no favorable response. They got virtually unanimous bad reviews, with a few exceptions that I remember very vividly. There were almost no people who liked them. I suppose when I was much younger I thought perhaps I could even make a living as a writer or be deeply respected. Gradually, it dawned on me that I would never make a living as a writer and that I would be respected by a handful of people who happen to be attracted to what I wrote. For some reason, the things that I write were not meaningful to a large number of people, and now I just know it, and don't expect otherwise. I've never met, let's say, President Bush, but I know enough about him to know that he just wouldn't appreciate my writing. It would be meaningless to him. And that doesn't shock me. On the contrary, I would be shocked if I got a letter from Bush saying, *The Designated Mourner* changed my life, it's incredibly profound. You wrote a heck of a play. You have really made an enormous impact on me."

I've always assumed that whatever I'm working on is the last thing I'll ever write and I've given it my all. And when I've finished it, I've taken at least a couple of years of where I really haven't really written a word. Because basically, I have to change quite a bit before I am able to write anything new. Otherwise I would simply write something that had already appeared in the piece that I had already finished. It's taken me a matter of years to write each of my plays.

I write things and somehow they become something. You could say it's a little bit as if I had a drawer in a closet somewhere, and every once in a while I would throw a scrap of food in there and it would all begin to rot into some strange mold. At a certain point I begin to sense some outlines or a shape, and that it might be about somebody or something rather than about the entire universe. But that's in the later stages, when my conscious mind comes into it.

I'm somewhat superstitious about writing. I'm not a very superstitious person in my daily behavior, but about writing I do think there is a connection between writing and secrecy. I don't talk about what I'm writing about. I'm quite superstitious that way. I have quite a bad memory, and it's served me well. When I put something away for awhile and then I come back to it, I honestly don't remember having written it half the time. There is something kind of exciting about it.

I wish I could live longer. I regret the shortness of life. But also I don't think I've ever quite grasped the concept of the future. I think if I had believed that the future was real, I would have saved money. I had some pretty good jobs in the eighties as an actor. I suppose that if I had been my own grandmother, who was quite poor and very, very serious about saving money, I would have saved a portion of each of those checks and who knows, even invested it. But the future has never been something I brooded about a lot. It's never seemed that real to me.

NICKY SILVER

Born in 1960 in Philadelphia, Silver has authored a vast spectrum of plays, including *Pterodactyls*, *Raised in Captivity*, *Fat Men in Skirts*, *Beautiful Child*, and *Fit to be Tied*. He has served as playwright-in-residence at New York's Vineyard Theatre and is the recipient of Oppenheimer, Kesselring, and Helen Hayes Awards.

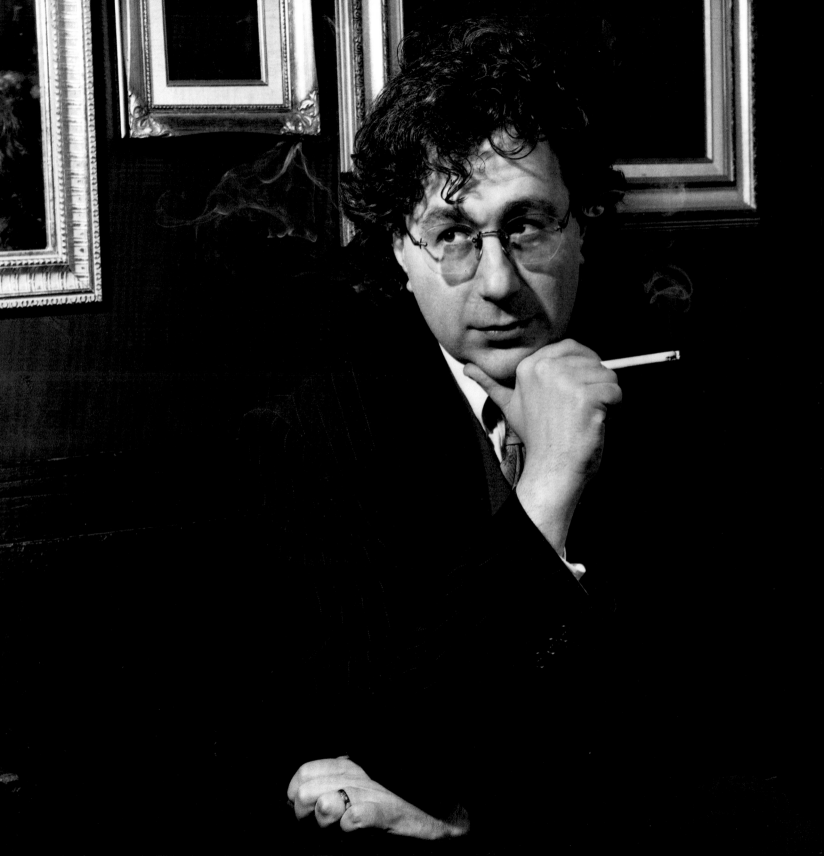

NICKY SILVER

As long as I can remember, I wanted to be in the theater. I don't think I ever had any other career aspirations, and I'm sure that there are deep-seated and pathetic psychological reasons for that. I've always been extremely verbal and good with language. I can't spell two words in a row correctly, but I've been pretty good with language. I didn't have the ego to be an actor—I have the ego, I'm sure I have a tremendous ego—but not of a particular kind. I didn't think I was attractive enough, or I didn't feel I could spend my whole life dieting. It takes a certain kind of narcissism to write plays of interest. That narcissism, generally, is matched by an equally grandiose sense of self-loathing. And it's that self-loathing that keeps one not wanting to look at one's picture for books like this, or seeing oneself on television, or that sort of thing. It's an odd combination of grandiosity and self-deprecation. I once told a therapist of mine that if I ever won an Oscar for writing a movie or something, I would never go for fear that the entire country would look at me on television and think, "Look at that fat, gay mess up there on the screen." And he pointed out to me that while that's incredibly self-deprecating, it's really narcissistic! What kind of narcissism is that, that I think the whole country is going to watch and care about me? That fear is what keeps one behind the scenes and makes one into a writer, whereas the narcissism is what makes one think one is interesting enough to be a writer in the first place.

Incidentally, I'm apparently quite successful in Germany now. Seriously. I'm the toast of Germany. I'm produced all over Germany. They love me. I assume it has something to do with a guilty conscience and my Judaic background, because I can't figure it out. Germany and the Scandinavian market—my two biggest markets.

I first came to New York in December of '76, when I was just turning seventeen to go early admission to college.

That was an incredibly fertile and exciting period in New York. We don't even live in a pale copy of it today. There was a lot of theater, and I read a lot of plays. I looked around, and I realized that most of what was being produced was very bad, and I thought, "Golly, if I can write a play that's mediocre, I'll have a career." And that's exactly what I proceeded to do. Mediocrity rises to the top, because it's about the best that we have going for us. Every now and then, someone skyrockets, but that's a very rare occurrence. That's why I became a playwright, because I thought I can be pretty fair at this, and pretty fair is all that it takes to be a success.

I wrote a play called *Bridal Hunt* as soon as I got out of college, and it was very vulgar, very mean-spirited, and I'm told that some people thought it was anti-Semitic. I thought it was just about my parents. I gave it to a friend of mine who worked as an assistant at the Phoenix Theater Company, which was, at the time, the oldest non-profit theater company in New York. I said, "Tell me if you think I can be a playwright." And without telling me, she gave it to these two men, Steve Rothman and David Copeland, and they really liked it, and they wanted to do a reading of it. I had never had a reading of a play—at this point, I'm only twenty-one years old. They warned me that because the play was so daring that I should expect a lot of walkouts, because the subscribers that come to the readings are old Jewish people—they'll be very offended. So then we did the reading…and I don't remember a whole lot about it except that the audience loved it. It could not be filthy enough for these old Jews. I'm telling you, they loved it. And I thought, "Well, now they'll produce it." Not only didn't they produce it, literally within twenty-four hours the Phoenix Theater announced that they were closing. So I feel like I shut down the Phoenix Theater single-handedly.

One day, I'm walking down the street and I passed this guy I knew, and didn't really like. We exchanged unpleasantries, and then he says to me, "Did you write a play called *Bridal Hunt*?" And I said, "Why? Who wants to know?"—thinking he's gonna hit me or something. He says, "We have a theater company—three men, three women—and we need a play on a bare stage. All the actors are in their twenties. I thought *Bridal Hunt* was fantastic and I'd like to commission you." This was a complete chance meeting on the street. He paid me, I think, three hundred dollars as my commission. And I delivered three hundred dollars worth of art. It was not a very good play, and I didn't have a computer yet, so I was still typing everything on a typewriter. All the characters had two letter names like Al, because I didn't want to type long names over and over again. And this guy produced it at the Sanford Meisner Theater on Eleventh Avenue. It was a very empty experience really, but it got me back in.

The owner of the Meisner, he said to me, "I think you have talent. I rent the space as much as I can, but there's always some times when I can't rent it. Would you like to do plays here when I can't rent it?" I said sure. So for the next six years, usually in the dead of summer and over Christmas week, I would do plays there with my friends. Very few people came in the beginning. Little by little, over the next six years, we developed a small but devoted audience. It was extremely exhausting, and I never got any reviews. So after six years of that, I said, "I'm gonna write another play, and I'm not gonna do it at the Sanford Meisner Theater. I'm gonna send it out."

I hadn't become a different writer. But the theater world seemed somehow ready for me in a way. I still think shocking people is a good thing—if you can do it. I don't think it's doable anymore. We've seen everything there is to see.

The vulgarization of America—of which I'm a grand supporter, I don't want to sound like Pat Robertson—it's fine, but it makes communication a little more difficult in some ways. It might have been Joe Orton or Robert Altman who said, "You have to wake people up before you can communicate with them." My play *Fat Men in Skirts*, for instance, was a play wherein, at the end of act one, a young boy, who's marooned on a desert island, rapes his mother to the strains of *Bali Hai*. This was very shocking. But, you know what, they might have been on *Jerry Springer* in the eighties. We're not going to be shocked by that anymore.

So my first play outside the Meisner, *Pterodactyl,* opened and it was a big hit and ran for six weeks at the Vineyard Theater. It won a lot of awards and people talked about it and we were on the cover of the *New York Times* Arts and Leisure section. One night, I walked into Joe Allen's. Joe Mantello was at the first table, Sarah Jessica Parker was at the next table, Patricia Carson, maybe Debra Monk—I don't remember who else was there, but I knew everyone and they all knew me. Suddenly I felt like, "Aha! I'm now part of the theater!" I no longer feel that way, but I did feel as if I was part of the theater community briefly for a shining moment. That was what I wanted and why I set out to be a writer—the sense of community. I write plays to be able to go to rehearsal. I don't write plays because I like sitting in my room alone writing plays. I don't enjoy very much the act of writing, but I do it to get to rehearsal.

I've always been attacked savagely in the press. When *Pterodactyl* opened, I was nobody—and Howard Kissel actually decided to out me in his newspaper. I'm paraphrasing, but he said something like, "Mr. Silver is clearly one of those homosexuals who thinks that heterosexuals are etcetera, etcetera." Not that I had a problem with being outed, per se. When I was four years old, I was put into therapy to cure me of being homosexual. My parents, by the way, are groovy Jewish liberals, but this was 1964, and they did what they were told. They took me for psychological testing and the psychiatrist told them I was developing a homosexual orientation. But Kissel knew nothing about me, except for what he could fantasize from seeing a play, and it was a personal attack as opposed to a description of the play. There's only so many years of that you can take. I'm not retiring, but I'm less energized to get back on the horse over and over again. There's only so much bludgeoning a soul can tolerate.

I opened with *Pterodactyl* and I followed that with *Raised in Captivity* and it appeared that I was going to get more abstract and darker, and then I followed that with *The Food Chain*, which was a commercial farce. And there's always been that dichotomy: I write a farce, I write something serious. And this annoys people. It does. It annoys them because they don't know, going in, which they're gonna get. Audiences want to know what they're getting for the most part, and critics want to be able to feel superior and have a sense of being ahead of the writer. John Guare is probably my hero. And John Guare, God knows, has probably written—well, four of them are masterpieces and the rest of them, the world turns its nose up at and says you should go away and die. We're not very forgiving of the small pieces it takes to get to the bigger ones.

I'm not a fan of experimental theater. You won't find me at a performance garage—do they still have performance garages? You're more likely to find me at Carol Channing in the seven-hundredth revival of *Hello Dolly!* When I first came to New York, there was a middle—there was accessible theater that was challenging, and what economics and marketing have done is they've gotten rid of the middle. There's now big, mindless extravaganzas and

then there's these sort of esoteric things that people pretend to like. I guess people like them. I don't. I need some jokes every now and then to get through the night. Really, theater is just something you sit through to get to dinner anyway, so must it be such a chore?

Oh, but I love actors. I give them cookies at auditions. And I write thank-you notes if I don't cast them, if I think they are good.

Sexuality is just a fact of life. Since I happen to be gay, at least historically, some of my characters are homosexual, just as some are homosexual in the world, but I've never written a play about being gay nor would it interest me to do so. Which is not actually true…that's a lie, because I wrote a play about being gay when I was in high school, when that's the appropriate time to write such a play—when you're first grappling with "Am I gay?". I write plays to try to figure something out, and I don't need to figure out my sexuality, so it's not as interesting of a subject to me. But they are just always there. And to me one of the nice things about *Food Chain* was it played to the blue-haired matinee audience and still the sexuality in that play was all over the map, and the nice moment in that play is when Otto's mother shows up, and she has no issue with his sexuality. She only has issues with his obesity, and the audience accepts that. These were theater-goers who were around when Tennessee Williams had to disguise his homosexuality in subtext. We don't have to anymore; it's a given, and not worth exploring because of that. I don't see myself speaking for any group. I barely speak for myself. I've never thought of myself as a gay writer. I hardly think of myself as a writer and I hardly think of myself as gay, so the combination is really troublesome. I was celibate for more years than you're alive.

The job of a play is to communicate. You can shock people to get their attention, you can lull them into a sort of false sense of security by making them laugh, you engage them by making them laugh, and then you pull the rug out from under them. I would describe my plays as like *The Three Stooges* except every now and then Moe pokes Curly in the eyes and real blood comes out and Curly really hurts and really bursts into tears—but you wouldn't care about that and you wouldn't get to that if it hadn't been funny prior to that. So I think it is a very conscious choice. It is also integral to who I am as a human being, because I have a strong sense of being funny. I don't have many selling points as a human being. That would be one of them. That would be *the one*. I think I can draw well. I have a good sense of color and design. I studied art in college. And I'm funny. Those are it. That's it. I'm done.

By the way, people think I say whatever comes into my head. I never say what comes in to my head. I'm very in control. That surprises people.

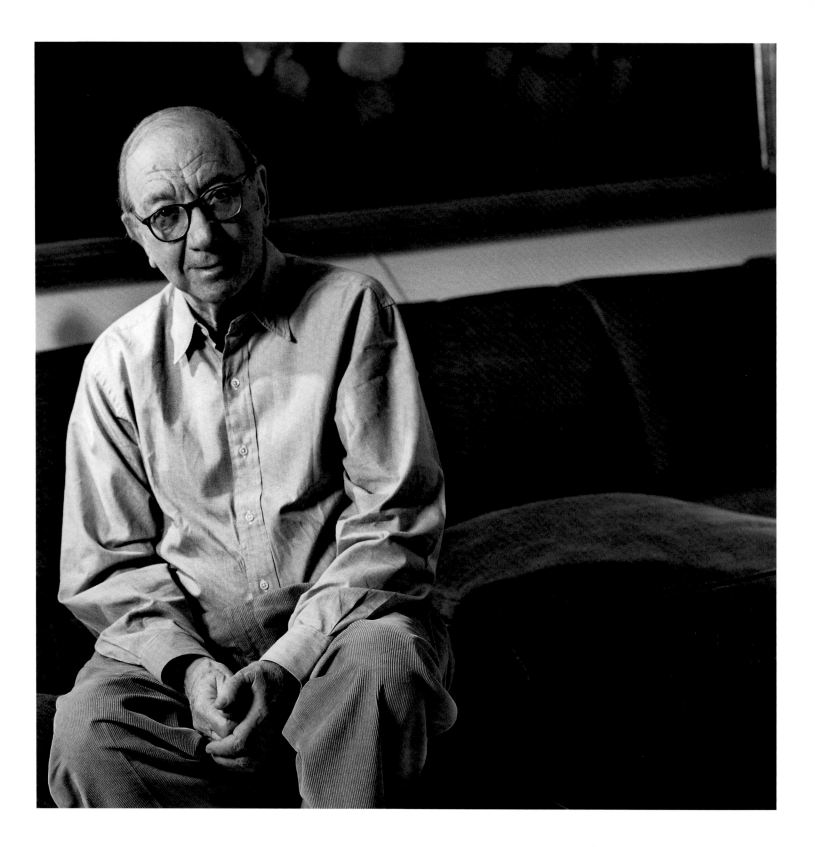

NEIL SIMON

Born in 1927 in the Bronx, New York, Simon has written dozens of plays and nearly as many major motion picture screenplays, including *Barefoot in the Park*, *The Odd Couple*, *They're Playing Our Song*, and *Brighton Beach Memoirs*. Among his numerous awards and honors are three Tony Awards for Best Play and the Pulitzer Prize for *Lost in Yonkers*; he has received more Tony, Emmy, and Academy Award nominations then any other writer.

When I was about fourteen years old, I started writing synopses about my friends in Washington Heights, where I grew up. I wrote about them and what I thought that each one of them would turn out to be like. And unfortunately, it was lost in moving, as many things get lost. I was never able to read it again. But it felt to me later on that what I was doing then, in a sense, was writing my first play. "I think he will grow up to be this and that and so on." That was the beginning of it.

When I was in the army, they had a sign up on the board at the Sergeant's office that said, "All of those interested in newspaper writing, come see sergeant so-and-so." I ran in, thinking they were going to give a class, but I was the only one who showed up. So the sergeant said, "You're the head writer for the army newspaper now." And I said, "What?" And I became the editor of the newspaper for the Army Air Force all over the country and in Europe. It was a little overwhelming. What I did eventually was to take newspaper stories, and rewrite them with a sense of humor.

I wasn't going to be the writer in the family. My brother Danny was. He was always looking for a partner, and he

NEIL SIMON

always thought that I was funny. He was working in the publicity room for Warner Brothers here in New York, and when I got out of the army in 1945, he got me a job. And there was a guy there who said, "You know, they're looking for writers for a show on CBS Radio." Somehow we got on that show when I was still just a kid. It was scary for me, but I had to hold my own, because they didn't look at us as two brothers, as a team—I was an individual, and if I didn't pull my oar, as they would say, I would be out of there. But I did, and then they gave us a very important assignment. Fortunately, they liked it.

I wrote comedy in the beginning mostly, because that's what I learned to do in television on the Sid Caesar show. My brother thought it was going to lead us to movies. I eventually wrote twenty-five movies, but I always kept writing plays. Fortunately, I had enough success to make it to the next step, and each step was a step up, until I wrote *Barefoot in the Park*, and then *The Odd Couple*. How, I'm not quite sure. I suppose because they came from real life. *The Odd Couple* happened because I saw it in my brother and his friend. The two of them were living together, because they just got divorced and they were watching their money to help pay their alimony. Danny would do the cooking and would always get angry at his friend, especially when he came home late with two girls for dinner. It was hysterical, and I said, "Danny, you should write this," and he started to, but Danny wasn't a playwright. I wrote it and it worked. Almost everything I wrote, for many years, had some kind of biographical sense to it. I wrote about those two boys over and over again, my brother and myself.

My brother was the most instrumental person in my life at that point. We would just be talking about something, about an aunt of ours, about how she behaves and how she

does this and that, and he would encourage me. He said, "You're going to be a great writer one day." I never thought that was possible.

What is funny? That is almost an impossible thing to answer. Something that makes you laugh? The best things in humor are what's universal, in terms of the character. People can say, "Yeah, I know that. I know that kind of person. I know that kind of situation." That's pretty much it. It's hard to explain, and it's almost impossible to teach. I mean, the only way to learn is by constantly doing it and doing it. But the more you try to be funny, the less funny you become. It has to just flow.

I never sit down and start to think, "I'm going to write a comedy." Once in a while it happens, like *Laughter on the 23rd Floor*. I'd been dealing with eight comedy writers in the room for Sid Caesar—you know it's going to be funny. But basically, I started to move into serious plays that also had humor. I looked for the quirks and the problems that characters have. Eventually, people would come up to me after a show in the theater, and ask "How did you know my mother? How'd you know my father?" They really thought that that was just between them and their family. But I thought it was universal.

There's nothing like working with a really good director, as I did with Mike Nichols five times. He was the best I ever worked with. He would read a play and say, "I love it, let's do it." He and I would work for six months on a play and he never wrote a line, but would say, "I don't know if I believe that. I don't know if that's strong enough. Why does she do that? Why does he do that?" And it just keeps going and going, and you can feel it start to get better. He always drew something out of me. *The Prisoner of Second Avenue*—I wrote that specifically about someone in my first wife's family. I got to the end of the play, and we saw a run-through of it the night before it was going to open, and Mike Nichols said to me, "The ending isn't going to work." And I said, "How do you know?" He said, "You'll see tomorrow—it's not going to work." I trusted him so much, I asked, "What should we do?" He said, "Well, we have to come up with something better—if I knew what, we wouldn't have a problem." He could drive you crazy. Later he said, "We still don't have an ending that's right." So I said, "You really don't think I could think of one now, at two in the morning!" He said, "Maybe." So we sat in the lobby. Everyone had gone to bed and we just kept working until two in the morning. When you find the right end of the play, it usually comes from something that's already there. I picked this scene, and I said, "What if in the end, it snows?" And Mike said, "I'll get the snow. I'll see you tomorrow." That was it. It worked. I was so glad that he made me sit there and talk about it. Sometimes you have to be pushed.

I was standing outside the theater one night and two men were talking about a scene in *The Odd Couple*. "I bet he changed the name to Felix Ungar so he could use that F.U. joke." It doesn't work that way. I was just looking for some way I could have fun with how Felix signs his notes to Oscar, how he could irritate Oscar, because everything he does irritates Oscar. "Mister Felix…Felix Ungar…F.U." When they did it the first night, the audience laughed so hard that Oscar had to get up, walk around, go up into the kitchen, get a drink of water, come back, and sit down, and by that time the audience had finally finished laughing. It was amazing, but I didn't know it would be like that. You never say, "This is going to get a laugh that will last five minutes." You discover something that's funny without trying to make somebody laugh. You just write what would happen.

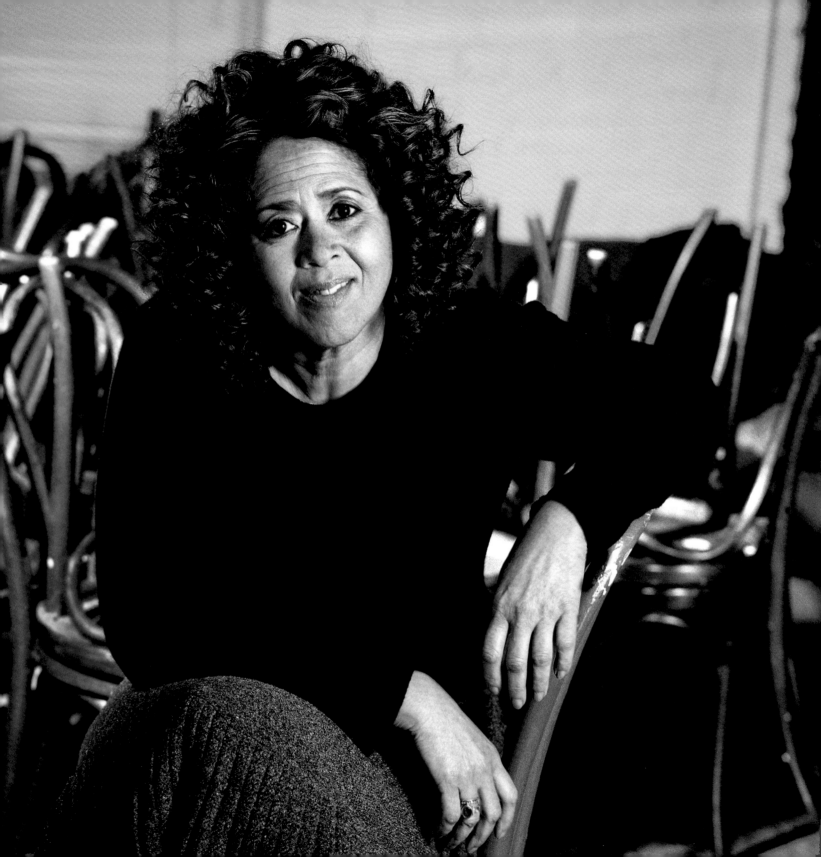

ANNA DEAVERE SMITH Born in 1950 in Baltimore, Maryland, Smith is an award-winning playwright, actor, and teacher. Her work, which includes such titles as *Fires in the Mirror* and *Twilight: Los Angeles 1992*, has garnered two Obies, two Tony Award nominations, and the prestigious MacArthur Fellowship.

Anna Deavere Smith

When I studied acting, I was fascinated with the study of Shakespeare as it was orally rendered. I was taken by the magic of how the language of Shakespeare creates character. There's that scene between Cordelia and Lear, where he wants her to say how much she loves him, that she loves him more than anybody in the world. She won't do it. Her answer is simply, "Aye, my Lord." This is a moment when one word, "Aye," is not a "yes" that is going to give him what he wants, but a "yes" which is not going to give him what he wants. That one word is going to change the course of her life.

I was just talking to a student about it. I said, "Imagine what it takes for her at that minute to say that word to him, because it's kind of an ultimatum. That one word is going to change him, and it's going to change her." And my student said, "I guess that's what identity is," and I said, "That's exactly right. It's individuation. It's the very moment when you pull away from something, when you have the opportunity to carve out a particular place for yourself that's your identity, for better or for worse." And than I said to her, "I really hope that in your life you have the opportunity to say one word that will change the course of somebody else's life."

As a young teacher I just didn't understand why my students' language, when they spoke a written text, wasn't more animated. I got interested in writers who at the time were not so well known, like Sam Shepard. He was writing in a way that was quite visceral—you speak the language, and you become the thing. Ultimately, what I needed to do to illustrate this to my students was to show them how people talked. So I started interviewing people and bringing that real language into the classroom.

For a time, I left teaching and started working in New York. One of the jobs I did was for KLM Airlines. I was in the complaint department, and I would have to read letters of complaint and write responses. That kind of language is very animated. And it was while I was with KLM that I started really doing these interviews. Having left the formal classroom, I nonetheless missed actors. So I did this workshop where I would walk up to people on the street and say, "I know an actor who looks like you; if you would give me an hour of your time, I will invite you to see yourself performed." At the first one of these, there were twenty actors and twenty real people—it was really extraordinary to see all these real people and their families parading in. It was great.

I was a mimic as a kid, so I thought to myself maybe I should just do these. Then I won't have to pay any actors. I'll do them. So I started working on them, and I did thirteen of them before anybody ever wrote about it.

That somebody happened to be Frank Rich, writing about *Fires in the Mirror*. So people started identifying me with this kind of work.

I went to an acting school that was attached to a large and successful repertory company. I'd go every night after class and sit in the second balcony and watch the performances. I would look over this large audience and I would think, "You know, everybody in the audience is white." And this was in the Bay Area—you know, there's a huge Asian population; Oakland has a very vibrant black population; there's a history of activism in the community. I felt there was this kind of gap in the audience in the theater I was seeing.

I came to the theater quite late in my life, in my twenties. I wasn't literate in it before. I hadn't studied it before. I expected that it would be relevant—and I was going to school in this place with an extraordinary diversity of human beings. I'd never seen diversity like that. I grew up in segregated Baltimore, black and white people. In San Francisco, you have people from all over Latin America; you got people from Asia, and, Wow! Why wasn't the theater where I was studying reflecting the world? That blew my mind.

I thought, maybe the reason everyone in the audience is white is because everybody on stage is white, except for these walk-on parts. I thought that if I were able to put different kinds of people on the stage, different voices, that would automatically diversify the audience. What I learned the hard way is just because I do represent different kinds of voices on the stage does not mean the audience will become diversified at all.

One interesting and maybe unsettling result is that I was labeled a "performance artist" in the media. I had just won a MacArthur Award; at the time, I had an endowed chair at Stanford University, and yet when you talk about a performance artist, you think about people who pour chocolate all over themselves. Anything that I did that gave me credibility intellectually was not acknowledged in that description. The media themselves wanted to keep distance from artists, particularly actors, because we are thought to be people who make up fictions and lies.

Sometimes, I am asked if I consider myself a journalist. First of all, I do not have a press pass and secondly, I do not have the financial support that a magazine, a network, or an online service gives its stories, unless I'm working for one of those entities. I do seek to involve myself in the world in the way that journalists do. I seek an understanding of the world around me in the concrete way that they do. I am not usually working on deadline, and they always are. I am often pleased to be in the company of journalists, because they know so much about what's going on around us and have a huge appetite to find out. I also like the way that good journalists think, inquire, and tell stories. I learn a lot from them. However, in the end, my quest is for metaphors, and my quest is to find a way to create fictions that tell truths. What journalism prides itself in is finding truth. Now, I do try to find the truth. I believe that we create fictions in order to illuminate truths. When I talk to people, I don't know whether they're telling me the truth or not, but I am concerned that I capture the authentic moment. I try to balance out the possibility of not hearing the truth by having multiple points of view, so the audience can come up with their idea of what the truth must be.

We live in this age when you have to have an opinion. But I don't think an opinion is the same as a point of view. I teach freshmen now at NYU—I really love freshmen— and in the beginning of the class I ask for questions.

Nobody had any questions. One kid finally asked, which I thought was a fabulous question, "What's going to happen in here?" In the end, at the last class, I said, "Do you have any questions?" Everyone had a question. One young woman said, "You change your lenses all the time. Tell us how you do that." I thought that was very interesting. You go to the eye doctor, and they have all these different lenses that they put in front of you to find out what you need in order to see better.

What I'm trying to do is switch the lenses all the time. Switching the lens though which I'm looking is the most important part of the process, not to present a point of view, but to put the audience through something. For example, with *Fires in the Mirror*, somebody said to me that it was a process of mourning. That's really right, because I started the show with an intellectual statement and then there were some things that were rather funny. Seeing people laughing and having a wonderful time, part of me would go, "Oh, I feel so bad for you, the audience, because it's going to turn and be really sad." I was trying to bring the audience through a variety of opinions, through the rage, and then ultimately hitting sadness and the tragedy of what happened in Crown Heights. I would rather take an audience down an emotional path than to give them a point of view.

I actually went to California from the East Coast after college, with the idea that I might find something to do that had to do with social change. I ended up in entertainment. Yet, I believe that art can make a difference, and that artists can intersect with the world in powerful and interesting ways. One of the books I read when I was learning how to do interviews was about the psychoanalytic interview. We know about the talking technique, not that it's used very much anymore—people prefer pharmaceuticals.

But nonetheless, for quite a long time, we heard the expression of language could heal psychological problems. I actually think there should be more exchange of language in medicine right now, that there is something very healing about people's feeling that they've been heard.

While I was in New Orleans after the hurricane, this was very much the case. If I were to do a play just about New Orleans, I would call it *Grown Men Crying*, because many grown men broke down crying in front of me, and several people who wept in my presence told me they hadn't wept yet until that moment. I don't think there's anything so special about me except that I try for that course of an hour to really hear them. Just giving a person your intense concentration has a lot of potential.

In one of my acting classes, I asked everyone, "Who could you never be?" One student said that she could never be her mother, "Because she's so nice." I told her to interview her mother, with the idea that she would try to "become" her mother by saying her mother's actual words over and over again. This is my simple technique. So she interviewed her mother and the piece that resulted—my mouth was just hanging open. It started with her mother saying, "I never loved your father. I was such a fucking asshole. I made such a mess of my life. I can't believe I made such a fucking mess of my life. I was such a fucking asshole at twenty-nine years old. I'm never going to have a meaningful love relationship in my life. Of course, I'm happy that I have you kids." And then she goes on to say, "I'm never going to have a meaningful relationship, and I'm not well. It's not like I'm going to wake up one morning, and it's going to be fine. It's not." I asked my student, "Your mother says she's not well, is she not?" And she said, "She is a cancer survivor."

It was magical to me to work with this young woman on a text of her mother who is facing what she thinks is inevitable disappointment in her life. And the girl shaking that off, talking about this, about her mother's failure, but doing it through the frame and the point of view of wanting to be her mother because her mother is so nice. I think that was real magic, that her mother passed on to her this thing that could seem like a burden to the daughter, but the daughter handled it with such precision. The daughter took on her mother's pain with such care and attention and was so meticulous that she did what I really believe we as artists have to do.

Mary Ellen Mark, the great photographer, writes in her book *American Odyssey* that the camera gave her the necessary distance to get close to people. My camera is this process of taking every stutter and failure of language that a person has; my camera is paying attention in that way, not just to what a person succeeds in saying but to what they don't succeed in saying. My student put that kind of a camera on her mother, and rendered this extremely moving piece about a woman who is dying without ever having been in love. It was so powerful to me. It was magic.

ALFRED UHRY Born in 1936 in Atlanta, Georgia, Uhry is best known for his first play-turned-film, *Driving Miss Daisy*, which won the Pulitzer Prize as well as the Academy Awards for Best Motion Picture and for Best Adapted Screenplay. Additional honors include two Tony Awards, for his play *The Last Night of Ballyhoo* and for his book of the musical *Parade*.

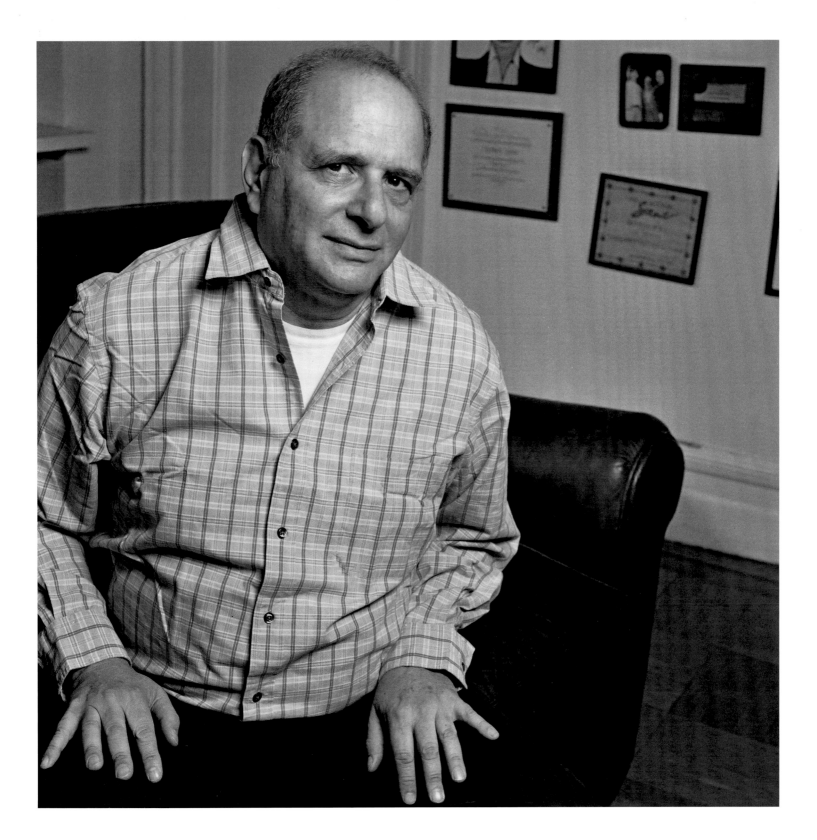

I was born in Atlanta. My mother was born in Atlanta. My grandmother was born in Atlanta. My grandmother's mother was brought to Atlanta as a small child in the 1840s from Germany when her family was trying to get away from Bismarck. So my Southern Jewish roots go way back. My father was in the furniture business and they had furnishing shows twice a year in New York, and when I got older they brought me a couple of times. My father didn't care for the theater much, so when my mother wanted to go, she took me. I saw all of these completely inappropriate plays for a child to see, like *Mad Woman of Chaillot* or *Detective Story*, which was about abortions when I didn't know what abortions were. But I got the theater bug.

I left Atlanta as a college freshman and went to Providence, Rhode Island, to Brown. I wrote musical comedies at Brown with Robert Waldman, a composer, and we decided to storm the bastions of New York and become the next Rodgers & Hammerstein. After a few years, we signed up with Frank Loesser's publishing company and I got lessons

Alfred Uhry

from Frank on how to write lyrics, which I certainly still use—he said to make every syllable count. He taught me to be very spare, and to this day I underwrite things. My first drafts are always the shortest, and I fill it in as I go on. It's the opposite of how most people work. If my first draft is ninety pages, I'm thrilled that I got it all down.

Eventually, Waldman and I collaborated with Terrence McNally. Our musical version of *East of Eden* ran one night. When we opened in Philadelphia, a man sitting in the balcony fell over dead into the aisle. They had to get a gurney and carry him out. That was my introduction to professional theater. It's funny that Terrence and I have separately done so many things that won awards, but together we lasted one night.

About twenty years ago, my friend Jane Harmon, who is a producer, asked me if I would go to see this play—I've forgotten the name—a two-character play about a white woman and a black woman in Minnesota, I think. After, Jane asked me what I thought, and I said, "I could write a better play than that." And then, all of a sudden, I thought I would write a play about my grandmother and her driver. I had never written a play before.

As a musical lyricist and book writer, I always found lyric writing very hard, but I always loved the dialogue part. So I wrote this little play, and from the beginning it was surrounded by some sort of light. My agent submitted it to a bunch of theaters, and most of them said that there wasn't any story, but Andre Bishop at Playwright Horizons wanted to do it, and did it. That was back in the late eighties, and 42nd Street was not what it is now; there were hookers all over the place. The play was supposed to run five weeks in a seventy-four-seat house, and then it ran ten weeks, and then it ran twenty weeks, and then they moved it to Broadway

and on and on and on. Before I knew it, the play was a huge hit and I won a Pulitzer Prize, and they made the movie, the movie won the Oscar, I won an Oscar. It was almost too much to believe. But that was *Driving Miss Daisy*.

I had never written about my family. When I was a child, I was going to write a novel about my grandmother's family, and never did, but it was always present in my mind. I thought no one would be interested in my own particular life.

I learn as I go, and I do a lot of thinking before I write. Once I start it's not so long, but it takes me a long time to hear. That's a big part of playwriting—just listening and watching. Sitting in the subway, sitting in airports, and just watching people. Why are those two together? Why do people on early morning flights drink? What are they thinking at seven o'clock in the morning? I watch people on the street sometimes. One time I was walking my dog, years ago, and this woman—she was a hooker—and she says to me, "You're dog isn't fit to wipe my canary's shoes." That's terrific! Another time, I had a young playwright that I worked with, a kid from Georgia, and he was staying here in Manhattan. He'd never been to New York, so as we were walking down Broadway I say, "New York is a really interesting city." A block away are two kids and they're both laughing. One's way in front of the other one, and he had this rope and it was tied to the other one's dick and he was leading him down the street. And I just said, "Well." And the young playwright said to me, "I'll never feel the same about a length of rope in my life."

Being Southern and being Jewish, I felt as a kid like I was always aware of the party, but that I wasn't invited to it. I think a lot of people feel outside of the swim. And there is certainly some minor angst in what I've written. In *Miss Daisy*, you realize that those are certainly two people that are outside looking in, and would never talk about it. There was a certain loneliness and a certain gap that they never could cross, even with each other. She had to have a stroke before she would tell him he was her best friend. I'm sure they never mentioned it again. Otherwise, I was incredibly not self-aware. I'm a fifties boy and we were all pretty buttoned up in the fifties. For a playwright, I think I've had an unusually straight life. I married when I was twenty-two. I had four children. My suffering was pretty internal. I didn't hang out with a lot of playwrights. I was polite. I was a good boy. In that respect, I always longed in a way for some sort of East Village life. I do hang out with actors and actresses now, but when I was young and hungry, I didn't do that. So I always felt like my own life was much more mainstream than most playwrights' lives. I've learned to use my own life. I think deeply and deeply care about things—but I think it comes out in a much more accessible way, not that I try to do that. I just am. That's me.

Playwriting should be a journey every time, and I emotionally don't want to go to the same place again. I couldn't write another piece about lynching in the South, because I already did that. I couldn't write another piece about going to a dance in Atlanta, because I've done that. I don't want to. It doesn't mean I have to write a play about tea plantations in Salaam or something I know nothing about. But I like to challenge myself.

I will always remember the first performance of *Driving Miss Daisy* at Playwrights Horizons, in a dilapidated seventy-four seat theater. Andre Bishop and I were standing outside the theater before the play. And he said to me, "I don't know what's going to happen with this play, but I can tell you that you are a playwright." I remember just feeling so warm. I think I'd been waiting to hear that all my life.

PAULA VOGEL

Born in 1951 in Washington, D.C., Vogel is the Pulitzer Prize-winning playwright of *How I Learned to Drive*, as well as numerous other plays including *The Oldest Profession* and *The Baltimore Waltz*, which won an Obie Award. Other honors include selection as playwright-in-residence for the Signature Theater Company and several National Endowment for the Arts fellowships.

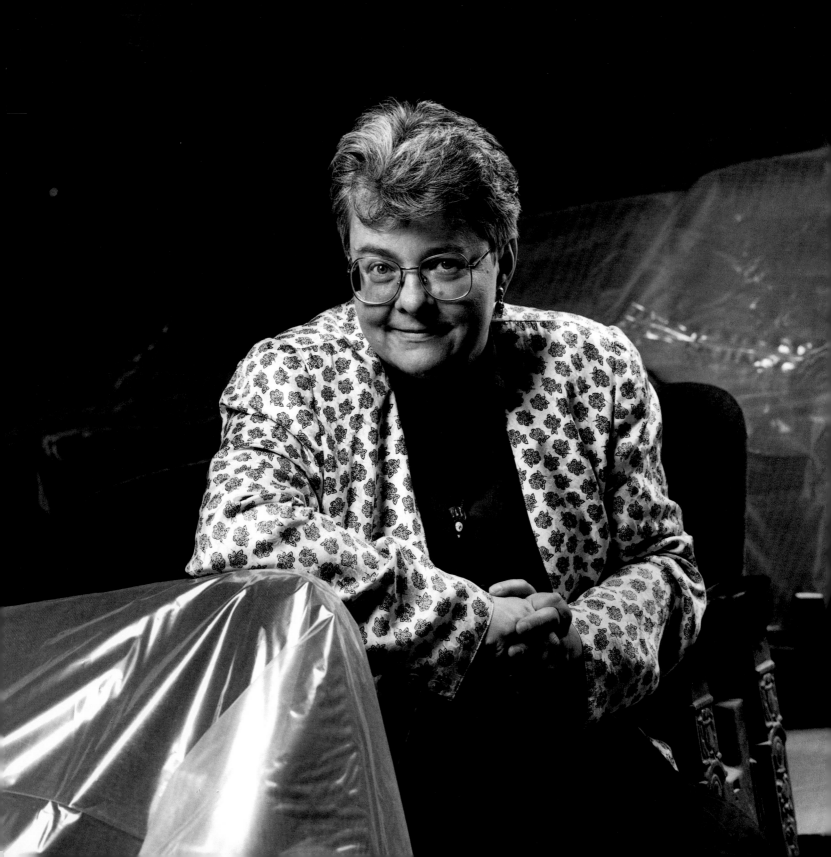

PAULA VOGEL

Playwriting is really an upper-middle-class profession, which is to some extent inbred. Someone has to subsidize the skills, and it's usually parents and friends, or someone's own trust fund, because there's not going to be a profit for a very long time. I didn't have any of that. I wasn't born with a silver spoon. I didn't have wealth. There weren't any doors open. My mother's a secretary. For many years of my life, I lived under the poverty line. It's a plus in that I've learned how to sustain my writing. I had to take several jobs at a time and still learn how to write. I had to believe in myself with an incredible persistence. I had to sustain my writing and figure out if I was going to be rejected anyway, I may as well be rejected for good reasons. And the good reasons are to have a singular voice that offends people who don't want to change the status quo. I started writing, really, to please myself, instead of thinking of it as something one would do to please one's parent's friends around the country club.

When I was fifteen, my brother put a copy of *Sexual Politics* in my hand. I read it in high school and I developed a very early feminist conscious. I'm very much the type of person, who, if you tell me to go away, I will dig in my heels. If someone says, "You can't belong to the country club," it just makes me say, "Alright, I'm going to apply to the country club and never get in, but I'm going to embarrass you by standing outside of the gates and letting people know that I'm standing outside of the gates." And that has very much been the case. There are still lots of theaters that are feet-first theaters for me.

I worked at my Brown job and put in the work of two jobs in a single job, which is what you have to do to build a program. When I got the opportunity to teach at Brown, I thought very much about my rejection by Yale. I looked very carefully at the wonderful writers that they were doing, but then I looked at the privilege of Yale and thought, "I'm going to found the anti-Yale. I'm going to teach writers who have fallen between the cracks because their voices are too singular or too original." I want to make sure that they get done.

Building a program in academia is more political than theater—actually, it's more political than the government. It was Dwight Eisenhower who said, when asked, "What was more political: being the commander during World War II or being president?" He replied, "Being the president of Columbia, where people kill each other over nothing."

Hopefully, when you sit down to write, you are trying something that has never been tried before. You are trying to test what the definition of theater is every time you write. The most harrowing political theater is also entertainment, it's not escapist. Anything that's performed, be it Beckett, be it Gertrude Stein, has a political resonance

because we are a community of citizens collected in one place to watch it. We are watching each other watch the play. We go out through the locked doors and into an American street. It was how the theater was defined. It was how the theater was designed, all the way back to fifth century B.C. The thing that was remarkable was that Greek citizens were obliged to go to the theater. There, in the midst of waging war, they had to sit and watch Euripedes' *Trojan Women*, that showed the impact of war on women civilians and children. The fact that senators who had voted to wage war would have to sit next to priests and watch that—that was tremendous.

In the fifth century B.C., there were subsidized tickets to the theater, so that theater was accessible to everyone, the impoverished in Athens. Rich citizens were obligated to produce theater. It was their honor and occupation to produce theater. This was the model from which we've retreated. What we've done is say, "Theater is entertainment. Theater is a commodity, and therefore it should be competing in the free market." Well, there is no free market. Democracy and the theater are intertwined. Is it entertaining? Yes. Is it religion? Yes. Is it political? Yes. It's all of those things. There is no simple, reductionist way of approaching theater. The more we say, "Oh, our patrons or ticket prices will provide the economic basis for theater," the more we're lying to ourselves. That's simply not true. It's not a commodity. It is not something to buy.

I only write now when I absolutely have to. I'm more concerned right now about the making of new playwrights than I am the making of my own new plays. Because it seems to me that I could easily not have been stubborn or stupid enough to persist in this. I don't want to lose other voices that are unique. That can be my contribution to the American theater. I am an optimist. I think

there's actually an inverse to the law of supply and demand. If there is a growing supply of really brilliant, shocking, stunning, original voices, there will eventually be a growing demand for it.

I think anyone can write a play. I think we were all born artists. I have proven that anyone can write a play. I will continue to prove that anyone can write a play. I know that the women in the adult correction prison that I've worked with did as well, if not better, than the graduate playwrights that I bring to Brown. Anyone can write a play. It is a play. It is a communal form. It is a form designed for an audience. If we can all be audience members, we are, in essence, all writers. One of the things that's really hard in theater is the elitism. I would like to see it be a much more popular, accessible form. The only way to do that is to go out and prove that anyone can write a play. The one thing that I will continue to do are these kind of boot camps with non-writers. Usually there's at least one person who starts writing and continues. It's that notion that we have to increase the supply of playwrights in order to increase the demand.

If you want to ask me how I sort of look at myself, it's like the little Johnny Appleseed approach. I'll go here, I'll spend a week, and I'll see within this community, who wants to play, and give as many tools as I can, and just hope that they continue. I get about one hundred e-mails a day from people all over the country. I sometimes have a hard time answering all of them, but I try. Because we have to increase that supply. We have to make sure we get out there and get the next generation through the doors.

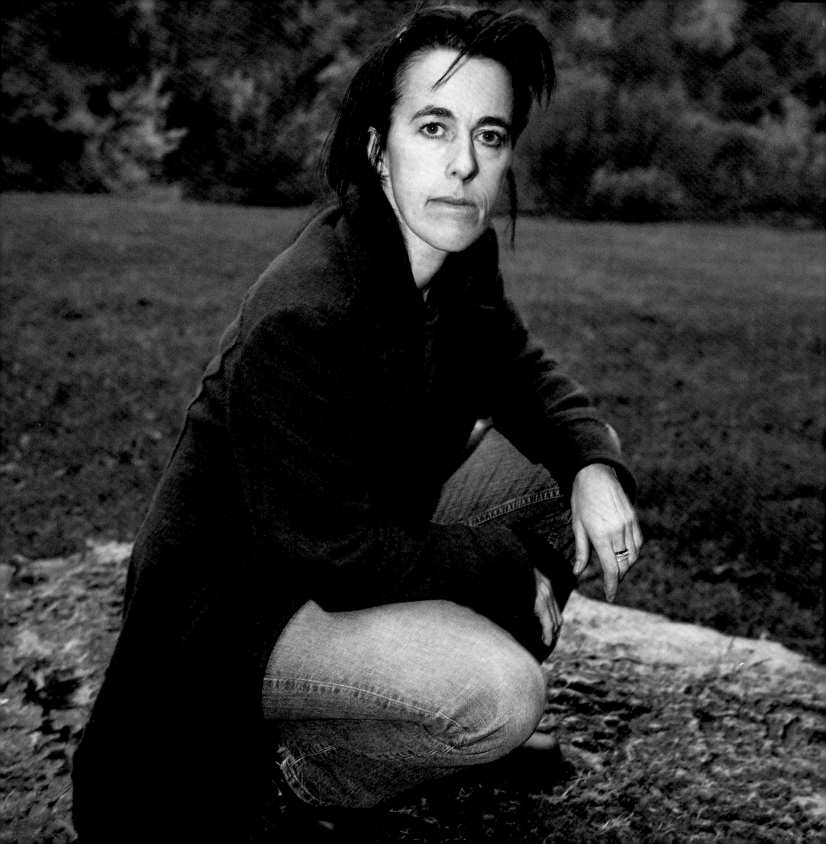

NAOMI WALLACE

Born in 1960 in Prospect, Kentucky, Wallace has written numerous plays, including *One Flea Spare*, *In the Heart of America*, *Slaughter City*, and *Birdy*. She is the recipient of many awards and honors including the Susan Smith Blackburn Prize, a National Endowment for the Arts grant, a Kentucky Foundation for Women grant, an Obie Award for best play, as well as a MacArthur Fellowship.

Both of my parents were political people, radical people. And my mother really began that education in our family. Her family is from Holland, and they were active in the fight against the German occupation in World War II. She was fourteen, and her mother had a safe house for Jews under their floor. She grew up very conscious of oppression, but also of the role that one can take in order to fight it. My parents were both very active against the Vietnam War and in the civil rights movement. So I grew up in a family involved in resistance to oppression, resistance to fascism, resistance to racism. That was just part of our initiation into the world, and my family's involvement in those issues was very formative in terms of my vision as a writer.

My mother's family was a working-class family, and my father's family came from a more privileged life in Kentucky. So growing up, I was always aware that we as a family had a privilege that most people did not have, because the area we lived in was very rural and the neighbors that we gathered with as kids were working class, African-American, and white. It was through that community that I started listening to language and learning from language, how people spoke and how they expressed their reality. Even at a very young age what struck me was how inquisitive people were even in the most dire of circumstances—how philosophical, how inquiring they were of their own state in the world.

I was also aware as a kid of the lie of the American Dream, and how damaging it was—but in a way also how brilliant it was that a whole people was brought up on this notion that if you just work hard enough you can get ahead, and how this left the majority of people with a feeling that they had somehow failed. But I saw people always resisting this, questioning—if I have worked so hard all my life, how could it be that I still have nothing? That affected me greatly.

I started writing poetry at a very young age. I would write poems for my teachers. Often these were about critters, searching critters, usually because they were missing legs or wings, and they had to go out and find them. When I look back, it was always about critters attempting to liberate themselves. My grandfather was one of the first conservationists in Kentucky, so I also grew up in a family that was very aware and caring towards animals and nature. That's where the idea of bugs and social justice comes from.

I didn't write my first play until I was thirty. I had read a play called *The Go-Back Land* by a close friend of mine, Lisa Schlesinger, and I thought, "I can do this." I'd never really thought about writing for theater until then because it always seemed a very strange medium to me. I didn't go to formal theater until my twenties. I remember it was Actors Theatre of Louisville and everyone was dressed up and almost all white, and it felt very alienating, stuffy and not at all really connected to what I thought was the real world. So I turned my back on it for ten years.

But Lisa's play was about the land and it was about a family and it was about history. It had a voice to it that I recognized. And then I realized, with theater, these voices that I had in my head, these other voices that I had so far only put into poetry, could actually be spoken on stage and one could hear them out loud.

The first play I wrote was called *In the Fields of Aceldama*. It was about a family, a farming family on the land, and about the death of a child. It ends with the mother leaving, so it's a dissolution of a family of three. One can say it explores the tradition of the dysfunctional American family, but it was broader than that. It brought in the Vietnam War and how that affected the family.

My own imagination pales in comparison to the events of history. My family instilled in me the idea that in order to understand this hour, we must go back to the hour before it. And so in order to understand this year, this decade, we must go back to the decades before it, the centuries before it. In order to put a character onstage, you have to understand what had happened before that, not just in their personal lives, but in their time of history.

One of the things that draws me to theater is that the past and present moment can interact in real time. My intention is to make the past alive again, to make it a living thing like history. If the past and present can interact through real time, through live bodies, there is a possibility for a spark when this happens—what I would call a light to see by.

Theater is one of the most intimate art forms because it is through the body that we see the story. And yes, there is a voice, but it can only happen through three-dimensional living, human beings on stage enacting a story. So that is something that drew me to the stage because being fascinated with history, one can also only be fascinated with the dead. Only onstage can history bring us its dead in living form, and only on stage can the dead open their mouths and speak to us. In a way, that is very regenerative in terms of possibility for tomorrow, and possibilities for the future.

The possibility for change is always available to us and I think that's what we learn from history. At any point in time when forces come together during revolution, during upheaval, there are all kinds of possible outcomes in that moment of pressure. Of course, in hindsight we only see the one path, that the change moved in one direction. But looking back, with our detachments and our distance, we can learn from that other choices could have been made, completely other directions could have been possible.

When we feel so solidified in our past—and we are taught through this culture and society that nothing changes—it's very difficult to make change. Mainstream history ignores the upheavals, the explosions, the reversals of direction.

Looking at the past is where I get my hope for the future. What inspires me is the continual, relentless resistance to what diminishes us. There is far more resistance happening in the United States today than is ever acknowledged in our media, real grassroots movements and people coming together across race, across class lines, and gender lines. So I think one cannot study history without being hopeful that change is always possible in any moment. It's not just that change is possible, it's that we, ourselves, are possible and can recognize our own agency, our own ability to interrupt, to challenge, to transgress in our daily lives. My hope is that I create theater that will bring questions to the fore, rather than giving answers. Once you give someone an answer, they have lost their own ability to discover it themselves.

I hope that my work is complicated, but, of course, entertaining as well. Above all, theater should entertain, because it's often through delight that we learn most fiercely.

NAOMI WALLACE

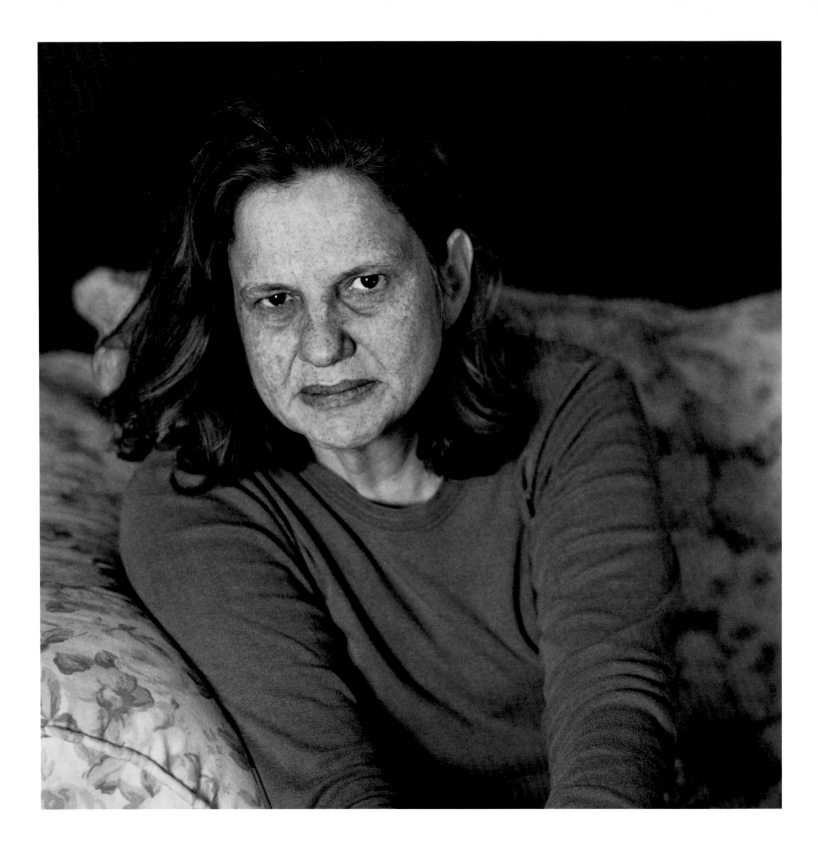

WENDY
WASSERSTEIN Born in 1950 in Brooklyn, New York, Wasserstein won the Tony Award and the Pulitzer Prize for *The Heidi Chronicles*, and wrote numerous other plays including *Uncommon Women and Others*, *Isn't It Romantic*, *The Sisters Rosensweig*, and *An American Daughter*. Other honors and awards include the New York Drama Critics Circle Prize and the Drama Desk Award. Wasserstein passed away in 2006.

WENDY WASSERSTEIN

It's hard to be a playwright, really hard. My mission initially was to put parts for women on stage, parts for contemporary women. Since that time, there are many more women writing plays, and certainly more women artistic directors. Look, I was the first woman to win a Tony Award. The only other time a woman had won was when the Hacketts won for *The Diary of Anne Frank*. So in some way, I feel that mission of opening a door has been successful. Someone now doesn't get a play put on because they're a woman or because it's a woman's subject. I don't think that's true at all. And that's a good thing. So now my mission is to just keep working.

My plays have generally been about educated women and the choices they're making in their lives. To some degree these women are invisible in the theater. But if you look at roles for women in the theater in an earlier age, that wasn't so. Look at Shaw plays, a number of them explored the dilemma of an intelligent woman. Ibsen plays, as well.

But in some ways, the women who you know in your daily life—I feel that those women are still invisible on the stage. On my elevator the other day I was feeling a lack of self-esteem (and everything else), and a woman suddenly said to me, "Oh, I love your plays and it's important you keep writing. I'm just like you, I went to Sarah Lawrence, and I'm Jewish, and I'm one of these women you write about." And then she said, "We've become invisible." I thought, "That's really interesting." So I guess if I have a mission, it's that.

In comedy, it's bright comedy for women—that's something I've tried to do, too. In *The Sisters Rosensweig*, the character of Gorgeous is really funny, played by Madeline Kahn. Really, deeply funny. But it's not degradingly funny, and that was more important to Madeline than even to me.

Madeline kept telling me this had to be a woman of some dignity because Gorgeous could easily be camp. But her joy in putting on that suit was genuine joy. The thought of a housewife who gets a Chanel suit is innately true, to whoever it is. It would be true to me, it would be true to some woman in Roslyn, New York. In fact, somebody sent me a pair of shoes about a month ago, and I have to say I was screaming around the house. I was really happy!

I was very influenced by the feminist movement. I don't think I would've been a playwright if I wasn't. My ideas to put women on stage did come out of being in school and reading feminist writers of the late sixties, early seventies. I think what Heidi asks in *The Heidi Chronicles*, "What do mothers tell their sons that they never bother to tell their daughters?" is something I think about, too. What is it about being a woman as opposed to being a man, and is there any difference now? I'd say yes.

Probably, in the long run, the best thing I did was start the Open Doors program at the Theater Development Fund. This is an amazing program. Last year, we had Hal Prince, Frank Rich, Alex Witchell, James Lapine, Bill Finn, Scott Ellis, and Graciela Daniele all involved in taking kids to the theater. They otherwise may never get to go—and they loved it. Every year at the end of the year, we have a party and invite all these kids. It is your birthright as a New Yorker to go to the theater, and I thought these kids deserved the same education you get if you go to Dalton or Exeter. That's what I wanted to give these kids: at least, the equivalent of some well-rounded high-school student. It was amazing.

There was a girl from the Bronx, the first girl going to college in her family. She's going to go to Sarah Lawrence, and said, "I never particularly felt part of the city, or felt the myth of America. It never moved me. Then I went to see *Oklahoma!* I was so touched by the cowboy and the farmer." I thought, "OK!" And then another girl—she went on to Haverford—said, "I never thought Broadway would be part of my life; it's just this separate white world." But after going she said, "I feel like a New Yorker. I am as much part of the city as anybody else." So it has been an amazing thing. Hal Prince has said this has changed his feelings about theater, it's reinvigorated him. Imagine—you're a New York City public high school student and you're going to plays with Hal Prince and talking to him afterwards about it! I mean, who does this? You don't get to do this in graduate school, frankly.

What's fascinating about bringing these kids to the theater is what they like. There is nobody at Disney or Fox who would think these kids would like *Parade* or Beth Henley's play *Impossible Marriage*. There is no way they would think that. They wouldn't take a kid to see an Edward Albee play. And it's not for the "shock" of it, it's because these are intelligent people. And this is how you determine the character of a nation. I don't think that's necessarily determined by saying prayers in the school, I think it's determined by art. I think it's determined by introspection and character, and what choices you have and make. I think art is part of health and education. It would be wrong to separate them.

I had a variety of theater experiences when I was young. I went to Yeshiva Flatbush, and I was Queen Esther in a Purim pageant in second grade. Then I went to the Brooklyn Ethical Culture School, where we used to do mini Shakespeare plays. I was Calpurnia, that sort of thing. And I think we used to write little festivals. In high school, I wrote the mother-daughter fashion shows for the Calhoun School, because I knew they'd let me out of gym.

And when I was in college—this is really true—I was studying to become a Congressional intern, and I kept falling asleep on the *Congressional Digest*. A friend of mine said, "Why are you doing this? We can take playwriting at Smith." I thought, well, that's better—and then we can go shopping. So I went to Smith, and I was very lucky to have a great teacher, Len Berkman. Years later, I got an honorary degree from Smith and I found out I had been in his first class of students. I had no idea about that.

I was always funny. And I always thought that I would get by, by being funny in life. But I thought you were funny in life, and then you became a lawyer. Except that I would be a terrible lawyer. I even applied to law school and didn't get in. I got into Columbia Business School, and I almost went. I came to New York and took writing from Israel Horovitz and Joe Heller and then I applied to business school and drama school, and I got into both. I thought I'll just go to Columbia Business School, and then I'll move to Chicago, work at Leo Burnett in advertising, get married, and I'll be normal. Sometimes still, I'll go to Chicago, and I think, you know, I could have had a normal life! I could be here, riding the escalators at the Water Tower!

I'm from a business family, too. My brother is a sort of famous banker and my sister was this pioneer in corporate America, and my dad was a businessman, too. So that world doesn't seem so foreign to me. Maybe that's why my plays, like *The Sisters Rosensweig*, are about regular people, because that's where I'm from. This is not an artistic family, except for my mother, who is a show unto herself. My mother, I feel, will be my best play, if I ever write it. I still believe she's the most interesting person I've known, and the most touching.

My grandfather was a playwright, too, on my mother's side. His name was Shimon Schliefer. He wrote Yiddish plays, and he actually knew the people of the Yiddish theater. He came to this country and he acted in Pittsburgh, and then came here and was the principal of a Hebrew school in Patterson, New Jersey. He used to come into New York and take my mother to the Yiddish theater. So there is a theatrical side there. I didn't really know him, and I don't know where his plays are. My father lost his plays. But I once met someone at Amherst College whose father was a Yiddish playwright, who knew of my grandfather. So I think that strain is there.

Chris Durang and I used to go to movies a lot at the Yale Film Society. I loved Chris Durang. He's someone I've loved all my life, actually. I met Christopher the first day of school at Yale. He was two years ahead of me and he saw me grimacing and Christopher said to me, "You look so bored, you must be very bright." And that's the first thing Peter Patrone says to Heidi in *The Heidi Chronicles*.

The way it begins for me is I see a character, and then I see a moment for a character. *The Heidi Chronicles* was taking that girl, a girl like Swoosie Kurtz, a happy, healthy smart girl, and having her get in front of a group of women and having her say, "I've never been so unhappy." That was the genesis of the play. The characters become interesting to me, and then I kind of figure it out. The characters lead the story.

The first reading of a play is great, but also terrifying. It still scares me now more than anything. Being in a room as the actors start reading a play out loud—that is thrilling. It just is, to hear what had been in your head for so long. It's a rather particular gift, I think, to know how to write to make people talk. If no one ever wrote plays again, Paramount Pictures could care less, and so could *Entertainment Tonight*. But I think it's completely humane. I feel like an artisan, like a craftsman, when I do it.

When things are very personal to you, they strike a chord. Like the speech in *The Heidi Chronicles* where she says, "I feel stranded." That's quite personal. Not that Heidi is me, but the emotion was one that I certainly had. And I think that also struck a chord with all these people out there in the audience. I love to tell this story: I was once on an airplane, and there was a woman with painted red nails and her hair all done up. I was staring at her because this woman was my age, but we were completely different. This woman and I had nothing in common. I have no idea what it would be like to wake up and be her—to know what happens first thing in the morning when she looks in the mirror and says, "Oh, I must put on all this stuff!" Well, this woman came up to me on the plane and said, literally, "You're Wendy Wasserstein and I love your work—you write about me." I thought, that was so interesting. I guess if you hit a chord, there's some response. What you think is true of a certain thing suddenly becomes universal. That's exciting, that some things are just true.

MAC
WELLMAN
Born in 1945 in Cleveland, Ohio, Wellman has authored numerous plays, most famously *Terminal Hip*, *A Shelf in Woop's Clothing*, and *The Distance to the Moon*. Among the many honors and awards he has acquired as a playwright are a fellowship from the National Endowment for the Arts and the Obie Award for Lifetime Achievement.

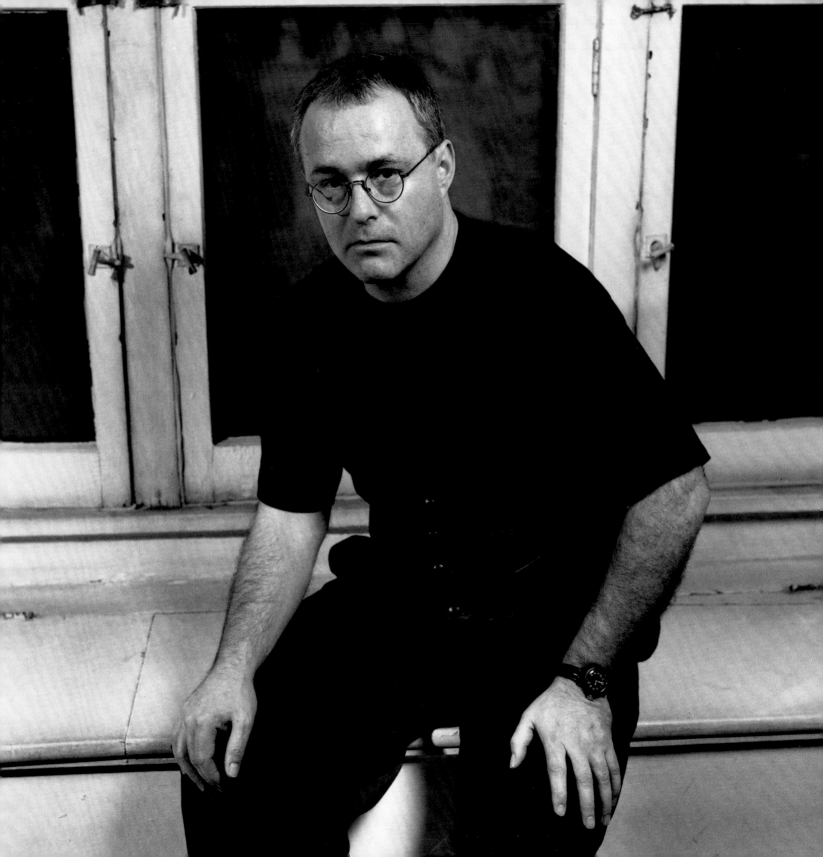

I was on my junior year abroad and I happened to be hitchhiking in the Netherlands, and I was picked up by a stage director who was a very important person in that country, in the Dutch avant-garde. She was a real bohemian and we became friends, and she is still a good friend of mine. I showed her some of my poems that had dialogue in them, and she said, "Have you ever thought of writing a play?" I said, "No, I have no idea what that is." She said, "I have a guy from Dutch radio coming next week if you want to make a proposal to write a play, come up with something." I didn't know anything about theater, but I did come up with an idea. It was made. It was made in Dutch, a language I don't understand. It started that way. The first four or five productions of mine, both stage and for radio, were all done in a language I didn't understand. I was kind of shocked and horrified when I first heard my plays in a language I could understand. So it's not something I pursued directly. It just sort of happened.

For years, I wrote what can only be called ghastly poetical plays, the kind of play written by poets who know nothing about theater. I came to New York, and I knew there was something wrong with them, I just didn't know what. Finally, I came in touch with real theater people and often they were interested in the texts but had no idea what to do with them. So I had to learn how to explain what I thought should be on the stage. There were actually good reasons for a lot of things that theater people think and do. I came across work that made me convinced that despite the fact that I was a damned poet, and always would be, I could make some kind of niche in the theater. I didn't want to be thought of as experimental at all. Now, I think it's actually a pretty good place to be again, because I think there's nothing wrong with an experiment. Life's an experiment. Most of what we do is experimental.

There's something about theater that's very political, even if there's not a political word or sentiment in the play, because it sets behavior up against language. The most interesting thing about our time is the fact that often what people say stands in stark distinction from what they do. A lot of theater tries to make this contradiction go away. I don't. I revel in it. I'm interested in the dialectic between language and gesture, behavior. We all know we're contradictory. We fight it all our lives and it's hopeless. We always want things that we shouldn't have, and we always have things we don't want that other people want and it's endless and humiliating and horrifying, but fascinating. And theater is a way of looking at that stuff.

I remember the first time I had a one-act done at a more or less reasonable theater here in New York. They did a reading of it, and at the conclusion of the reading the actors and the director said, "You have such a deep understanding of human nature." And all I was trying to do was make fun of the main character. And I said something like, "All I wanted to do was to nail his ass to the wall." And I realized I created a problem for them. I committed an indecorous act. They were taking it seriously and I meant it as a joke. Actually, they were seeing something in it that I did not see. Whether I was right or they were right is neither here nor there. It taught me that whatever my intentions were, it had nothing to do with the work that I had created. What it meant for me was meaningless. I'm at this point much more interested in what the play actually says in its own terms.

I always considered myself not a kind of didactic political playwright, but I also thought, if I've talked all this time about political theater, I ought to try to write one just to see. Then this incident happened with the Mapplethorpe photographs and Jesse Helms, and it just seemed to cry out for somebody. Jesse Helms was a consummate politician,

but he knows nothing about anything else. I waited five, six months for some big playwright to write about this obviously theatrical problem of people on Capitol Hill looking at dirty pictures. Why doesn't someone write that play? It's just asking for it. I said, finally, "If no one else is going to do it, I'll do it." That became *7 Blowjobs*.

There were people who hated it. Even in the arts community, the feeling I got was that it was in bad taste to do this kind of thing, that the more high-minded approach was to do the op-ed approach. I don't agree, because it would not be engaging social realities in any aggressive way. I was not just throwing my opinion out there. I was making fun of them for their hypocrisy. One of the great and noble traditions in this country is of making fun of politicians for being fat-assed, lying, corrupt, hypocritical buffoons, and not even bothering to take them seriously at the op-ed level when they're obviously crooks, and just mocking them because Americans love to make fun of people who are buffoons. That's a noble and healthy thing. Well, it used to be considered so.

I just make something and then it appeals to whomever it appeals to. Obviously, I'm demanding from an audience something different than most of what the mainstream people do. I do want to provoke. I do want to make them think. I want them to think about assumptions. I think the job of an artist is to challenge all assumptions, not in the interest of being a wiseass or a prophet in a new era, but just because when you challenge assumptions then you suddenly see there are different things going on that you never saw.

One of my exercises for my students is I tell them to go into a restaurant, to write down all the conversations, and to bring them in. They bring in real conversations and it's so

much crazier than any play, and usually better. When you write down what you're hearing you're actually getting in pure form your style as a writer. You can learn so much about how you take in language and listen to people. What should happen on stage has to be at least as interesting as what you get in the world, on the street, because people are not always concerned about the motivation or explaining things to you. There are other agendas.

A problem with playwriting is you do use up human experience when you write a play. It's different from poets and novelists. Young playwrights particularly use up huge bouts of their experience quickly and there's nothing left to write about, and if they haven't done it well, they're dead. Hopefully when you get older you can write about smaller things that may be just of significance as those big things.

MAC WELLMAN

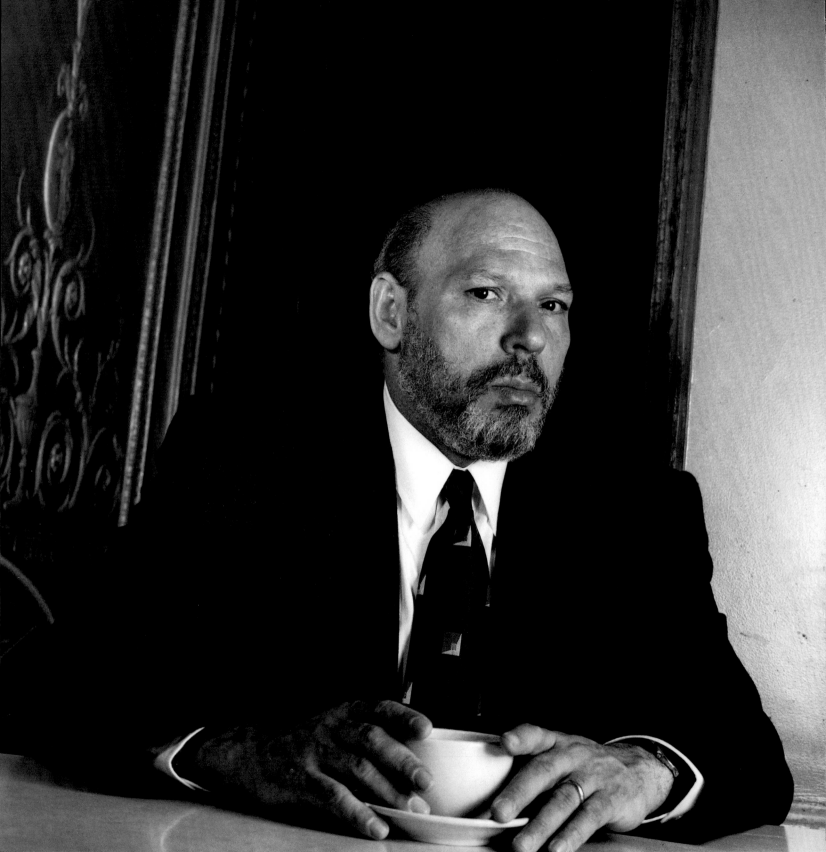

AUGUST WILSON Born in 1945 in Pittsburgh, Wilson has written several important plays, including *Ma Rainey's Black Bottom*, *Fences*, *Joe Turner's Come and Gone*, and *The Piano Lesson*. He is one of America's most celebrated dramatists, having earned numerous prizes, among them the Tony Award, the New York Drama Critics Circle Award, and the Pulitzer Prize for Drama. Wilson died in 2005.

AUGUST WILSON

I personally became aware of theater as a political tool. It's a tool for actually politicizing the community. In 1968, me and a friend started an amateur community theater called Black Horizons, with the express purpose of using that to raise the consciousness of people. My friend wrote a play—I had never actually seen a play written down before. I read it, and I said, "Let's do it." And he said, "How?" And I said, "I don't know, let's get some people." And we got some people.

It's difficult to say what impact any particular performance has on an individual in the audience. It may alter their thinking forever—you don't necessarily see the results of that. We were excited by the fact that people wanted to come back. They wanted us to do another play, so obviously they were gaining something from it. And the plays we were doing then were very political, so the assumption is that those ideas were being passed on to the people and they were embracing them.

My idea of language comes from my years working as a poet. If I were not a poet, I'd be a different kind of playwright, I think. Poetry forces you to think a certain kind of way. I mean, when you sit down to write your poem you have a sort of distillation of language and ideas and you sort of choose very carefully the exact word. When I started writing plays, I brought all of that sense of craft and sense of the idea of art.

I wrote *Jitney* in 1979, and that was the first play in which I took advantage of black speech, if you will. Up until that point I did not value and respect the way in which black people talked; I thought that in order to make art out of it you had to change it. When I found out otherwise, during the writing of *Jitney*, that was really freeing. I discovered it simply from a quote that Sekou Touré wrote in a pamphlet,

The Political Leader as a Representative of a Culture. He said, simply, that language describes the idea of the one who speaks it. I found that idea liberating and realized that there is nothing wrong with the way that black people talked, that their language was simply describing the idea, and their way of speaking it was as valid as any other.

I dropped out of high school at fifteen, but, as I say, I dropped out of school but I didn't drop out of life. I didn't want my mother to know that I wasn't going to school, so I would get up every morning and I would leave the house as though I were going to school, and instead I would go to the library. I went to the library and I felt free. In school they would labor over, say, the Civil War, four pages a day for two months, and I'd go to the library and read four books on the Civil War. One of the things about the library is that the information was given to you. In formal education, you have to prove your proficiency at a certain thing in order to move on to the next level, but when you go to the library, they don't even ask you if you can read! They just give you the information. So, I felt free that I could read the things that interested me. I read books on theology, I read books on cultural anthropology, on the average mind, the origin of table manners, on furniture making—things that I certainly wasn't getting in school. And I thought, all this information is here and it's totally free, and it just blew me away. It's not the best way to get an education, however. I have hodgepodge knowledge—I know a little bit about everything, or at least a little bit about the things that interested me. When I was twenty, after five years, I left the library, and I left my mother's house, and I went out in the world to find what else there was to learn.

I was writing all the time. That's where my old habit of writing in bars and restaurants comes from. Because when you're a twenty-year-old poet, you can't sit at home and write poems, because you don't know anything about the world. So I was out exploring life and I was always ready at a moment's notice to sit down and write something. And I feel fortunate, because a lot of my friends at that time were painters and there was a constant struggle for them to keep their tools, to get chrome yellow paint for their paintings, and the canvas and all of that. I felt my tools were very simple, that you could actually borrow them from anyone: a pencil, a piece of paper, a paper bag, a napkin.

Early on, I was shielded from the indignities that came with being black. For instance, as I discovered later, in Pittsburgh in the forties, if you went to a store, they did not give you paper bags. No matter what your purchase is, blacks didn't get paper bags. You had to carry your purchase out without a bag. My mother certainly didn't tell me that, because she didn't want me to know. She was trying to be the authority figure in my life, and for me to know she couldn't get a paper bag in a store would in a sense destroy that. And also, if she had told me, she would have came home one day and I'd have had five-hundred paper bags there in the house that I got from somewhere. "Hey, Ma, there's your paper bags!"

When someone asked Romare Bearden about his work, he said, "I try to explore in terms of the life I know best, those things that are common to all cultures." And I thought, "That's a fair artistic manifesto there. Why don't I do that?" And at the same time, I was reading James Baldwin. In one of his essays, he called for "a profound articulation of the black tradition," which he defined as, "that field of manners in ritual of intercourse that can sustain a man once he's left his father's house." And so, to this "field of manners" in ritual, I added the word "social"—rituals of social intercourse that are yours, so that when you leave

257

your parents' house, you are fully clothed in manners, in a way of life that is sufficient. And so that became what I thought I would do—take that tradition and place it on stage to demonstrate that it existed, first of all, and that it was capable of sustaining you, and that there were no ideas that could not be contained by black life.

I wrote a play called *Ma Rainey's Black Bottom* which was set in the twenties, and then I wrote a play called *Forwardness Street* which was set in the 1940s, and then I was working on *Fences* and it was in '57, and I thought, "I wrote three plays in three different decades, why don't I just continue to do that?" So I did, and that was the best thing that happened to me as an artist, because I didn't have to search around for an idea for something else. I would just pick a decade and go.

I don't have any problem in being referred to as a black playwright since that's what I am. I can't deny that. Sometimes, the implication of that is that there's at least, you know, thirty-seven white writers out there who are better, but you're the best black writer that we have. Otherwise, I don't have a problem.

Success is wonderful, but you can't sit down to write with that on your shoulder. I always say I'm a struggling playwright, because I am struggling to get the next play on the page. You sit down in the chair, and it's the same chair that Eugene O'Neill sat in, that Tennessee Williams sat in, that Chekhov, Arthur Miller, whoever you want to name, that's the same chair—it's the playwright's chair. And you're confronted with the same problems—how to get a character on stage, how to get out your exposition, how to develop a character. Those problems have been brilliantly solved by some of these playwrights, so you have a ready made model, but basically it's you and the page. A play, after all, is just words on the page, and words are free. You don't have to go down and buy five pounds of words. There can be five thousand words. And if it doesn't work, you tear it up and start over. You sit there until you get something. My point is, I found that empowering. "Oh my god, I'm sitting in the same chair as Eugene O'Neill! That means I can write the same thing that he wrote! I can write just as good as Chekhov—maybe better!" Because that's all it is, just words on a page. What words am I going to put on the page? How am I going to tell my story and develop my characters? There is absolutely no reason you can't write a play as good as Chekhov, or William Shakespeare for that matter. When you sit down and write, write the best play that's ever been written.

If you're not trying to do that, why bother to sit down? Why not write the best play that's ever been written? Whether you achieve it or not, that's a whole other situation, but certainly if that's what you're trying to do, to me, you're bound to do better work than if you're not trying to do that. I read this quote from Frank Lloyd Wright in which he said he didn't want to be the best architect that ever lived. He wanted to be the best architect that was ever *going* to live. So now, you see, you have to beat your predecessors, but you've also got to beat your successors. So now, when I sit down and write, I try to write the best play that's ever going to be written in the history of the world.

I don't believe in writer's block. Writer's block is people trying to prove that they are writers. They say, "Oh, I've got writer's block, that must mean I'm a writer." I always say there is another way to prove that you're a writer. Just go ahead and write it! When you sit down to work, it's not always there. If it's not there, get up. Do something else. Come back tomorrow. Try it again, you know? And then if you're terrified, just do it! It doesn't matter, because the

words are free. If it doesn't work, tear it up, start over, have fun! That's really the way I approach it. Some days the play's not ready to be born and you're just sitting there. Come back a couple weeks later and—bingo—there it is. But if you sit around saying that you've got writer's block, you're doing a disservice to yourself.

The next step, the first rehearsal period, is so important because the characters you've created are still in the process of being defined. You've already presented the possibilities of their definition in the script—now the actor has to take and embody that. Very often, as they do that, you see the character emerge, and then you get other ideas about the character. I will often go to the actor and say, "Okay, what do you need? You've got to stand up here and say all these words. Are you missing anything? How do you feel?" Sometimes, they're like, "Oh yeah! When the other character, the other actor says that to me, I feel like I should have a different response." I totally trust that, because their process of embodying these characters has lead them to certain places. I'll ask, "What kind of response do you think they would have?" They tell me and sometimes I go and write it. I'm willing to accept that kind of contribution from anyone. I don't care—it can be a visitor to rehearsals who suggests something, and I might say, "That guy has a good idea. Thank you." I've gotten ideas from interns, from actors, directors—I'm open and willing to listen because, ultimately, it belongs to all of the actors, all of the people—it's our project. They are all helping me carry the weight of this play. Helping to realize, in essence, my vision—but I need all of them to communicate it.

Sometimes something amazing happens when those words I wrote alone become a scene on the stage. During rehearsal of *Ma Rainey's Black Bottom*, we were up at Yale, and it's the point where it says, "Toledo steps on Levy's shoe." So we're rehearsing this, and the actors did that, and they did it in such a manner that we thought that the two individual actors were having a dispute and were ready to come to blows. Myself, Duane Andrews, who was the music director, and someone else all sprang out of our seats to get in between these two guys. And they looked at us like, "What are y'all doing, man? This is the play!" But it was so real that all of us, without consulting one another, jumped up to stop these two guys from fighting. They were just saying the lines of the play, but it was one of the most stunning moments I remember.

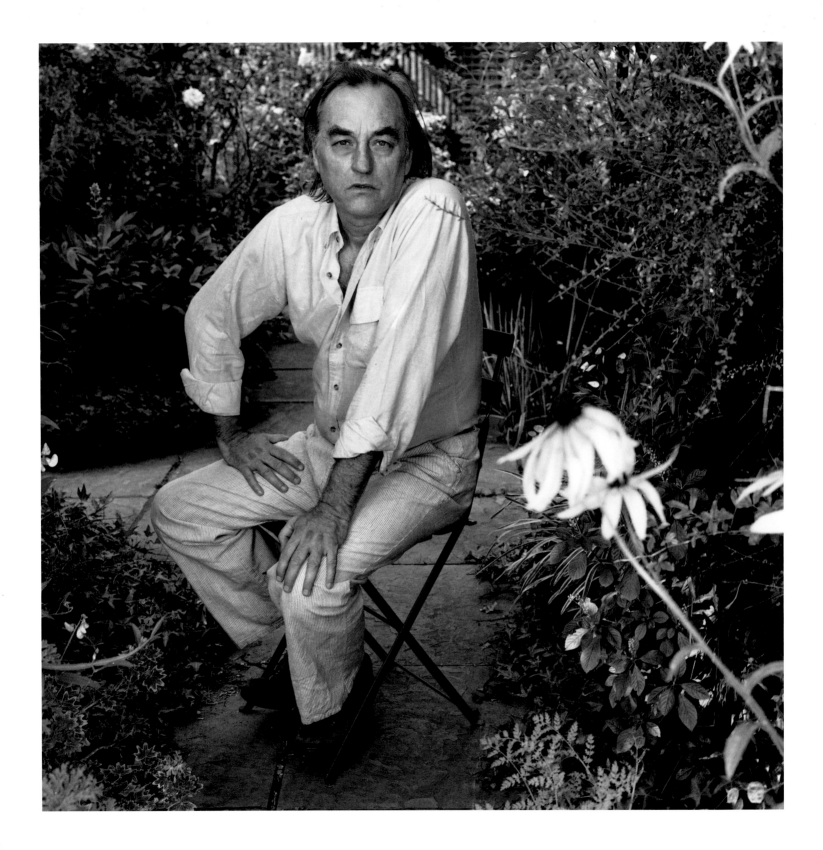

LANFORD WILSON

Born in 1937 in Lebanon, Missouri, Wilson is the author of dozens of plays, including *Lemon Sky*, *The Hot L Baltimore*, and *Burn This*. He is the recipient of numerous honors, including the Pulitzer Prize for Drama for his play *Talley's Folley*, Obie Awards, multiple Tony Award nominations, and induction into the Missouri Writers Hall of Fame and the American Theater Hall of Fame.

I was working at an ad agency in Chicago and writing short stories on my breaks. One day, I thought of a story and I said, "Oh, that would work better as a play." I started writing and by the second page I knew I was a playwright—it was that clear. If someone would have asked me that afternoon, I would have said, "I am a playwright. I write plays." Doors just opened all down the hall, just flew open. The possibilities were endless.

I had never had an experience like that before. I also knew immediately that I would never be satisfied with anything. That as soon as I finished something I would start something new to help me be better. It was a fucking miracle. I saw no future at all, no rewards, I just saw my work. I knew what I was supposed to work at. I knew what I was supposed to do. I knew what I could do. I knew I could write a bunch of plays. I wanted to tell good stories, beautifully done, with beautiful language. Not Shakespearean language, just music to your ears, and yet sound just ordinary as soap. Just a regular old story as if in other words you would never be conscious of the sound of the play over the story you are getting. Well, I sometimes fudged on that one. But anyway, I knew all of that instantly. I was twenty years old. Then I realized, I don't really know how to do this. So I took a class in playwriting, and learned about conflict expression and all the things a play is supposed to have.

I went to Chicago for two weeks to visit all my friends from Ozark, Missouri, who had gone to Chicago and I ended up staying there for six years, trying to write plays. I wrote three plays, all of them very bad. Then I went to New York and found the Caffe Cino in the Village on Cornelia Street, and I started writing a different kind of play. I started writing about things and people I knew.

Balm in Gilead was a turning point. I was just writing down things I heard in the cafe, in an all-night café. I am an all-nighter. And I would just sit down there and whenever I heard something interesting I would write it down. Sometimes I would write a whole little dialogue based on something I had heard. I was just writing sound patterns and stuff like that. I imagined it as a novel in play form, if it was ever published. Certainly nothing to be produced, because I had fifty-five characters in the first draft. It was just something to do. It was an exercise in writing, it was an exercise in dialogue, it was an exercise in sound. Only much later did it evolve into a play. And when I finished it I really liked it. It hadn't crossed my mind that I was writing a full-length play. It would be the first full-length play I had written. I was thrilled by that.

The first time I saw something I had written performed was in Chicago. I wrote the monologue for a drag queen in a bar. I told him a friend of mine wrote it, and gave it to him. This is a big huge butch guy with a beard. He was a bartender and he had about a six-days growth of beard, with his shirt buttoned to where it gaped, the holes gaped from button to button. Just a terrific bartender and a terrific guy. He sounded like a truck driver. He used to do Phyllis Diller acts. He would put on a wig. He would just be bartending and then suddenly he would have on this wig that piled up like Marie Antoinette. He didn't change anything else, he still had on the same clothes, the same shirt, and the same beard, and he would do a beautiful rendering of one of Phyllis Diller's routines. It was funny, it was a scream. And so in Phyllis Diller's rhythms, I wrote him a comic piece and told him that a friend of mine wrote it. The scary thing was, the next night, I went to the bar and was absolutely shocked out of my gourd when from the back room came my words. He just understood it perfectly and he understood the rhythm of it perfectly.

I didn't admit I wrote it for three or four years. He said he had known all along, and he was just embarrassingly encouraging, saying, "You've got to write."

I have a fascination with Chekhov. I did. It was years and years ago. It was back in *Gingham Dog* days. I was told that I wrote something like Chekhov. I had read his stories. I had read a few of his stories and none of his plays. And so I said, "God, if I am going to be compared to Chekhov I should at least know what he was like." And so I read Chekhov and was blown away. But I am not like that. I see exactly what they mean, but I am not like that at all. It is just this longing that he had for a better world—a slight dissatisfaction or disappointment with the way things are. We do share that, so I could see what they were talking about. I wanted to translate *Three Sisters*. So I went to Berlitz for quite a while. I learned Russian and I could talk to cab drivers and stuff like that. It was great fun. But now I've lost it, among other things.

I haven't written anything in almost three years. What's the reason? I stopped drinking, for one thing, even though I never wrote when I was drinking. I would wake up in the morning and write and then be finished by about four or five or so. And then along about seven I would celebrate the day with a Martini and then several more. And then my doctor said that that was a very bad idea and that my liver was shot, or nearly shot. So I stopped drinking and I haven't written a word since. I sure would like to write another damn play.

LANFORD WILSON

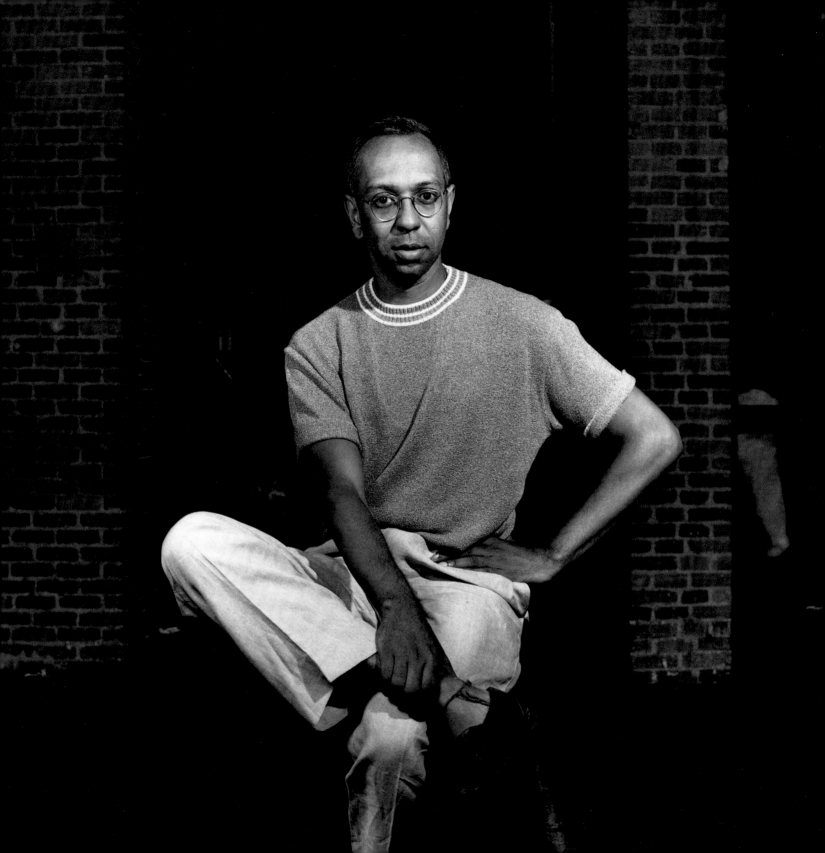

GEORGE C. WOLFE

Born in 1954 in Kentucky, Wolfe received the 1996 Tony Award for his direction of *Bring in 'da Noise, Bring in 'da Funk*, and has authored numerous other titles, including *The Colored Museum* and *Jelly's Last Jam*. Other awards and honors include grants from the Rockefeller Foundation, and the National Endowment for the Arts, as well as numerous Tony Awards. As longtime artistic director of the Public Theater, Wolfe was designated a "living landmark" by the New York City Landmarks Conservancy.

GEORGE C. WOLFE

In the landscape of theater, the writer has a tremendous amount of power. What the writer thinks, what the writer feels, what the writer believes is of tremendous value. Now, there are aspects of my personality which allow me to be a good director or a good producer or a good member of the theater community and a responsible artist. But I think in many respects the more reflective aspects of my personality, as well as the most wicked and most subversive, are those of the writer.

I'm not really big, I don't have a lot of muscles, I don't have that stuff going on. So my mind, my language and how they worked together, were my earliest weapons of survival, my earliest means to carve out a space for myself. I think I'm fundamentally irreverent. There's a part of me that looks at the world as if I'm on the outside, looking in. The writer in me never wants to be in front of the class telling everybody what to do. The writer in me prefers looking at the person who's telling everybody what to do and finding him foolish and finding everyone else in the room believing him just as foolish. There's nothing greater than seeing the foolishness in what people are fighting passionately about. If people are passionately defending something, more often than not, I will say the exact opposite thing. That's the satirist in me, the subversive, the same person who wrote *The Colored Museum*.

I'm scared of snakes and I'm scared of certain heights, but I'm really not scared of people. If I believe in something, I have no fear. The passion and beliefs are stronger than my fear, my curiosity about a moment is stronger than my fear, my sense of adventure is greater than my fear. So it's not exactly that I have no fear, it's just that if someone's violating the work, I'm going to step to the foreground. Not because I'm brave and heroic, but because I believe it needs to be protected. That is the source of the warrior energy in me.

If I could only do one thing, it would be the writing. Producing fulfils a certain kind of responsibility that I feel toward other artists. Various people supported me very early in my career and let me play. And I got to play, and I've had a great career as a result of it. Now my job is to create structures so that other artists can play and grow. Directing fulfills the need inside of me to be a part of a community, to go on a journey with a group of people with a shared a belief system and common goal. And the writer in me is the person who has secrets, secrets about the human condition, secrets about life and love and loss that I want to share with people. It's the private me getting to express itself.

The mission is more unconscious as a writer. When I begin writing, I can't be loaded with agendas. What you try to

do is put yourself completely inside the moment. With producing, it's somebody else's moment. With directing, you're in the process of crafting the moment. But in writing, the moment is springing forth from you.

I think I'm writing for people who are dead—ancestors, people from my family—and I'm trying to honor people who didn't get honored enough. I know that sounds strange—"I'm writing for dead people!"—but I think that's what's going on. I'm writing for my grandmother, or for Paul Robeson. Not Paul Robeson himself, but for that person who was destroyed for being as brilliant as he was, as they were.

When I was little, I would write stuff all the time, all the time, all the time. I went back to my hometown recently, and one of my cousins told me that whenever everybody would play house, I wouldn't just play, I would tell everyone what lines they were supposed to say. That's the writer and director in me, even back then.

My senior year in college, I wrote my first play, called *Up For Grabs*. There's this point where this character named Babba Z, who is like a black revolutionary figure, is giving this political sermon, and it was very funny. The actor who was doing it was very funny—and the whole audience was laughing and laughing. And then right in the middle of the speech, he got shot, assassinated, which was then followed by a chant which chronicled a four-day riot. "Babba Z was murdered and the people screamed and their screams turned to anger and their anger to rage as the night saw black for days." And it ends up with this very quiet moment. I remember sitting in the back of the theater and feeling this extraordinary sense of power. Not power in the sense that somebody else is beneath you and you're on top of them, but power in the sense that I had

crafted words that have an audience laughing one minute, and then it shifted and they were suddenly very silent and still and overwhelmed. That's an amazing thing and it made me want to make sure that I was always very responsible with that power. You know what I mean?

Years later, I was living above 95th Street and I was sitting at home, writing, probably drugged out on 8,000 cups of *cafe con leche*. At one point, I wrote something, and I knew it was wicked and naughty and was going to piss a whole bunch of people off. I felt like there was this little demon on my shoulder, laughing and saying, "Do it! Do it!" There was another moment while I was writing *Harlem Song*, where I heard that same little creature saying, "Say that thing you're thinking…go for it!" Periodically, there's part of me that goes, "Oh, that's a boundary—push beyond it." Not just to be provocative, but because there's something on the other side that's going to arouse an audience that will then make them vulnerable to what's coming next. There's a great sense of power in that.

And there was another moment when I was directing *Jelly's Last Jam* at the Virginia Theatre. I had just described over the god mike what I wanted to have happen, and the stage manager said, "Okay, George, we think we can make that happen, but we're going to need about fifteen minutes to figure it all out." Inside a theater is like a village. There are eight gazillion people running around—technicians and actors and costume people. I just thought, what an incredible gift that all of these people are now going to spend the next fifteen minutes trying to make a moment that is a vision in my head possible. It's almost the same thing as when I was sitting at college watching *Up For Grabs*. And I was reminded again, you need to be very smart about what you request and what you need. Don't ever violate the power of your talent. You know what I mean?

DOUG WRIGHT

Born in 1962 in Dallas, Texas, Wright received the Pulitzer Prize, the Tony Award, the Drama Desk Award, and a Lucille Lortel Award for his play *I Am My Own Wife*. Other works include *Watbanland*, *The Stonewater Rapture*, and *Quills*, for which he received an Obie Award. He serves on the board of the New York Theater Workshop.

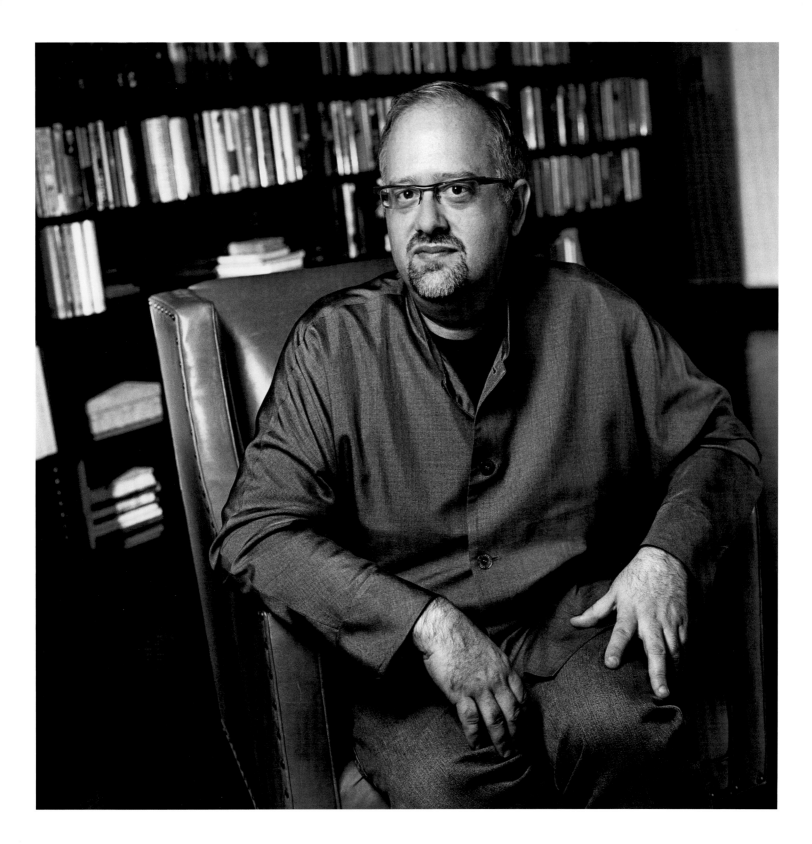

Doug Wright

As a playwright, you have less in common with the novelist or the poet than with a cookbook author. With your list of characters, you have a list of ingredients, and the play is how they all come together to form an event. This character crosses the table and says these words, and this results. When you write a play you're creating a template for a three-dimensional event so that it can be constant from venue to venue, regardless of director or cast. So the same way Martha Stewart writes a recipe for lemon bundt cake, the playwright is writing a particular recipe and hoping that it results in his intended dish each time.

My first play was this sort of epic, pseudo-British melodrama that I wrote when I was eleven years old. It was four exhaustive acts, and it was called *The Devil's Playground* —it was set in this Gothic manor house and in the end everyone died. I remember finishing the manuscript and being so flushed and proud and certain I'd be the youngest author to ever get produced. My mother, in this astonishing gesture of support, typed the entire manuscript, because she wanted to encourage me and she wanted it to look professional. I think that maniacal act of devotion gave me the requisite to keep going.

I was a kid in Texas, but I had this fatal affection for old movies and for the theater—my parents took me to see my first play when I was impressionable and I took to it immediately. Growing up gay in Texas you find yourself marginalized and silenced because you're afraid to voice authentic feeling for fear of being censured. So you start to observe the world and you become markedly sensitive to other people, because you're always wary of a potential attack. You become good at reading and examining people, partly to preserve your own safety. On another level, Texas has an astonishing, larger-than-life sense of itself—it's a state with a lot of color, a lot of willful eccentricity. There is a kind of grandiosity of expression down in Texas. Nothing's a story; everything's a tall tale. And that fuels drama. Anytime you embrace hyperbole, you're on your way towards drama and Texas certainly does that. So I think it's those things combined—being gay in a flamboyant state.

How does a play start? As a young man, I was living in Astoria, Queens, and taking the subway home every day after temping, and I'd hear these remarkable women with their sort of high-lacquered hair, their Candies platform shoes, and their Strawberry shopping bags, and they would speak in this incredible vernacular, this Queens idiom that I found fascinating. So I started trying to capture it at home on paper, and the voice of this young, New York-based secretary started to come out and it eventually became the play *Watbanland*. So that play happened because I heard a particular voice on the subway in the early evening.

If it's a character, it's not always an adequate idea. If it's a voice, it's not always an adequate idea. If it's a theme, it's rarely an adequate idea. But if it's an event, then you have the seeds of drama. *Quills* started when a former lover gave me an autobiography of the Marquis de Sade as a Christmas gift. That probably spelled the end of the relationship, but

I remember reading in the biography that the Marquis was penning such extravagant pornography that the asylum decided to confiscate his pens and I thought, "That's a hell of an event. That's the beginning of a play."

A wonderful director, Lloyd Richards, once gave me the best piece of advice I've ever had. He said, "Write for people who are smarter than you are." I thought that was a gorgeous challenge. It's always about rendering a problem with a little bit more complexity, or creating a character with a tad more nuance, or asking the thematic question a little more pointedly, and taking it a step further—always challenge yourself to write for somebody you admire who lives slightly beyond you, and that will create a work of integrity.

Opening night, I never watch a performance, because the slightest hiccup can make me apoplectic. I am just not a reasonable human being on that night. I know that work is under heightened scrutiny, so with every little line flub, every little pause that's over-long, if the set is a fraction off its mark, or a single joke doesn't get a laugh as hardy as it did the night before—I become irrational. I can't be there. I don't know why.

My favorite moment with a critic was when I wrote one musical early in my career and John Simon apparently called it, "the gayest event in New York since the Stonewall riots." And I think he meant that in, perhaps, a less than flattering light. We were ready to print it on t-shirts. We thought it was heaven. So sometimes the bad reviews are ironically the ones that exhilarate you, because you touched a nerve. There's this one quote—I don't remember who said it—but my boyfriend often uses it to console me: "A critic slits the throat of the songbird to discover how it sings." I've always thought that was relatively apt.

We don't have real theater critics anymore. What we have —they're kind of like personal shoppers for the theatergoer, and you can hardly blame them or the audience for wanting that kind of coverage, because a night at the theater has become a major investment. If you're going for Mother's Day and you want a thrilling Sunday afternoon for mother —and if you're taking the whole family, you're talking about a thousand-dollar day—then you want *Consumer Reports*. You don't want George Bernard Shaw commenting on the ideological waste of the piece and the time it's presented. So with ticket prices what they are, you can hardly blame the readership if they want that kind of reportage. But I don't think it does much to nurture good writing.

I feel like being a playwright is like saying I'm a Gothic stone carver or I blow glass for a living, like it's that archaic a form. I find I apologize for it a lot. I also find it's the most vital art, because it is in three dimensions, it's immediate stimuli and response from the audience, it creates public debate in the way we rarely see it in our culture. Theater is one of the few refuges we have left for honest discourse and so it's an indispensable medium. But, like so many people, I do think it's a dying one. With *I Am My Own Wife*, I had a play that achieved more than I could ever hope for theatrically, yet if I had been reliant on that play for an income that year, I would have been in default on all my bills. I had to take screenwriting jobs even while I had a successful play running on Broadway and I think that's so sobering. Playwriting, properly put, is my avocation, because I cannot afford to do it full-time. That's a pretty dismal state of affairs in terms of the art, and yet if I could devote myself full-time to it tomorrow I would, because I think it's the most worthwhile thing I could do.

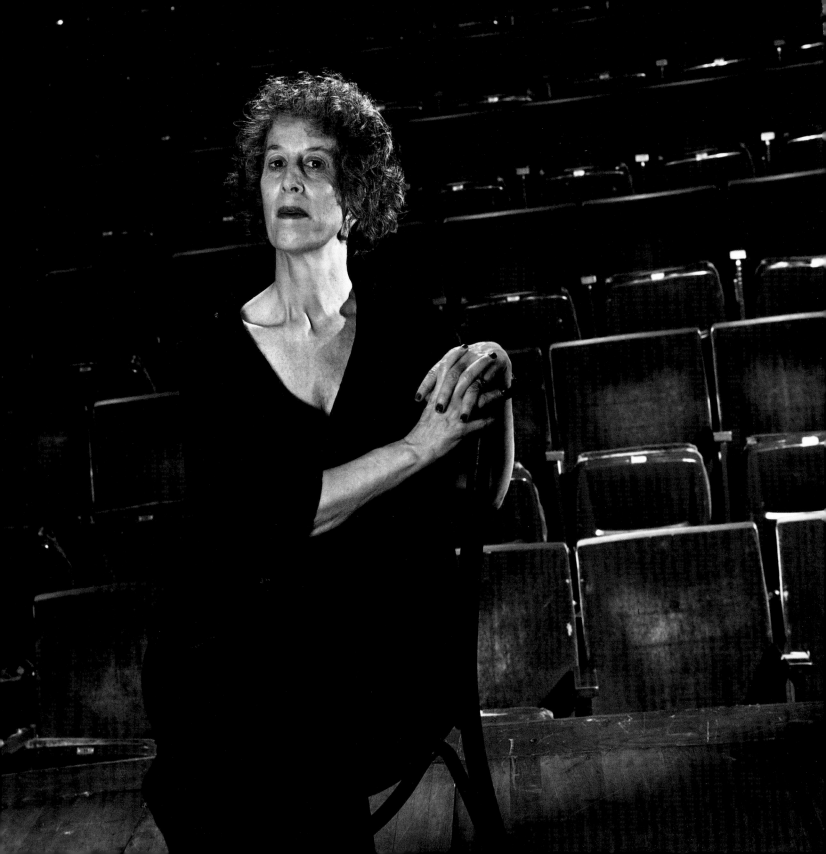

SUSAN YANKOWITZ

Born in 1941 in Newark, New Jersey, Yankowitz is a playwright, novelist, lyricist, and librettist best known for her plays *Foreign Bodies*, *Terminal*, *A Knife in the Heart*, and *Night Sky*. She has received a Drama Desk Award and has been honored with grants from the Guggenheim and Rockefeller Foundations, among others.

I see the theatrical event as something magnetic, hypnotic, emotionally and physically compelling. The audience leans forward in their seats; you, the writer, entice them into your work with everything at your disposal—light, sound, movement, gesture, image—not only words, as some believe. In fiction, you are limited to language, but in plays you also take advantage of bodies, voices, objects, space, sometimes masks or music. You are blessed with many more possibilities.

Not that words are unimportant. Not at all. In any play, everything pertaining to language is important: what's said, what's not said, how it's said, the vocabulary, the syntax, the stammering, the inability to express a feeling, the humor, the timing of when revelations come, how they come. There's no element of dialogue that is insignificant. Every word counts as an expression of character, mood, motive and theme. Subtext is communicated exclusively by the relationship between what's said, what's unsaid, and what's enacted. Two people having a heated argument about politics at a table might be playing footsie under the table, for example. Or a woman could kiss a man passionately just after stating that she hates him. The physical action adds another layer to the discourse and skews or complicates its meaning. A playwright has a unique opportunity to juxtapose visual and verbal impressions, creating multiple levels that will ultimately color the viewer's interpretation.

In a society addicted to movies, ads, internet and television, many people have no appreciation of subtext. They may be satisfied, perhaps, by plot or spectacle and go home humming the story or the chandelier. In my view, a successful theater experience includes such pleasures but is not limited to them: at its richest, it brings the audience members into conjunction with the eternal human dilemmas, joys and sorrows; it's a mirror—deliberately distorted by artifice—of who we are.

From childhood, I always expected I would become a writer of some sort, but playwriting never occurred to me. In college, I never even took a theater course. The year after I graduated, I went to India with a boyfriend who was writing plays, and I was intrigued enough to give it a whirl. The form suited me; perhaps it was already dormant in my genes, as my mother had been an amateur actress who always longed for a life on the stage.

When I left India, I came back to New York and through a series of coincidences, was introduced to the stunning, unorthodox work of Joe Chaikin and the Open Theater, a conception of theater that was non-naturalistic, non-linear, and anti-psychological. Its effect on me—and on its audiences—was simultaneously visceral and abstract, intellectual, political and emotional, daring and unpredictably powerful. Almost immediately, I connected to the group and its vision. Two years later, I was at Yale Drama school as a

SUSAN YANKOWITZ

playwright, to learn the craft, and four years after that, was invited into the Open Theater as the writer of *Terminal*.

The process entailed a long and true collaboration, to which every member of the group contributed. Roles overlapped. The actors were encouraged to bring in material which I then shaped. I suggested physical images; the director wrote lines for several scenes. Everyone participated, and everyone felt pride of possession when the piece was completed. I never tired of seeing productions of *Terminal*, in both its old and new incarnations. I could stand at the rear and each time be thrilled and moved to tears at the end, as though the piece weren't my own. And in truth, it wasn't my own—it belonged to everyone who had shared in its creation: among others, the shaman who danced and chanted an ancient ritual to call up the dead, an embalmer who described his somewhat morbid and shocking techniques, the designers who concocted a set of slabs that could represent a headstone, a bed, a gurney and a wall at the same time.

Which is not to say that all collaborations or production situations are necessarily joyous. Many of them have caused me more frustration and pain than I care to document. And writing on my own is also a balancing act, especially in a period which is in love with smiley faces and uplift. I've always despised that adage, "Write what you know," a bromide that leaves no room for the imagination. For me, writing is wonderful precisely because it impels the artist outward, from the self into the world. How else will we understand others if we don't inhabit them imaginatively? But we live in a time so politically correct that, for instance, when I wrote a novel about a deaf mute, some people were offended that a hearing person dared that act of empathy. If one were restricted to writing about oneself, Shakespeare couldn't have created Lady Macbeth, Oscar Wilde couldn't have conceived a heterosexual romance, etc. It's absolutely ludicrous to incarcerate writers in their own time, background, milieu, and identity. It subverts the very essence of writing, which is to metaphorically connect with those outside the narrow realm of self.

In my work, I am actively attracted to characters quite alien from me: the mother of a mass murder, a woman who becomes aphasic, a survivor of Jonestown, an opera singer, a deaf-mute. I tend to invent them from the outside in—what they look like, how they move, the sound of their voices, the expression of their sexual desires, their physical mannerism. My great pleasure in it is not being myself for a while. After all, I've lived with myself for so many years; it's boring to navel-gaze.

Naturally, I have many friends in theater—actors, playwrights, critics. I can't have been doing this for so long without having formed relationships. But playwrights in general are the most isolated members of the theatrical community: we write a play in solitude, then hand it to actors, who come together, with a director, as a group. The playwright stands outside the production, represented by words on a page. You stand or sit or agonize outside and then it takes you another three years to write another play, and three more to see it on its feet. In the meantime the actors and director have skipped from your project to ten more. To some degree, writers are really mercenaries, invited to the party because of our scripts, kicked out when the production team gets going. We labor on our own most of the time—and when our work is finally given life, we're shunted aside, a spectator of our own creation. Everyone else is working together, but unless the circumstances are unusual—a collaborative effort, an ensemble creation— the playwright remains on the outside. It's a strange, ironic, though not altogether disagreeable, fate.

Acknowledgements

The authors are deeply grateful to friends who offered support and advice: Nick Baran, Roberta Bernstein, Carrie Casselman, Sylvia Cedeño, Jeremy Desmon, Tom Gitterman, Mollie Knox, Tim McGlaughlin, Sandra Scott, Brian Singer, Paul Slattery, Whitney Stevens, Zachary Thacher. As transcribers and editors, Margaret Bristol, Melissa Katzman, Isabelle Loverro, Ashley Nichols, Randi Sherman, Rachel Sontag, and Jeanette Wishna helped tremendously with the "technical" aspects of the interviews.

Thanks to our publisher Umbrage Editions who made the six-year journey see the light, to publisher Nan Richardson, Amy Deneson, and especially Emma Bedard who played a crucial role in guiding this project to completion. Lastly, we offer our highest gratitude to the playwrights who shared their time and wisdom. We are honored to have had the chance to get to know them, including those great artists—Jack Gelber, Wendy Wasserstein, August Wilson —who are no longer with us. Their wonderful and important work will continue to inspire.

Bibliography

Adler, Thomas P. *American Drama, 1940-1960: A Critical History*. New York: Twayne, 1994.

Aronson, Arnold. *American Avant-Garde Theatre: A History*. New York: Routledge, 2000.

Austin, Gayle. *Feminist Theories for Dramatic Criticism*. Ann Arbor: University of Michigan, 1990.

Barlow, Judith E. *Plays by American Women: The Early Years*. New York: Avon Books, 1981.

Bigsby, C. W. E. *A Critical Introduction to Twentieth-Century American Drama*. New York: Cambridge University, 1982-1985.

Bigsby, C. W. E. *Contemporary American Playwrights*. New York: Cambridge University, 1999.

Bigsby, C. W. E. *Modern American Drama, 1945-2000*. New York: Cambridge University Press, 2001.

Bordman, Gerald, *The Oxford Companion to the American Theatre*. New York: Oxford University Press, 1984.

Bronner, Edwin, *The Encyclopedia of the American Theatre 1900-1975*. San Diego; New York: A.S. Barnes & Company, Inc., c. 1980.

Brown, Janet. *Feminist Drama: Definition & Critical Analysis*. Metuchen, New Jersey: Scarecrow Press, 1979.

Clum, John M. *Acting Gay: Male Homosexuality in Modern Drama*. New York: Columbia University Press, 1992.

Cortes, Eladio and Mirta Barrea-Marlys, ed. *Encyclopedia of Latin American Theater*. CT: Greenwood Publishing Group, Incorporated, 2003.

Counts, Michael L. *Coming Home: The Soldier's Return in Twentieth Century American Drama*. New York: Peter Lang, 1988.

Crawford, Mary Caroline, *The Romance of the American Theatre*. Boston : Little, Brown, and Company, 1925.

Crespy, David. *Off-Off-Broadway Explosion: How Provocative Playwrights of the 1960s Ignited a New American Theater*. New York: Watson-Guptill Publications, Inc., 2003

Davis, Walter A. *Get the Guests: Psychoanalysis, Modern American Drama, and the Audience*. Madison: University of Wisconsin Press, 1994.

Demastes, William W. *Beyond Naturalism: A New Realism in American Theatre*. New York: Greenwood Press, 1988.

Engle, Gary D. *This Grotesque Essence: Plays from the American Minstrel Stage*. Baton Rouge: Louisiana State University Press, 1978.

Erdman, Harley. *Staging the Jew: The Performance of an American Ethnicity, 1860-1920*. New Brunswick, New Jersey: Rutgers University Press, 1997.

Furtado, Ken, and Nancy Hellner. *Gay and Lesbian American Plays: An Annotated Bibliography*. Metuchen, New Jersey: Scarecrow Press, 1993.

Gavin, Christy. *American Women Playwrights, 1964-1989 : A Research Guide and Annotated Bibliography*. New York: Garland Publisher, 1993.

Gilder, Rosamond and Freedley, George. *Theatre Collections in Libraries and Museums an International Handbook*. New York: Theatre Arts, Inc., c. 1936.

Hamalian, Leo. ed. *The Roots of African American Drama: An Anthology of Early Plays, 1858-1938*. Detroit: Wayne State University Press, 1991.

Hatch, James V., and Ted Shine. eds. *Black Theatre U.S.A.: Plays by African Americans 1847 to Today*. New York: Free Press, 1996.

Herman, William. *Understanding Contemporary American Drama*. Columbia: University of South Carolina Press, 1987.

Hill, Errol, ed. *The Theater of Black Americans*. New York: Applause Theatre Book Publishers, 1987.

Hughes, Glenn, *A History of the American Theatre, 1700-1950*. London; Toronto: Samuel French, c1951.

Kattwinkel, Susan. *Tony Pastor Presents: Afterpieces From the Vaudeville Stage*. Westport, Conn: Greenwood Press, 1998.

Kritzer, Amelia H. ed. *Plays by Early American Women, 1775-1850*. Ann Arbor: University of Michigan Press, 1995.

Kubiak, Anthony James. *Agitated States: Performance in the American Theater of Cruelty*. Michigan: University of Michigan Press, 2002.

Marra, Kim, ed. *Staging Desire: Queer Readings of American Theater History*. Michigan: University of Michigan Press, 2002.

Mason, Jeffrey D. *Melodrama and the Myth of America*. Bloomington: Indiana University Press, 1993.

Meserve, Walter J. and Mollie A. Meserve. eds. *When Conscience Trod the Stage: American Plays of Social Awareness*. New York: Feedback Theatrebooks & Prospero Press, 1998.

McNamara, Brooks, ed. *Plays from the Contemporary American Theater*. New York: Signet Classics. 2002.

Murphy, Brenda, ed. *Cambridge Companion to American Women Playwrights*. New York: Cambridge University Press, 1999.

Murphy, Brenda. *American Realism and American Drama, 1880-1940*. New York: Cambridge University Press, 1987.

Nelson, Brian. ed. Asian American Drama: *9 Plays from the Multiethnic Landscape*. New York: Applause, 1997.

Parker, Dorothy, ed. *Essays on Modern American Drama: Williams, Miller, Albee, and Shepard*. Toronto: University of Toronto Press, 1987.

Philbrick, Norman, ed. *Trumpets Sounding: Propaganda Plays of the American Revolution*. New York: B. Blom, 1972.

Robinson, Marc. *The Other American Drama: Cambridge Studies in American Theatre and Drama*. New York: Cambridge University Press, 1994.

Roudané, Matthew C. *American Drama Since 1960: A Critical History*. New York: Twayne, 1996.

Sanders, Leslie C. *The Development of Black Theatre in America: From Shadows to Selves*. Baton Rouge: Louisiana State University Press, 1988.

Savran, David, ed. *In Their Own Words: Contemporary American Playwrights*. New York: Theatre Communications Group, 1999.

Savran, David. *Queer Sort of Materialism: Recontextualizing American Theater*. Michigan: University of Michigan Press, 2003.

Scharine, Richard G. *From Class to Caste in American Drama: Political and Social Themes since the 1930s*. New York: Greenwood Press, 1991.

Shaland, Irene. *American Theater and Drama Research: An Annotated Guide to Information Sources, 1945-1990*. Jefferson, NC: McFarland, 1991.

Smith, Susan H. *American Drama: The Bastard Art*. New York: Cambridge University Press, 1996.

Vorlicky, Robert. *Act Like a Man: Challenging Masculinities in American Drama*. Ann Arbor: University of Michigan Press, 1995.

Wainscott, Ronald H. *Emergence of the Modern American Theater, 1914-1929*. CT: Yale University Press, 1997.

Wilson, Garff B. *Three Hundred Years of American Drama and Theatre, from Ye Bare and Ye Cubb to Chorus Line*. Englewood Cliffs, New Jersey, Prentice-Hall, 1982.

Young, William C., *Documents of American History: Famous American Playhouses*. Chicago : American Library Association, 1973.